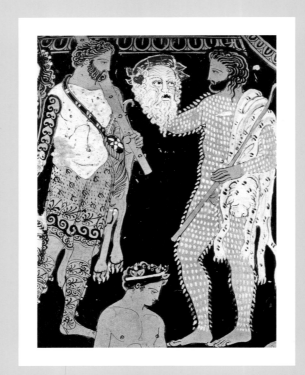

THE ART OF ANCIENT GREEK THEATER

MARY LOUISE HART

WITH CONTRIBUTIONS BY

J. MICHAEL WALTON

FRANÇOIS LISSARRAGUE

MARTINE DENOYELLE

H. A. SHAPIRO

AGNES SCHWARZMAIER

NÉGUINE MATHIEUX

THE J. PAUL GETTY MUSEUM | LOS ANGELES

© 2010 J. Paul Getty Trust
5 4 3 2 1

Published by the J . Paul Getty Museum, Los Angeles
Getty Publications
1200 Getty Center Drive, Suite 500
Los Angeles, California 90049-1682
www.gettypublications.org

This book is published on the occasion of the exhibition *The Art of Ancient Greek Theater*, on view in the
J. Paul Getty Museum at the Getty Villa in Malibu, August 26, 2010, through January 3, 2011.

Gregory M. Britton, *Publisher*
Dinah Berland, *Editor*
Katya Rice, *Manuscript Editor*
Catherine Lorenz, *Designer*
Anita Keys, *Production Coordinator*

Photography by Ellen Rosenbery
Typesetting by Diane Franco
Printed and bound in China through Asia Pacific Offset, Inc.

FRONT COVER: Tragic Mask of a Young Man (detail, plate 39), ca. 150 B.C. Greek, from Asia Minor (Turkey); found in
Amisos, Turkey. Terracotta, H: 17 cm (6 11/16 in.). Paris, Musée du Louvre CA 1958
BACK COVER: Tragic Mask of a Young Man (plate 39), ca. 150 B.C.
FRONTISPIECE: Three Chorusmen, 410–380 B.C. (detail, plate 16); PAGE ii: Dionysos and the Cast of a Satyr Play, ca.
400 B.C. (detail, plate 44); PAGE 4: Aerial View of the Theater of Dionysis, Athens (detail, fig. 1.1); PAGE 6: Dionysos
with Maenads and a Satyr, ca. 410 B.C. (detail, plate 2); PAGE 50: Orestes Slaying Klytaimnestra, ca. 340 B.C. (detail,
plate 23); PAGE 52: Medea Departing in a Chariot, ca. 400 B.C. (detail, plate 27); PAGE 102: *Phlyax* Scene of Zeus
Courting Alkmene, 350–340 B.C. (detail, plate 58); PAGE 104: *Phlyax* Scene with the Centaur Cheiron, Xanthias, and
Nymphs, 380–370 B.C. (detail, plate 53)

Library of Congress Cataloging-in-Publication Data

Hart, Mary Louise.
 The art of ancient Greek theater / Mary Louise Hart ; with contributions by J. Michael Walton ... [et al.].
 p. cm.
 Published on the occasion of an exhibition on view at the J. Paul Getty Museum, Aug. 26, 2010–Jan. 3, 2011.
 Includes bibliographical references and index.
 ISBN 978-1-60606-037-7 (hardcover)
1. Theater in art—Exhibitions. 2. Theater—Greece—History—To 500—Exhibitions. 3. Art, Greek—Exhibitions.
I. Walton, J. Michael, 1939– II. J. Paul Getty Museum. III. Title.

N8252.H37 2010
704.9'497920938—dc22
 2010013284

CONTRIBUTORS TO THE PLATE ENTRIES: Juliette Becq (JB), Michael Bennett (MB), Salvatore Bianco (SB), Herman
Brijder (HB), Ángeles Castellano (ACH), Margarita Moreno Conde (MMC), Anita Crispino (AC), Juan Garcés
(JG), Jasper Gaunt (JMPG), Federica Giacobello (FG), Alison B. Griffith (ABG), Mary Louise Hart (MLH), Violaine
Jeammet (VJ), François Lissarrague (FL), Marinella Lista (ML), Laure Marest-Caffey (LM-C), Sophie Marmois
(SM), Jean-Luc Martinez (J-LM), Néguine Mathieux (NM), Mette Moltesen (MM), Bodil Bundgaard Rasmussen
(BBR), Miria Roghi (MR), Maurizio Sannibale (MS), Agnes Schwarzmaier (ASch), Ambra Spinelli (AS), Michael
Turner (MT), René van Beek (RvB), Irma Wehgartner (IW)

CONTENTS

FOREWORD

THEATRICAL PERFORMANCE AS WE KNOW IT in the West was born in Athens in the mid-sixth century B.C. with choral dances held in honor of Dionysos, the Greek god of wine and patron of the theater. Rooted in religious festivals, theater became a hallmark of civic life and was one of Greece's most enduring cultural exports. Tragedies by Aeschylus, Sophocles, and Euripides as well as the comedies of Aristophanes and Menander that were performed in Athens and elsewhere, subsequently influenced visual arts throughout the Greek world.

The Art of Ancient Greek Theater is published on the occasion of an exhibition at the J. Paul Getty Museum, the first exhibition of its kind in the United States to consider the vibrant imprint that ancient Greek tragedy and comedy left on the visual arts of classical Greece. The Getty Villa in Malibu, the venue for the exhibition, hosts an active program of performances and workshops, anchored annually by a specially commissioned play; the 2010 season opens with a new production of *Elektra*, a work of Sophocles that was first staged around 413 B.C.

Inspired by performances and the apparatus of theater—including costumes, masks, and stages—visual artists delighted in depicting "backstage" events as well as enigmatic twists on familiar plotlines from the classical canon, in some cases preserving evidence of plays that would otherwise have been lost to time. Through the history of theatrical performance and stagecraft the authors of this volume explore the world of Greek drama made visible in ancient Greek theater arts, which come alive on these pages through the revealing and often amusing depiction of tragic and comic scenes on vases, sculpture, reliefs, mosaics, and expressive masks. The careful observations by painters and sculptors, demonstrated by the immediacy of these works, allow us to imagine the enthusiastic presence of artists and artisans among the audience.

Greek antiquities from museums large and small in Australia and New Zealand and across Europe and the United States extended loans of important objects, enabling a breadth of coverage that would otherwise have been unreachable. The Getty's cultural partnership with the Republic of Italy has been an essential factor in assembling key objects, including the great volute krater by the Pronomos Painter from the Museo Archeologico Nazionale in Naples, depicting a troupe of actors and chorus celebrating a triumphant performance. Our enterprise would not have been possible without the ongoing encouragement of Stefano De Caro, director general of archaeological heritage, and the staff of the Ministry of Culture in Rome. Additionally, I am thankful to directors Thomas Campbell, The Metropolitan Museum of Art; Henri Loyrette, Museé du Louvre; and Neil MacGregor, The British Museum, for the generosity of their loans.

An international group of scholars contributed to this publication, and we are grateful to each one of them for their insights into one of the most defining and influential aspects of Greek culture. At the Getty Museum, my sincere thanks go to associate curator Mary Louise Hart, the exhibition curator and editor of this volume, and to Karol Wight, senior curator of the Department of Antiquities, for realizing a display that has been anticipated for the Villa for many years.

Nearly one hundred objects—as important for their artistic quality as for their historical significance—are reproduced and discussed in this volume. We hope this book will offer readers a deeper appreciation of the many ways that art can illuminate the literary legacy and performative culture of classical Greece.

Michael Brand, Former Director
The J. Paul Getty Museum

ACKNOWLEDGMENTS

THIS BOOK AND THE EXHIBITION IT ACCOMPANIES have been many years in the making. We were initially inspired by the work of Richard Green and Margaret Mayo and thank them for beginning the conversation with us during the renovation of the Getty Villa in Malibu. As the exhibition evolved, Oliver Taplin and Eric Csapo provided crucial advice, and J. Michael Walton generously took on the task of applying his expertise to the theatrical grounding of the text. The book and the exhibition could not have been accomplished without the pioneering work of these scholars.

Significant loans from Italian collections were authorized by the archaeological superintendents Angelo Bottini and Daniele Candilio in Rome, Umberto Spigo in Padua, Pier Giovanni Guzzo and Mariarosaria Salvatore in Naples, Antonio De Siena in Potenza, and Giuseppe Andreassi and Teresa Elena Cinquantaquattro in Taranto.

Our thanks are extended also to the museum directors and staff members who generously shared expertise and loaned us works from their collections: Geralda Jurriaans-Helle and René van Beek, Allard Pierson Museum, Amsterdam; Peter Blome and Vera Slehofer, Antikenmuseum und Sammlung Ludwig, Basel; Andreas Scholl and Agnes Schwarzmaier, Antikensammlung, Berlin; Dame Lynne Brindley, The British Library, London; Lesley Fitton, Judith Swaddling, and Susan Woodford, The British Museum, London; Timothy Rub, former director, and Michael Bennett, Cleveland Museum of Art; Ulrich Sinn and Irma Wehgartner, Martin von Wagner Museum, Würzburg; Carlos Picón and Joan Mertens, The Metropolitan Museum of Art, New York; Valeria Sampaolo, Museo Archeologico Nazionale, Naples; Antonietta dell'Aglio, Museo Archeologico Nazionale, Taranto; Clara Gelao, Museo Archeologico Provinciale, Bari; Concetta Ciurcina, Museo Archeologico Regionale Paolo Orsi, Syracuse; Ruby Sanz and Paloma Cabrera, Museo Arqueológico Nacional, Madrid; Rita Paris, Palazzo Massimo alle Terme, Museo Nazionale, Rome; Salvatore Bianco and Patrizia Macri, Museo Nazionale della Siritide, Policoro; Malcolm Rogers and Christine Kondoleon, Museum of Fine Arts, Boston; Per Kristian Madsen and Bodil Bundgaard Rasmussen, Nationalmuseet, Copenhagen; Flemming Friborg and Mette Moltesen, Ny Carlsberg Glyptotek, Copenhagen; Laura Feliciotti, Intesa Sanpaolo Gallerie di Palazzo Leoni Montanari, Vicenza; James Steward and J. Michael Padgett, Princeton University Art Museum; Alison B. Griffith, Logie Collection, University of Canterbury, Christchurch, New Zealand; David Ellis and Michael Turner, University of Sydney Museums; and Antonio Paolucci and Maurizio Sannibale, Vatican Museums, Vatican City. My sincere thanks also go to Mr. and Mrs. Guido Malaguzzi-Valeri in Rome, for making possible the loan from their collection of the exceptional Apulian vase with a scene of comic pipers.

This book benefits from the acumen and generosity of the scholars who contributed essays. In addition to J. Michael Walton, emeritus professor of drama at the University of Hull, U.K., I would like to thank Martine Denoyelle, research adviser in the history of ancient art and the history of archaeology at the Institut National d'Histoire de l'Art, Paris; François Lissarrague, director of studies in the School of Advanced Studies in Social Sciences at the Centre Louis Gernet, Institut National d'Histoire de l'Art, Paris; Agnes Schwarzmaier, curator at the Antikensammlung, Berlin; and H. A. Shapiro, professor of archaeology and classics at the Johns Hopkins University, Baltimore. Curators from the lending institutions graciously agreed to write many of the individual object entries in this volume. Their names and affiliations are listed at the back of this book. I am grateful also to Hans R. Goette for generously providing his photography of ancient Greek theaters for the book and the exhibition.

Finally, I extend sincere thanks to everyone at the J. Paul Getty Museum who collaborated on the book and the exhibition, including—in the Department of Antiquities—Karol Wight, senior curator, and Claire Lyons, curator, who provided constant support and advice; Laure Marest-Caffey, curatorial assistant; David Saunders, first as a Getty Museum graduate intern and now as assistant curator; Ambra Spinelli, graduate intern for 2009-10; and Nicholas West, former graduate intern and now curator at the Lancaster Museum/Art Gallery. Katherine Havard, the St. Johns College Hodson Intern for 2009, researched play texts and ancient Greek theaters in the Mediterranean; and Toby Schreiber, volunteer, provided organizational support.

Jerry Podany, senior conservator of antiquities, negotiated the conservation of vases from the Boston Museum of Fine Arts so that they could be included in the exhibition. During the process of restoration, his staff, including Susan Lansing-Maish, Jeffrey Maish, and Eduardo Sanchez, brought to light new information that is included in this volume, accompanied by fresh photography by Ellen Rosenbery. The staff of the Getty Museum's Exhibitions department, led by Quincy Houghton with Liz Andres at the Getty Villa, deserve praise for their essential organizational skills and management. Merritt Price, Davina Wolter, and Debi van Zyl skillfully created an exhibition design to showcase objects of extraordinarily diverse scale and media; Kevin Marshall and his team handled the objects with exquisite care; and the mountmakers David Armendariz, BJ Farrar, and Mackenzie Lowry extensively researched the objects and traveled to most of the lending collections in order to design custom mounts for the installation at the Villa. Registrars Sally Hibbard and Amy Linker coordinated the myriad loans and complex shipping arrangements for the exhibition, and Sahar Tchaitchian edited the gallery texts and international materials.

At Getty Publications, appreciation goes to Gregory Britton, publisher; Dinah Berland, senior editor and project manager for the book; Katya Rice, manuscript editor; Catherine Lorenz, designer; Anita Keys, production coordinator; Danielle Melcher and Pamela Moffat, photo researchers; and Karen Stough, proofreader—the team that ultimately made this book possible. MLH

INTRODUCTION
THE ART OF ANCIENT GREEK THEATER

VIVID PORTRAYALS OF THE HALLMARKS of ancient drama—elaborate costumes, complex choreography, scenic architecture, and the mask—which still remains an icon signifying tragedy and comedy—mark the influence of performance on the visual arts of ancient Greece. Composed of vase-paintings inspired by renowned tragedies and farcical comedies, depictions of actors and their world, and terracotta masks and figurines of lively comedic characters, the art of ancient Greek theater crosses centuries of artistic production throughout the cities of the ancient Mediterranean.

Drama developed out of choral dances for Dionysos in Athens in the mid-sixth century B.C., inaugurating the earliest vase-paintings of ancient Greek performance. The tragedies of Aeschylus, Sophocles, and Euripides, along with the comedies of Aristophanes and Menander, are cornerstones of the Western literary canon. These plays were originally performed in competition during either the Lenaia or the Great Dionysia—annual celebrations of the cult of Dionysos held in Athens—and subsequently re-performed in festivals there as well as in Magna Graecia and Greek cities around the Mediterranean. Though not a religious rite itself, dramatic performance was an integral part of the festivals. According to tradition the first tragedy took shape around 534 B.C. when a chorusman named Thespis delivered a prepared speech—to the chorus.[1] Around fifty years later, in 486 B.C., comedies joined tragedies in the competitions.

On vases, scenes of Dionysos are often paired or combined with theatrical iconography. Most of these vases were originally made for the *symposion*—which, as a ritual of wine-drinking, Dionysos oversaw—and many of them were subsequently recovered from burial contexts. As the god of theater (including the choral ode and the dithyramb), wine, and mysterious transformation, Dionysos is often shown in the company of actors, with vines winding throughout his realm. The domains of Dionysos, the sponsor of every production, thus governed much of the art inspired by tragic, comic, and choral performance.

From their genesis in choral performance, both tragedy and comedy retained a performative structure characterized by choral song and dance. To be approved to produce a tetralogy (three tragedies followed by a satyr play) in the festival was to be "granted a chorus." The earliest depictions of performance in Athens show a lively and diverse group of strangely costumed chorusmen often dancing to the pipes of their musicians (plates 5–9).

The space of the theater—the *theatron*, or "seeing place—enclosed an audience of thousands together with the dancing chorus, musicians, and masked actors in their elaborate costumes framed by the

skene with its painted scenic decorations. A single poet's tetralogy took all day to perform. Attending theater during one of these festivals meant engaging in a communal marathon of sight and sound in the open daylight of the city. The resulting influence of dramatic performance on the visual arts is not only remarkable but quite complex.

Depictions of tragic and comic performance were almost entirely the product of the Greek colonies and the indigenous southern Italian and Sicilian cities of Magna Graecia, where the popularity of Athenian drama supported an enthusiastic output of re-performances. Long before 472 B.C., when Aeschylus's *Persians* (the earliest surviving play) was the second part of his winning tetralogy at the Great Dionysia,[2] Athenian vase-painters witnessed performances but did not summon their considerable talents to represent them. So even though it may be possible to detect their interest in particular plays or playwrights—the Phiale Painter, for example, seems to have been fond of Sophocles, as the content of his imagery indicates—Athenian artisans preferred to paint the "backstage" of the theater world, depicting remarkably detailed compositions of actors, including the great Pronomos vase (plate 44) and the costuming scene now in Boston (plate 15), which make specific reference to the world of theater without representing the performance itself. It was the vase-painters of Magna Graecia who responded to performance with innovative iconography and firsthand expression. Poets and performers were brought to southern Italy and Sicily by wealthy and powerful tyrants who wished to patronize these famous celebrities. Aeschylus died in Sicily, and the Sicilians' passion for Euripides is reflected in a story about Athenian prisoners captured during the Peloponnesian war in 413 B.C. and subsequently imprisoned, coincidentally, not far from the theater at Syracuse:

> A few [of the Athenians] were rescued because of their knowledge of Euripides, for it seems that the Sicilians were more devoted to his poetry than any other Greeks living outside the mother country. Even the smallest fragments of his verses were learned from every stranger who set foot on the island, and they took delight in exchanging these with one another. At any rate there is a tradition that many of the Athenian soldiers who returned home safely visited Euripides to thank him for their deliverance, which they owed to his poetry. Some of them told him that they had been given their freedom in return for teaching their masters all they could remember of his words, while others, when they took to flight after the final battle, had been given food and water for reciting some of his lyrics.[3]

Artistic response to performances of tragic plays can be reflected in various ways. The work of the playwrights was based on well-known myths and legends, forged through their poetry to fresh interpretations. The vase-painters' artistic responses to the plays were grounded in traditional methods of representing mythical narratives. In some cases the choice of scene alone conveys theatricality; at times certain compositions are strong enough to convey an idea of how some lost or alternate versions of surviving plays may have been performed. Unique patterns of reception are discernible in the work of some vase-painters. The Tarporley Painter, for example, seems to have been fond of a variety of theatrical scenes (plates 16, 50), while the Choephoroi Painter repeated the same scene so often that the popularity of Aeschylus's *Choephoroi* may be deduced from the evidence of the vase-painter's output (plate 22). Rarely, as in the case of the Capodarso Painter's *Oedipus Tyrannos* (plate 26), the depiction of the apparatus of the theater

conveys the powerful effect of the performance on the audience. Limited by their media but sharing in the cultural knowledge of venerated themes, painters had their own plots to weave.

The traditional style and iconographic approach to representing tragic scenes stands in direct contrast to the way painters depicted comedy, for in no other genre of ancient Greek art is the artist's attention to actuality more evident. In representations of these original travesties, parodies, and farces, where gods and centaurs share the stage with plotting slaves and thieves, we find some of the most vivid painting from the ancient world. Compositions are built from an assemblage of carefully rendered stages, scenery, masks, and costumes, often with an immediacy that reflects the painter's enthusiastic presence at a performance of the play. Among depictions of *phlyax* comedies are references to the plays of Aristophanes and his contemporaries Kratinos and Eupolis, as well as to the plays of comic poets of Magna Graecia, such as Epicharmus and Rhinthon, from whom only fragments remain.

The production in the fourth century B.C. of terracotta masks and figurines representing characters from Menander's social drama indicates the popularity of New Comedy across the Mediterranean. These small devotional statuettes, caricatures of Athenian families and the scoundrels who wreaked comedic havoc on their lives—parasites, pimps, prostitutes, and slaves—were lively and very popular; their production continued well into the Roman era. Menander's plays were performed in a Hellenistic world of such geographic dispersion and popularity that later Roman comic poets such as Plautus and Terence could still be strongly influenced by their style and comic types.

Like theater, visual art is constructed of images communicated by signals and references. The art of ancient Greek theater provides a glimpse of actors, choruses, and musicians performing the works of the world's great playwrights. From a tradition that typically eschewed reference to specific events, this art emerged to form a genre containing rare elements of portraiture, expression, even spatial illusion. As a body of work it is on par with some of the most vivid and compelling art surviving from antiquity.

NOTES

1 DFA², p. 130.

2 The other plays in the tetralogy—*Phineus, Glaukos of Potniai*, and the satyr play *Prometheus Fire-Lighter*—did not survive.

3 Plutarch, *Life of Nicias*, 29.3-5; translation after Small 2003, p. 60.

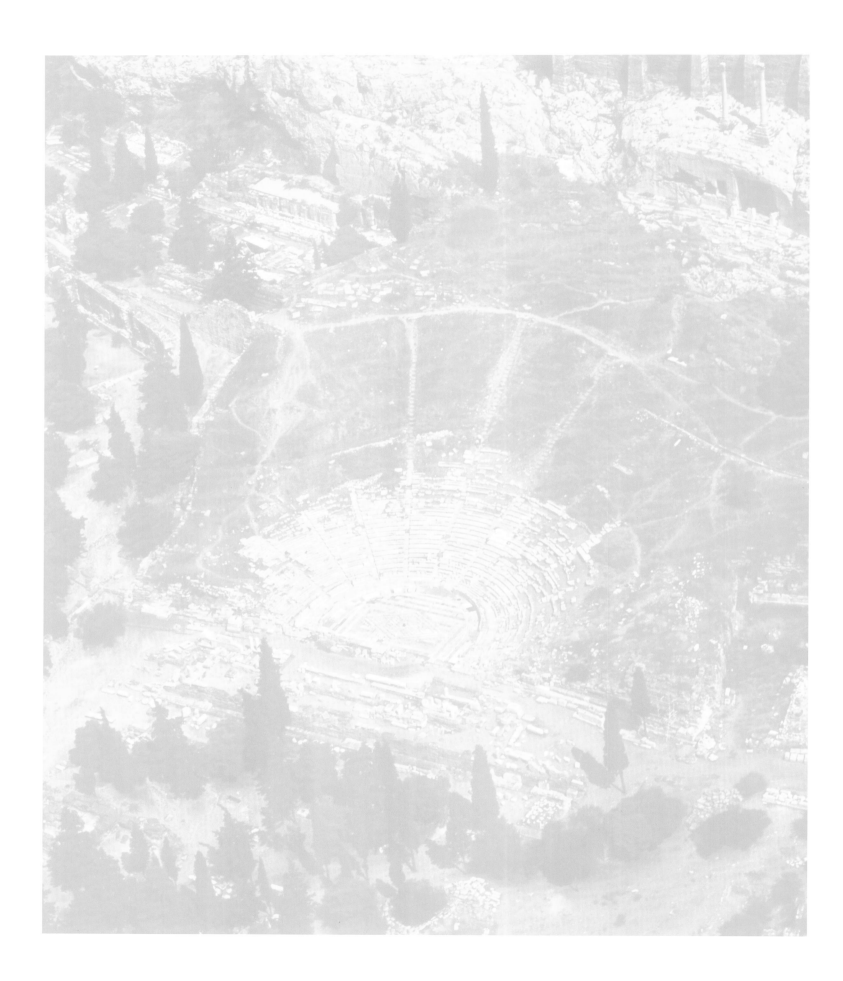

PART I

GREEK THEATER AND ITS PERFORMANCE

A PLAYING TRADITION

J. MICHAEL WALTON

SOCIETIES ANCIENT AND MODERN throughout all the inhabited continents have shown a need to investigate their relationship with the external forces dominating their lives. The need may be expressed in a variety of ways: praying for the future and giving thanks for the past; appeasing gods and ancestors; marking special occasions with rituals; affirming a national identity through dance and music; playing games and rehearsing stories. Such manifestations may cover anything from Fourth of July parades to opera at the Met.

The student of anthropology or cultural history may consider many of these activities dramatic or quasi-dramatic. The very existence of similar patterns of behavior in so many parts of Greece from the earliest times suggests some common factors in the drama that emerged in the sixth century B.C. as Greek tragedy and comedy. These had their heyday during the fifth century B.C., but it is no exaggeration to suggest that their influence in the Western world has pervaded every theater and every dramatic performance since. Today Greek tragedy is represented by a small selection of plays. The surviving dramas of Aeschylus, Sophocles, and Euripides amount to a total of 33 from a possible 297.

THE ORIGINS OF TRAGEDY

Direct evidence of how and why tragedy emerged in precisely the form that it did in Athens is conflicting and confusing. Snippets of information can be found in a variety of sources, from the charming if sometimes gullible historian Herodotus, a contemporary of both Sophocles and Euripides, to Aristotle writing his *Poetics* more than a hundred years after the death of Aeschylus, to a host of later grammarians, encyclopedists, and special-interest writers such as Lucian of Samosata, Athenaeus, and Plutarch, and others who remain anonymous, all writing well into the Christian era. These texts are augmented by comments in the margins by some of those scholiasts who copied the old manuscripts by hand and are responsible for the texts, including the variant readings. This means that we have to rely on commentators of various kinds, all of whom had access to sources that we no longer have, and none of whom was specifically engaged in tracing the history of the theater. Significantly, most of them were farther distanced in time from the original performances than we are from those of Shakespeare.

The most influential has been Aristotle, a philosopher and sometime tutor to Alexander the Great. His *Poetics* is an unrevised treatise (probably no more than lecture notes) on the background to Greek tragedy, which had gone into decline with the death of both Euripides and Sophocles some twenty

years before Aristotle himself was born. In a long essay whose main purpose is to make a case for drama, which his mentor Plato had recommended be banished from the ideal state, Aristotle includes his own version of where tragedy came from. Though hardly a coherent account, it suggests influences from other parts of Greece, and even Sicily, in the development of both tragedy and comedy. Aristotle identifies three factors or features of early poetry that seem to have been of significance: the dithyramb, the epic poetry of Homer, and a natural instinct—innate from childhood—for *mimesis*, or imitation.[1]

The dithyramb was a kind of circular dance, performed and sung to a musical accompaniment by a chorus of as many as fifty participants (see plate 13). Though not much more is known about it and no actual dithyrambs survive, a competition for dithyrambs preceded the performance of tragedy at Athenian dramatic festivals. Such competitions continued as part of those festivals even when tragedy and comedy became the primary performance. The many choral scenes that appear on vases attest to the importance of choral dance and music in religious and dramatic celebration (see plates 6, 8, 9, 11, 12). Frequently the choral scenes show men dressed as animals of one kind or another—dolphins, ostrich-riders, birds, or horsemen. No known tragedy had an animal chorus, but they were common in Old Comedy. Comedy as a separate dramatic form was featured from early times but only later became a part of the competition proper. Tragedy included an afterpiece with comic elements, the satyr play, whose choruses were the part-human, part-animal acolytes of Dionysos. The satyr chorus mocked the tragic action, sending up the characters and making the potentially serious ridiculous. In Old Comedy the choruses reflected the main themes and actions of the play; they were more versatile and independent.

The epic poet Homer is himself an obscure figure, but his two main works, the *Iliad* and the *Odyssey*, provided much of the background and many of the characters of Greek tragedy. These two poems, the earliest written texts in Greek, originated as oral poetry for recitation by a rhapsode, or bard, and developed—as in similar traditions elsewhere in the world—through the presentation of individual singers and entertainers before eventually being put in written form. Bards and minstrels were professionals. They had a formidable bank of material to call on and could adjust its content or style to the occasion or the mood of the audience. It is not known when the *Iliad* and the *Odyssey* were written down, but during the Bronze Age, the setting of the Trojan War, writing was rare if not unknown; thus the poems probably did not appear as written texts until considerably later. Recitations from Homer continued to be a part of the Dionysian festivals, along with the dithyramb, even after tragedy made its first appearance.

What we know about the storytelling tradition in Greece comes for the most part from the *Odyssey* itself, where the bard is a respected figure, a musician as well as a speaker, accompanied on occasion by a group of dancers, a chorus, who enhance through movement the tale he is unfolding (*Odyssey* VII.258–67). The extent to which the storyteller or bard was an "imitator," someone employing the art or skill of Aristotle's *mimesis*, is a topic to which I will turn later.

An alternative way to account for the birth of tragedy is to associate it with various forms of community ritual. There is plenty of evidence that such procedures formed a regular part of civic activity throughout the Greek world. Celebrations relating to ancestor and hero worship were, and remain, common in societies in all parts of the globe. Seasonal change and the influence of the weather on sowing and harvesting can establish various forms of ceremony whose effectiveness is judged by their efficacy. Religious practice, shamanism, oracular pronouncement, and prophecy all have their part in a conscious

world that takes full account of, and pays attention to, the mystical world and the world of the spirit. As we will see below, the world of religious belief underpinned and underlined the theatrical experience in Athens. What is less clear and less emphasized is the extent to which the secular made a contribution to the "invention" of drama.

Whatever the influences from elsewhere in the ancient world—from the Minoans in Crete, from the Middle East, from Egypt, and from the disparate communities that made up the city-states of mainland Greece, the Peloponnese, and the islands—one fact stands out: in Athens toward the end of the sixth century B.C. a type of dramatic performance was born that marks the cornerstone of Western theater. Ritual may well have provided one of the transitional stages, but ritual grows and maintains its power through repetition. In contrast, dramatic works, both tragedy and comedy, are typified by their novelty. The plays we have are not repetitions of old stories but variations on them, offering the aesthetic experience of suspense, surprise, and shock. The stories may have been familiar in their broad outline—for instance, Oedipus killing his father and marrying his mother—but the drama resided in the detail, the causes and the responsibility. As in visual art, any of several aspects of a situation may be depicted, or the same situation may be handled differently. The art resides in what is individual, with a new voice or a new message.

In tracing the origin of Greek tragedy and comedy we are served no less by what was written down as playtext than by what was represented in various forms of art—reliefs, statuettes, mosaics, and especially vase-painting. A constant, if incompletely preserved, stream of art and artifacts can tell us how the theater developed in Greek life and the importance it held. Moreover, it gives us some sense of what the aesthetics of stage performance might have involved. The art and artifacts are not the equivalent of production photos; rather, they present identifiable actions, events, or scenes, sometimes composite views of many plays that have survived and of some that have not. Many of the vases can be dated with considerable accuracy. They supply information about stages, properties, furniture, and masks. They can also provide a persuasive sense of stage picture, the juxtaposition of people and objects in space, as well as the physical language (*cheironomia*) that is the central feature of any masked acting tradition.

In later times the name Thespis (sixth century B.C.) emerged as that of the founding father of Greek tragedy. Thespis is so well entrenched in later consciousness that actors to this day are called thespians. The tradition goes back at least to Aristophanes, who speaks of Thespis in his *Wasps* (422 B.C., lines 1478–79) as the "inventor" of tragedy. Later embroidered accounts of his life claim that he originally performed on the road with a traveling theater, that he used stylized makeup or linen masks, and that he was the first to produce a play in a competition in Athens for the prize of a goat (*tragos*, hence "tragedy").[2] One possibility that many would favor is that it was the leader of the chorus, the *exarchos* or *koryphaios*, who emerged from the group to become the first "actor" (see plate 8), but it seems no less plausible that someone independent of the chorus made the giant leap from reciter to actor. Thespis is as good a candidate as any. But what did that leap imply? Everything, it would seem, returns us to Aristotle's word *mimesis*, imitation. A storyteller—a rhapsode or bard—speaks in the third person: "Orestes went to this place, did that, or spoke as follows." He gives a performance. He may imitate a character's mannerisms or give him a special voice. He does not "act." Perhaps what Thespis did was to turn himself into the first actor by not describing a character but pretending to *be* him. And this he did by the simple process of putting on a mask. That was the crucial moment that created the first actor.

FESTIVAL AND DRAMA

Though the Great (or City) Dionysia was the major festival for the performance of tragedy from its first manifestation through the time of Aeschylus, Sophocles, and Euripides, it was founded by Peisistratos at some earlier date, probably about 560–550 B.C. If it was someone called Thespis who introduced the dramatic form of tragedy with a chorus and a single actor, then this certainly happened before Aeschylus was born. The first play to have survived as a written text is Aeschylus's *Persians*, and for this at least we have a firm date. It was performed in 472 B.C., eight years after the battle of Salamis, when the Athenian fleet defeated the invading Persians. The play is a history play, unlike any other we possess. As a fictional account of the sea battle and the return home to Sousa of the defeated Xerxes it is a remarkable historical document, but it gives few hints as to how tragedy developed in its first sixty years. Half the lines are spoken by a chorus, and no more than two actors are present onstage at any time.

The first drama festival of the year in Athens was the Lenaia, held during the winter in a month equivalent to our January. There is less evidence for the arrangements of the Lenaia than for those of the Great Dionysia, but like that larger festival the Lenaia was restricted to citizens and metics (those living in and around Attika but without the full privileges of citizenship). Aristophanes indicates that he is now offering his *Acharnians* at the Lenaia after being fined the previous year for presenting a play at the Great Dionysia under a pseudonym (*Babylonians*) that "ridiculed the state in the presence of foreigners" (lines 502–8). The Lenaia concentrated on comedy anyway, with a few tragedies. The season must have had much to do with the organization. Attending the theater in what is customarily the wettest and coldest time of the year in Greece must have limited the enthusiasm for an extended program of even the hardiest of audience members.

The Great Dionysia was a different matter. The festival was held in the spring, in a month equivalent to today's March/April. This was a time when the weather improved enough for trade and diplomatic contact to be renewed between Athens and its island and other sea-traveling neighbors. The audience for this occasion was not simply local. The city was on show. Foreign visitors of all kinds might be present, and perhaps not only men. Argument still continues over whether women would have been allowed to attend the theater, but the suggestion that a seating block might have been reserved for them has support. There was a charge for admission, and tickets or tokens were issued. At some later date a fund was introduced to subsidize those who could not afford the price of entry. The total gate receipts must have amounted to a considerable sum, which strengthens the suggestion that the state leased the theater to an individual. Someone had to be responsible for management, good order, and the general upkeep of the stage and auditorium. Theaters need attendants and people to keep order, as well as backstage staff to operate the machinery. A lessee may have kept the box-office take as his remuneration.

The festival lasted for five or six days. This might seem a lengthy period, but it must be viewed in the context of a working year that had no regular breaks of the kind that later defined the Judeo-Christian week. The first days of the festival included a number of ceremonies and a torch-lit procession to escort the statue of Dionysos from Eleutherai (his legendary home) to the theater (fig. 1.1) and back. The god remained at the theater until the conclusion of the drama program. There were processions and presentations from various colonies and allies. In some years there was a parade of the sons of those who had died in battle during the previous year. Competitions were held in Homeric recitation and in dithyrambic performance.

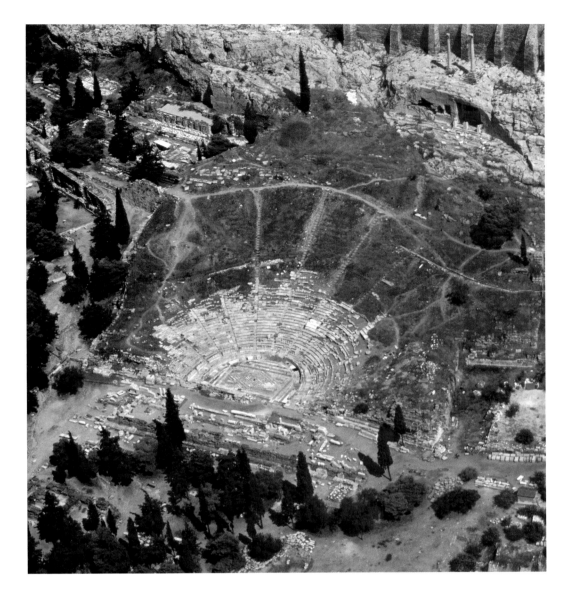

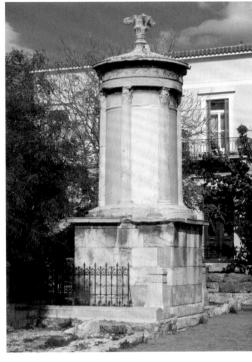

FIGURE 1.1
Aerial View of the Theater of Dionysos, Athens.
Photograph: H. R. Goette

FIGURE 1.2
Choregic Monument of Lysikrates, erected on the occasion of
a prizewinning dithyrambic performance, 335–334 B.C. Athens.
Photograph: H. R. Goette

The dramatic program was just as competitive. Sometime in the fall of the year, playwrights were invited to propose a group of four plays, a tragic tetralogy, for presentation at the next year's Great Dionysia. The last of the four plays was a farcical satyr play. How advanced the writing process needed to be at this point is unknown, but a state official (one of the *archons*) chose three playwrights to compete for first, second, and third place. The playwrights selected were "granted a chorus," which meant they would receive state support with the provision of three actors and a musician paid for by the city. Other costs were met by wealthy citizens designated by the *archontes* as *choregoi*. These men were earmarked annually to perform liturgies on behalf of Athens—in other words, to pay the expenses of some civic enterprise. This could be any number of things: footing the bill for a state banquet, equipping a warship, meeting the cost of a dithyrambic contest, or producing a set of plays. The civic responsibilities associated with music and theatrical performance could involve substantial costs. A *choregos* paid all the expenses of the chorus, who although amateurs were trained by a professional choreographer. In addition the *choregos* was responsible for music, masks, costumes, properties, and any other items on the production budget. In return he might expect to enjoy some of the glory of a successful production and even erect a monument to his success (fig. 1.2). As the festivals became more competitive, new prizes were awarded to victorious dramatists and later to actors, leading to the rise of professionalism. Winners were selected by judges, one from each of the ten

tribes of Athens. To avoid any personal responsibility (or accusation of bias), all ten cast their votes, but only five winners were selected.

The fifth century B.C. was the time of Athens's greatest military, political, social, and artistic development. As in many subsequent eras, drama reflected both progress and change. The production process was refined to a subtle blend of artistic skill, human ingenuity, and divine benevolence. Such was the theater in Athens, and its overseer and inspiration was the god Dionysos.

DIONYSOS, GOD OF THE THEATER

The theater precinct in Athens was named after the god Dionysos. Both of the major dramatic festivals at which tragedies and comedies were performed, the Lenaia and the Great Dionysia, were held in his honor; so were the succession of local festivals known as the Rural (or Country) Dionysia. Another major festival, the Anthesteria, celebrating the broaching of the new wine, was also dedicated to him, and so were at least three others. His cult was a violent though significant one in Athens, but the god himself was a latecomer to the Olympian pantheon. He scarcely merits a mention in Homer but was later to replace Hestia, goddess of the hearth, in the twelve gods of Olympos.

As a character in Euripides' *Bacchae* he gives the story of his birth. His mother, Semele, was one of the four daughters of Kadmos, the founder of Thebes. Zeus took a fancy to her; she was only one of many mortal conquests whom the king of the gods wooed in a number of guises. When his wife, Hera, found out, she approached Semele and suggested that she invite Zeus to appear to her in his proper form. The pregnant Semele was taken by the idea and picked her moment to exact a promise from Zeus that he would grant her whatever she wished. Zeus's true manifestation being a thunderbolt, Semele was struck by lightning and burnt to a cinder. The god rescued the embryo from the ashes and preserved it in his thigh. In due course Dionysos was born, immortal but half human. When his earthly family rejected him, Dionysos returned to Thebes to wreak revenge on his father, his aunts, and his cousin Pentheus, now king of Thebes. He did so with calculated cruelty and the use of his special powers to bemuse and befuddle perceptions, so that Pentheus's own mother led the local women in pulling her son's body to pieces in the belief that she was killing a lion.

Dionysos became god of theater and also the god to whom the theater space itself was dedicated. Exactly why makes for an intriguing insight into the Athenian psyche, as well as into the nature of the experience of theater to which the Greeks subscribed.

The Olympian gods in tandem oversaw and complemented the powerful forces and emotions that mankind struggles to contain. Zeus with his lightning and thunderbolt; Apollo, god of the sun, prophecy, and music; Artemis, goddess of hunting, the moon, chastity, and childbirth; Aphrodite, goddess of physical love. In the surviving tragedies and comedies Apollo, Athena, Aphrodite, Artemis, Poseidon, and Hermes all appear at least once. When it transpired that the world was not so easy to explain and frequently not ruled by reason, Dionysos took his place as the god of unreason. This persona relates to one of his principal provinces, that of being the god of wine; it is this persona in which he most often appears in pictorial representation (see plate 3). His male associates are the satyrs, who compose the chorus of the satyr play that concluded every group of three tragedies. The plot of a satyr play was typically rooted in a farcical situation based on one of Dionysos's exploits or adventures. The female acolytes of Dionysos are the maenads,

over whom he exerts control, not through wine but from the imposed power of ecstasy, a "standing outside of oneself" that can lead to delusions, extraordinary powers, and the working of what seem like miracles. This is the power he demonstrates in *Bacchae* when Agave and her sisters rip her son apart. It is a madness reflecting all that is beyond comprehension in human existence, sometimes peaceful, more often dangerous and terrifying in its consequences.

Greek gods were not role models. They were dangerous but, by and large, predictable. None was more dangerous than Dionysos, because he was unpredictable. The theater he represents is a place of danger, a place to confront your fears, a place to exercise your emotion more than your reason. No wonder the rational Plato was wary of tragedy and comedy. Many of the choral odes in the surviving tragedies are in praise of the peaceful and positive sides of Dionysos and the benefits or consolations he affords in a harsh world (as in *Bacchae* 64–169). His festivals and his drama gave a break from the routine and, especially to women, a release from the realities of everyday life. Dionysos appears in only one other surviving play, Aristophanes' *Frogs*. This comedy was performed only a year before the defeat of Athens by Sparta in the Peloponnesian War. Dionysos, the central character, is consciously an actor playing the role of Dionysos, god of the theater. So upset is this stage Dionysos at the death of Euripides that he goes down to Hades to bring him back to earth to save the city and its drama festivals. In Hades a competition between Euripides and the long-dead Aeschylus leads to Dionysos's decision to resurrect Aeschylus, on the grounds that he is more likely to be able to provide sound counsel on how to cope with the war. These two stage appearances of Dionysos, both in the same year—once in a tragedy, once in a comedy—show to what extent the theater had become a place where the major issues of life could be debated, and where lessons on how life should be lived could be presented. The final defeat by Sparta in the Peloponnesian War in 404 B.C. marked the end of such freedom of expression, and effectively the end of a theater of political purpose in Athens.

NOTES

1 Russell and Winterbottom 1989, pp. 51–90.

2 *DTC²*, pp. 69–89.

1

Actor Holding a Mask

Fragment of a votive relief, ca. 350 B.C.

Greek (Attic); acquired in Rome but allegedly found in Athens

Pentelic marble with traces of red color in the corner of the eye and over the left ear

H: 78 cm (30¹¹⁄₁₆ in.); W: 25 cm (9¹³⁄₁₆ in.)

Copenhagen, Ny Carlsberg Glyptotek IN 465

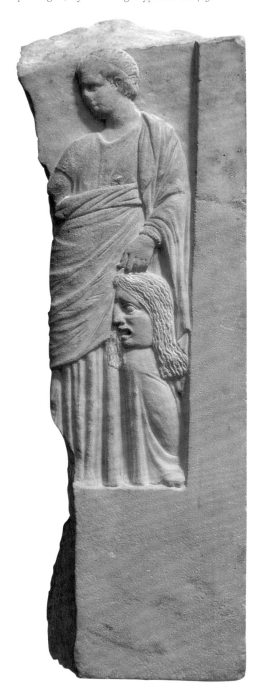

THE FRAGMENT CONSTITUTES the lower left-hand side of an Attic stele with a frame around a representation in relief. The base of the frame is completely flat and rather tall (23 cm), while the frame on the side is narrow and tapers upward (from 6.8 to 5 cm).

Only one figure is preserved, but his gesture and his gaze show that there must have been at least one more person to his right, perhaps the god Dionysos. The young man has short hair and wears a female costume consisting of a short-sleeved chiton and a large cloak draped around his body. He wears a bracelet on his left wrist, and in his left hand he carries a large theatrical mask by a strap on its top. This is a full mask covering the back of the head. With long, flowing hair, large eyes, and an open, downturned mouth, it is the mask of a middle-aged, distressed woman, probably a heroine. The young actor or chorus member is playing a female role in a tragedy.

The motif is not common, but a comparable scene is found on a relief from Piraeus, now in the National Archaeological Museum in Athens (fig. 1.3). Here the god of the Greek theater, Dionysos, is reclining on a bench holding a costly drinking horn, a rhyton, in his hand. To the left are three actors dressed in long garments. The one looking toward Dionysos is holding, by the chin, a mask of a bearded man wearing a wreath. The two other actors carry *tympana* (hand drums) in their left hands; one of them carries a mask of a bearded old man in his right hand. The third actor wears a female chiton. A large hollow where his face should be shows that he probably wore his mask, which is now missing. Here we have three actors from a tragedy, two male and one female. It has been suggested that they were performing Euripides' *Bacchae*, in which the main characters are Pentheus, Kadmos, and Agave.

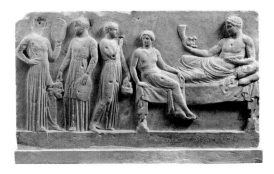

FIGURE 1.3

Dionysos (?) Reclining on *Kline*, with Actors, 400–390 B.C.

Marble relief from Piraeus

Athens, National Archaeological Museum, 1500.

Hellenic Ministry of Culture/Archaeological Receipts Fund

Actual theater masks were probably made from stiffened linen covered in paint; as we have seen, they were carried by a strap. Expression and individuality were given by the slant of the eyes, the form of the brows, the presence or absence of wrinkles, and the hairstyle.

The Piraeus relief is somewhat older than our relief fragment, but both would have celebrated a successful theater production. The *choregos*, the man who defrayed the cost of the production, would dedicate a monument, often a tripod or a wreath, to Dionysos. One such choregic monument carrying a tripod is the Lysikrates monument in Athens (see fig. 1.2 in "A Playing Tradition," herein), which bears a long inscription commemorating a specific production of the year 334 B.C. MM

BIBLIOGRAPHY: Poulsen 1951, p. 173, no. 233; *MTS²*, p. 34, AS 4; *DFA²*, p. 188; Webster 1970b, pp. 43, 151, 183, A20, pl. 9; Moltesen 1995, p. 137, no. 71.

2

Dionysos with Maenads and a Satyr (side A)
**Perseus Frightening Satyrs with the
Head of Medusa; Dancers at the Festival
of Apollo Karneios** (side B)

Red-figured volute krater, ca. 410 B.C.

Name vase of the Karneia Painter

From Lucania, South Italy

H: 72 cm (28⅜ in.); Diam: 47 cm (18½ in.)

Taranto, Museo Archeologico Nazionale 8263

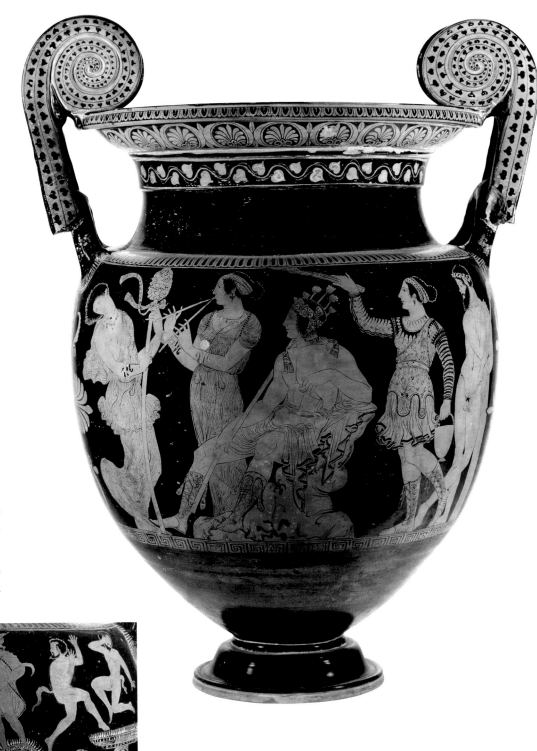

THE SOVEREIGNTY OF DIONYSOS on this
magnificent krater, intended for mixing wine with
water, is not in doubt. On the obverse, he is seated
on a rocky outcrop amid his retinue. He wears a
pair of high, lined boots (*kothornoi*), a himation
around his waist, and a ribbon in his hair. He holds
a kantharos (drinking vessel) in his left hand and
a flowering *thyrsos* (ritual staff) in his right. He
watches intently as a maenad dances in ecstasy, to
music provided by a companion playing the *aulos*.
Behind, the nocturnal setting is illuminated by a
maenad who carries torches aloft as well as a situla

PLATE 2 | **15**

(pail for wine). She wears a short chiton under an animal skin, and boots. All the maenads wear elaborate jewelry, which is rendered in relief. At right, a satyr leans against a stele.

The setting of the picture on the reverse, which is divided into two registers, is indicated by a pillar on the left inscribed with an epithet for Apollo. The festival of Apollo Karneios, which included elements of wine harvesting and ceremonies of expiation, was celebrated in Sparta and its colonies, of which Taranto was one, in late August. The vase-painter has juxtaposed two major elements in the festival, a dramatic performance (above) and a dance (below). In the upper register, five satyrs react with horror as Perseus holds up the head of Medusa, whom he has just slain. In myth, this Gorgon had the effect of turning to stone anyone who looked directly on her. Perseus wears the winged cap and a *chlamys*; the *harpe* (curved knife) he used to behead her rests in the crook of his arm. Two of the satyrs cover their eyes or look away; but two look directly at the head, one even turning back to do so. In the excitement, two *thyrsoi* have been abandoned. The presence of satyrs and their lively gestures, which denote humor rather than terror, suggest that a satyr play must lie behind the image.

In the dance below, three pairs of figures are augmented by a flute player who carries his instrument and its mouthpiece. He acts as link for the two events depicted, both of which require his accompaniment. The vast wicker hats and the spiky crowns worn by the participants must have been significant features in the festival, as must have been the pirouetting movement undertaken by the central female.

The krater, which seems to be a locally made rival to Attic vases imported into Magna Graecia, such as the Pronomos krater (plate 44),

was found in a tomb that also contained an Athenian hydria of the late fifth century B.C.
JMPG

BIBLIOGRAPHY: Beazley 1928, p. 73; Moon 1929, p. 20; Wuilleumier 1939; Trendall 1938, p. 40, no. 1, pls. 24–25; *CVA* Italy, fasc. 15, Taranto, Museo Nazionale 1 (1940), IV d,r, pls. 1–6; Beazley 1955, pp. 315–16; Schauenburg 1960, p. 99ff., pl. 33; Arias, Hirmer, and Shefton 1962, pp. 387–88, pls. 230 235; Mingazzini 1966, p. 133, fig. 59; *LCS*, pp. 55, 280, pl. 24, supp. 1: 4, supp. 2: 153, supp. 3: 19; Simon 1969, fig. 148; Belli 1970, pp. 170–71; Trendall 1974, p. 38, no. 350, pls. 24–26; Robertson 1975, p. 429, pl. 135; *LIMC* III (1981), s.v. Dionysos, p. 490, no. 801, pl. 393; *LIMC* IV (1988), s.v. Gorgo Gorgones, p. 315, no. 341; *RVSIS*, fig. 23; D'Amicis, Dell'Aglio, and Lippolis 1991, exh. cat., pp. 132–37; Mattusch 1992, p. 81n11; Casadio 1994, pp. 265–84; *LIMC* VII (1994), s.v. Perseus, p. 335, no. 32, pl. 276; Malkin 1994, p. 157; Pugliese Carratelli 1996, exh. cat., p. 707, no. 198; *LIMC* VIII (1997) s.v. Mainades p. 786 no. 4; Dearden 1999, p. 245; Miller 1999, p. 246; Denoyelle 2002; Gaunt 2002, pp. 630–31, no. 14; *ThesCRA* II, 100 Initiation 64 (Burkert); *ThesCRA* II, 323 Dance 194 (Shapiro et al.); *ThesCRA* II, 365 Music 189 (Pretagostini); *ThesCRA* v, 393 Cult Instruments 1513 (Krauskopf); Carpenter 2005, p. 228; Ceccarelli and Milanezi 2007, pp. 199, 200, fig. 19a–b; Taplin 2007, pp. 34–35, fig. 15.

3

Bust of Dionysos and Comic Actors, One Costumed as Papposilenos (side A)
Dionysos with a Satyr and a Maenad (side B)

Red-figured bell krater, 390–380 B.C.
Attributed to the Choregos Painter
From Apulia, South Italy
H: 38 cm (14 15/16 in.); Diam (rim): 40.3 cm (15 7/8 in.)
Purchase, John L. Severance Fund
Cleveland Museum of Art 1989.73

PRESERVED INTACT and in pristine condition, this Apulian bell krater attributed by A. D. Trendall to the Choregos Painter features scenes related to the multifaceted personality of Dionysos. Its singular iconography and exquisite draftsmanship distinguish it as a vase of exceptional importance.

The obverse is dominated by a colossal and almost frontal bust of a youthful Dionysos. His head nods slightly to the right and is adorned with a fillet whose ends loop over each ear, are tied over a berry-strewn laurel wreath and meet at the center of the forehead. His large, carefully drawn eyes impart an otherworldly expression. It is unclear whether the bust of Dionysos represents an actual prop in a stage performance or whether it is symbolic of his fundamental divine roles: god of the mysteries, god of wine, and god of drama. A cloak ornamented with an embattled border and a meander band covers his left shoulder. The shaft of his *thyrsos* rests on his left shoulder and passes behind his head, and from it spread two branching grapevines, left and right above. To the left a *phlyax* (comic actor) wearing a laurel wreath and a slave mask stands on tiptoes as he reaches excitedly for a cluster of grapes. He wears tights, a short belted tunic with padding, and an artificial *phallos*. Behind him is a flaming thymiaterion on a high base. Another *phlyax*, in profile, at the far right stands with bent knees on a low platform

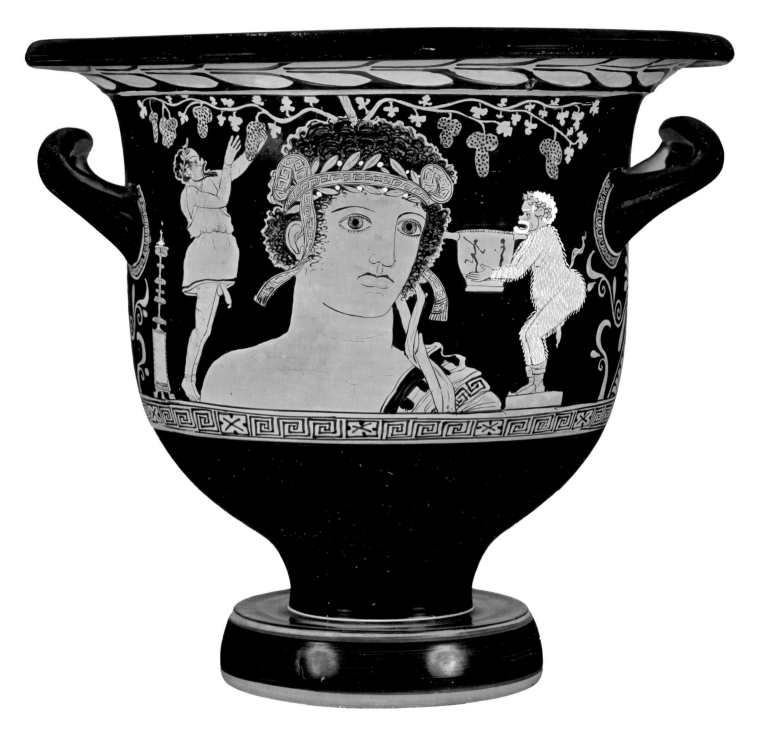

holding a large skyphos on which a dancer and an *aulos* player are applied in black-figure. He wears a mask of an old man, an ivy wreath, and a hairy Papposilenos (elderly father of the satyrs) costume with an applied *phallos*.

Dionysos appears again on the reverse. He is at the back of a procession moving right. He strides forward with his *thyrsos* in his extended left hand

while he raises his cloak with his right. In front of him is a bearded satyr playing the *aulos*. An *aulos* case of animal skin hangs from his left forearm. Leading the way is a maenad wearing a belted peplos and a long, flowing mantle. With her head tilted back, she is about to strike a *tympanon* with her open right hand. All of these figures wear fillets around their heads with small spiked appliqués at the front. MB

BIBLIOGRAPHY: Cleveland Museum of Art 1991b, p. 73; Cleveland Museum of Art 1991c, pp. 63–68; Cleveland Museum of Art 1991d, p. 8; *RVAp* supp. 2, pt. 3 (1992), postscript 495, no. 1/125; Trendall 1992, pp. 2–15, figs. 1, 4, 5, 9, cover (color); Green 1994, pp. 86–91, 95, figs. 3.23, 3.24; Taplin 1994, pp. 25–26, fig. 5; *CVA* Cleveland (2000), pp. 50–51, pls. 92, 93; Easterling and Hall 2002, p. vii, rep. cover; Revermann 2005, notes.

PLATE 3 | 17

4A

Miniature Clay Mask of a Satyr

300–100 B.C.

From Centuripe, Sicily

H: 14 cm (5½ in.); W: 15 cm (5⅞ in.)

Amsterdam, Allard Pierson Museum 9997

TERRACOTTA MASK of a clean-shaven satyr with open eyes, an open mouth, and a wrinkled forehead. The head has long, pointed ears. Traces of red paint are visible in the long hair, which is adorned with a wide, curving ribbon with fruit and ivy leaves running through it.

4B

Miniature Clay Mask of a Young *Hetaira*

300–100 B.C.

From Centuripe, Sicily

H: 11.5 cm (4½ in.); W: 12.6 cm (5 in.)

Amsterdam, Allard Pierson Museum 9995

TERRACOTTA MASK of a young *hetaira* (prostitute) with open eyes and an open mouth. The face is painted white, the plaited hair and lips have traces of red paint, and the eyes show traces of blue. An ornament on the forehead is fixed to a small tuft of hair. The mask has a hole at the top for suspension.

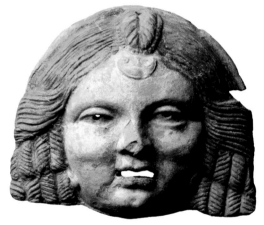

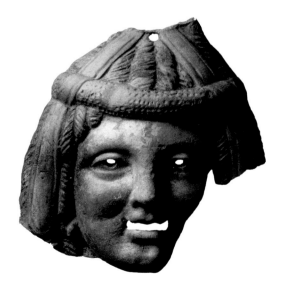

4C

Miniature Clay Mask of a Young *Hetaira*

300–100 B.C.

From Centuripe, Sicily

H: 11.5 cm (4½ in.); W: 13.5 cm (5⁵⁄₁₆ in.)

Amsterdam, Allard Pierson Museum 9996

TERRACOTTA MASK of a young *hetaira* with open eyes and an open mouth. The hair is plaited and decorated with a wreath or fillet and vertical ribbons. The face is painted white with traces of silver paint on the cheeks. Blue paint is also visible in the eyes, and red in the hair. The mask has a hole at the top for suspension.

These miniature terracotta masks were made in ancient Centuripe, in Sicily. As a result of their archaeological context, they have retained a remarkable amount of colorful pigment delineating their hair and facial features. They were found together with masks of a Pan and a silenos in a cemetery, a setting that establishes a devotional context for their production.

These small masks emulate types of full-size theatrical masks that were used in performances of New Comedy, popular throughout southern Italy and Sicily from the late fourth century B.C. to Roman times. The subjects of these comedies were derived largely from the day-to-day activities of family life and revolve mostly around improbable romantic entanglements. New Comedy masks typically represent stock comedic characters such as *hetairai* (courtesans, or prostitutes) of all ages, masters and slaves, young and old men, parasites, flatterers, and musicians. The silenos, satyr (as represented by the mask in 4A), and Pan help point to an honorific deposit for Dionysos, since these hybrid creatures were as much a part of his mythical world as the characters in a play. RvB

BIBLIOGRAPHY: (A) unpublished; (B) Allard Pierson Museum 1980; (B and C) Brijder and Jurriaans-Helle 2002, pp. 152–53.

CHORAL DANCE IN ARCHAIC ATHENS

MARY LOUISE HART

CHORAL PERFORMANCE FLOURISHED IN ATHENS long before tragedy as we know it was first presented at the Great Dionysia. A remarkable group of vases dating from about 560 B.C. to about 480 B.C. reveals the diversity of performance and its representation in pre- and early-dramatic Athens (see plates 5–9, 11, 12).[1] These vase-paintings do not present myths or legends, nor can any of the rituals of daily life be recognized. They are further distinguished from other vase-paintings of the time by a number of stylistic features, including the patterned repetition of poses and the introduction of masks and distinctive headgear. There is also often an aulete (a double-pipe player) among the dancers (see plates 6, 8, 11, and fig. 1.6), indicating with certainty that the scenes depict choral dances accompanied by music. Taken together, the vase-paintings display an active performance environment characterized by a rich variety of presentation at a time of complex and energetic artistic experimentation.

The brightly colored costumes on the Louvre komast cup (plate 5) with their well-padded rumps and chests have earned the quasi-mythical beings who wear them the epithet "padded dancers." These figures are iconographically related to early depictions of dancing satyrs as well as wildly dancing drunken humans known as komasts. A slightly later cup in Amsterdam (plate 6) depicts identically costumed masked dancers with unusual headgear moving in separate groups, each group unified by its own choreography, accompanied by some of the earliest auletes to be represented in Greek art.

Often referred to as the "Knights" (a reference to the Aristophanes comedy of 424 B.C.), an important black-figured vase in Berlin (fig. 1.4) shows, on its primary side, three chorusmen costumed as warriors, wearing individually crested helmets, "riding" three partners in horse costume. They face a piper, and there is no doubt that they are participating in a costumed choral dance. This is the earliest vase to show men clearly costumed as animals dancing in choral formation; the reverse of the vase depicts a satyr chorus performance. The horse-riders have been interpreted as an early manifestation of a fifth-century B.C. comic chorus, and although they evoke later comic choruses (see, e.g., plate 11), any specific connection to or identification with the plays of Aristophanes, such as his *Knights*, *Wasps*, *Birds*, or *Frogs*, is misleading and anachronistic. These vases appeared decades before comedy was introduced as a dramatic form at the Great Dionysia in 486 B.C., forty years before the birth of Aristophanes.

The Knights is contemporaneous with the "Stilt-Walkers" in Christchurch, New Zealand (plate 7), with another chorus costumed as soldiers (as the majority of them are), in this case inexplicably walking

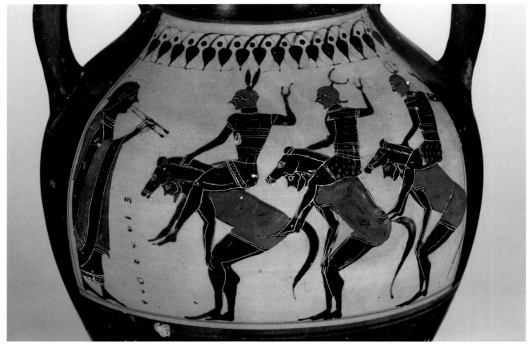

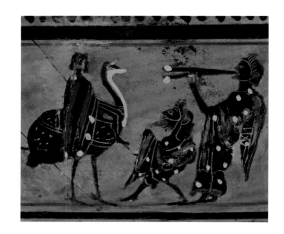

FIGURE 1.4

Chorus of Knights. Attic black-figured amphora (detail, side A) attributed to the Painter of Berlin 1686, ca. 550–540 B.C. Antikensammlung, Staatliche Museen zu Berlin F1697. Photo: Jürgen Liepe

FIGURE 1.5

Chorus Member as a Youth Riding an Ostrich, Masked Performer, and Piper. Attic black-figured skyphos, ca. 520–510 B.C. (detail, plate 8, side B). Courtesy Museum of Fine Arts, Boston. Photo: Ellen Rosenbery

on stilts. A generation later, an ostrich-riding chorus of armed youths on a black-figured skyphos in Boston (plate 8) continues the phenomenon. The small masked performer facing the ostrich-riders is a figure of great interest (fig. 1.5). Similarly costumed, he could be their leader, the *exarchos* or *koryphaios*, the one who emerges from the chorus to lead them. He could also be their trainer or choreographer, or he could be their interlocutor, requiring a large mask to distinguish himself from the performing group. If the latter, this figure, painted during the formative years of tragedy, may be one of the earliest surviving depictions of an ancient Greek actor.

Choruses of dolphin-riders on vases (see plates 8, 9) have drawn attention to the emergence of dithyrambic performance in the mid-sixth century B.C.[2] Introduced into Athens by the poet Lasos of Hermione, the dithyramb was a choral performance of fifty men or boys designed to be danced in a circle. It was invented in Corinth by a poet and musician named Arion, whose famous story of kidnapping by pirates and rescue by dolphins is told by Herodotus (1.23–24). Herodotus also mentions the dedication of a statue in Arion's honor inscribed with the very words—*epi delphinos*, "on a dolphin"—that are sung by the dolphin chorus on the masterful psykter in New York (plate 9). That vase and its contemporary, the black-figured skyphos in Boston (plate 8), are late-Archaic (ca. 520 B.C.) examples of an iconographic phenomenon of hoplite-riding dolphin choruses. A century later, in the Classical period, dithyrambs were still being performed at the Great Dionysia, but as the Kleophon Painter's depiction of a dithyramb on the krater in Copenhagen (plate 13) shows, the magic of Arion's dolphins had by that time been replaced by the idealized representation of an actual dithyramb.

NOTES

1 Sifakis 1971, pp. 73–75, first grouped many of these vases, summarizing previous scholarship; Green 1985, pp. 99–103, conveniently lists eighteen and illustrates them in his figs. 4–21.

2 Csapo 2003, pp. 86–90, and Rusten 2006, p. 52.

5

***Komos* Scene**

Black-figured komast cup, 575–565 B.C.

Attributed to the KY Painter

Greek (Attic)

H: 9.4 cm (3¹¹⁄₁₆ in.); Diam: 20.1 cm (7¹⁵⁄₁₆ in.)

Paris, Musée du Louvre Cp 368 (E 742)

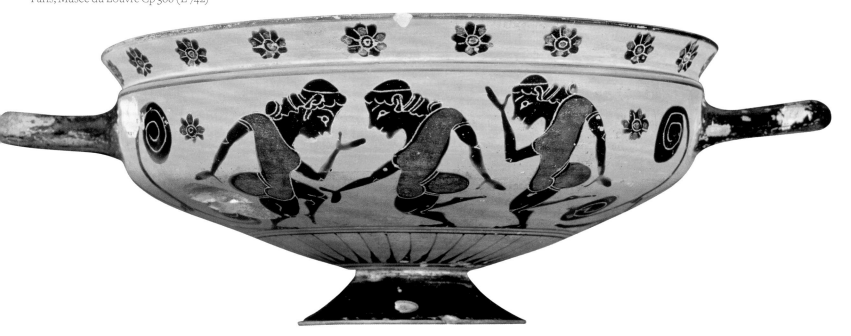

BLACK-FIGURED ATTIC CUPS produced in the first quarter of the sixth century B.C. borrow their shape and decorative repertoire from Corinthian-produced cups and skyphoi. These cups, called komast cups, portray dancers who have been interpreted as komasts (men in search of drink) associated with the realm of Dionysos. The Louvre cup belongs to this typology. It has a wide, deep bowl with a slanting lip decorated with a border of rosettes, horizontal black handles surrounded by decorative vegetation, and a truncated base that is also painted in black with thin radiating lines that emphasize the lower part of the bowl. In the center, three male figures wearing red tunics are dancing wildly. The scene prefigures that of the *komoi*, lines of joyful drinkers participating in the banquet. Such dance scenes, which first appeared in the Corinthian repertoire in the Archaic period, decorated many Attic vases until the Classical period.

On komast cups one notes that the dancers' silhouettes appear heavy, with large posteriors. Some have pointed out the addition of padded costumes on the stomachs and buttocks of these figures, who could be the ancestors of comic actors or the choir of satyrs in performances of satyr plays.

The adaptation of the decoration to the form, the placement of most of the dance scene on the exterior of the bowl, the importance given to predominantly human-figured representations, the placement of the ornamentation in secondary spaces, and the system of decoration are unique to Attic production and particularly to this group of komast cups created by the KX Painter and the KY Painter. SM

BIBLIOGRAPHY: Villard 1946, p. 155, pl. 1,1; *ABV*, p. 32, no. 9; Brijder 1983, pp. 74, 224, no. K9, pls. 3B, 64A; *BAdd²*, p. 8; Denoyelle 1994, p. 64, no. 27.

PLATE 5 | 21

6

Pre-Dramatic Performance
of a Satyr Chorus

Black-figured Siana cup, 560–550 B.C.

Attributed to the Heidelberg Painter

Greek (Attic)

H: 9.5 cm (3¹¹⁄₁₆ in.); Diam (rim): 25 cm (9¹³⁄₁₆ in.)

Amsterdam, Allard Pierson Museum 3356

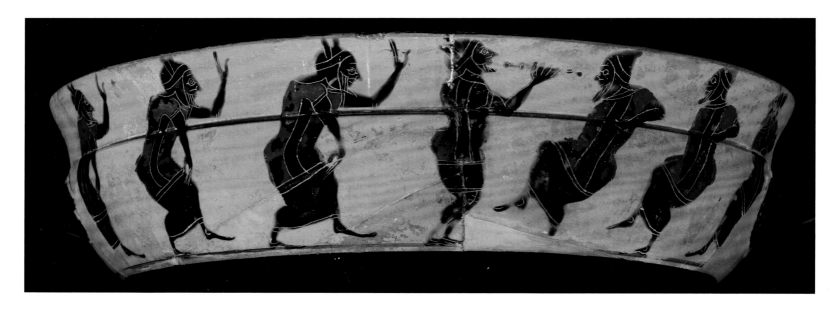

THESE FOUR TRIOS of disguised men, dancing to the sound of the *aulos* blown by the player in the center on each side of the cup, may be one of the earliest representations of chorus members in dramatic performance. All the men are wearing a strange garment: a short red tunic decorated with a vertical black band patterned with white meander hooks over a long chiton reaching to the ankles or a short one reaching to the knees. Even more interesting is the headgear. On side A the men wear black caps with flaps covering the cheeks, the ears, and the nape of the neck. The caps of the right-hand trio are pointed, as on side B, but the headgear of the left-hand trio and the *aulos* player is rounded. The vertical objects in their headbands are most remarkable.

The garments and tunics of the dancers may be related to the costumes of actors, particularly actors of later tragedy. The caps with flaps on side A and the pointed caps on side B show some similarity to Thracian headgear. The vertical objects in the headbands of the left-hand trio and the piper on side A may be interpreted as equine (horse's or donkey's) ears. If we accept that interpretation, the connection with satyrs becomes evident: these three dancers are most likely impersonating "humanized and refined satyrs" singing a ritual song (dithyramb) in honor of Dionysos, the god not only of wine but also of drama. They play their part in a chorus and dance the *tyrbasia* (dithyrambic dance), which should be performed in satyr dress. All the men on the cup dance rather stiffly in a choreographed manner, in trios with identical stances.

The cup in Amsterdam is dated to 560–550 B.C., about two decades before the official date (534 B.C.) of Thespis's first Great Dionysia victory in Athens. It is Thespis who is regarded as the inventor of tragedy, introducing the ritual song (dithyramb) in honor of Dionysos. Choral performances by men dressed as satyrs may have been a regular feature of public or semipublic entertainments for decades preceding 534 B.C. The Amsterdam "satyr men" constitute a pictorial illustration of such performances. HB

BIBLIOGRAPHY: *CVA* the Hague (Scheurleer), p. 1, pls. 2, 4, 5; *ABV*, p. 66, no. 57 (Heidelberg Painter); Webster 1970a, pp. 14, 36n102, 70, 83, fig. 3; *IGD*, I,8; Green 1985, pp. 99–100, no. 1; Brijder 1986, pp. 69–81; *BAdd²*, p. 18; Brijder 1991, p. 493 (refs.), fig. 96, pl. 112f–g; *CVA* Amsterdam, p. 2, pls. 82–85, p. 4, figs. 12, 13.

7

Battle of Lapiths and Centaurs (side A)
Chorus of Stilt-Walkers (side B)
Black-figured amphora type B, 550–525 B.C.
Attributed to the Swing Painter
Greek (Attic)
H: 41.4 cm (16¼ in.); Diam: 27.2 cm (10¾ in.)
Christchurch, New Zealand, James Logie Memorial
Collection, University of Canterbury 41/57

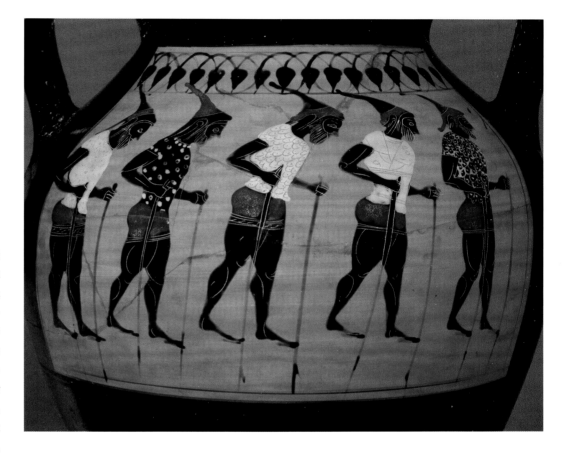

THIS UNIQUE SCENE by the Swing Painter— most active from 540 B.C. to 520 B.C.—features five men on stilts, moving toward the right. Each figure wears a long, pointed cap, a false-looking beard, and a corselet over a *chitoniskos* (short tunic), all of which have added color (red, white, or black). The corselets vary: three men wear white corselets incised to suggest animal skin (the first figure, at left), feathers or scales (the third figure), and metal (the fourth figure). Animal skin and scales are also rendered on black with added white paint (the second and fifth figures, respectively).

It is universally agreed that the men are part of a comic chorus from an early type of dramatic performance. The singular costume would seem to indicate a specific character or characters, but the identity remains uncertain. There are words in Greek for stilt-walkers or dancers, such as *kadaliones* and *kolobathristes*, or the Lakonian *gypones*. Whether or not the means of locomotion was central to understanding the characters' identity, the men are foreign and, given their military costume, potentially threatening. This scene is comparable to others that feature a chorus of knights riding on men dressed as horses, or armed men riding dolphins, which began to appear about 540–530 B.C., decades before the first Great Dionysia, of 486 B.C.

Side A features a Lapith, probably Kaineus, lying on the ground and being attacked by three Centaurs. ABG

BIBLIOGRAPHY: Webster 1959; Brommer 1968; Webster 1970a; *IGD*, I,10; Trendall 1971; Boardman 1974; *CVA* New Zealand, fasc. 1 (1979), pl. 8, nos. 3, 4; Böhr 1982; Green 1985; Cohen, Shapiro, and Trendall 1995; Boardman 2001; Green 2007c; Green 2009.

On *gypones*: Brommer 1968; Webster 1959, pp. 64–65; Webster 1970a, pp. 15, 70; Trendall and Webster 1971, p. 21 (based on Pollux's *Onomastikon* 4.104). On stilt-walkers (known from Hesychios's *Lexicon*): *CVA* New Zealand, fasc. 1 (1979), pp. 7–8. On comparable scenes: Green 1985, pp. 98–101, nos. 3, 6; Green 2009, pp. 58–62.

PLATE 7 | 23

8

Chorus of Six Hoplites Riding Dolphins, with a Piper (side A)
Chorus of Six Youths Riding Ostriches, with a Piper and a Masked Figure (side B)

Black-figured skyphos, 520–510 B.C.
Greek (Attic)
H: 16 cm (6⁵⁄₁₆ in.); Diam: 22 cm (8¹¹⁄₁₆ in.)
Gift of the heirs of Henry Adams, 1901
Boston, Museum of Fine Arts 20.18

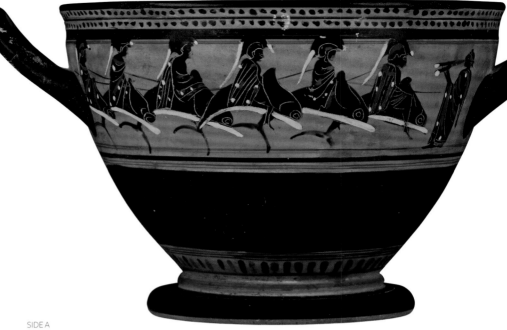

SIDE A

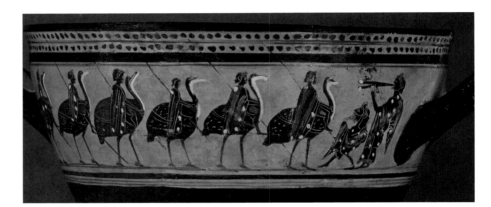

SIDE B

ON SIDE A, six hoplite warriors ride leaping dolphins to the accompaniment of an aulete (double-pipe player), whose presence signifies the depiction of a choral performance. Similarly, side B has a chorus moving to the right, depicted as six youths armed with spears riding ostriches toward an aulete. Between this chorus and the aulete is an enigmatic figure, often discussed as the earliest appearance in vase-painting of a masked performer interacting directly with the chorus while not being a choreut. Painted some three decades before the official installation of comedy at the Great Dionysia in 486 B.C., this vase provides important evidence for the emergence of the actor within dramatic performance. Depending on whether the chorus is interpreted as "proto-comedy" or dithyrambic, the masked performer could be identified as a "proto-actor" (if an early comic chorus) or as an *exarchon*, the leader of the dithyrambic song.

The enigmatic masked figure wears a *chlamys* (cloak) decorated with the same added-white dots and red ribbons used to embellish the cloaks of the other performers (see fig. 1.5). He leans back energetically and raises his right arm within his cloak, evidently addressing the chorus without joining them. There is extensive damage and overpaint in this section of the vase, but the top half of this figure is mostly preserved. The deeply incised mask is of outsize proportions. The round eyehole is carefully circumscribed; the mouth is open. Red has been applied to the mask's stiffly protruding beard and at the top of the crown. The oblong ear is sharply incised and touched up with a dab of red. Seven incised lines spring from the brow of the mask; they delineate what appear to be tufts of hair, or possibly feathers, but definitely not ears. Black smudges at the top edge of this area are not part of the decoration. The identity of this mask is uncertain. It has the long hair and beard of the satyr, but the lack of pointed ears in the mask, together with the himation covering the entire body, suggests a different kind of performer. MLH

BIBLIOGRAPHY: *IGD*, I,11; Green 1985, p. 103, no. 17, fig. 20a–b; Green 1991, p. 22; Csapo 1997, p. 268, pl. 6B; Steinhart 2004, p. 21, pl. 9.1–2; Csapo and Miller 2007, p. 23n116, cover ill.; Csapo 2008, p. 64, pl. 12.2.

Thanks to Susan Lansing-Maish (assistant conservator, J. Paul Getty Museum) for her assistance with UV and microscopic analysis of this vase.

9

Chorus of Hoplites Riding Dolphins

Red-figured psykter, 520–510 B.C.
Attributed to Oltos
Greek (Attic)
H: 30.2 cm (11⅞ in.); Diam: 22.9 cm (9 in.)
New York, The Metropolitan Museum of Art
1989.281.69

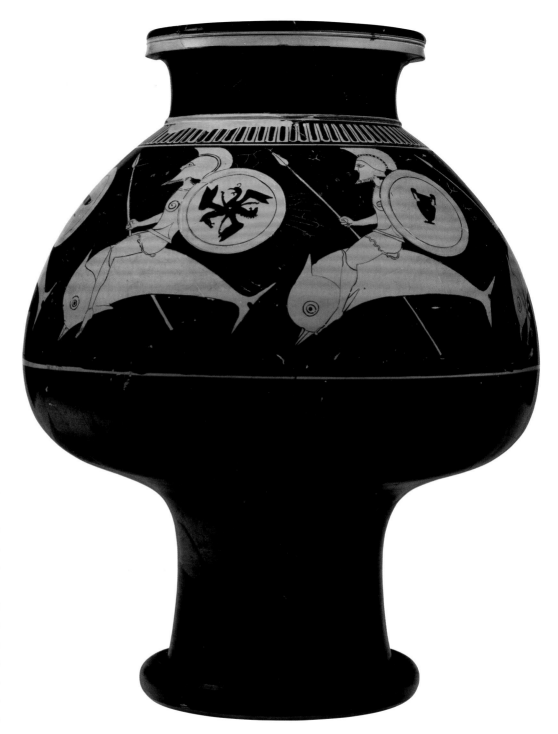

A SKILLFUL DECORATOR of drinking cups destined for the symposion, Oltos here composed a choral dance circumnavigating the exterior of a psykter, a vessel specifically shaped to chill the wine inside it when submerged in ice-cold water. Carefully designed to be utilized in this way, this vase depicts dolphins that appear to be leaping over the water as they dive around the surface of the vase without interruption, unencumbered by the presence of a piper. Comparison with a figurine in the Louvre (see plate 10) and with other vases confirms that in practice choreuts would have strapped their costumes around their waists.

This vase presents one of the later examples of animal-chorus depictions, which flourished in the second half of the sixth century B.C. Like the chorus members on the skyphos in Boston (see plate 8), these six choreutai are costumed as foot soldiers, wearing helmets and carrying spears. Here they also carry shields; the repeating disks are enlivened by a variety of shield devices: kylix (drinking cup), kantharos (special shape of drinking cup, an attribute of Dionysos), volute krater (mixing vessel), and two whirligigs.

The words *epi delphinos*, meaning "on a dolphin," are repeated, inscribed retrograde as if issuing from each choreut's mouth; the words refer to the ode the choreutai would sing as they performed. Identification as a dithyrambic chorus is indicated by the emphasis on circular composition and strengthened by the repetition of the inscription, which is linked to Arion, the inventor of the dithyramb. MLH

BIBLIOGRAPHY: *ARV*², pp. 1622–23, 7bis; Sifakis 1967, pp. 36–37, pl. 6; *IGD*, I,15; Boardman 1975, p. 57, fig. 58; Davies 1978, p. 78n41; Green 1985, p. 101, no. 6, p. 102, fig. 9 (with bibliog.); Green 1991, p. 26; Csapo 2003 (see esp. the compendium of dolphins in vase-painting); Steinhart 2004, p. 21, pl. 8,2; Rusten 2006, pp. 49–54 (on the iconography of dolphin choruses, dithyrambic choruses, and choral forms generally); Steinhart 2007, p. 223, fig. 39; Picón 2007, no. 106, pp. 100, 427.

PLATE 9 | 25

10

Figurine of a Warrior Riding a Dolphin

500–475 B.C.

Greek (Boiotian); found in Tanagra

Terracotta

H: 9.5 cm (3¾ in.)

Paris, Musée du Louvre MNB 3017

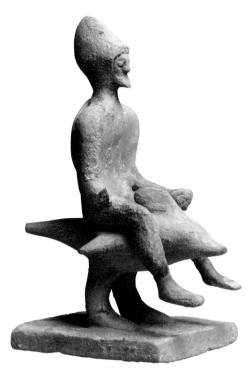

THIS FIGURE IS OFTEN IDENTIFIED with Taras, the mythical founder of the Italiot city of Taranto; the city's symbol, a warrior riding a dolphin, is noted in literature and on local coins. However, the likely provenance of this figurine, confirmed by the existence of similar pieces in Tanagran tombs and by its similarity to a scene found on Attic vases (such as plate 9), suggests that it is related to the theater. This hypothesis is supported by the presence of legs that are clearly shown beneath the dolphin along with a second set of legs atop the animal; this and the figure's helmet suggest an actor costumed as a mounted warrior. Instead of having the traditional padding, he is armed with a prop in the shape of a dolphin, and thus he can be interpreted as a member of the chorus in a comic or dithyrambic performance.

The technique (molded head, modeled bodies) and the vivid polychromy (yellow and red) that is still visible on the figurine associate it with the series of genre subjects, for which Boiotia was particularly well known between 520 B.C. and 475 B.C.; the theme of the piece is, however, quite unusual. VJ

BIBLIOGRAPHY: Besques 1954, p. 19, B109, pl. 14; Higgins 1986, p. 92, fig. 101; Barcelona 2000, exh. cat., no. 155.

11

Chorus of Birds

Black-figured oinochoe, ca. 480 B.C.

Attributed to the Gela Painter

Greek (Attic)

H: 15.6 cm (6⅛ in.)

London, The British Museum 1842,0728.787

(B 509)

AT THE FAR LEFT, a bearded aulete wearing a himation plays the double pipe for a pair of men costumed as birds. The pair look back at the aulete as they dance to the right. They wear tight-fitting stippled costumes that cover all but hands, feet, and heads; "wings" are attached to their arms. Purple crests and beards animate their masks. These performers also wear animal skins, parts of which hang down between their legs. Vines decorate the background, suggesting a Dionysiac context.

Comedy became an official event at the Great Dionysia in Athens in 486 B.C., around the time this vase was painted but long before the production of Aristophanes' *Birds* in 414 B.C. The bird chorus on the pitcher shown here is a late example of the phenomenon of animal choruses (see also plates 8, 9). Seen as the precursor to Athenian comedy, they were performed as early as the mid-sixth century B.C. The tradition of bird choruses continued late into the fifth century B.C., with red-figured depictions of actors costumed as birds certainly falling within Aristophanes' productive period (ca. 427–385 B.C.). An Attic red-figured calyx krater by an anonymous painter

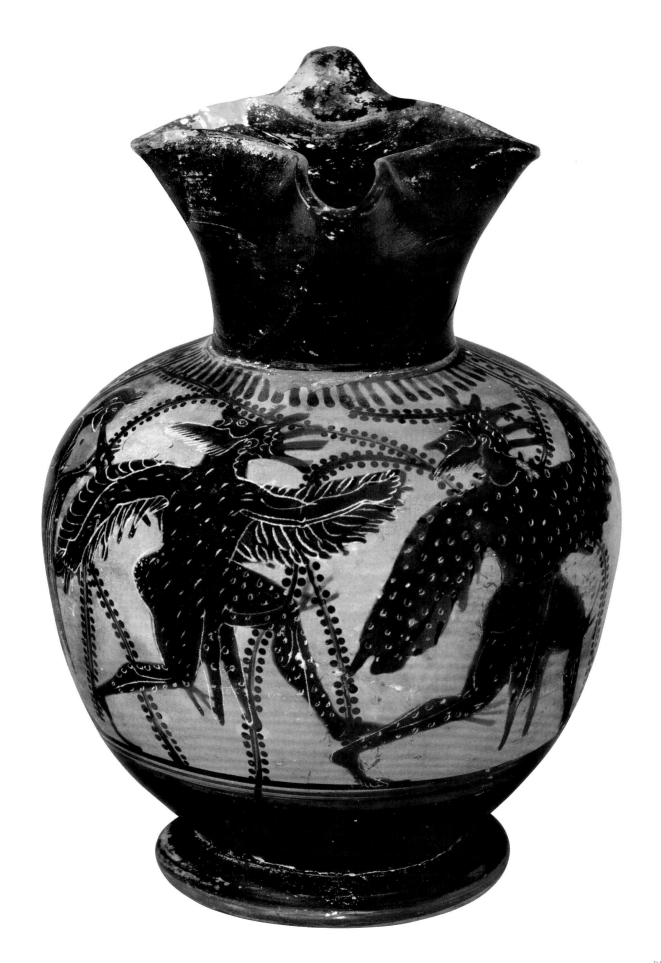

PLATE 11 | 27

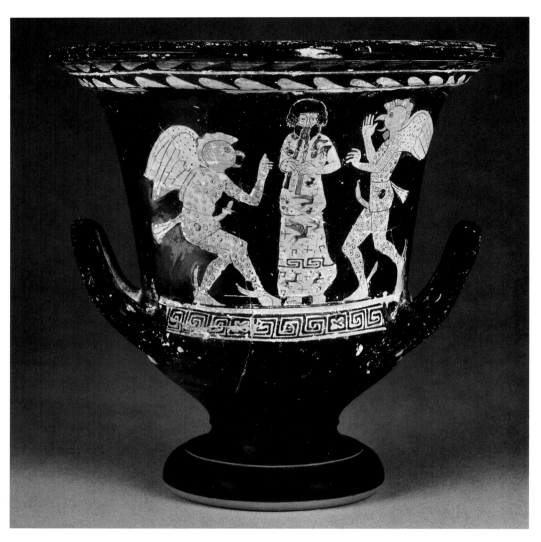

(fig. 1.6) shows two actors costumed as cocks facing each other agonistically. The presence of an aulete between them aids interpretation of the scene as a comic choral performance, and the clearly delineated costumes identify the birds as actors. Interpreted by J. R. Green as representing Aristophanes' *Birds*, the scene has also been attributed by Taplin to the competing Discourses of Aristophanes' *Clouds*. MLH

BIBLIOGRAPHY: *ABV*, p. 473, no. 187; Bieber 1961, fig. 123; *DTC²*, p. 151ff. (on animal choruses with specific examples, including this vase); *IGD*, I,12, plate facing p. 9; Green 1985, pp. 108–11, no. 8, fig. 11a–c; Green and Handley 1995, pp. 17–19, fig. 3; Green 1991, p. 26; Taplin 1987; Taplin 1993a, p. 101ff., pl. 24.28.

Two late-fifth-century B.C. red-figured bird vases are iconographically connected to this one: Carlos Museum, Emory University, Atlanta, Georgia, 2008.4.1, and formerly J. Paul Getty Museum 82.AE.83, fig. 1.5 (photo courtesy of the Republic of Italy).

FIGURE 1.6

Two Actors or Chorus Members in Bird Costumes Accompanied by a Piper. Attic red-figured calyx krater, ca. 415 B.C. Photo: Courtesy of the Italian Ministry of Culture, Department of Antiquities

12

Chorus Approaching a Tomb Monument (side A)
Two Satyrs Dancing around a Large Column Krater (side B)
Red-figured column krater, 500–490 B.C.
Attributed to an unidentified Mannerist painter
Greek (Attic)
H: 36.5 cm (14½ in.); Diam (with handles): 36.6 cm (14½ in.)
Antikenmuseum Basel und Sammlung Ludwig BS 415

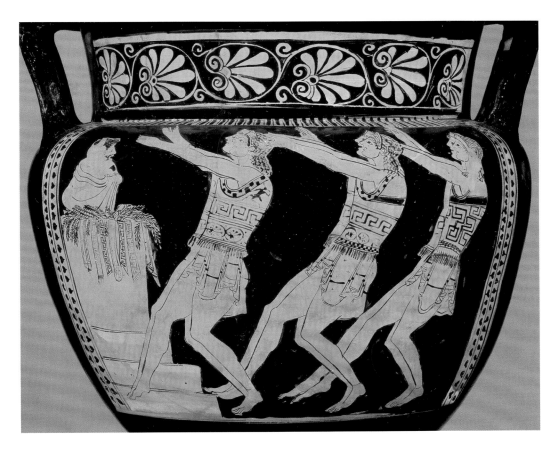

WITH ARMS UPRAISED, three pairs of choreutai dance toward a monument at the left of the scene. The dancers' identical movements, costumes, and masks characterize them as members of a tragic chorus. Simple lines preserved at their left ankles may indicate footwear; their full masks include diadems binding long hair; their uniformly open mouths and the sharp lines that run from their ears and down around their jaws define the chins, mouths, and noses of their masks. They wear short chitons underneath ornamented cuirasses; a small satyr decorates the shoulder of the first choreut on the left. Poorly preserved inscriptions usher from their open mouths. They move toward a tomb with its characteristic steps and garlands. From behind or from the surface of the monument floats or rises the upper half of a cloaked male figure crowned with myrtle. He appears to be wearing a mask with an open mouth.

This singular and important vase-painting has been well studied and published. It is dated early within the context of the Persian Wars and has often been linked to the subject of Aeschylus's *Persians*, produced in 472 B.C. There the scene of the raising of the ghost of King Darius spectacularly focused the Athenian audience on the distress of the city's recent enemies. J. R. Green (1991) notes, however, the lost dramatic sources predating Aeschylus in which the dead were summoned to advise the living, and alternative interpretations, among them supplication to a lost hero, or—from a realm outside of choral performance—a pyrrhic (military) dance, bear merit. MLH

BIBLIOGRAPHY: Schmidt (M.) 1967, pp. 1–2, pl. 19; Simon 1983, pp. 103–4, pl. 32.3; *CVA* Basel 3 (1988), pls. 6.3-4, 7.3-5 (with bibliog.); Green 1991, pp. 34–37; Green 1994, pp. 17–18, fig. 2.1; Blome 1999, p. 87, fig. 116; Miller 2004; Taplin 2007, p. 29, fig. 8.

For the original staging of the scene in Aeschylus's *Persians* of the raising of the ghost of Darius, see Taplin 1977, pp. 105–6, 114–19. Alternative interpretations of this scene include Wiles 2007, pp. 19–20 ("riddle about wine and the attractions of youth"), and Steinhart 2004, p. 20, where the possibilities of a pyrrhic dance and an Amazon chorus are evoked.

PLATE 12 | 29

13

Chorus of Six Men Grouped around a Tall Pole (side A)
Satyr Carrying a Torch Flanked by Two Maenads (side B)
Red-figured bell krater, 430–420 B.C.
Attributed to the Kleophon Painter
Greek (Attic)
H: 46 cm (18 in.); Diam (rim): 48 cm (19 in.)
Acquired in 1957
Copenhagen, The National Museum
of Denmark 13817

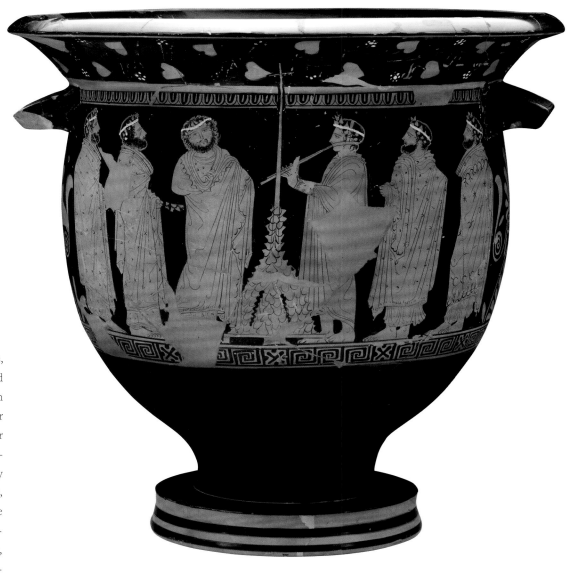

THE SIX MEN constitute a chorus with four singers, a piper, and a *choregos* (citizen producer). They stand on either side of a tall pole covered in ivy, rising from an ivy-covered stand. A fillet is draped over a crossbar at the top of the pole. The four singers, two on either side, wear ornamented himations over long, elaborate chitons. Two or perhaps three of them hold ivy branches. The flute player wears a long-sleeved, short, decorated chiton and an undecorated himation. He plays a double flute attached to his head with a *phorbeia* (mouth strap). The *choregos*, shown face front, wears a plain himation over a long, decorated chiton. All six wear an ivy wreath and a white band with a golden stripe around their foreheads. Inscriptions in added white, now worn off, identify the six men—reading from the left, the singers Epenikos and Pleistias; the *choregos*, Phrynichos; the flute player, Amphilochos; and the singers, Theomedes and Xremes. The dominance of the vine may suggest that the dithyramb is being performed in honor of Dionysos at the Great Dionysia. The decorated garments of the chorus may also support this; several ancient writers talk about the lavish robes used in the

great procession at the Dionysia and how a *choregos* might ruin himself financially in fitting out his chorus. The *choregos*, Phrynichos, has tentatively been identified with a poet of Old Comedy, Phrynichos, although he did not write dithyrambs. *Choregoi*, who tended to be wealthy citizens rather than poets, were more likely to be able to afford such markers of wealth. Based on the elaboration of the scene and the meticulous naming of all participants it is tempting to suggest, but hard to prove, that Phrynichos, the *choregos*, ordered the vase in the workshop of the

Kleophon Painter to celebrate this performance at the Great Dionysia. However, the unusual scene on this krater still leaves questions unanswered. BBR

BIBLIOGRAPHY: *CVA* Copenhagen, fasc. 8, pls. 347–349; *BAPD*, vase 215175; Friis Johansen 1959; Rumpf 1961, pp. 208–14; *ARV²*, p. 1145, no. 35; Fronig 1971, pp. 27–28 (see nn. 179–80 for further refs.); *IGD*, I,17; Webster 1972, p. 48; *DFA²*, pp. 16–17, 61–62 (for lavish robes); *BAdd²*, p. 335; Reilly 1994, p. 501, figs. 3, 4; Matheson 1995, p. 135, fig. 120; *LIMC* VIII (1997), s.v. Silenoi, p. 1115, no. 41d, pl. 753.

14

Votive Image Commemorating a Tragic Performance

Joined fragments of a red-figured volute krater, ca. 400 B.C.

Attributed to near the Pronomos Painter

Greek (Attic); found in Taranto

H: 35.2 cm (13⅞ in.); W: 34.4 cm (13½ in.)

Antikensammlung, Martin von
Wagner Museum der Universität
Würzburg H 4781

MEMBERS OF A TRAGIC CHORUS are assembled in the lower register of this highly fragmentary scene. They wear elaborate costumes and hold white-painted female masks. An aulete (flute player) in an embroidered, sleeved chiton stands in the center of the scene. To the right, a female figure with skin in added white paint turns toward the right. She may be either a muse or the personification of tragedy. She is standing behind a chair, of which a small fragment of the back survives, and with her right hand she touches the shoulder of a figure seated on it, perhaps the playwright.

In the upper register, Dionysos, his feet resting on a stool, and Aphrodite, with added white skin and Eros winging toward her, are seated on either side of a pillar topped by a tripod. Behind Aphrodite

stands a figure wearing a sleeved chiton and holding a mask in his hand, either the leader of the chorus or an actor. To the left of Dionysos is a large cauldron with a tripod on a three-stepped base, and to the left of it is a figure in an embroidered garment with a *nebris* (fawn skin) draped over it (an actor playing Artemis?). The fragmentary chorusman at the far left is wearing a white chiton and mantle and holding a scepter. The tiny fragment of clay-colored toes just beneath the three-stepped base indicates that there was another figure between the cauldron and Dionysos.

As on the famous name-vase of the Pronomos Painter (plate 44), this stylistically related vase-painting in Würzburg presents chorus members, an aulete, and possibly the author of a play in

the lower section, while painted in the upper part are the play's actors together with various gods, including Dionysos as patron of the theater and Aphrodite, perhaps as "patroness of the play." It is not a picture of an actual theatrical performance. In its blend of divine myth and reality it was likely based on a votive image dedicated in commemoration of a prizewinning performance. IW

BIBLIOGRAPHY: *ARV*², p. 1338; *CVA* Würzburg 2, pls. 41.1–5; Simon 1982, p. 11, fig. 4.2; Moraw and Nölle 2002, pp. 73–76, figs. 90, 91; Taplin 2007, p. 30, fig. 10.

PLATE 14 | 31

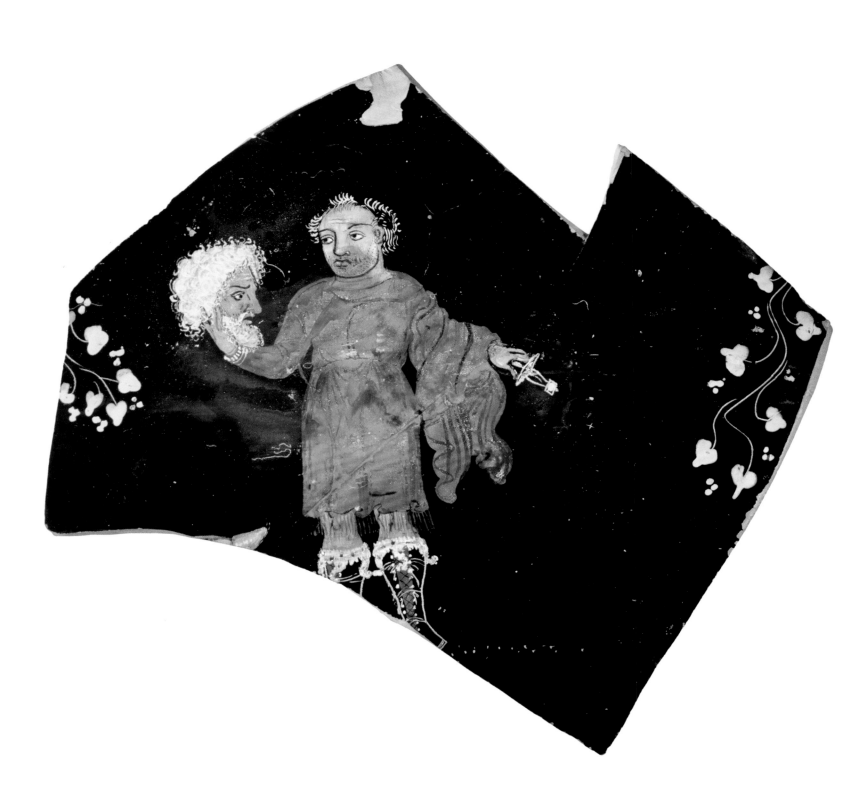

ACTORS, CHORUS, AND MASKS

J. MICHAEL WALTON

TWO ILLUSTRATIONS FROM VASE-PAINTING supply compelling evidence about Greek actors and acting. A red-figured pelike from the fifth century B.C., a time when both Sophocles and Euripides were competing in the dramatic contests, often against each other, shows two young men getting into costume for a performance (plate 15). They appear to be dressing as women and are sufficiently similar to be members of a chorus. The figure on the left is already prepared and seems to be addressing or brandishing a cloak. The man on the right is in the act of putting on his boots (*kothornoi*). In the center, on the floor between them, is his mask.

The other painting (fig. 1.7) is from the fourth century B.C. and from Taranto rather than Athens. It shows a middle-aged and almost bald actor in a short tunic and wearing his boots. He is addressing his mask, that of a middle-aged or elderly man who looks rather more impressive than the actor and certainly has a finer head of hair. In his left hand he carries a stage prop, which might be a dagger or a small flask. The role he is playing is unclear. He could be a messenger, the Tutor in Sophocles' *Elektra*, or Kreousa's old retainer in the *Ion* of Euripides, who tries to poison the title character.

These two representations alone dispel some of the popular misconceptions about performance in the Greek theater. The first has to do with *kothornoi*, the high boots. Though some sort of platform sole was added to the actor's footwear in Hellenistic times (plate 18), there is no direct evidence that it was a feature of stage costume in the theater of Aeschylus, Sophocles, and Euripides. As we see the *kothornoi* here, they are soft, knee-length lace-up boots without an elevated sole. In art they are part of the iconography that can signify an actor or a theatrical scene (e.g., plates 15, 21–23, 25–27, 30, 31, 36, 44, 49). Stage costume served to identify the character, and it was also practical, in the sense of being what actors could comfortably wear for the amount of movement and action required of them. Two vases (figs. 1.8, 1.9) show that the need for comfort did not prevent the costume from being elaborate or even sumptuous, where appropriate. The Pronomos vase (fig. 1.9) also confirms that the actors in the three competing tragedies performed in the satyr play that followed as well.

In some plays a character might change mask in midperformance. Oedipus, for example, returning to the stage after blinding himself, might now wear a mask to indicate what he has done. The mask might even serve figuratively. In Euripides' *Bacchae*, when Agave enters with her son's head impaled on her bacchic wand, what she used for this terrible stage prop may simply have been the Pentheus mask.

FIGURE 1.7
A Tragic Actor Perusing His Mask. Apulian (Gnathian) red-figured krater fragment attributed to the Konnakis Group, ca. 340 B.C. Martin von Wagner Museum der Universität Würzburg H 4600. Photo: Peter Neckermann

The central characters of both tragedy and the satyr play wore masks to suit their age, role, and status. The masks of Greek tragedy were not the exaggerated gaping-mouthed grotesques of which Lucian would complain several centuries later in his treatise on dance (*Peri Orcheseos* 26–30). Terracotta masks show Greek tragic masks to have been surprisingly lifelike (plate 37). For the chorus, whose nature was both corporate and individual, they were by necessity uniform (plates 6–9, 11, 12, 15). In the satyr play (an element of tragedy, not of comedy), the masks and costumes reflected the animalistic personas of the satyrs with horse's tails, sometimes the legs of a goat, and often sporting a *phallos* (plates 16, 41, 42, 44–49).

A number of reasons have been advanced to explain why actors wore masks in Greek tragedy and comedy. One is that it enabled the characters to be seen better in a large open-air theater; another, that it made the doubling of characters by a small number of actors easier, as well as the assumption by males of female roles. A third suggestion proposes that each character had a single, fixed expression that tied the mask to the dominant character trait of the part he was playing. None of these is wholly convincing. Were we able to travel back in time and invite an actor from ancient Greece to speculate on the purpose of the mask, his response, I suspect, would have been rather different. Why did Greek actors wear masks? Because the mask is what defined the actor. If the assumption that Thespis "invented" acting by putting on a mask is accurate (see "A Playing Tradition," earlier in this volume), then the mask was simply the central feature of an actor's performance. Acting *was* the mask. Any assumption that a mask limits an actor's performance, or dictates a static and frozen style is to misunderstand physical acting. The mask and physical acting are inextricably linked.

At this point we need to make a brief detour. No examples of early tragedy survive to show how plays may first have been performed by a single actor, together with a chorus. This is how it all seems to have begun, if Aristotle can be trusted. He believed that Aeschylus introduced a second actor, Sophocles a third (*Poetics* 1449.a.13). But what do these extra actors imply? A second actor makes dialogue possible with someone other than the chorus. A series of scenes can be included in which new information is

FIGURE 1.8

Andromeda (detail). Attic red-figured calyx krater attributed to near the Pronomos Painter, ca. 390 B.C. Antikensammlung, Staatliche Museen zu Berlin V.I. 3237. Photo: Christa Begall

FIGURE 1.9

Actors holding their masks. (detail, plate 44), ca. 400 B.C.

regularly supplied about what is happening offstage. Either actor can leave the stage from time to time, to return as someone else.

Aeschylus's *Oresteia* and *Prometheus* both require the third actor that Sophocles introduced early in his own career. Sophocles explored the possibility of the triangular scene where the information of one character has a different response from his two listeners. In *Oedipus Tyrannos*, the news that Oedipus is not the son of the King of Corinth is greeted with relief by Oedipus but dismay by Jocasta (plate 26). In *Elektra*, the news that Orestes has been killed in a chariot race provokes relief in Klytaimnestra, despair in Elektra. Eventually Euripides took things further. *Phoenician Women* features a cast of eleven as well as the chorus. Although this play can theoretically be performed by three actors, the same is not true of Sophocles' last play, *Oedipus at Kolonos*, without the most implausible of casting contortions, which would involve one of the characters, Theseus, being played in turn by all three of the actors. In comedy, restrictions on the numbers were almost certainly more relaxed. Four actors are regularly required in some plays by Aristophanes, and in Roman New Comedy, based on Greek originals, five speaking characters are often present. The chorus for Greek tragedy changed in number too, from twelve in Aeschylus to fifteen later in the century, with twenty-four likely for Old Comedy.

In a work of performance art, what is important is not the numbers but the range of expertise demanded of the performers. The choruses until well into the fourth century were made up of amateurs, young fellow tribesmen of the *choregos*. If, as is probable, they performed in all four plays of a tragic submission to the Great Dionysia, the same group who would have had to sing and dance in Aeschylus's *Oresteia* as old men of Argos would then have changed into the masks and costumes of the female palace slaves of Klytaimnestra in *Libation Bearers*, then the Erinyes who persecute and hunt down Orestes in *Eumenides*, and, finally, a group of lewd and obstreperous satyrs. They had to be singers and dancers, highly trained and highly motivated.

Aeschylus, apart from being a playwright, was his own first actor, probably the director and the composer too. Sophocles apparently abandoned acting because of a weak voice, and there is no suggestion that Euripides ever acted at all. With prizes at stake, the actors became professional. Their range too was considerable. Any one of them might have had to assume male as well as female roles in the same play—gods, kings, messengers, slaves, anyone from Helen of Troy to Herakles or even Dionysos, the god of the theater himself. Sometimes the greatest versatility must have been demanded by the least prominent actor, as many as six roles in a single play of a group of four. The other professional was a musician who accompanied the lyric passages and perhaps some of the dialogue too (plates 6, 8, 11, 14, 44–46, 54, 55). Music was an important element of performance as an accompaniment to choral and lyric passages. An aulete—a player of the double pipe (*aulos*)—is featured on many theatrical vases, though not those representing tragedies, and some plays appear to have involved percussion in addition to the *aulos*. In later centuries, when the Artists of Dionysos traveled from city to city in the Greek world under the auspices of the theater guilds, the standard company for tragedy consisted of three actors and a musician, augmented by a local chorus and extras.

All of this underpins the nature of masked acting, a subject to which we can now return. Masked acting was a highly developed skill that combined what is required of modern-day mime artists, opera singers, and principal dancers; it relied heavily on *cheironomia*, the language of gesture. The voice was, of course, of major importance, to which Sophocles' truncated career as a player bears witness, but the ability to command the space in a mask, when either speaking or listening, involves stance and balance, a mastery of playing the shape and contours of the mask-face from the neck, the shoulders, and the complementary gestures of hand and arm. Such skills are rarely seen today, but when they are, it becomes apparent just how highly trained and controlled these actors must have been to show the range of emotion that even the most temperate of Greek tragedies demanded.

THEATER SPACES

The Agora was the original marketplace in old Athens, a flat area where large numbers of people could gather for all manner of civic purposes. It was the obvious location for the first dramatic performances with some sort of grandstand for spectators and a place for players. A later story suggests that it was the collapse of one of these scaffolds during the performance of an early play of Aeschylus that prompted a move to the southeastern slope of the Acropolis, where all the plays of Aeschylus, Sophocles, and Euripides that have survived were first performed (fig. 1.10).[1]

This was not, it should be stressed, a purpose-designed structure; rather, it was a hollowing out of the hillside to seat an audience who would witness plays performed below them with a dancing place for the chorus (*orchestra*) and some kind of playing area behind for the main actors. There may even have been no *skene* (scenic facade), though it would be hard to focus on actors without some background against which to frame them. Soon after the middle of the fifth century B.C., Perikles initiated a massive building program that included the transformation of the top of the Acropolis with a series of shrines and temples, including the Propylaia, the Erechtheion, and the massive Parthenon, dedicated to Athena, the city's patron goddess. The old theater was updated into a theatrical precinct with permanent seating in the *theatron*, where the audience would watch the action from almost two-thirds of the way around the circular *orchestra* (fig. 1.11). In the center of the *orchestra* probably stood a low altar called a *thymele*, which would have provided an essential focal point for the masked dancers.

The symmetry of the *theatron* was broken by a large, roofed building, the Odeion of Perikles (443 B.C.), which encroached on the left side (as seen from the audience) of the *theatron*. This building was the venue for a number of festival-related events, such as the *proagon*, a kind of live "trailer" that took place

FIGURE 1.10

Aerial View of the Acropolis, Athens, showing the Theater of Dionysos at bottom left and the Theater of Herodes Atticus in the upper left corner. Photograph: H. R. Goette

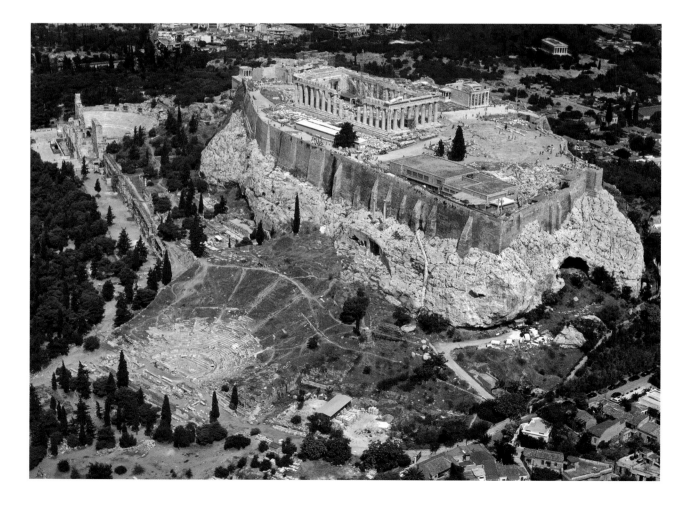

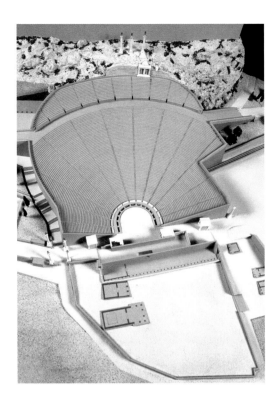

FIGURE 1.11

Model of the Theater of Dionysos, Athens, ca. 300 B.C.
Makrygianni Museum, Athens.
Built by M. Korres, N. Gerasimov, P. Dimitriades;
architectural study by M. Korres. Photograph: H. R. Goette

FIGURE 1.12

Vase-Painting of *Skenographia* (Scene Decoration) of Temple
or Palace. Apulian (Gnathian) red-figured bell krater fragment
attributed to the Konnakis Group, ca. 350 B.C.
Martin von Wagner Museum der Universität Würzburg H 4696.
Photo: Karl Oehrlein

a few days before the festival began, with playwrights presenting their companies, unmasked, to give some preview of their program.

At the south side of the *orchestra* a long hall was built, perhaps with dressing rooms, used in part for evening ceremonials or refreshments. In front of this hall was the *skene*, a wooden and adaptable scenic facade with whatever scenery was used to indicate the setting. It is probable but by no means certain that in front of the *skene* was a low platform stage from which the *orchestra* could be reached by steps or ramps. All the surviving seven tragedies of Sophocles and the nineteen of Euripides were written for performance in this Periklean Theater.

The best idea of how the *skene* may have functioned comes from some later vase-paintings that show columned porticos with double doors set back from, and framing, a stage area (fig. 1.12; plates 34, 35). Though one of these plays, Euripides' *Stheneboia*, has not survived, the plays of Sophocles and Euripides usually require settings with a single entrance from the back, most often from a building, which served as any sort of dwelling from palace to farmer's cottage (in the two playwrights' versions of *Elektra*), military tents (Sophocles' *Ajax*, Euripides' *Rhesos*), temples (Euripides' *Ion* and *Iphigenia among the Taurians*), and caves (Sophocles' *Philoktetes*, Euripides' *Cyclops*).

The most satisfactory way to account for such versatility is to presume that the stage background in the Periklean Theater consisted of a wooden facade in the form of a familiar temple frontage to which painted panels could be added to suggest the status and location of the setting. In Athens, as well as in theaters of the fifth or fourth century B.C. elsewhere in Greece and the Greek world, additional entrances and exits could be made along the *parodoi* that ran between the edge of the auditorium and the stage area (fig. 1.13).

The physical interdependence of the three main areas—the *theatron*, the *orchestra*, and the *skene*—is intriguing. Patrons in the front-row seats were within arm's length of the *orchestra*'s edge. The *orchestra* was usually, though by no means always, the province of the chorus. The chorus witnessed events as they unfolded, sometimes taking sides and making their own contribution to the action, on other occasions dissociating themselves so as not to become involved. The choral odes that intercut the main action

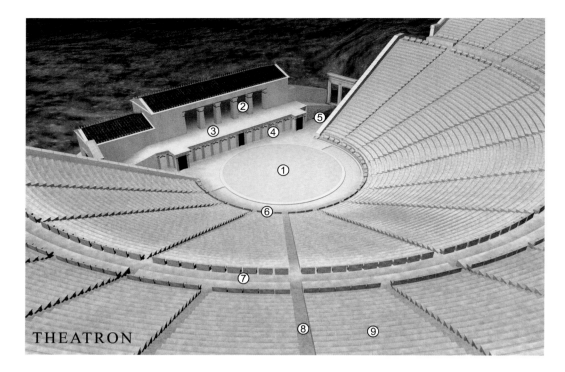

THEATRON

FIGURE 1.13

Computer Model of a Greek Hellenistic Theater, based on the Theater at Epidauros, 4th century B.C. (see fig. 1.14).
Created by Martin Blazeby, King's Visualization Lab, King's College London

were sung and danced from the *orchestra*. What this meant, of course, was that the chorus could within the same play serve as both observers and participants, intermediaries between the spectators and the players. This relationship allowed them not only to comment on what was happening but also to take some responsibility for it. One example—from Euripides' *Medea*—must serve, though playwrights explored the possibilities in all sorts of different ways.

The chorus in *Medea* is made up of local women of Corinth. Medea is a foreigner and a non-Greek at that. Deserted by Jason, the father of her children, Medea asks the chorus, as women, to give support to her plans, which they do. As scene follows scene they find themselves co-conspirators in the murder of the princess, whom Jason has now married, the king (the father of the princess), and Medea's own two sons. Between times they sing about the dangers of extreme passion and advocate remaining childless to avoid the pain to which parents may be heir. They even advise Medea not to go through with the killing of her children. Their physical place, between audience and actors, emphasizes the moral dilemma that an audience might feel in being invited by the playwright both to understand and to abhor the act of infanticide.

Other theaters in the Greek world at this time, and in the following century, mostly followed the Athenian model of taking a hillside and locating a playing space below (fig. 1.14). For topological reasons, a few, such as the small theater at Thorikos, had to adjust to a restricted *orchestra*. Many of what seem like Greek theaters in Italy, Turkey, North Africa, France, and elsewhere were actually built or adapted by the Romans. The Periklean Theater in Athens was rebuilt in stone by Lykourgos in the time of Menander, and the remains that can still be seen today are not Greek at all, but Roman.

A few hundred yards from the ruins of the Theater of Dionysos in Athens is the Theater of Herodes Atticus, these days the principal venue for the Athens Festival and used for visiting concerts and stage performances (see fig. 1.10). The most noticeable difference between a Greek theater and a Roman one was the location. The Greeks found a suitable place and adapted the geography to accommodate a playing place. Theirs was a "theater" to involve and challenge the spectator. Theater was a major part of the democratic and civic process in classical Athens, tackling issues of the day and matters of immediate concern, all through the flexible parables of myth. To present their entertainments, the Romans erected a

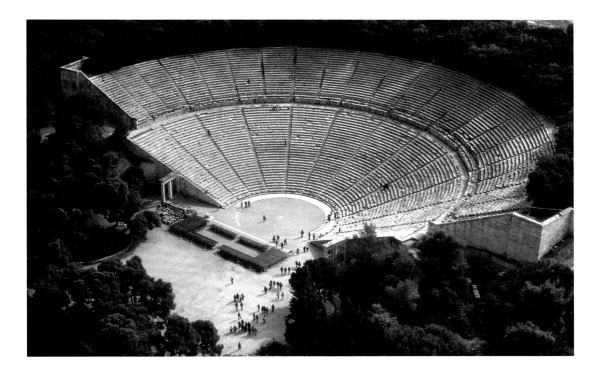

FIGURE 1.14

Aerial View of Theater at Epidauros. Photograph: H. R. Goette

building from the ground up, in which they staged a wide range of events, from popular performances to mock sea battles and even gladiatorial competitions.

STAGE PRESENTATION AND EFFECTS

The temptation to generalize about Greek tragedy as though it were all of a kind is one that a surprising number of cultural commentators still find hard to resist. Not only do the three tragedians Aeschylus, Sophocles, and Euripides differ in approach, but the style of each shows considerable variation from play to play, even among the small number of surviving tragedies. This should not really be a surprise. The art of playmaking was still in its infancy, and though it grew up fast in the hands of these remarkable individuals, the prime aim was not simply to retell an old story but to surprise the audience by a new approach in the telling. Mostly they dramatized stories from a body of myths. But these myths had many forms. There was no central text and no orthodoxy.

Homer's version of the Trojan War might offer a framework and a number of characters whose basic actions were fixed, but those actions were not set in stone. The murder of the victorious Greek general Agamemnon, on his return from Troy, was understood, but the hows, the whys, and the who-bys were open to individual interpretation. That Oedipus should marry his mother Jocasta and have children by her was not going to be challenged, but the circumstances and consequences were.

Many of these myths were extended sagas from which each tragedian would select a single episode to stage, for a single performance, on a single day. Until the play started an audience had only a limited idea of what they were about to see or where, within any extended story, a tragedy might focus. By good fortune a version of the Elektra story survives from Aeschylus as *Libation Bearers* (plates 20–23), the second play of the *Oresteia*; and, as a single play, *Elektra*, from Sophocles and Euripides, when connected tetralogies had gone out of fashion. The three dramatists' startling differences of emphasis and treatment confirm the importance of novelty in each new play.

Each playwright—and this must have included many other competitors whose work has not been preserved—learned the art of theatrical presentation from his own experience and that of his predecessors. As we have seen, Aeschylus with his second actor, and Sophocles with his third, enhanced the scope

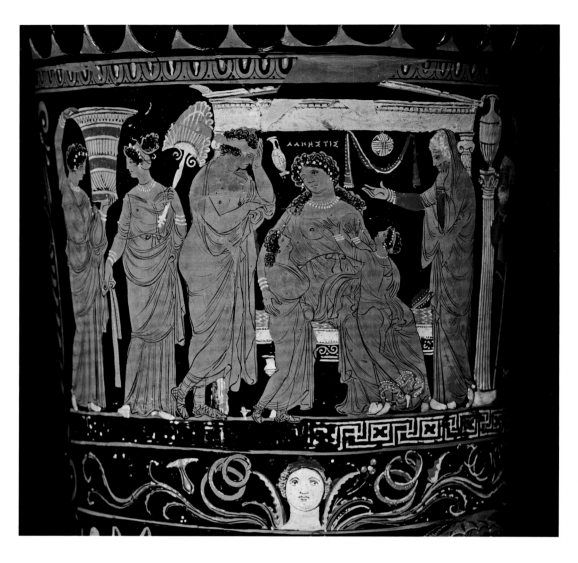

FIGURE 1.15

The Death of Alcestis (detail). Apulian red-figured loutrophorous attributed to a forerunner of the Ganymede Painter, 350–325 B.C. Antikenmuseum Basel und Sammlung Ludwig, inv. S 21. Photo: Andreas F. Voegelin

of a scene. But just as significant is Aristotle's recording that Sophocles introduced *skenographia*, meaning literally writing or decoration on the *skene*, the stage building. The modern term *scenography* is perhaps too grand for Sophocles and Euripides, but the Greek term does cover the use of scenery to indicate location, the employment of stage properties and furniture (fig. 1.15), and the introduction of stage machinery.

In later times, as one of the less reliable encyclopedists, Julius Pollux, claimed, there were machines to produce all sorts of special effects, from the appearance of ghosts to the change of setting by swiveling prismatic scenic units. The purpose of several machines—leaving aside their operation—is hard to fathom, but others have a more obvious purpose, such as lightning and thunder machines, of which there are later illustrations from an ingenious craftsman, Heron of Alexandria.[2] There is no direct evidence that either kind of device was in use in the fifth century B.C., but there were scenes of thunder and lightning. Two stage machines—the *ekkyklema* and the *mechane*—are attested by direct reference to them, not in tragedy but in comedies of Aristophanes. Both were probably an accepted feature of most of our surviving tragedies too. The *ekkyklema* was a platform wheeled out from behind the double doors in the *skene* to display a scene that had taken place offstage. A stage picture of the butchered corpses of Agamemnon and Kassandra is wheeled on in Aeschylus's *Agamemnon*, and the same scene is echoed in *Libation Bearers*. Sophocles and Euripides regularly use the device—in Sophocles' *Ajax*, for the display of dead animals; in Euripides' *Herakles*, for the title character's own children. The *mechane*, or "machine," was a crane operated from offstage that could lift characters, usually gods, over the *skene* to deposit them on the upper story, or

simply to leave them dangling to deliver their message. In *Medea* the title character makes her escape from the roof of her house with the bodies of her dead children in a dragon chariot supplied by her grandfather, the Sun (plates 27, 28).

Though the latter of these machines sounds at best quaint, both came to form a major part of staging simply by altering the dimensions of the acting area to place more emphasis on depth and height. They also served to enhance what may be described as the central feature of theatrical technique that Aeschylus, Sophocles, and Euripides explored and mastered, the stage image. It was suggested earlier that the blind Oedipus might have returned to the stage with a changed mask. What would really have shown his loss of sight and status was less a bloody mask than the outstretched hands and the hesitant step.

What the theater in Athens became in a surprisingly short period of time was a sophisticated, independent art form that was a synthesis of the other arts. It echoed the city's architecture and decoration, the sculptures and the paintings, the music and the dance. The static was made to move, and the dramas were displayed in a concentrated visual context to match the language of what we now have only as texts. The playwrights, each within his own distinctive style, invented and explored the rhythm of the dramatic, from its sequences of rhetoric and dialogue to the moments when words cease and are overtaken by tableau and image.

There is space here for only one example from each playwright, though no play disappoints when viewed with a theatrical eye. When Aeschylus has Agamemnon return from Troy with the mad prophetess Kassandra as his concubine, his wife, Klytaimnestra, greets him by rolling out a carpet of red tapestries. She invites him to walk on it to the palace. He demurs. She persists until he removes his shoes and walks in silence to his house, a figure of blood, wading through blood, to the murderous bath where his wife has prepared to spill his blood.

In Sophocles' *Elektra*, Orestes, now grown up, returns to Argos to avenge the murder of his father. He decides not to confide in his sister but, as part of a plan to deceive Klytaimnestra, turns up with an urn that he says contains the ashes of the dead Orestes (plates 21, 22). This stage property becomes the focus of attention as Elektra pours out her grief for her dead brother, until that very brother who has brought the urn weakens in his resolve and finally admits who he is.

In Euripides' *Trojan Women*, set just after the fall of Troy, Hecuba mourns the loss of almost all her family. Her daughter-in-law, Andromache, is wheeled on with her baby son, perched on top of a cartload of booty looted by the Greeks. News arrives that the victors want to kill the baby too. Andromache is dragged off to the Greek ships. The next time that Hecuba sees her grandson is when his tiny corpse is carried in on the shield of Hektor, his dead father.

As in the greatest drama, there are times when words simply fail. If there is a single legacy from the Greek tragedians more telling than any other, it is this.

NOTES

1	See Pickard-Cambridge 1966, p. 9; Beacham 2007.
2	Brumbaugh 1975, pp. 28, 128.

THEATER MASKS

AGNES SCHWARZMAIER

WHY DID THE ACTORS IN ANCIENT GREEK THEATER wear masks? Literary tradition has it that Thespis, considered the inventor of Attic tragedy, first made up his protagonist's face with lead white and other substances before introducing the use of theater masks. These were simply more practical: the limited number of actors—all of them male—frequently had to play a number of different roles, including female ones, of different ages. Masks allowed them to slip into a different role quickly, without taking the trouble to apply new makeup. To that end, not only did the actor have his face covered by a mask; he also had a wig attached, so that his head was entirely hidden. The personality of the actor was completely sublimated; with the mask he went beyond playing a role to changing his identity.

Actual theater masks were likely made from organic materials. Ancient writings mention linen fabrics coated with a layer of lime or plaster and attached hair. Wood veneer, cork, and leather were possibly used as well. Masks were also painted to seem as realistic and expressive as possible—an innovation reputedly introduced by Aeschylus. Female masks were painted a light color, almost white, whereas male ones were the color of skin browned by the sun.

Of such masks nothing survives, unfortunately. To form some idea of what they were like, we are dependent on reproductions in more permanent media—clay, stone, or bronze—or depictions on statuettes, in vase-paintings, in votive and tomb reliefs (e.g., see plate 1), and in wall paintings and mosaics.

The earliest representations of theater on Attic vases date from the sixth century B.C. and depict choruses wearing animal-head masks. The first masks with human faces appear around 470 B.C. (e.g., see plate 12).[1] Reproductions of masks in terracotta appear late in the second half of the fifth century B.C. on, for example, Middle Comedy figurines (see plates 59–70 and H. A. Shapiro's "Middle Comedy Figurines of Actors" in part 3), which were presumably based at least in part on late-fifth-century types.

Masks varied in accordance with the type of drama and the character portrayed. Comedy masks often presented grotesque, exaggerated expressions, whereas masks of the main characters in tragedy frequently showed facial features distorted in emotional pain. Chorus members wore identical masks, as one sees on the pelike in Boston by the Phiale Painter (plate 15), the krater in Sydney by the Tarporley Painter (plate 16), and the krater in Naples by the Pronomos Painter (plate 44).

FIGURE 1.16
Actors dressed as female members of a tragic chorus
(detail, plate 14), ca. 400 B.C.

On the Boston pelike, two actors are preparing for their appearance as members of a female chorus. The same is true of the chorus members playing the roles of satyrs on the Sydney vase and the actors holding painted female masks in the Würzburg fragment (fig. 1.16). The Naples mixing vessel, however, presents the actors in either a satyr play or—more probably—the entire tetralogy, consisting of three tragedies and a concluding satyr play. They are seen to be visiting a shrine to Dionysos, in which the god, the playwright, and the flute player (aulete) are present as well. The chief roles in the piece were taken by Herakles, an Oriental king, his daughter, and—as leader of the chorus—the Papposilenos (elderly father of the satyrs) in his shaggy white costume. The masks of the three protagonists are essentially the same as contemporary tragic masks, so it appears that the same masks could be used for the primary roles in both the tragedies and the satyr play (whereas the satyr chorus always wore identical satyr masks). Nevertheless, it is often difficult to attribute a mask out of context to one of the three dramatic genres, for characters with pained expressions might also appear in comedy.

Scholars long presumed that the main dramatic figures donned different masks to reflect their emotional changes, but in this they were doubtless influenced by our modern theatrical tradition, in

which facial expressions are crucial to the performance of a role. We now know that the features on an ancient Greek mask—as in Greek portraits—did not register fleeting emotions; rather, they conveyed the figure's essential nature, his or her unchanging character and social status.[2] In addition, much would suggest that theater masks reflected the changing aesthetics of the times, that they were subject to the same artistic and stylistic trends as contemporary sculpture or painting, and that artists and maskmakers influenced each other.

At the same time, there were changes within the dramatic genres that are naturally reflected in the forms of masks. In tragedy, for example, it is possible to document a major change in the early Hellenistic period: the main figures assume a more imposing, more exalted appearance, thanks to their increasingly thick-soled boots (*kothornoi*) and larger masks, which made them easier to see from the back seats of the large Hellenistic and Roman theaters. Masks were enlarged primarily by the addition of the so-called *onkos*, a mass of hair standing straight up from the forehead that might vary in height with the character's social standing (plate 37). Servants and heralds—that is to say, figures of lesser status—wore masks without the *onkos*. Introduced around 300 B.C., this toupee became increasingly stylized over the course of the Hellenistic period until it came to form a kind of shield that towered over the back of the head as well (plate 38). The *onkos* continued to be a feature of tragic masks even during the late Roman Empire.

In comedy, an increasing number of fixed character types appear to have been introduced as the Old Comedy gave way to Middle Comedy and finally to New Comedy. Among them were masks for slaves, cooks, parasites, flatterers, and others whose characters were obvious from their masks. In New Comedy the male masks presented a new hairdo with the so-called *speira*, a rolled arrangement of hair above the forehead and along the temples; it appears on certain masks of young men as well as slaves (plate 88).

The *Onomastikon* of Julius Pollux (IV.143–54), a dictionary from the second century A.D., preserves lists of mask types for both tragedy and comedy. Scholars have related its descriptions of forty-four comic masks to New Comedy from the time of Menander, since Menander's plays and Hellenistic comedy masks had survived for a long time in Roman theater. Even so, it may be risky to apply the Pollux descriptions to the surviving depictions of masks, for two reasons. First, the text of his dictionary survives only in excerpts from late antiquity that are incomplete and at times ambiguous. Second, the visual evidence presents us with a broader range of types than his lists would lead us to expect. Accordingly, it is impossible to determine which roles or characters many masks were intended to represent.

In clay reproductions of masks one often notes variants having to do with the technique used in their creation: after clay masks were formed in molds, they were frequently reworked by hand. The numerous masks of young women from Centuripe, Sicily, such as those from Amsterdam's Allard Pierson Museum (see plates 4B, 4C), present a wide variety of hairstyles. The masks from Centuripe, most prob-

ably found in the area of the necropolises, are thought to have had a devotional function with no immediate relationship to actual theatrical performances. Comparable finds, such as those from the necropolis on the Aeolian island of Lipari, make it clear that such masks served as cult symbols for Dionysos, the god of wine and theater, in the worship of whom *ekstasis*, or "stepping outside oneself"—the adoption of a different personality—was part of the ritual.

NOTES

1 Scholl 2000, pp. 44, 51; *DFA*², p. 191.
2 Halliwell 1993, p. 195ff.

15

Chorusmen Donning Female Costumes
(side A)
Bearded Man in a Mantle Leaning
on a Staff (side B)

Red-figured pelike, 440–435 B.C.

Attributed to the Phiale Painter

Greek (Attic); found in Cerveteri

H: 24.1 cm (9½ in.); Diam: 18 cm (7¹⁄₁₆ in.)

Purchased from E. P. Warren, 1898,

by Henry Lillie Pierce Fund

Boston, Museum of Fine Arts 98.883

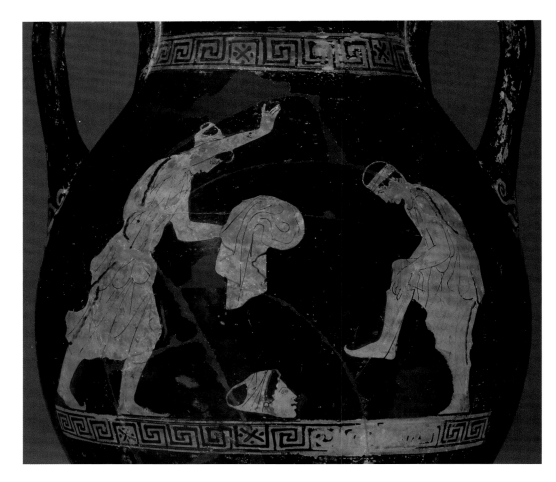

THE PHIALE PAINTER is notable for the remarkable diversity of his iconography, which includes references to the plays of Sophocles, his contemporary. On this pelike (wine storage jar), two chorus members are depicted in the act of costuming for a performance. Both choreutai wear knee-length peploi of the type also worn by Thracian women and maenads. The young man at the right is pulling on his performance boots (*kothornoi*). He wears a band around his head in preparation for taking on his mask, which sits on the ground facing him. An earring can be seen on the right ear of the mask.

The youth at the left has finished costuming. He wears a mask identical to the one on the ground—a full female mask with an open mouth and dark hair bound with fillets. His is the active pose of the choreut rehearsing the balance of his complex choreography: while extending his right leg back he raises his right arm above his head, bending his left knee and extending his left arm. He holds a woman's mantle (himation) over the mask on the ground; the gazes of the two choreutai equally focus attention toward the *prosopon*, meaning both "mask" and "character." As the painting

shows, the actor takes on the character when he takes on the mask. Significantly, the Phiale Painter has rendered inanimate the eye of the mask on the ground by painting a short stroke of red over it; in contrast, the eye of the mask worn by the dancing choreut is rendered naturalistically open and focused. MLH

BIBLIOGRAPHY: Caskey and Beazley 1931, p. 56, no. 63 (with refs.); Caskey and Beazley 1954, p. 102, no. 63; *ARV²*, p. 1017, no. 46; *Para²*, p. 440, no. 46; *MTS²*, p. 47, AV 20; Boardman 1989, p. 223, fig. 124; Carpenter 1990, p. 315; Oakley 1990, no. 46, pp. 13 (with n. 60), 39 (with n. 273), 45, 73–74, pls. 26a, 35f.

See Halm-Tisserant 1989, pp. 108–9 (with n. 69), pl. IIIc–d, for a comparison of this composition to one on a kalpis from the Polygnotos Group (Basel BS 481) with the head of Orpheus between two figures.

16

Three Chorusmen in the Moments before or after the Performance of a Satyr Play (side A)
Three Draped Youths (side B)

Red-figured bell krater, 410–380 B.C.
Attributed to the Tarporley Painter
From Apulia, South Italy
H: 33 cm (13 in.); Diam (rim): 36 cm (14⅛ in.);
Diam (foot): 15.8 cm (6¼ in.)
Sydney, Sydney University Museums,
Nicholson Museum Collection NM 47.5

THE THREE ACTORS wear the *perizoma*, the typical shorts-like garment of satyr players. These are laced at the front and support an attached semierect *phallos*. At the back of the actor on the right, the usual attached tail is visible. The garments are decorated with an inset thin black horizontal band along their top and bottom edge; those of the two actors on the left are further decorated with a vertical stroke pattern along these bands. The decoration is possibly meant to represent stitching, perhaps used to bind the raw edge of leather. A vertical row of dots connected by curved lines running down either side of the *phallos* would appear to indicate lacing. On each side of the garments is a decorative wheel-like motif.

The two actors on the left hold bearded satyr masks that they either are about to put on or have just removed. They face each other as if in conversation. The actor on the right wears his mask and appears to be dancing in character. On the ground, behind this actor, lies a decorated *tympanon*, a drum typically associated with the world of Dionysos. While well attested in Attic art, this is one of only two known South Italian examples of actors shown putting on or taking off their costumes for a satyr-play performance. The other is an unprovenanced Apulian bell krater in Moscow (Pushkin State

Museum of Fine Arts II 1b 1423, *CVA* Pushkin 2, pl. 3). The Tarporley Painter was one of the earliest artists to represent theatrical scenes on South Italian pottery, showing a special interest in representations of masks being worn, held, or suspended in the background (e.g., see plate 50).

The Sydney krater is from Sir William Hamilton's second collection, put together between 1789 and 1790. It was sold to Thomas Hope in 1801 and then, with the final breakup of the Hope Collection in 1917, to Weetman Pearson, 1st Viscount Cowdray. Enormously wealthy, Pearson was an English civil engineer who among his many achievements built the East River Tunnels in New York. Such was his influence in the infrastructure of Central America that President Wilson put a stop to his activities in the region before "he would have owned Mexico, Ecuador and Colombia." In 1946 the krater was bought at auction in London by one of the great early South Italian attribution scholars, Noël Oakeshott (née Moon), on behalf of A. D. Trendall, curator of the Nicholson Museum. MT

BIBLIOGRAPHY: For a full bibliography of the krater, see *CVA* Australia, Nicholson Museum 1 (2008), pp. 17–19, pls. 2, 3. On its colorful history, see Turner 2004, pp. 93–103.

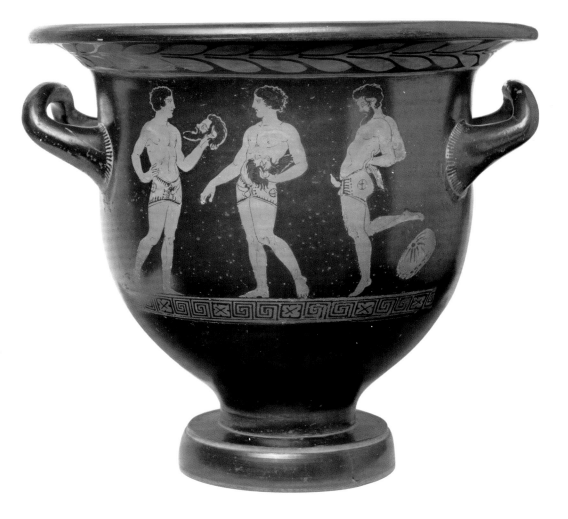

17

**Triumph of Three Actors
after a Performance** (side A)
Dionysos with Satyrs and Maenads (side B)
Red-figured bell krater, 340–330 B.C.
Attributed to Python
From Paestum, South Italy
H: 46.8 cm (18½ in.); Diam (rim): 46.5 cm
(18¼ in.); Diam (foot): 21 cm (8¼ in.)
In the collection of the painter Anton Raphael
Mengs, 1759–1773; in the Vatican Library, 1773–1900
Vatican City, Vatican Museums 17370

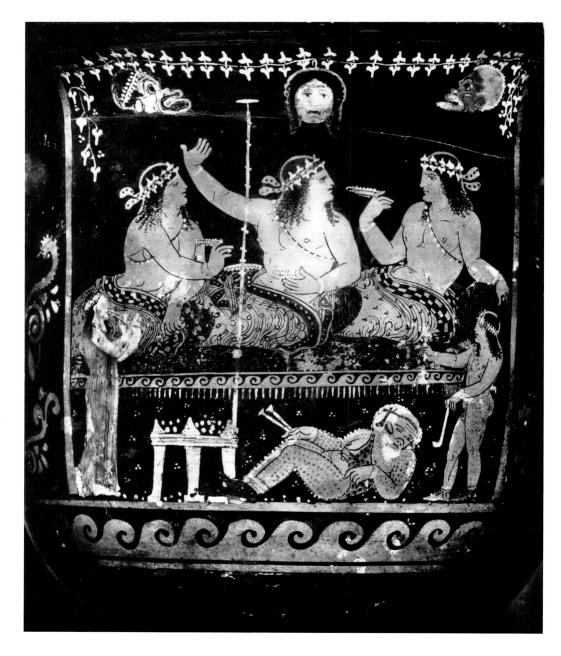

ON SIDE A OF THE VASE, three young actors take part in a symposion after a theatrical performance. They are depicted reclining on a single *kline*, absorbed in playing *kottabos*, a game that involves tossing wine lees contained in the bottom of their drinking cups in an attempt to hit a dish or cup set atop a pole. The prizes for the winner of the game, including three pyramid-shaped pastries, are arranged on a low, three-legged table. Flanking the *kline* are two small servants—on one side a flute girl dressed in a tunic, on the other a naked youth with the features of a satyr who is holding a *simpulum* (ladle) and a thymiaterion (incense burner). Beneath the *kline* is a Papposilenos, possibly a costumed actor, stretched out fast asleep, grasping a double flute. His head is wrapped in a *taenia* (headband); he is wearing sandals and a fawn skin. The allusion to the theater and to Dionysos is further emphasized by a garland of ivy set above the scene, from which hang three theatrical masks (one of a woman and two of comic *phlyakes*), and by the Dionysian depiction on side B. In that depiction we see a young Dionysos, seated, with a *thyrsos*, resembling the actors in the principal scene. He extends a patera to a bearded silenos while a woman places a wreath on his head. Above are two facing busts of a bearded silenos and a maenad, each with a *thyrsos* and closely resembling the corresponding figures below.

Initially attributed to the Paestan vase-painter Asteas, the vase has since been uncontroversially assigned to the body of work of Python. According to A. D. Trendall, this Vatican krater constitutes one of the artist's finest creations, and one of the closest to the signed works. MS

BIBLIOGRAPHY: Trendall 1953–55, pp. 29–31 (AD 1), pls. VIIIa–b, IXc; Röttgen 1981, pp. 129–48, figs. 5, 6; Hurschmann 1985, pp. 144–49, pl. 20; Trendall 1987, pp. 146–48, n. 245, pl. 92; *LIMC* VIII (1997), s.v. Silenoi, p. 1113, n. 20d; Sannibale 2005, pp. 296–97, n. 200.

18

Figurine of a Tragic Actor Costumed as Herakles

175–150 B.C.

Produced and found in Amisos, Turkey

Terracotta

H: 16 cm (6¼ in.)

Paris, Musée du Louvre CA 1784

LOCATED ON THE SOUTHERN COAST of the Black Sea, in the region of Pontus, the city of Amisos distinguished itself with its coroplastic production of large numbers of figurines in terracotta primarily during the Hellenistic period, in which theatrical representations played a certain role, especially in the production of comic masks.

The figurine here, however, shows a tragic actor, as indicated by the costume and the mask held in its left hand. The actor is wearing a long robe (a chiton with sleeves covered with a sleeveless belted tunic) and the high boots (*kothornoi*) that were introduced in the second century B.C.; the club he is holding in his right hand identifies him as Herakles. Finally, the mask stands out by the height of the *onkos* and by the face with its open mouth and knitted brow. These features, according to Pollux, indicate that the mask is that of a main character and suggest an association with the *melas aner* (black man). Thus the figure could represent the hero of Euripides' *Herakles* (see plate 33), a play that was very popular during the Hellenistic period and was adapted by Seneca in the Roman period. VJ

BIBLIOGRAPHY: *MTS*², pp. 9, 16, 21, 61 (ZT 1), 158; Besques 1972, p. 79, D 467, pl. 102c; Bernabò Brea 1998, p. 50, fig. 35; Summerer 1999, pp. 65, 70, 123, 206, cat. SV2, pl. 53; Rodá de Llanza and Musso 2003, exh. cat., p. 178.

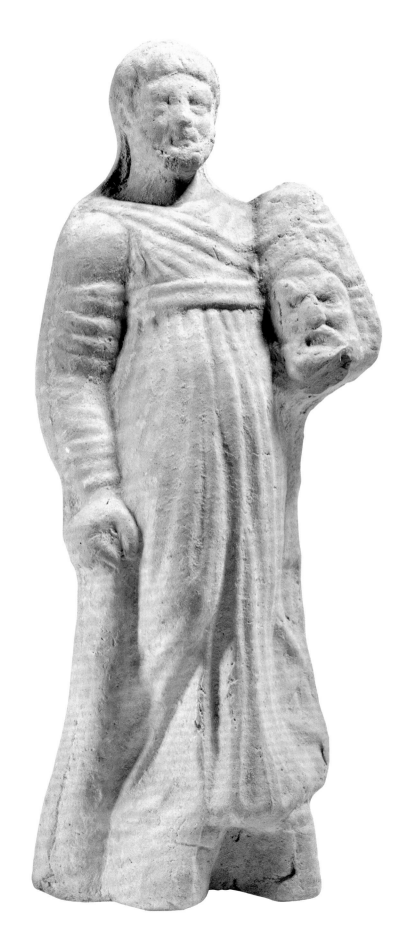

PLATE 18 | 49

TRAGEDY AND THE SATYR PLAY

VISUALITY AND PERFORMANCE

FRANÇOIS LISSARRAGUE

THE ANCIENT GREEK THEATER was a unique experience in terms of visual culture. Staging characters and heroes from epic poetry transformed them into a tangible physical presence acting and speaking directly before the eyes of the beholder. The audience not only heard stories of myths and heroes but actually saw them, creating the effect described by the Greek word *theatron*, "the seeing place," which refers to the sensory and visual experience of witnessing a play in a large outdoor theater. The immediacy of this presence had an extremely strong impact on the spectators, and the theatrical illusion was sometimes devastating. According to legend, the first time Aeschylus put the Erinyes (the goddesses of revenge and punishment, also known as the Furies) onstage at the beginning of his *Oresteia*, the effect was so striking that children fainted and pregnant women miscarried. That type of visual experience was one of the major steps in the history of illusion and mimetism: the spectator could see the gods and the heroes of the past as if they were materializing in front of him. That kind of illusion functions as long as the limits of the stage are not trespassed—as long as the space of the representation is kept separate from the space of the audience, the stage from the seats. Comedy, unlike tragedy, often plays with the confusion between these two spaces, featuring interaction between the onstage performance and the audience, thus breaking the theatrical illusion in a humorous way.

Considered in this framework, the theatrical performance has a double dimension. It can transport the audience into the imaginary world of the past, making absent beings present, brought back from the past or from Olympos, or it can use the interaction between audience and stage to explore the possibilities of fiction. Such an experience, shared by vase-painters, opens the way to reflections about what a representation is, not only on the stage but also in painting. Indeed, parallel to the literary development of theatrical performances in Athens, from 500 B.C. on, is pictorial evidence, gleaned particularly from vase-painting. Many vases show stories that we know were played onstage, and this material has often been used to understand the plays or at least some aspect of their staging. The early philologists, in the nineteenth century, tried to match some of the vase-paintings to the plays that have reached us, or to reconstruct lost plays of which we know only the titles or a few lines, using imagery as a kind of stage view or snapshot. The idea is interesting but very speculative, as there is no way of controlling the result. It was tempting, and certainly necessary, to move from a purely textual knowledge of the plays to a more visual sense of the representation, since Greek plays were made not to be read but to be performed, with music, dance, and choral songs. It is certainly worth trying to

53

reconstruct that dimension of the play, and vase-painting seems potentially useful in producing some visual background for that experience; but the results are often rather forced and of little help.

Another way of interpreting vase-painting in relation to the history of ancient theater has been suggested in recent years, leaving more space to visual poetics and to the imagination of vase-painters. Many of them were certainly part of the audience and had seen most of the plays that are lost to us. Rather than mechanically reproducing what they saw onstage, they took their inspiration from the experience of being in the audience and observing not just one play but, in the case of tragedy, four plays in one day. In turn they went back to their studios and played with the visual dimensions of that experience.

Although in many cases we cannot say that a certain image must be linked to a certain play, we can see how the main elements of a myth are elaborated in a picture. We can also detect several ways of rendering or transcribing the visual record of what was shown onstage, resulting in numerous degrees of referentiality to theater production in a single vase-painting. We can also note important differences between Attic vase-painting and the vase-painting from Magna Graecia, not only in terms of chronology or style, but also in terms of the use and composition of theatrical iconography.

Explicit reference to theatrical experience is often marked by objects such as masks, elements of the stage itself, musical instruments, and depictions of choruses (which could represent many kinds of choral performance, not necessarily or only theatrical). In Attic vase-painting, we see actors engaged in various activities backstage, so to speak, more often than playing their parts in the actual tragic performance (e.g., plates 16, 17). The most remarkable example is the Pronomos vase (plate 44), where we see not only a cast of named actors holding their masks but at the same time the characters of a satyr chorus, an *aulos* player, the playwright or poet holding a roll, and even more—the god Dionysos himself as a visible presence among the human company of Dionysiac artists. This image is, more explicitly, celebrating a victory in competition (several tripods, the prize given to the winner, frame the picture), rather than describing a specific play (and scholars trying to identify the play disagree on various options). It seems that Attic vase-painters, when referring explicitly to the theater, are more intrigued by its ritual dimension, or its technical aspects, than by the story itself.

Pottery from Magna Graecia is richer and more varied in this respect. It appears in the wake of Attic vase-painting, using shapes like big volute kraters that are more directly connected with local funerary rituals. Early examples refer to tragic stories without necessarily displaying any stage element. An Apulian krater in the Louvre shows Orestes seated on the altar of Apollo in Delphi together with the omphalos, signifying the center of the world (plate 24). Sword in hand, he has asked Apollo for protection and purification for the crime of matricide. Apollo stands behind him, holding a branch of laurel and raising a sacrificed piglet over Orestes' head to purify him. On the upper left, two Erinyes are still asleep; the ghost of Klytaimnestra appears to wake them. This image is described close to the beginning of the *Eumenides*, but certainly not showing what one could have seen onstage. It combines several elements of the action in one vision and builds more of a synthesis of the main values and moments of the story than an accurate representation of stage performance.

Later in the fourth century B.C., a Paestan painter, Asteas, represents the madness of Herakles destroying his own household (plate 33). The hero is holding his baby while his wife, Megara, runs away in despair toward a door. The picture is divided by columns that seem to echo stage decoration, with

an upper row of figures whose names are inscribed: Alkmene, Iolaos, and at the very left Mania—madness—holding a whip. No extant tragedy matches precisely what we see here, but the architecture points to a theatrical organization of space, and the painter probably has in mind an unknown variant of Herakles' madness.

The pleasure of playing with various levels of representation is quite explicit on an Apulian calyx krater showing the stage of a comic play (plate 55). The main panel is divided horizontally by the floor of the stage, to which access is given by a stair in front. The floor is sustained by four columns and the space under the stage concealed by a curtain. On the upper part of the panel we see the play in action: three comic actors, characterized by their masks and padded costumes. The one on the left is leaning on his stick, gesturing toward the two *aulos* players in the middle. They seem to move around a white altar, and although we do not know what play is being performed or what the plot might be, we can easily perceive the importance of music in the scene. Here the two *aulos* players are actors. A further level of representation appears at the right part of the picture, separated from the left side by a tree. There, next to the handle and partly hidden by the tree, we see a crouching *aulos* player. He (or she?) wears no mask, no comic costume; he is not an actor playing an *aulos* player but an actual *aulos* player, producing the real music that the actors, with their masks, cannot produce but must be lip-synching. The comic effect is linked to the fact that because the real *aulos* player is visible the illusion is broken. The real player wears a band extending around his mouth and the lower part of his head, called a *phorbeia*, which helps to stabilize the flute and maintain the proper sound. The actors wearing their masks cannot wear the *phorbeia* and so cannot produce such a sound; they can only mimic the act of playing. By these means the painter shows us the mechanism of theater production; following the comic parody of theatrical illusion, he is taking us behind the stage, denouncing the artificiality of the representation. To put it as O. Taplin did, we have here a wonderful example of "metatheatricality."[1]

Sometimes vase-painters go even further. An early Apulian bell krater in Cleveland is a good example of the kind of pictorial games painters could play when using theatrical elements (plate 3). The main side of this krater shows a huge bust of Dionysos, the god of wine and of theater. He is shown in three-quarter view, crowned with a *mitra*, a long stick on his shoulder, from which two branches of grapes grow, running along the rim of the krater. The scale of the bust gives a kind of supernatural power to the apparition of Dionysos. He is like an epiphany, an overwhelming presence. Two figures are actively moving around the god: the one on the left, picking grapes from the vine; the other on the right, already holding a big painted skyphos, a wine vessel for the symposion, showing in turn a small image in black silhouette of a dancer in front of an *aulos* player. From grape to wine, the drinking party is on its way. What is remarkable is that these two figures are actors, of two different types—on the left, a comic actor with a long hanging *phallos*, and on the right, from a satyr play, a satyr wearing boots, with woolly hair, an upraised tail, and the same hanging *phallos*. His white hair and tufted costume make him look like a Papposilenos, the old father of the silenoi and the leader of the satyr chorus. Thus both comedy and satyr play, as well as wine drinking, are suggested in connection with the god. To sum up, we have here at least three levels of representation: the god, as an epiphanic bust; the theater, through the presence of two different kinds of actors; the painted picture in the picture, on the skyphos. No specific play, or even theatrical performance, is referred to here, but more generally the power of Dionysos, on a drinking vessel.

The use of such theatrical elements in vase-painting to suggest the power of Dionysos is not uncommon. These objects, masks, and theatrical dress are often found in images that do not describe an actual performance or even the daily life of actors but rather present pictorial signs of the Dionysiac world. On a bell krater attributed to the Paestan painter Python, we see a symposion of three young men playing the popular game of *kottabos*, which consists of tossing wine lees toward an unstable target and making love wishes (plate 17). Under the couch lies a silenos, holding his pipes and asleep. A young auletris is standing on the left and a young satyr as wine bearer on the right. Above the drinkers hang three masks: two in profile, from comic plays, and a frontal one, of a woman, apparently more tragic. It has been suggested that these drinkers are actors, but we do not need to take these theatrical masks as realistic. The satyr under the bed and the young wine bearer are not realistic; they come from the Dionysiac world, a fanciful world of happiness and illusion, of which the theater is one major dimension and vase-painting is certainly the second. Performance and visual experience are strongly complementary; Greek vase-painters have cleverly explored the various possibilities of these combined experiences.

NOTE

1 Taplin 1993a, p. 70.

THEATER AND ICONOGRAPHY

MARY LOUISE HART

WHEN CONFRONTED WITH DEPICTING THE PUBLIC STAGING of dramatic poetry—the profound stillness of Orestes and Elektra's reunion, the astonishing flight of Medea's chariot, tales and images conjured by a powerful address, or "messenger speech"—the painters of ancient Greek vases approached their task according to a complex set of visual paradigms rooted in the traditional ways in which epic and mythic narratives had been depicted for generations. Although artisans and playwrights both relied on knowledge of myth and legend to achieve their narrative aims, the vase-painters were extremely limited in comparison to the poets, who were actively engaged with the production of the play and could utilize the many tools of performance—choreography, sets, properties, masks, costumes, and music—to realize their vision. For the vase-painters, the overwhelming sensory experience of viewing a tetralogy in a *theatron* with thousands in attendance had to be expressed as a single scene on the curved surface of a vase destined for the relatively intimate use of the symposion. To provide clarity the artisans relied on practical approaches, such as choosing a vase shape to accommodate their compositions and employing recognizable iconographic tools. While knowledge of the play as it has come down to us is essential for comprehending the iconography fully, an awareness of the many ways in which performance must have inspired and influenced these depictions plays a critical role in our understanding as well.

Uniquely theatrical features include elaborate costume (see especially part 1, fig. 1.5; part 3, fig. 3.3; and plate 44); furniture (see part 1, fig. 1.15); architectural constructions, generally temples, that reflect the *skenographia* introduced by Sophocles (e.g., see part 1, fig. 1.12; plates 34, 35); and the presence of distinctive characters such as the famous Erinyes of Aeschylus's *Oresteia* (plates 23–25, 27).

A messenger speech from Euripides' *Andromache* describes Orestes hiding in ambush to watch the assassination of Neoptolemos (plate 34). These speeches—many of them still considered to be some of the most powerful poetry ever written—were delivered onstage by messengers, heralds, shepherds, palace servants, guards, and others who related an important event that had taken place offstage and would have a major effect on the plot. Creating a mise-en-scène in order to depict the content of a messenger speech is a remarkable concept. In this case the painter was not depicting something he had seen but something he imagined as he heard it described in the play. One famous messenger speech tells of the violent death of Hippolytos: on the great vase by the Darius Painter, a *paidagogos* ("tutor," or old man who witnesses and reports) is shown watching the horrific event; the action is later narrated in one of the most powerful

speeches in dramatic literature.[1] The *paidagogoi* are conventionally shown wearing the costume of a traveler's cape, sometimes a *pilos* (a traveler's cap), and *kothornoi* (actor's boots) and are often depicted holding on to or leaning on staffs. Their presence in a scene (in, for example, plate 30, which gives an alternative to the Medea legend) can identify it as theatrical.[2]

While the architecture and theatrical apparatus of the stage were typically shown in scenes of comedy, they were almost never shown in tragic scenes, which echo the reserve and physical separation from the audience that tragic performance entails. Only two depictions of tragedies being performed on a stage have been preserved. They are both attributed to the Capodarso Painter, who worked in Sicily from about 350 B.C. to 320 B.C. One is the relatively large-scale polychromatic depiction of the famous recognition scene from *Oedipus Tyrannos* (plate 26).[3] The Oedipus vase bears several markers of theatricality. The well-suited shape—a calyx krater—may have been chosen to show off the extended horizontal composition, which includes a stage floor supported by additional infrastructure. Four actors stand between two columns that support a stage-set entablature.[4] The old man on the left is shown face front, an atypical way to depict the human face in a tradition where the profile was preferred. Artists used the frontal face to convey situations of psychological intensity, including drunkenness and death. Here the Capodarso Painter seems to have used it to suggest a tragic mask. The startling and unnatural countenance underscores the tragic nature of the scene and thereby draws attention to the expressions of Oedipus and Jocasta. Furthermore, the old man is costumed as a *paidagogos*, wearing *kothornoi* and a traveler's cape. By placing his characters on a stage, clothing them in ornate costumes, suggesting the use of a mask, and employing the *paidagogos* as a messenger, the artist has managed to express a lively theatricality without going to the extremes of comic representation. This approach—by a single painter in Sicily—is in striking contrast to methods used by vase-painters elsewhere in Magna Graecia and in Athens.

Some of the earliest theatrical depictions from Magna Graecia include the stunning Medea/Telephos krater now in Cleveland (plate 27) and a counterpart attributed to the Policoro Painter from ancient Herakleia (plate 28). Looming over the scene in plate 27 are two extraordinary, winged, female monsters who bear a close resemblance to Erinyes. Here they function as iconographic symbols referring to the crime of infanticide as well as to this scene of horrific destruction. In the last quarter of the fifth century B.C., these vase-painters were already using visual references to theatrical performance: identifiable characters, theatrical costumes and props, allusion to well-known staged moments, and unique theatrical apparatus such as the *mechane* used as the chariot of the sun that carried Medea from Corinth to Athens. By this date Euripides' plays were being re-performed in Magna Graecia: the scenes on these vases have been interpreted as evidence not only for productions in Heracleia but also for the connections to Athens that their narratives display.[5] On the great Medea krater in Cleveland, Medea flies away in the chariot of Helios; the two children lie dead over an altar; and Jason, the nurse, and the *paidagogos* mourn helplessly. The painting is obviously of *Medea*, but the narrative depicted is not consistent with the Euripides text that has survived. In the finale of the version we know today, Medea takes the dead boys with her in the chariot as her final devastating blow to Jason, leaving him unable to bury his sons. The variety of representations of this tragic drama (such as those illustrated in plates 27–30) is a case in point, indicating the fluidity of these narratives and the fact that many versions of a myth could coexist in dramatic form. Likewise, vase-painters would have had their own interpretations of these performances.

Aeschylus's *Oresteia* won first prize at the Great Dionysia in 458 B.C. The most lauded of all Athenian playwrights, Aeschylus died in Gela, Sicily, only two years later, having traveled to Magna Graecia at least twice, first at the invitation of Hieron of Syracuse (where he revived *Persians* in 468 B.C.).[6] Inspired by Trojan legends as ancient and venerated as Homer, the *Oresteia* is the only trilogy to have survived from ancient Greece (its satyr play, *Proteus*, is lost). The tale of Orestes is the subject of more vase-paintings from Magna Graecia than any other single narrative, attesting to the popularity of the plays in that region. In *Agamemnon*, the first play in the trilogy, the king returns home from Troy to be murdered by his wife, Klytaimnestra, and her lover, Aigisthos.[7]

For the second play, *Libation Bearers*, many extant depictions reflect inspiration from two staged scenes. The most popular is the reunion of Elektra and Orestes at the tomb of their father, where they make the pact to kill their mother (plates 20–22). Sophocles and Euripides both wrote plays about Elektra that include her reunion with her brother and their subsequent revenge on Klytaimnestra for her crime.[8] Vase-painters took up the reunion scene as well: the silent approach of Orestes to his grieving sister, who either sits at the grave or stands beside it, typically looking off into space and compositionally separated—by either the vase shape or the tomb monument—to indicate her grief and psychological isolation. The earliest example is an Attic vase (plate 20) painted around 440 B.C., less than a generation after the production of Elektra in the Theater of Dionysos. Intimate in size but epic in scale, the Penelope Painter's approach is in keeping with Athenian tradition. It lacks details of costume or stage set and focuses on ritual activities of plot-driven characters, but it includes one very important detail—an inscription on the tomb's stele. Scenes of women mourning at graves are so common on Athenian vases of this time that without the inscription this painting could be of any Athenian woman mourning a deceased relative. Orestes and Pylades stand on the reverse side of the cup, separated from Elektra as she reverently garlands her father's grave. In the wake of Aeschylus, the Penelope Painter has shown how a member of an established Athenian workshop continues to use traditional iconography to represent a specific dramatic moment. It is a rare example; by far the largest number of vases with scenes of Athenian tragic drama have come from Magna Graecia. There Lucanian, Apulian, Campanian, and Paestan vase-painters added details of props, sets, and costumes to identify theatrical narratives. These details add to an atmosphere of temporality, another distinctive feature separating these depictions from the timeless compositions of Athenian vase-painters.

Iconography unique to certain plays can be key: in *Eumenides* (lines 57–71, trans. Shapiro and Burian), the third play in the *Oresteia* trilogy, Aeschylus has the priestess of Apollo come upon the slouching, stinking females, their eyes dripping a foul ooze. Pythia wonders what she has seen that they could resemble; she recalls a wall painting of Harpies and thinks also of the monstrous Gorgons. The horrid appearance of the Erinyes and their pursuit of Orestes can serve to identify the *Oresteia* in vase-painting; even though they appear in *Eumenides* only as evil demons who pursue Orestes to Delphi after he kills Klytaimnestra, in art they appear in reunion scenes as well. One is already present in *Libation Bearers* just before the queen's death (plate 23), where the character Erinys signifies the impurity that will accrue to Orestes upon her murder. She also presages the play *Eumenides*, in which she and her sisters pursue Orestes to Delphi and Athens. There they are transformed into Eumenides (Good-Willing or Kindly Ones) when the cycle of revenge is stopped by the outcome of Orestes' trial. A vividly painted volute krater attributed to the Black Fury Painter (fig. 2.1) powerfully conveys the scene at the temple: the priestess's terror as she

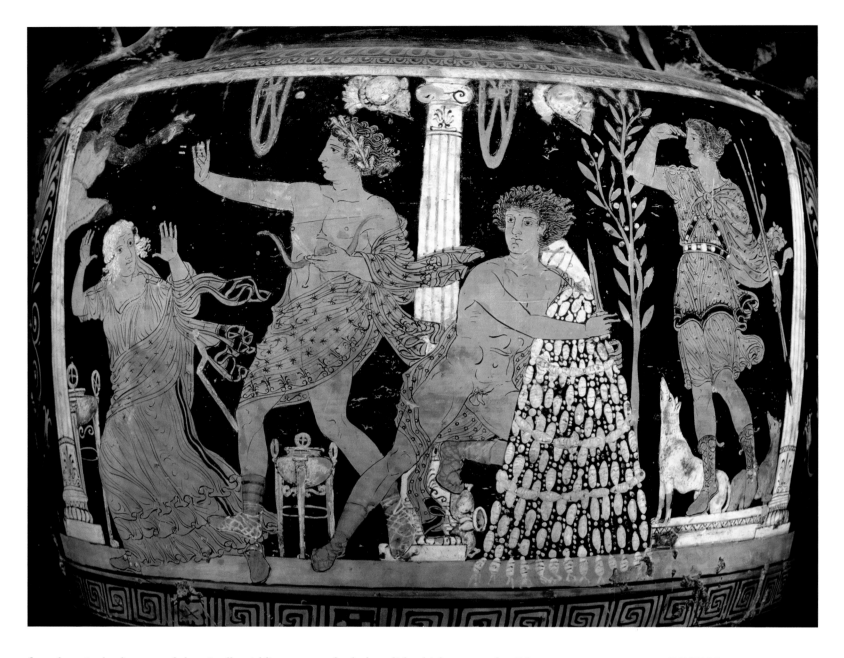

flees, dropping her huge temple key; Apollo wielding command as he brandishes his bow toward an Erinys lurking in the upper left corner; Orestes behind him clinging to the omphalos (the center of the world and the symbol for Apollo's sanctuary in Delphi), as Artemis observes from behind a laurel tree. The figures are set into an architectural framework that both defines the sanctuary space and simultaneously recalls a theatrical tableau. The scene depicts how visual performance could be communicated through the physicality of the characters with attention to energetic action, reaction, and gesture. This synthesizing of plot and character, typical of the South Italian approach, finds conceptual expression on the British Museum krater (plate 25) attributed to Python, which shows all of the main characters in *Eumenides* gathered together as if for a cast call. Although there is no scene in Aeschylus that contains this assembly of gods, *daimones*, and mortals, their compilation effectively recalls the significant themes of the trilogy and could not have been created outside of a pictorial context for theatricality.

FIGURE 2.1

Orestes in Delphi. Detail of panel from an Apulian red-figured volute krater attributed to the Black Fury Painter, ca. 390 B.C. From Ruvo di Puglia. Naples, Museo Archeologico Nazionale di Napoli 82270

NOTES

1 Volute krater in the British Museum (F279); see Taplin 2007, pp. 137–38, with references.

2 Green 1999 lists forty-nine examples of *paidagogoi* on vases.

3 The other, in the Museo Civico in Caltanisetta, no. 130, shows an unidentified tragic scene being performed on a stage. Taplin 2007, pp. 261–62, fig. 105.

4 The Herakles and Auge comedy in Lentini, Sicily, shows a similar approach to set supports behind the actors (see part 3, fig. 3.9, herein).

5 Allan 2001, p. 68.

6 See Herington 1967, pp. 81–82, for a potential chronology (with testimonia) for Aeschylus's trips to Sicily.

7 Prag 1985, with references to many mythological depictions of the death of Agamemnon.

8 Euripides' *Elektra* is of disputed date. It was once thought to have been performed before 413 B.C., but current scholarship favors a date as early as 420 B.C. Sophocles' *Elektra* was produced around the same time, 418–410 B.C., so it is difficult to know which of these *Elektra*s came first.

19

Double Portrait Bust of Aristophanes and Sophocles

Ca. A.D. 130

Roman; found in Hadrian's Villa at Tivoli (?)

Marble

H: 50 cm (19¹¹⁄₁₆ in.)

From Campana collection, acquired in 1861

Paris, Musée du Louvre CP 6473 (Ma 84)

THIS DOUBLE BUST links two artistic figures who represent the main literary genres of Greek theater: tragedy and comedy. Sophocles (ca. 496–406 B.C.) is one of the most famous Greek tragic authors, well known from seven surviving plays; two of these, *Oedipus Tyrannos* and *Antigone*, are revered in Western literature. The second head belongs to the Athenian poet Aristophanes (ca. 448–386 B.C.), the author of some forty plays and famous for his caustic humor. The bust, once used as part of the decoration of a library or a room devoted to Dionysos, is based on posthumous full-length statues produced during the fourth century B.C., after originals that have been lost but are known through many Roman replicas. J-LM

BIBLIOGRAPHY: Richter 1965, pp. 131 (figs. 699–701), 141 (fig. 793); Raeder 1983, no. III,36.

20

**Elektra and an Attendant at the
Tomb of Agamemnon** (side A)
Orestes and Pylades (side B)

Red-figured skyphos, 450–430 B.C.
Attributed to the Penelope Painter
Greek (Attic); found in Basilicata, South Italy (?)
H: 16.3 cm (6⁷⁄₁₆ in.); Diam (with handles):
30 cm (11¾ in.)
Copenhagen, The National Museum of Denmark 597

THE MOTIFS ON THE TWO SIDES of the vase take us into the opening scene of *Libation Bearers*, the second play of Aeschylus's trilogy, the *Oresteia*. The women have, as the inscription on the stele indicates, arrived at the tomb of Agamemnon. The place is marked by a slender, slightly tapering stele on a three-stepped base crowned by a large palmette. Elektra, left, and her maid (representing the chorus) have come to decorate the stele with fillets, which the maid carries on a large tray. In an important recognition scene from the play, Elektra notices a lock of hair left on a step of the tomb and a series of footprints matching her own. At this point Orestes and his friend and fellow traveler Pylades, who from their hiding place have been watching the scene at the tomb, step forward. Sister and brother are reunited.

The Penelope Painter is the first Attic painter to depict Elektra and Orestes' reunion by their father's tomb and the only painter to so cleverly make use of both sides of a vase to convey the dramatic moment of the meeting. He is thus being true to Aeschylus's version of the play by letting the viewer relive Elektra's slow understanding of the signs left by Orestes. The meeting of sister and brother is known on only one other Attic vase but becomes popular in South Italy, where it is typically treated as a single scene. BBR

BIBLIOGRAPHY: *ARV²*, p. 1301, no. 5; *MTS²*, p. 138; *IGD*, III.1,2; Brommer 1973, p. 480, no. B1; Kossatz-Deissmann 1978, p. 93ff.; Shapiro 1994, pp. 130-34, figs. 91, 92; Salskov 2002, p. 12, fig. 5; Storey and Allan 2005, p. 104, fig. 2.1; Taplin 2007, p. 50n8 (with further refs.); *CVA* Copenhagen, fasc. 8, pls. 351, 352; *LIMC* III (1986), s.v. Electra I, p. 713, no. 34, pl. 546.

PLATE 20 | 63

21

**Elektra, Orestes, Pylades, and
a Female Attendant at the Tomb
of Agamemnon** (side A)
**Man and Two Young Women in
a Sacred Space** (side B)

Red-figured Panathenaic amphora, 380–360 B.C.
Attributed to the circle of the Brooklyn-Budapest
Painter
From Lucania, South Italy; found in Anzi
H: 67.5 cm (26½ in.); Diam (rim): 18.9 cm (7½ in.)
Naples, Museo Archeologico Nazionale di Napoli
H 1755 (82140)

SIDE A FEATURES THE SCENE of the meet-
ing between Elektra and Orestes at their father's
grave. The names of Elektra and Agamemnon are
inscribed alongside the figure of the young heroine.
Her fingers intertwined, Elektra is seated at the foot
of Agamemnon's grave; the stele is topped by a war-
rior's helmet.

Orestes and Pylades, both nude, arrive
from the right. Orestes, with a *chlamys* over his shoul-
der, holds a spear; his *petasos* (wide-brimmed hat)
hangs from his neck. He is accompanied by the loyal
Pylades, who also carries a spear. Elektra, on the
opposite side of the funerary monument, is accom-
panied by an unidentified female figure who stands
holding a *cista* (offering chest). An amphora of the
same shape as the vase itself has been set at the foot
of the tomb as an offering. Two dancing figures, one
male and one female, are painted on it.

On side B, a man with a staff sits in the
center of a sacred space, defined by hanging *taeniai*
(fillets) and weapons; he is flanked by two young
women. ML

BIBLIOGRAPHY: *CIG* 8419; *LCS*, no. 597; Moret 1979, p. 237,
figs. 2, 3; *LCS* supp. 3, p. 72, BB 62; *LIMC* III (1986), s.v. Elektra,
p. 710, no. 6, pl. 543; *DFA*², no. 178; Knoepfler 1993, p. 61, pl. 9;
Todisco 2003, L23 (from Basilicata); Taplin 2007, pp. 52–53.

22

Elektra, Orestes, and Pylades at the Tomb of Agamemnon (side A)
Amazonomachy (side B)
Red-figured pelike, ca. 350 B.C.
Attributed to the Choephoroi Painter
H: 46.2 cm (18³⁄₁₆ in.); Diam: 31.1 cm (12¼ in.)
Paris, Musée du Louvre MNB 167 (K 544)

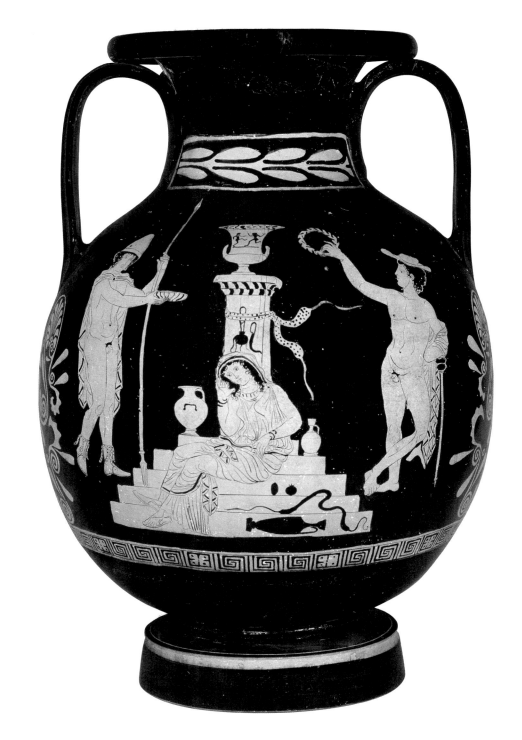

ON SIDE A OF THIS PELIKE, a type of amphora, is the opening scene of Aeschylus's *Libation Bearers* (*Choephoroi*): the meeting of Orestes and Elektra at the tomb of their father, Agamemnon, murdered by their mother, Klytaimnestra. At the center of the composition Elektra is seated on the steps of the tomb on which a stele has been set, topped by a calyx krater decorated with two dancing figures. Elektra, elegantly dressed in a chiton with a himation as a veil, is holding her head in her right hand in a gesture of sorrow. The offerings brought by the *choephoroi*, by order of Klytaimnestra, decorate the monument: strips of fabric, aryballoi, strigils, hydriai, lekythoi, and fruit. On the left, Orestes, wearing a *pilos* (cap), a *chlamys*, and slippers, is holding a spear and a *phiale* with which he is getting ready to carry out a libation (which does not occur in Aeschylus's text). The young man on the right, probably Pylades, Orestes' friend, crowns the monument, leaning on a caduceus usually associated with Hermes. The painter has chosen the moment when Orestes reveals himself to his sister and explains to her that he has received the order from the god Apollo to avenge Agamemnon by killing his murderers. Judging by the surviving vase-paintings, this tragedy was popular. It was represented by this anonymous Lucanian vase-painter so many times that he was named the Choephoroi Painter. After Aeschylus, Sophocles (possibly in 413 B.C.) and Euripides (possibly before 415 B.C.) each wrote a powerful Elektra tragedy.

The other side of the vase portrays a battle scene between a Greek warrior and an Amazon. Amazons, warrior women who lived in the Caucasus and in Asia Minor, wore tunics with long sleeves, trousers (*anaxyrides*) decorated with linear motifs, and Phrygian caps (leather caps with ear flaps) and fought with bows and arrows, axes, and *pelte* (studded shields). SM

BIBLIOGRAPHY: *LCS*, p. 120, no. 599, pl. 131,3; *IGD*, III.1,5; *LIMC* I (1982), s.v. Amazones, p. 612, no. 394, pl. 490; *LIMC* III (1986), s.v. Elektra I, p. 711, no. 7, pl. 543; Knoepfler 1993, p. 64, pl. 11; Madsen 1997, pp. 64, 65, 70, fig. 3; Taplin 2007, p. 53.

PLATE 22 | 65

23

Orestes Slaying Klytaimnestra (side A)
Two Draped Youths (side B)
Red-figured neck-amphora, ca. 340 B.C.
Attributed as close to Asteas
From Paestum, South Italy
H (to top of handle): 47.7 cm (18¾ in.);
Diam (body): 19.8 cm (7¹³⁄₁₆ in.)
Gift of Stanley Silverman
Malibu, J. Paul Getty Museum, 80.AE.155.1

WHILE IMAGES on numerous vases can be related to the opening scene of Aeschylus's *Libation Bearers* (plates 20–22), this amphora bears the only definite representation of one of the other iconic scenes from the play: the slaying of Klytaimnestra by Orestes in revenge for his father's murder. Mother and son, whose kinship the artist has emphasized by giving them similar features, are captured in a moment of shocking violence. Klytaimnestra has fallen to her knees and bares her breast in a dramatic gesture that evokes her plea from Aeschylus's text: "Easy, my son, take pity on this breast, child, that you so often, half-asleep, would suck with soft gums for the milk that let you grow!" (lines 1024–26, trans. Shapiro and Burian). Orestes, with a resolute expression, seizes her hair and threatens her with his brandished sword. The bust of an Erinys, a retributive deity with snakes coiled around her head and arms, looms over the scene, condemning the matricide.

The composition on this vase demonstrates not only an excellent knowledge of the play but also emancipation from any actual theatrical setting. Details such as Klytaimnestra's bold gesture clearly refer to the Aeschylean plot, but at the same time the lack of realistic theatrical elements (such as masks) eliminates the possibility that the depiction accurately portrayed the scene as staged. This liberty allowed the painter to create an image of great expressiveness.
LM-C

BIBLIOGRAPHY: *LIMC* VI (1992), s.v. Klytaimnestra, p. 77, no. 31, pl. 37; Mayo and Hamma 1982, exh. cat., pp. 229–30, no. 105; *RVP*, pp. 183–84, no. 2/418, pl. 129a–b; Taplin 2007, pp. 56–57, no. 5 (ill.).

24

Purification of Orestes (side A)
Two Couples (side B)

Red-figured bell krater, 380–370 B.C.

Attributed to the Eumenides Painter

From Apulia, South Italy; found in Taranto (?)

H: 48.7 cm (19³⁄₁₆ in.); Diam: 52 cm (20½ in.)

Paris, Musée du Louvre Cp 710

THE EXCEPTIONALLY LARGE eponymous bell krater by the Eumenides Painter portrays the beginning of the third part of Aeschylus's *Oresteia* trilogy (458 B.C.), *Eumenides*, and thus illustrates the importance of classical Attic tragedy to the vase-painters of Magna Graecia. The scene unfolds in the temple of Apollo in Delphi, symbolized by the omphalos placed on the altar. Orestes is seated on the monument, his head bowed, and holds the dagger with which he has just killed his mother, Klytaimnestra, to avenge the death of his father, Agamemnon. The god Apollo is standing behind him, wrapped in a richly embroidered himation, and is performing an act of purification by sprinkling Orestes with the blood of a baby pig he is holding by one of its rear legs. On the right, Artemis, Apollo's sister, dressed like a hunter, is witnessing the scene. A group of three women occupies the left portion of the tableau. Two of them are sleeping Erinyes, wearing short chitons held by straps crossed across their chests and *endromides* (soft boots). A woman wearing a himation as a veil over her head brings her hand close to the head of one of the Erinyes; she is the ghost of Klytaimnestra, who is trying in vain to awaken them from the sleep in which Apollo has plunged them to protect Orestes. Below, a third Erinys seems to be arising from the earth to take part in the scene. This vase is an important example of the many portrayals of Orestes taking refuge in

Delphi, a subject that appeared in Attic ceramics in the fifth century B.C. and was popular in Magna Graecian ceramics in the following century.

Specialists have identified two stylistic currents in Tarentine production, plain and ornate. The vase in the Louvre has certain characteristics of the plain style, such as the choice of shape, the absence of polychromy, and the iconographic repertoire, but also shows influences from the ornate style, such as the large size of the vase, the composition of the scene animated by many characters, the fluidity of the drawing, and the care given to the treatment of physiognomy, in particular for the three-quarter views of the faces. The Eumenides Painter, faithful to Aeschylus's text, interprets and recreates on this vase the scene of purification in Delphi, the tale of which was simply

evoked by the actors in the tragedy. The reverse side, in a more somber treatment, presents two couples in conversation. SM

BIBLIOGRAPHY: Cambitoglou and Trendall 1961, pp. 21, 22, no. 1; *MTS²*, p. 75, TV 13; *RVAp*, vol. 1, p. 97, no. 229; *LIMC* II (1984), s.v. Artemis, p. 730, no. 1382, pl. 560; *LIMC* III (1986), s.v. Erinys, p. 833, no. 63; *LIMC* VII (1994), s.v. Orestes, p. 74, no. 48, pl. 54; Aellen 1994, p. 27, no. 5; Denoyelle 1994, p. 168, no. 79; Pugliese Carratelli 1996, exh. cat., p. 711, no. 223; *CVA* Louvre, p. 25, pls. 50–52, 1,2; Sena Chiesa and Arslan 2004, exh. cat., p. 280, no. 281.

PLATE 24 | **67**

THE ERINYES

FRANÇOIS LISSARRAGUE

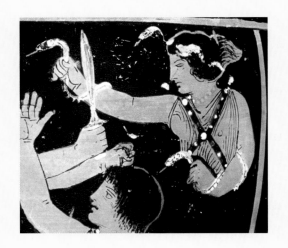

FIGURE 2.2
Eriny Threatening Orestes (detail, plate 23).
Malibu, California, J. Paul Getty Museum, Villa Collection.
Photo: Ellen Rosenbery

THE ERINYES (FURIES) ARE ARCHAIC GREEK *DAIMONES*, a group of three feminine goddesses born from Gaia (Earth) and the blood of Ouranos (Sky) after he was castrated by his son Kronos. The product of familial violence, the Erinyes persecute murderers, embodying revenge and madness. Aeschylus put them onstage at the beginning of *Eumenides*, the third play of his *Oresteia* trilogy. Orestes has killed his mother, Klytaimnestra, to avenge the murder of his father, Agamemnon, who had been killed on his return from the Trojan War by his wife and her lover, Aigisthos. The endless chain of revenge and pollution is interrupted by the intervention of the gods, mainly Apollo, for purification, and Athena, who establishes a tribunal to judge murderers. After that process, the terrible Erinyes (Angry Ones) become Eumenides (Kindly Ones).

In Aeschylus's play the Erinyes are not actually shown onstage; instead, they are described by the Pythia, priestess of Apollo, who discovers them sleeping in the temple and tries to produce a verbal image (*ekphrasis*) of them. They are so terrible that she compares them to various mythological monsters: they are like Gorgons, or rather like Harpies without wings. She refers to paintings showing such monsters, using her visual experience to produce for the audience a picture of what is not visible onstage.

Greek vase-painters dealt in different ways with the challenge of representing these horrific beings. They might, for instance, use color in an unnatural way, or add wings to the figures. The goal was to make these beings as different from the human figures on the vase as possible, rendering them as beings from another world.

On a Paestan amphora showing Orestes killing his mother (plate 23), the bust of one Erinys appears in the upper right corner wearing a costume similar to that of the Apulian Erinyes (fig. 2.2). Snakes crown her windblown hair; they writhe down her arms and into her hands, where they become weapons. The resulting portrait is of a huntress ready to pursue the killer. In contrast, on a krater in the Louvre (plate 24) we see an equivalent of what Pythia saw inside the temple, but this vase-painter approached the depiction of the Erinyes without the gruesomeness of Aeschylus. Here the two monsters at the upper left of the scene lie in elegant repose, painted with beautiful, calm features; they resemble humans more than *daimones* (fig. 2.3). On the left the standing shadow of Klytaimnestra emerges to rouse them. A third Erinys, half hidden, rises from the ground line next to Orestes' feet. The Erinyes are marginal in the picture; they do not interact with the main scene of Orestes and Apollo at the altar.

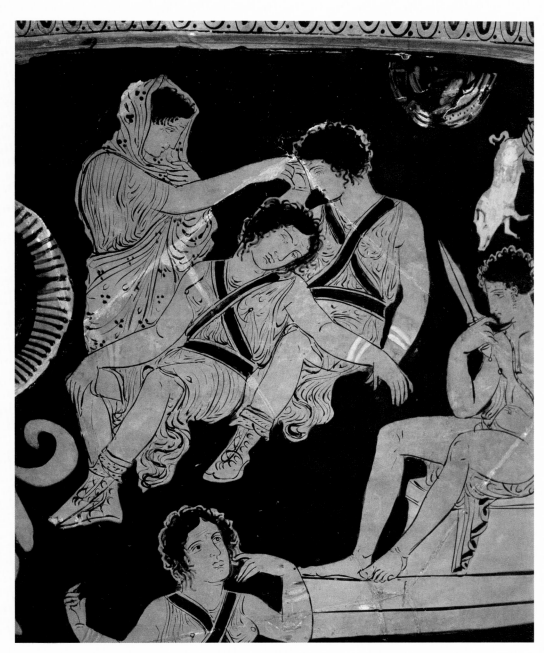

FIGURE 2.3

Klytaimnaestra Attempting to Rouse Two Erinyes
(detail, plate 24). Paris, Musée du Louvre.
Photo: Réunion des Musées Nationaux / Art Resource, NY

25

Orestes at Delphi, with Athena, Apollo, Erinyes, and Unidentified Figures (side A)
Dionysos with Satyr and Maenad; Busts of Satyr and Maenad Above (side B)
Red-figured bell krater, 350–340 B.C.
Attributed to Python
From Paestum, South Italy
H: 56.5 cm (22¼ in.); Diam (rim): 51 cm (20¹⁄₁₆ in.)
London, The British Museum 1917,1210.1

IN THE CENTER OF SIDE A, Orestes kneels in front of the omphalos and Delphic tripod looking up at Athena, who stands in a relaxed posture looking down at him, her helmet tipped back and a spear in her right hand. To the right of Orestes, Apollo, nude, holding a laurel branch, turns to the right toward a small Erinys with large wings wearing a short chiton and boots. Another, more menacing Erinys hovers above the tripod. Both Erinyes are identified by the snakes in their hair and elsewhere about them. The bust of a woman appears in the top left corner, possibly Hera, Leto, or Klytaimnestra herself. In the opposite corner, at the far right, is the bust of a *pilos*-wearing youth who must be Pylades, Orestes' companion. Rather than evoking a stage set or a memorable moment from a performance, this scene appears to have been conceived as a tableau of characters from Aeschylus's *Eumenides*. This final play of the *Oresteia* begins with Orestes taking refuge from the Erinyes at the sanctuary of Apollo at Delphi (hence the presence of the tripod) but is only finally resolved by Athena after Orestes' purification and arrival in Athens. MLH

BIBLIOGRAPHY: *CVA* British Museum 2, pl. 1.1; Trendall 1936, no. 108, pls. 17, 19b; Bieber 1961, p. 27, fig. 97; *IGD*, III.1,11; *LIMC* II (1984), s.v. Athena, p. 1015, no. 626, pl. 765; Williams 1985, p. 64, fig. 74a; *RVP*, no. 244, pl. 91; Green and Handley 1995, p. 47, fig. 24.

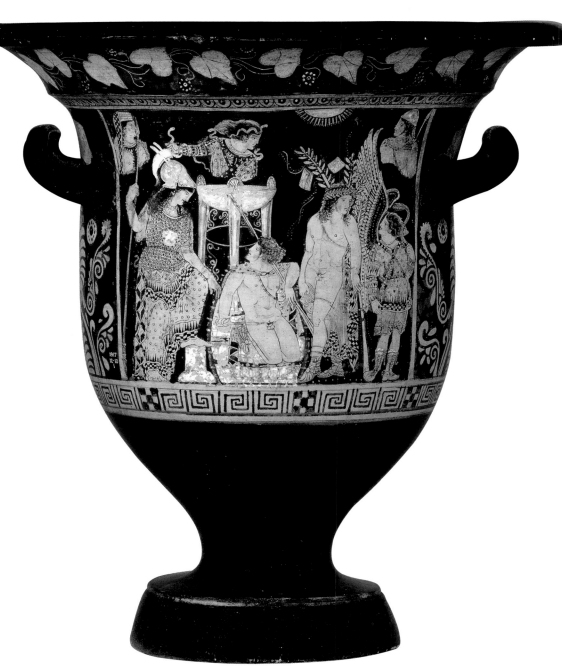

26

Recognition Scene from Sophocles'
Oedipus Tyrannos (side A)
Three Draped Standing Female Figures
(side B)

Fragmentary red-figured calyx krater, 330–320 B.C.

Attributed to the Capodarso Painter

From Syracuse, Sicily; found in the zone to the south

of the city hospital, tomb 34

H: 24 cm (9⅞ in.); Diam: 30 cm (11¾ in.)

Syracuse, Museo Archeologico Regionale

Paolo Orsi 66557

THE ACTION TAKES PLACE in a space that represents a stage set, with the main characters standing on a raised platform between four columns emphasized by added white pigment. On the left, an elderly white-haired man clad in the traveling clothes and boots of the *paidagogos* leans on a staff and gestures with his left hand toward a tall, richly clad couple in the center of the composition. Both look toward him, focused on what he is saying. The painter emphasized the psychological power of the scene by turning the figure of the old man toward the audience, as if he is speaking directly to them. He does not wear a mask, but his anguished expression communicates an event of great magnitude. The man to his left, on whose face is clearly depicted an expression of dramatic confusion, stands between two female figures rendered on a smaller scale. The woman standing next to him also turns toward the old man and raises her veil to her face with both hands. A final figure, probably a handmaiden, faces away from the others, concluding the action with a similar gesture of anguish.

This unusually powerful composition very probably depicts the scene in Sophocles' *Oedipus Tyrannos* (line 924ff.) in which the Old Corinthian relates to Oedipus the death of his foster father, King Polybus. As the conversation unfolds, Oedipus and Jocasta discover his true birth: he was rescued from death and taken to Corinth, where he became the

son of the childless royal couple. The vase shows the dramatic instant in which Jocasta, understanding the import of this revelation before her husband, realizes the secret of her real relationship to Oedipus. She will leave the stage in a state of anguish to put an end to her own life.

In Sophocles' text, the girls, Antigone and Ismene, are not present in this scene; they do not appear until the end of the play. Their presence in the scene on the vase, however, adds pathos and shows the originality of the painter's approach to interpreting the text of the stage play. In contrast to typical representations of tragedy, which avoid showing the architecture of the stage, there is evidence that Sicilian vase-painters had their own, more realistic approach. Another vase attributed to the Capodarso Painter shows an unidentified scene that must have been inspired by a tragic source (Taplin 2007, pp. 261–62). AC

BIBLIOGRAPHY: Trendall 1969–70, p. 46; *IGD*, III.2,8; Voza 1973, pp. 83, 98–100, pls. 32, 33; *LIMC* I (1981), s.v. Antigone, p. 820, no. 1, pl. 659; *LCS* supp. 3, p. 276, no. 98a; Giudice 1985, p. 259, fig. 299; Schefold and Jung 1989, p. 67, pl. 47; *RVSIS*, p. 236, pl. 429; Dearden 1990, p. 240; *LIMC* V (1990), s.v. Iokaste, p. 683, no. 5; Taplin 1993a, p. 112, pl. 6.112; Csapo and Slater 1994, p. 63n130, pl. 4a; Green 1994, p. 186, no. 35; *LIMC* VII (1994), s.v. Oidipus, p. 9, no. 83, pl. 14; Green and Handley 1995, p. 43, fig. 20; Portale 1996, p. 711, no. 232; Taplin 1997, pp. 85–86, pl. 17; Allan 2001, pp. 67–86; Green 2002, p. 124, pl. 19; Todisco 2002, p. 88, pl. 21.1; Small 2003, pp. 54–57, pl. 27; Small 2005, pp. 109–10, pl. 7.3; Taplin 2007, pp. 90–92; Billing 2008, pp. 229–45.

PLATE 26 | 71

27

Medea Departing in a Chariot (side A)
Telephos, Agamemnon, and Baby Orestes
(side B)
Red-figured calyx krater, ca. 400 B.C.
Attributed to near the Policoro Painter
From Lucania, South Italy
H: 50.5 cm (19⅞ in.);
Diam (rim): 49.9 cm (19⅝ in.);
Diam (foot): 22 cm (8¹¹⁄₁₆ in.)
Purchase, Leonard C. Hanna Jr. Fund
Cleveland Museum of Art 1991.1

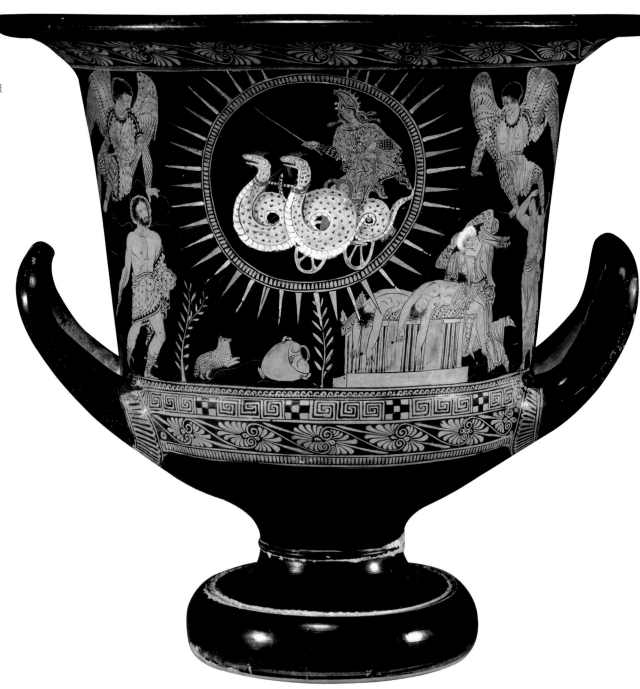

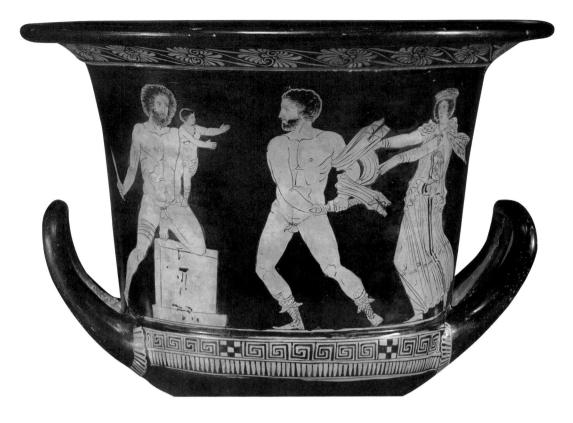

THIS INTACT AND IMPOSING Lucanian calyx krater attributed to near the Policoro Painter uniquely illustrates two scenes most likely inspired by two plays written and produced for the Athenian stage by Euripides. The association is strengthened by the references in the two scenes to children either murdered or purposely endangered in Greek myth. The Greek colonists of South Italy and Sicily held Athenian drama in reverent esteem and had a particular fondness for Euripides.

On the obverse is an inventively dramatic depiction of the final scene of Euripides' *Medea*, which premiered in Athens in 431 B.C. Medea is the center of attention, wearing a Phrygian helmet and driving an airborne chariot yoked to enormous spotted snakes within a radiate nimbus. The coiled bodies of the bearded and crested serpents partially obscure her chariot as Medea goads them on with a *kentron* in her right hand and the reins grasped in her left. She does not take her dead sons with her as in the play, but has left their lifeless bodies pathetically draped over an altar below to the right. A tattooed old nurse standing behind the altar is overcome with grief at the sight; the aging *paidagogos* behind her reacts with restrained horror. Jason, shown with curly hair and beard, looks up helplessly at Medea from the lower left. Before him on the ground are a leaping dog and an overturned hydria. Hideous hook-nosed and winged Erinyes with sagging breasts look down on the grisly scene from the upper left and right corners, a detail not found in other representations of Medea.

It is likely that the scene on the reverse was inspired by Euripides' lost play *Telephos*, first performed in Athens in 438 B.C. Telephos, the son of Herakles and Auge, was wounded by Achilles after the Greeks landed in Mysia by mistake. An oracle revealed to him that his wound could be healed only by the person who inflicted it. Telephos traveled to Greece and sought the aid of Klytaimnestra, and in desperation he took the baby Orestes hostage to compel Agamemnon to help him. Agamemnon agreed to heal his wound with the rust from Achilles' spear.

On the krater Telephos, bearded, is shown with his left knee propped up on a blood-spattered altar and his right thigh wrapped in a bandage. He holds the infant Orestes hostage while brandishing an upright sword. With arms extended, Orestes gestures to his parents, Agamemnon and Klytaimnestra, to save him. Orestes is dressed in short boots, and a string of amulets is suspended from his shoulder. At the center of the scene, Agamemnon is bearded and wears laced boots. His mantle slides down his left arm and flaps in the air as he draws his sword from a scabbard and begins to rush toward Telephos and his son. Behind him Klytaimnestra, wearing a crown, peplos, and pinned mantle, extends her arms in a gesture similar to her son's. According to the myth, this scene of threatened violence will be resolved without bloodshed. MB

BIBLIOGRAPHY: *LIMC* I (1981), s.v. Agamemnon, p. 260, no. 14a; Tompkins 1983, pp. 76–79, no. 14 (Cody); *Apollo* 117 (June 1983), pp. 493–95, fig. 7a–b; *LIMC* III (1986), s.v. Erinys, p. 837, no. 101; *LIMC* V (1990), s.v. Iason, p. 635, no. 71; Sotheby's New York 1990, no. 14 (illus., color); Cleveland Museum of Art 1991a, p. 72 (illus., color); Carpenter 1991, fig. 283; Cleveland Museum of Art 1992b, p. 76, no. 1; *LIMC* VI (1992), s.v. Medeia, no. 36, pl. 199; Cleveland Museum of Art 1992c, pp. 18–19; Taplin 1993a, pp. 16–17, 22–23, 26, 37–38, 116–17, nos. 1.101 and 1.102, facing p. 20 (illus.); Aellen 1994, p. 39n39; *LIMC* VII (1994), s.v. Telephos, pp. 866–67, no. 59, pl. 600; Easterling 1997, p. 79, fig. 12; Sourvinou-Inwood 1997, pp. 269–71, fig. 3 (erroneously called a bell krater); Matheson 1997–98, pp. 23–24, fig. 5 (detail); *CVA* Cleveland (2000), fasc. 35, pp. 48–49, pl. 89–91; Neils et al. 2003, exh. cat., fig. 17, p. 23; Revermann 2005, pp. 3–18; Storey and Allan 2005, p. 152, fig. 2.4; Cassimatis 2005, fig. 2A–B, pp. 48–49; Taplin 2007, pp. 122–23.

PLATE 27 | 73

28

Medea Departing in a Chariot

Red-figured hydria, ca. 420 B.C.

Attributed to the Policoro Painter

From Lucania, South Italy; found in Policoro
(Herakleia), South Italy

H: 43 cm (16¹⁵⁄₁₆ in.); Diam (rim): 16.8 cm (6⁵⁄₈ in.);
Diam (foot): 14.8 cm (5¹³⁄₁₆ in.)

Policoro, Museo Archeologico Nazionale
della Siritide 35305

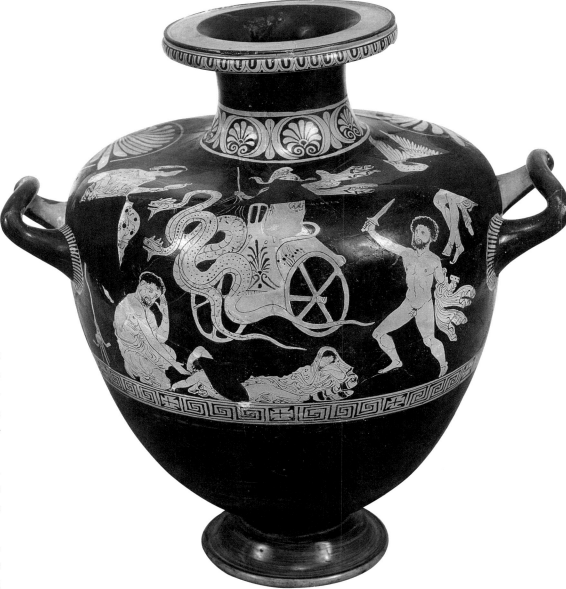

THE SCENE IS DOMINATED by Medea in Eastern garb (part of the figure is missing), depicted with a fluttering cape as she makes her escape in the chariot drawn by two dragons in the shape of serpents, a gift from the sun god. She is identified as Medea by an inscription.

At the bottom, in the center of the scene, are her two murdered sons, depicted as if they were sleeping: one is naked, spread out on a cape, while the other is wrapped in a cape that covers his head.

To the right of the two dead boys is Jason, nude, brandishing a sword in his right hand as he hastens in pursuit of Medea; his cape has wrapped itself around his left arm, and his left hand grips the sheath of his sword. To the left of the dead boys is their aged tutor, wrapped in a cape but with his right shoulder left uncovered. His left hand clapped to his forehead, his right hand extending out toward the lifeless bodies of the boys, and his staring eyes all reveal the horror of the scene. Next to him, tied to a staff, are a small oil jar and two strigils for use in the boys' athletic activities.

Above are two figures, one on either side of the chariot. To the right is an incomplete winged figure wearing Eastern-style sandals. This figure may perhaps be identified as Helios, who gave the

chariot to the sorceress in the version of the tragedy by Euripides. To the left is a young woman, seated, holding a mirror. She is dressed in a lavish peplos and wears jewelry and an embroidered headband. Rather than Selene, who is often associated with Helios, this figure should be identified as the daughter of King Kreon—Kreousa or Glauke, depending on the source—who gazes at herself in the mirror in contentment at the gifts from Medea that she has already put on, such as the embroidered peplos and the golden crown. According to G. Pianu, the figures should be seen as depictions of a winged genius

and the goddess Aphrodite, who have both come to Medea's aid because Jason has broken the laws of love. Beneath the two handles a goose is depicted.

This vase was found in the same tomb in ancient Herakleia (modern Policoro) as the pelike shown in plate 31. SB

BIBLIOGRAPHY: Degrassi 1965, pp. 5–37; Degrassi 1967, pp. 193–234; *LCS*, p. 58, no. 286, pls. 26.3, 27.3; *IGD*, III.3,34; *LCS* supp. 3, p. 19; *RVSIS*, no. 28; Pianu 1989; *LIMC* VI (1992), s.v. Medeia, p. 391, no. 35, pl. 198; Pianu 1997, pp. 87–165; Allan 2001; Taplin 2007, pp. 117–21.

29

Medea (side A)

Two Youths (side B)

Red-figured amphora, ca. 330 B.C.

Attributed to the Ixion Painter

From Campania, South Italy;

found in Cumes, Italy

H: 48.5 cm (19⅛ in.); Diam: 18.2 cm (7³⁄₁₆ in.)

Paris, Musée du Louvre Cp 786 (K 300)

THE IXION PAINTER was an artist from Campania, a region where Italic influences and western Greek culture intersected. He worked near Capua, where most of his vases were found. Like some other Campanian artists, the Ixion Painter showed an interest in themes from mythology and epics.

On this elongated amphora, typical of those produced in Campania, the painter has depicted a scene from Euripides' tragedy *Medea*. The formidable sorceress Medea, daughter of the king of Colchis, is shown killing one of her sons. She clutches him violently by his hair while stabbing him with a sword, causing blood to flow from his body. The elegant, bejeweled Medea is wearing a peplos over a long-sleeved tunic that serves as a reminder of her barbarian origins; she also wears a himation around her waist. Her wavy hair is swept back in a chignon and held in place by a tiara. The child, pain written on his face, seems to implore Apollo, whose effigy stands on a pillar in the background. The scene unfolds in a sanctuary, as indicated by the presence of certain architectural elements: the divine statue on a pillar, the two columns, and the altar. These architectural elements also evoke pillars used in stage scenery. According to Euripides' play, Medea famously assuaged her desire for revenge against Jason by killing their two sons. Perhaps influenced by a variation

on the narrative, the Ixion Painter has limited the action to the death of one child.

On the other side of the vase, a secondary scene shows two youths wrapped in mantles and wearing large crowns. SM

BIBLIOGRAPHY: *LCS*, p. 338, no. 786, pl. 131,3; *IGD*, III.3,36; *LIMC* II (1984), s.v. Apollon, p. 240, no. 450; *LIMC* VI (1992), s.v. Medeia, p. 391, no. 31, pl. 198; Clair 2005, exh. cat., p. 50, no. 5.

PLATE 29 | 75

30

Medea at Eleusis (side A)
Dionysiac Scene (side B)

Red-figured volute krater, 340–330 B.C.

Attributed to the Darius Painter

From Apulia, South Italy

H: 100.1 cm (39⁷⁄₁₆ in.); Diam: 37 cm (14⁹⁄₁₆ in.)

Museum purchase, Carl Otto von Kienbusch Jr.,

Memorial Collection Fund in honor of

Francis Follin Jones

Princeton, New Jersey, Princeton University

Art Museum 1983.13

WITHOUT THE INSCRIPTIONS "Eleusis: the temple" on the architrave of the stylized temple and "Medea" below the central female figure, the identification of this scene would have remained problematic. While the Sanctuary of Eleusis is evoked by the presence of Demeter and Kore in the upper right and the crossbar torches held by the youths in the lower left, no clue would prompt the identification of the woman as Medea. The tragic heroine is not wearing the traditional attributes of the sorceress or her Eastern clothes, and there is no known story placing her at Eleusis.

The presence of the old man at Medea's side with the traditional accoutrements of the *paidagogos* suggests a connection with tragedy. Representations of Medea in fourth-century South Italian vase-painting are well known and usually depict Euripides' vengeful heroine about to kill her children or, having done so, fleeing Corinth in a snake-drawn chariot (plates 27–29). In contrast, this krater shows a demure Medea conversing with the *paidagogos*, while her children—alive—sit on the altar below. Because of the presence of the hero at the lower right, this scene has sometimes been linked to the madness of Herakles, but that tragic event takes place in Thebes rather than in Eleusis. A more likely interpretation of this vase is that its iconography reflects the plot of a lost tragedy, in which Medea does not murder her children but brings them to the sanctuary for safekeeping under the care of the *paidagogos* (Giuliani and Most 2007).

The choice of this unusual subject matter exemplifies the Darius Painter's predilection for myths of relative rarity as well as his familiarity with dramatic themes. He was the first Apulian vase-painter to realize the possibilities of vases of monumental dimensions to communicate the dramatic themes that proved to be well suited to his multifigured and complex compositions. LM-C

BIBLIOGRAPHY: *RVAp* supp. 1, p. 78, no. 41a, pl. 12.1–2; Trendall 1984, pp. 4–17; Schmidt (M.) 1986, pp. 169–74; *LIMC* VI (1992), s.v. Medeia, p. 394, no. 68; Green 1999, pp. 37–63; Giuliani and Most 2007, pp. 197–217; Taplin 2007, pp. 238–40.

31

Children of Herakles (side A)
Two Pairs of Standing Youths (side B)
Red-figured pelike, ca. 420 B.C.
Attributed to the Policoro Painter by
Nevio Degrassi and to the Karneia Painter
by A. D. Trendall
From Lucania, South Italy; found in
Policoro (Herakleia), South Italy
H: 42.5 cm (16¾ in.); Diam (rim): 23.2 cm (9⅛ in.);
Diam (foot): 19.5 cm (7¾ in.)
Policoro, Museo Archeologico Nazionale
della Siritide 35302

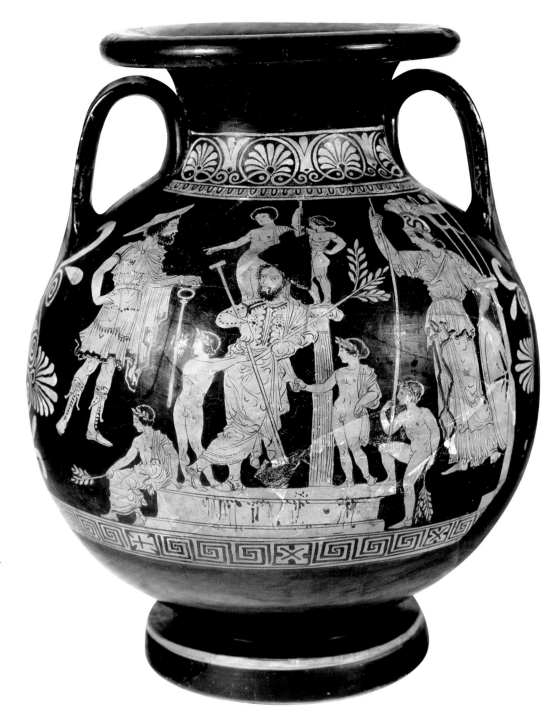

SIDE A PRESENTS A COMPLEX SCENE with a central group of figures posed on a broad, bloodstained altar base. The figures are arranged in a pyramidal composition. At the center, surrounded by young boys, is an elderly bearded figure leaning on a column. He is wearing an embroidered outfit and an ample cape that covers his head. His staring eyes and furrowed brow clearly show that he is worried. In his right hand is a long scepter; his left hand holds an olive branch. The column on which he is leaning is fluted, with an Ionic capital; atop it is a statue of a nude young god standing erect with a staff in his hand, his head garlanded with laurel. To the left of the group is an elderly bearded herald, dressed in a short embroidered outfit and high sandals, with a broad *petasos* on his head. In his left hand he holds a caduceus. To the right stands Athena, fully armed.

The elderly character in the central group is Iolaos, Herakles' charioteer. In Euripides' *Children of Herakles* of about 430 B.C., Iolaos escorts the suppliant children of the god-hero to the Sanctuary of Marathon in the wake of Herakles' death and apotheosis. There they are under the protection of the Athenian king Demophon, safeguarded against the persecution of Herakles' enemy Eurystheus.

Kopreus, the herald of Eurystheus, stands to the left of the group, intending to drag the young Herakleidai away from their refuge at the altar.

Athena, who symbolizes the protection of the king of Athens, wears a long embroidered chiton and an ample cape; in her right hand she holds a spear, while her left hand grips a round shield that rests on the ground. She wears an Attic helmet adorned with a serpent and a long crest. Behind the goddess is a tripod atop a tall, smooth shaft with a Doric capital.

This vase was found in the same tomb as the hydria shown in plate 28. SB

BIBLIOGRAPHY: Degrassi 1965, pp. 5–37; Degrassi 1967, pp. 193–234; *LCS*, p. 55, no. 283; Griefenhagen 1969; *IGD*, III.3,20; *LIMC* IV (1988), s.v. Herakleidai, p. 725, no. 2, pl. 442; Pianu 1989, pp. 85–94; Pianu 1997, pp. 87–165; Bianco 1998, p. 256; Allan 2001; Taplin 2007, pp. 126–27.

PLATE 31 | 77

32

Children of Herakles (side A)
Four Standing Youths (side B)
Red-figured column krater, ca. 400 B.C.
Attributed as close to the Policoro Painter
From Lucania, South Italy
H: 52.5 cm (20½ in.); Diam: 37.7 cm (14⅞ in.)
Berlin, Antikensammlung, Staatliche Museen
zu Berlin—Preußischer Kulturbesitz 1969.6

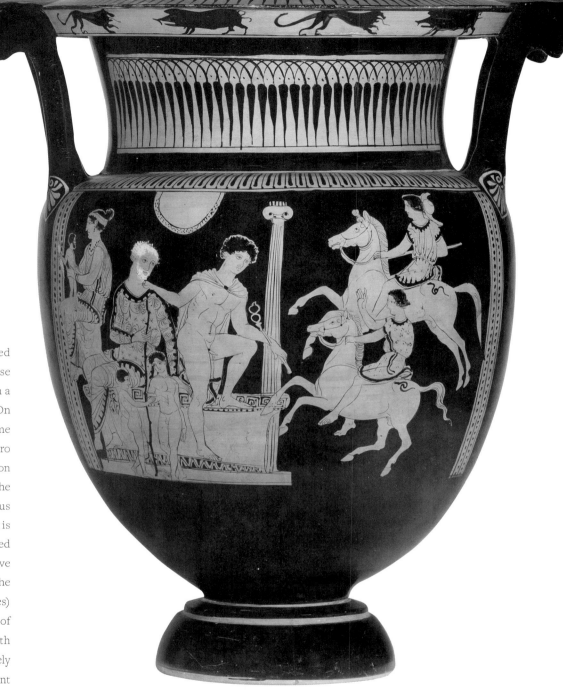

THIS CAREFULLY CONCEIVED and executed column krater was painted by an artist with close stylistic ties to the Policoro Painter, from whom a *Children of Herakles* has also survived (plate 31). On this vase, the field has been bisected by the same Ionic column that unifies the design on the Policoro Painter's pelike into a solid pyramid. Here the action is equally divided into two zones; to the far left, the seated Alkmene attends to a small statue of Zeus that she holds on her lap (to indicate that she is hiding in the temple of Zeus); the old, white-haired Iolaos, dressed in elaborate garments evocative of theatrical costume, is seated on the altar of the temple with two children (the children of Herakles) standing in front of him. Kopreus, the herald of Eurystheus, stands in a dominating posture, with his foot irreverently placed on the altar, aggressively grasping Iolaos by the neck; he takes the dominant position and appears to be in charge of Iolaos and the children. But the entire right side of the picture is taken up with an unusual scene of rescue: two cavalrymen from Athens have arrived (in the persons of Akamas and Demophon, the sons of Theseus) to take the children to the city for their safety.

That two important vases on the same theme have survived from two closely linked painters probably indicates a local popularity for this play (as for *Medea*, plates 27, 28). That the resulting depictions are so different is characteristic of the artistic individuality of painters in Magna Graecia. MLH

BIBLIOGRAPHY: Griefenhagen 1969; *IGD*, III.3,21; *LCS* supp. 3, p. 320; *LIMC* IV (1988), s.v. Herakleidai, p. 725, no. 3; Todisco 2003, L15, pp. 391–92 (with bibliog.); Taplin 2007, pp. 129–30.

33

Madness of Herakles (side A)
**Dionysos Riding a Panther with Satyrs
and Maenads** (side B)
Red-figured calyx krater, ca. 350 B.C.
Signed by Asteas
From Paestum, South Italy
H: 55 cm (21⅝ in.); Diam: 50 cm (19¾ in.)
Madrid, Museo Arqueológico Nacional 11094

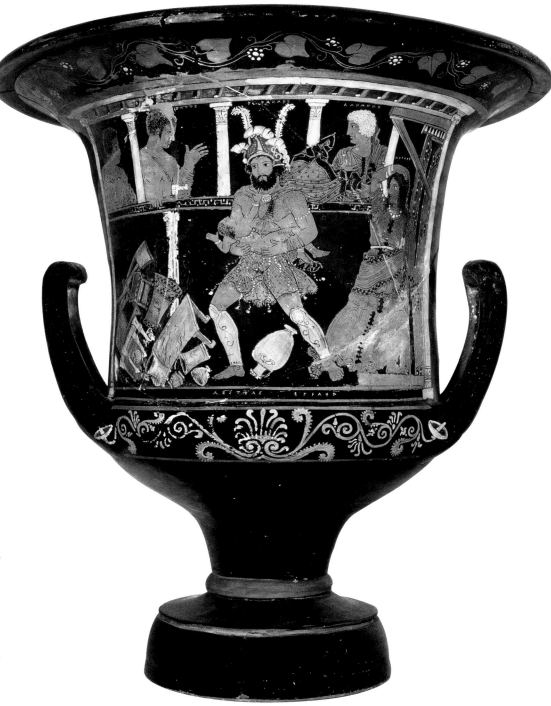

THE PAESTAN VASE-PAINTER ASTEAS—who
proudly signed his name with two sigmas directly
under the figure of Herakles—effectively conveys
the Euripidean madness of the hero by presenting the
action in a shallow plane before a theatrical tableau
constructed of elements derived from stage scenery.
In this painting Asteas offers a characteristic example
of a Paestan scene from the fourth century B.C., appar-
ently inspired by Euripides' much earlier *Herakles*
(from about 415 B.C.). The painting is contemporane-
ous with those shown in plates 17 and 25, by Asteas's
colleague Python.

 In the play, Herakles has succumbed to
Hera's persecution and gone into a mad frenzy of
destruction, setting his home on fire and killing his
family. His figure, inscribed with his name, domi-
nates the action from the center of the composition.
He is dressed in a *chlamys* (cloak), a transparent
chiton, a Samnite helmet with feathers, and *ocreae*
(elaborate greaves). He carries one of his sons in his
arms, apparently with the intent of throwing him
into the fire already ablaze with his own household
goods. This bonfire symbolizes the destruction of
everything Herakles will touch. His wife, Megara,
whose name is inscribed, grasps her head in terror
as she flees through the set-like door on the right.
As is common on Paestan vases, a colonnade sup-
ports framed portraits of characters important to

the scene below. Above on the left are Mania, mad-
ness, sent by Hera to goad Herakles into insanity;
Iolaos, nephew and faithful friend of Herakles; and
Alkmene, his mother (all with names inscribed).
Herakles' famous twelve labors were imposed as
punishment for this horrific event. ACH

BIBLIOGRAPHY: Trendall 1936, pp. 31–34, pls. 7, 8; Robertson
1975, p. 440, pl. 139a; *RVP*, p. 84, no. 127; Aellen 1994, vol. 1,
pp. 20, 33–34, 41, 54, and vol. 2, p. 203, pls. 12, 13; *LIMC* IV
(1988), s.v. Herakles, pp. 835–36, no. 1684; Taplin 2007,
pp. 143–45.

PLATE 33 | 79

34

Killing of Neoptolemos at Delphi (side A)
Dionysos with Satyrs and Maenads in Thiasos (side B)

Red-figured volute krater, 360–350 B.C.
Attributed to the Lycurgus Painter
From Apulia, South Italy; found in Ruvo di Puglia
H: 65 cm (25½ in.); Diam (rim): 32.7 cm
(12¹³⁄₁₆ in.); Diam (foot): 16 cm (6¼ in.)
Vicenza, Intesa Sanpaolo F.G-00111A-E/IS

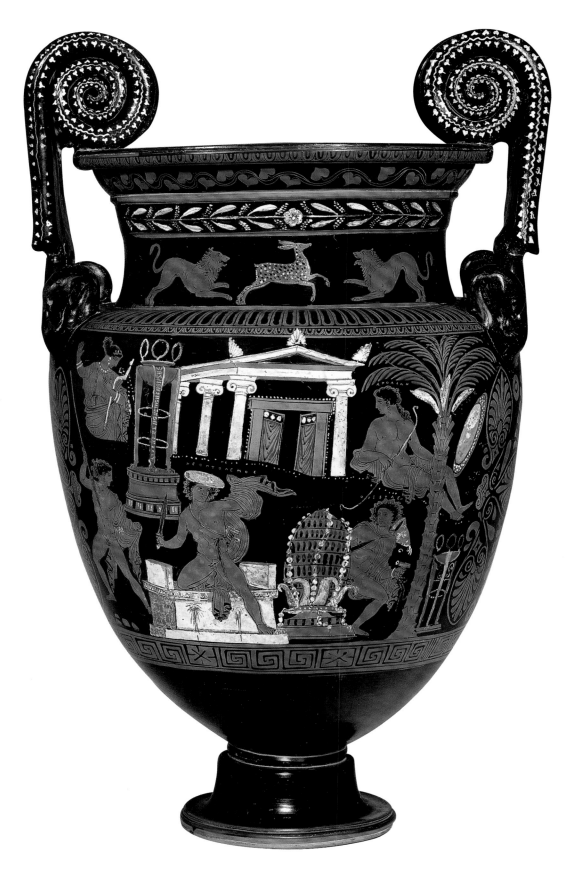

THE LEGEND OF THE KILLING of Neoptolemos
by Apollo at Delphi was well known in antiquity
but uncommon in art; it survives only in a mes-
senger speech from Euripides' *Andromache*, where
Euripides seems to have developed Orestes' culpa-
bility in the murder. Neoptolemos, identified by an
inscription, wears a *petasos* and has a *balteus* across
his chest; he is kneeling with one knee on the blood-
stained altar, brandishing his sword in a violent
movement. His cape, wrapped around his raised
left arm, falls behind his wounded nude body. The
hero's gaze is turned on Orestes, the antihero of the
tragedy, whose name is inscribed as well. Orestes
wears a cape and has a *pilos* hanging from his neck.
He is depicted in ambush, his sword unsheathed,
as he lurks in concealment behind the omphalos.
On the left a nude assassin raises his spear against
Neoptolemos. The murder was plotted by Orestes,
who was in love with Hermione, who was in turn the
jealous bride of Neoptolemos, the son of Achilles.

Details of the scene suggest the sacred and
theatrical setting: the open temple of Apollo (which
also recalls stage scenery), an elaborate tripod, a
smaller tripod standing next to it, a tall palm tree, the
Pythian priestess who clutches the keys to the temple

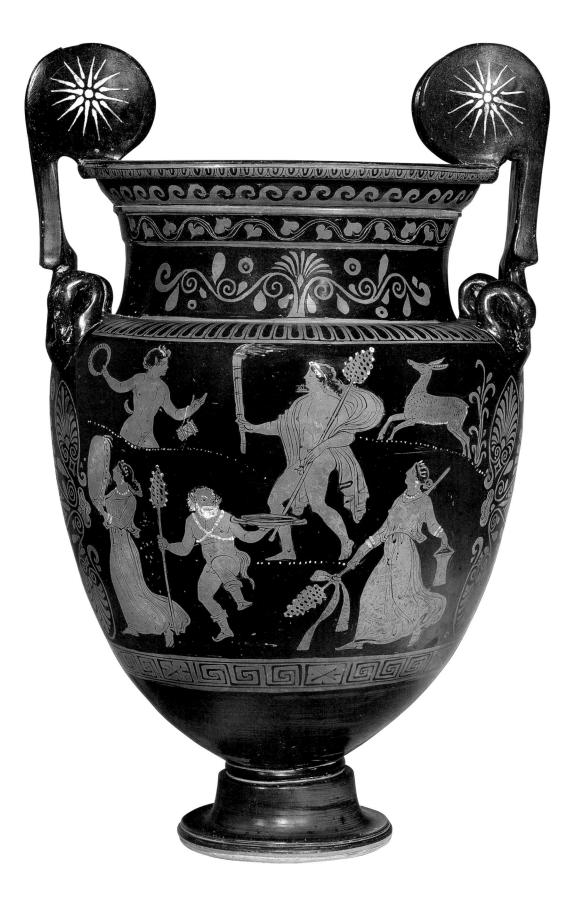

to her breast, Apollo with long hair and a bow. This vase was formerly attributed to the Iliupersis Painter and bears a close stylistic resemblance to the vase shown in plate 36.

At the center of side B is Dionysos crowned with a wreath and carrying a *thyrsos*. He walks forward holding a torch; around him in rhythmic movement are a maenad holding a *thyrsos* and a situla; a silenos, with high boots and a double baldric, holding a *thyrsos* and a *phiale*; and a maenad with a *tympanon*. In the upper register, partially concealed behind small hillocks, is a satyr, with a panpipe and a wreath. A fawn walks forward on the right. FG

BIBLIOGRAPHY: *IGD*, III.3,9; *CVA* Italy 49, Milan—Collection "H.A.," fasc. 1, IV, D, pls. 1 (1–2), 2 (1–5); *RVAp*, vol. 1, p. 193, no. 4, pl. 60,3; Sena Chiesa and Arslan 2004, exh. cat., p. 232, no. 235; Dolci 2006, pp. 306–9, figs. on pp. 307–10; Montanaro 2007, no. 340.1, pp. 938–40; Taplin 2007, pp. 139–41, figs. on pp. 139, 140; Catoni 2008, exh. cat., p. 321, no. 23.

PLATE 34 | 81

35

**Meeting of Orestes and
Iphigenia in Tauris** (side A)
Two Women and Two Youths (side B)

Red-figured volute krater, 350–325 B.C.
Attributed to the Iliupersis Painter
From Apulia, South Italy; found in Ruvo di Puglia
H: 62.6 cm (24½ in.); Diam (rim): 32 cm (12½ in.)
Naples, Museo Archeologico Nazionale di Napoli
H 3223 (82113)

THIS VOLUTE KRATER, characterized by a low neck bearing a frieze with animals, a stag surrounded by lions, and by swan protomes where the handles are attached, features on side A the meeting between Orestes and Iphigenia in Tauris. The names of Orestes, Pylades, and Iphigenia are inscribed in white near their heads. Pylades stands to the left in a pensive pose, Orestes is seated on the altar of Artemis with his head lowered, and Iphigenia, in the garb of a priestess, walks toward her brother, accompanied by a young servant bearing an offering patera on her head.

In the upper section of the scene, the deities Apollo and Artemis are depicted seated with a slender laurel branch between them. To their right, a small Ionic temple, its doors partway open, suggests the temple of Artemis as well as scenery one might have found in a performance.

On side B are two women with veiled faces and two young men, fingers intertwined. ML

BIBLIOGRAPHY: *IGD*, III.3,28; *RVAp*, vol. 1, p. 193, no. 3; *LIMC* v (1990), s.v. Iphigenia, p. 714, no. 18, pl. 468; Knoepfler 1993, p. 61; Sena Chiesa and Arslan 2004, exh. cat., pp. 280–81, fig. 282; Taplin 2007, pp. 150–51; Montanaro 2007, pp. 360–61, no. 55.1.

36

Sacrifice of Iphigenia (side A)
**Seated Youth Facing Right with
Two Standing Women and a
Standing Youth** (side B)

Red-figured volute krater, 360–350 B.C.
Attributed as close to the Iliupersis Painter
From Taranto, South Italy
H: 71 cm (28 in.); Diam: 40.6 cm (16 in.)
London, The British Museum 1865,0103.21 (F159)

THE SACRED SETTING of Iphigenia's sacrifice is
indicated by two bucrania painted in added white
hanging on the black ground. Beneath these, six
figures are centered around a white altar on two steps.
Agamemnon (or Kalchas) stands behind it, extending
the sacrificial knife toward the approaching victim.
Her contours are echoed by those of a deer stand-
ing on its hind legs. To the left of the altar an acolyte
holds a tray of offerings. Behind him stands a woman
in elaborate dress (perhaps Klytaimnestra); Apollo
and Artemis (whose hunting garb resembles theatri-
cal costume) observe from an elevated register.

 Euripides' *Iphigenia at Aulis*, left unfinished
at the playwright's death and completed by his son
and others, ends with a messenger's tale of how
Artemis substituted a deer for Iphigenia at the
moment of sacrifice. Although the plot reads like
a prequel to *Iphigenia among the Taurians*, it was
actually written about a decade later and produced
posthumously in Athens in 405 B.C.; this vase was
produced about fifty years later, in Magna Graecia.
Artists in antiquity were sometimes called on to
paint the phenomenon of metamorphosis, a chal-
lenge they met in a variety of ways. However, this

cloaking of the woman by the deer has almost a sense
of costuming about it, and one wonders how close
the influence of a performance was to the painting of
the scene. Since the surviving manuscript is so cor-
rupt and the speech containing the miracle (though
ancient) is not original, we cannot know what shape
the play took in Athens, but this painting may reflect
a remarkably inspiring performance much later in
Magna Graecia. MLH

BIBLIOGRAPHY: *RVAp*, vol. 1, p. 204, no. 104; *LIMC* v (1990),
s.v. Iphigenia, p. 712, no. 11, pl. 467; Green and Handley 1995,
pp. 47–48, fig. 22; Woodford 2003, pp. 6–7, fig. 3; Taplin 2007,
pp. 159–60, no. 52; Buxton 2009, pp. 107–9, fig. 45.

PLATE 36 | 83

37

Tragic Mask of an Old Man
3rd century B.C.
Terracotta
H: 11 cm (4⅜ in.)
Acquired posthumously from the
Peter Mavrogordato Collection,
Römhild/Meiningen, Thuringia, 1980
Berlin, Antikensammlung, Staatliche Museen
zu Berlin—Preußischer Kulturbesitz 33480

38

Tragic Mask of a Bearded Man
25–1 B.C.
From Myrina, Turkey
Terracotta
H: 6.8 cm (2¾ in.); W: 6.5 cm (2½ in.);
D: 5.7 cm (2¼ in.)
Paris, Musée du Louvre Myr 350 (Myrina 561)

THIS MASK REPRESENTS an old tragic hero with a well-tended beard and long hair swept forward into a crown above his forehead. This padding of hair—called an *onkos*—was an innovation introduced to tragic masks in about 300 B.C. The wide-open eyes, the brows slanting downward on the sides, and the open mouth create an expression of great pain. The nostrils appear as indentations beneath the pointed nose. The mask was originally painted; traces of pigment remain on the right side of the face. A dark pinkish red was applied over a white ground.

The long hair, the tall *onkos*, and the curly beard characterize the old man as a respected figure, a nobleman of some kind, possibly a king or a venerated hero. But without further attributes he cannot be identified more precisely. ASch

BIBLIOGRAPHY: Schwarzmaier 2006, p. 61, no. IV.7, fig. 137.

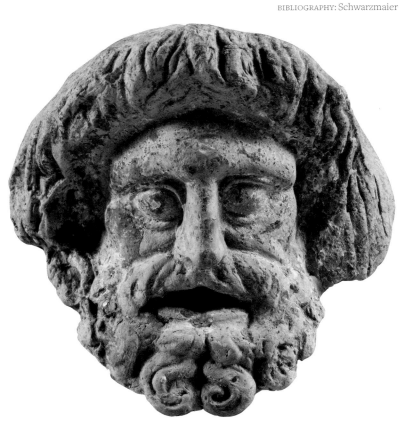
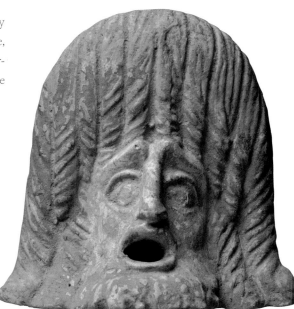

39

Tragic Mask of a Young Man

Ca. 150 B.C.

Greek, from Asia Minor (Turkey); found in

Amisos, Turkey

Terracotta

H: 17 cm (6¹¹⁄₁₆ in.)

Paris, Musée du Louvre CA 1958

THIS SMALL TERRACOTTA MASK was created with a bivalve mold. Compared with two other masks of the same type discovered in the necropolis of Myrina and now at the Louvre (Myr 351 and 353), it is the most expressive, with its delicate surface and the level of detail it shows. The exaggerated features of the face—wide-open eyes, raised and protruding eyebrows, and a wide-open mouth—convey strong emotion. The polychromy, more or less well preserved—only traces of yellowish brown on the hair and blue paint on the eyes are visible—must have emphasized its nature and revealed its identity. Thus this tragic mask, set apart by the *onkos*, or the conventional enlargement of the forehead hidden by a wig, has been identified as the *leukos aner*, one of six types of tragic masks representing an old man, as described by Julius Pollux in his *Onomastikon* (IV.133–42). The short beard, the long, carefully detailed curls, the light colors, and the position of the eyebrows are all characteristic of this type of mask, worn by elderly heroes of tragedy. Originally made of perishable materials, it was reproduced here in terracotta to be placed in a tomb. NM

BIBLIOGRAPHY: Besques 1963, p. 193, pl. 230A; *MTS²*, p. 58, MT 3; Bernabò Brea 1998, pl. 45, fig. 23. Myr 351 and 353 are in Besques 1963, p. 193, pl. 228g–h.

THIS TERRACOTTA MASK is defined by the presence of curls falling on either side of the face, embellished with a crown that is held by a double set of ceremonial ribbons. The almost feminine look of the face is due to the soft shape of the clean-shaven cheeks, evocative of youth.

According to L. Bernabo-Brea's reading of *Onomastikon*, this tragic mask might correspond to the figure of the *apalos*, "the delicate": a very young man, much like the Chrysippus of the Euripides tragedy of the same name, or Paris in his *Alexander*. VJ

BIBLIOGRAPHY: Besques 1972, p. 87, D 510, pl. 111d; Bernabò Brea 1998, p. 59, fig. 65; Summerer 1999, pp. 74, 155, 156, 185, cat. MII13, pl. 53; Rodá de Llanza and Musso 2003, exh. cat., p. 99.

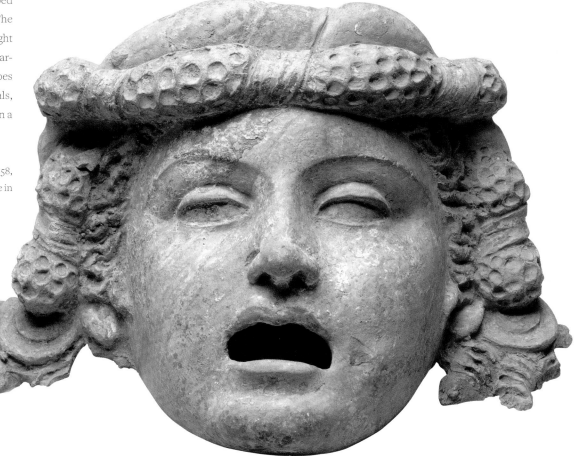

PLATE 39 | 85

THE SATYR PLAY

FRANÇOIS LISSARRAGUE

THE SATYR PLAY—*TO SATURIKON*—is a very specific kind of performance, rather unfamiliar to us and not as well preserved by the classical tradition as comedy and tragedy. This kind of representation takes its name from the fact that the chorus is always made of satyrs, the companions of Dionysos, characterized by their horse's ears and tails as well as by their obscenity. It is thought that the genre arose out of Athenians' concern that the representations during the Great Dionysia did not have enough to do with Dionysos and that some sort of Dionysiac dimension should be installed in the festival. Most satyr plays have been lost and are known only by title or from short quotations. There is one about the invention of writing; another has satyrs becoming athletes—a very funny concept to the ancient Greeks, given the aesthetic perfection of the athletic body to which most of the audience would have aspired.

A satyr play always follows the tragic trilogy and is also composed by the tragedian. We are told that Aeschylus was the best satyr-play writer of his time, but only a few fragments of his work in that genre have reached us. The presence of satyrs as a chorus turns the tragic background into a kind of comic performance. But satyr play is distinct from comedy; the main characters are serious, taken from the heroic past, and there is no interaction between actors onstage and the audience. The theatrical convention of dramatic illusion established by the foregoing trilogy is maintained.

We have only one complete satyr play, Euripides' *Cyclops*, inspired by the story in Homer's *Odyssey* (plate 43). The main characters—Odysseus, Silenos, and Polyphemos—are serious characters. The humor comes from the chorus. The satyrs are supposed to be the slaves of the Cyclops, a terrible man-eating, one-eyed monster who lives in isolation near Mount Etna. The Cyclops does not eat the satyrs because they are not comestible; they would move too much in his stomach. When Odysseus arrives near the cave where the Cyclops lives, looking for food and water, he brings some wine in exchange. The satyrs become very excited when they smell the drink. As the Cyclops has no experience of table manners or wine, Odysseus can use the ignorance of the giant to intoxicate him and can then blind him as he falls asleep. To the Homeric story Euripides adds the excitement of the satyrs, joking about their greediness and cowardice. He also shows, through the ignorance of the Cyclops, appropriate and inappropriate drinking of wine. In a way, the fiction in the play is to show what happens to those who do not know how to drink, and in the process the invention of table manners becomes a scene in the play. Like *Cyclops*, many satyr plays seem to tell mythological stories of an earlier world before the invention of culture.

Sophocles' *Ichneutai* (*The Trackers*) (plate 40), another satyr play of which a substantial portion has survived, is based on the mythological story of the baby Hermes stealing the bulls of his brother Apollo. As in the Homeric hymn, Hermes kills the cattle, thereby inventing sacrifice. To be forgiven he invents the lyre, using a dead tortoise for the soundbox and the guts of the cattle for the strings. In the play we see the satyrs, like dogs, searching for the cattle and listening in astonishment to the lyre for the first time, as if music had never before existed.

40

Manuscript Fragment from Sophocles' *Ichneutai*

Late 2nd century
Found at Oxyrhynchus (el-Bahnasa), Egypt,
in 1906–7 during an excavation campaign led by
Bernard Grenfell and Arthur Hunt
Papyrus
H: 18.4 cm (7¼ in.)
Presented by the Egypt Exploration Society, 1914
London, British Library Papyrus 2068

COPIED TOWARD THE END of the second century, this manuscript contains one of the best-preserved ancient Greek satyr plays, second only to Euripides' *Cyclops*. Only the first half of *Ichneutai* (*The Trackers*) has survived, with large portions of seventeen columns preserved, totaling nearly 450 lines.

Sophocles (ca. 496–406 B.C.) intended the play to be performed after a set of three tragedies, as a humorous conclusion to the tragic-trilogy competition at the Great Dionysia. *Ichneutai* tells the story of the search for Apollo's stolen cattle by a group of satyrs led by Silenos. During the play, young Hermes is revealed to be the thief. The original ending, now missing, probably concluded with Hermes giving Apollo his wonderful invention, the lyre, which became the main instrument associated with Apollo.

The frame displayed here contains the remains of fifty-two lines (lines 297–348) in two columns. These include an exchange between the nymph Kyllene (Hermes' nurse) and the chorus of searching satyrs who, terrified by a mysterious noise, had begun to shout and stamp their feet. Kyllene, who objects to their undignified behavior, explains that the noise is the sound of a lyre made by Hermes from tortoiseshell and cowhide. This detail provides the search party with a vital clue, since they suspect that the hide once belonged to one of Apollo's cattle.

The original scribe copied the text with firm, precise oval and slightly inclined letters. The same scribe also added signs marking paragraphs and the underlying poetic rhythm. Choral odes are distinguished from lines of iambic verse by indentations. Every hundredth line is counted, probably to determine the calculation of the scribe's payment. Later, another scribe added punctuation and corrected various readings. The fifth-century B.C. play was adapted by Tony Harrison as *The Trackers of Oxyrhynchus* in 1988 and is the only satyr play to have been produced both at Delphi and at the National Theatre in London. JG

BIBLIOGRAPHY: Hunt 1912, pp. 30–86, pl. II (cols. 4 and 5, P.Oxy. 1174); Hunt 1927, pp. 72–73 (six small fragments later identified as being part of British Library Papyrus 2068, P.Oxy. 2081a); Milne 1927, pp. 49–50 (no. 2068, P.Lond. Lit. 67); Lloyd-Jones 1996; Harrison 1990; Mertens-Pack 3 Online Database.

fr. 33

PLATE 40 | 89

41

Statue of an Actor
Costumed as Papposilenos

2nd century

Roman; found in 1957 on the beach of
Torre Astura near a Roman villa

White marble

H: 94 cm (37 in.)

Rome, Palazzo Massimo alle Terme,
Museo Nazionale Romano 135769

THE STATUE DEPICTS AN ACTOR disguised as
Papposilenos, the oldest member of the band of satyrs
that raised the young Dionysos. The Papposilenos
served as the *koryphaios* (chorus leader) in the satyr
play because in a sense he was the least unbridled
and vulgar. To some extent he mitigated the obscen-
ity and crudity of the other players as he paraphrased
the heroic themes proper to tragedy.

 The distinctive hairy costume of the
Papposilenos covers the entire body like a fleece: it
consists of a short tunic with sleeves, characterized by
the dense curls of the wool, and a pair of leggings with
tufts of goat's hair covering the legs. Over the costume
he wears a *chlamys* that hangs from the left shoulder,
draping the arm and the hip, and is fastened around
the waist, emphasizing the padded belly.

 The helmet-shaped mask is bald except
for a curl on the forehead; the ears are pointed, and
the face has exaggerated features. The eyebrows
are dense and knitted together, the eyes are staring,
the mask has a snub nose, and the dense mustache
and beard are arranged in a shell around the orifice
of the mouth.

 Both the costume and the mask are imme-
diately suggestive of the character of Papposilenos,
yet a number of details clearly show the intention of

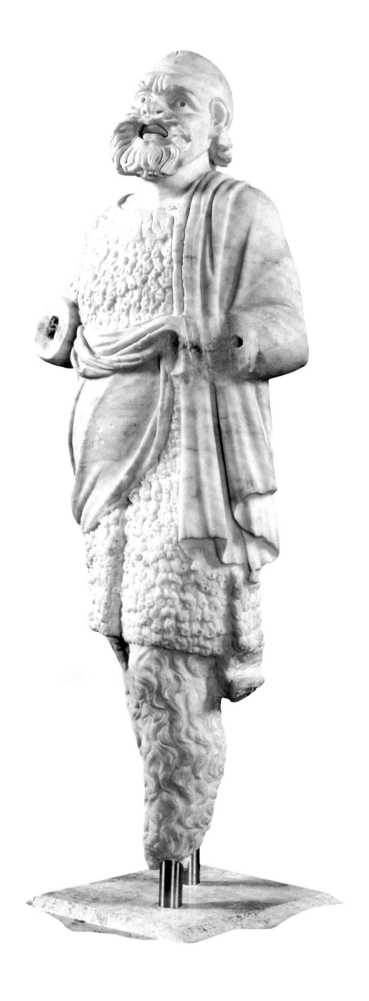

portraying not so much the old Silenos as the actor wearing the Silenos mask and costume, caught in the act of performing, in the typical stance of the orator. A number of details, such as the hair on the nape of the neck, the lips, the teeth, and the eyes behind the perforations of the mask's pupils show that masks have lost their original fixity to allow actors to render a more expressive performance, though without losing their effect on the audience. Indeed, the actor captures attention with the movement of mouth and eyes that "seem to send flames through the mask as he performs," as Cicero described it (*De oratore*, 2.193). MR

BIBLIOGRAPHY: Iacopi 1958, pp. 98–106; Museo Nazionale Romano 1979, pt. 1, no. 108, pp. 156–58; Paris 1990, exh. cat., no. 14; Nicola 2007, exh. cat., p. 75.

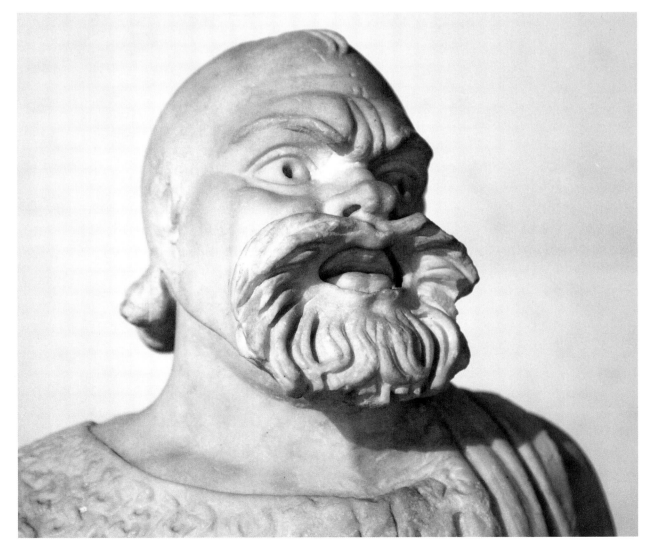

DETAIL, PLATE 41

PLATE 41 | **91**

42

Figurine of an Actor Costumed as Papposilenos

200–100 B.C.

From Myrina, Turkey

Terracotta

H: 18.5 cm (7¼ in.); L: 8.4 cm (3¼ in.);

D: 7 cm (2¾ in.)

Paris, Musée du Louvre Myr 670 (MNC 526)

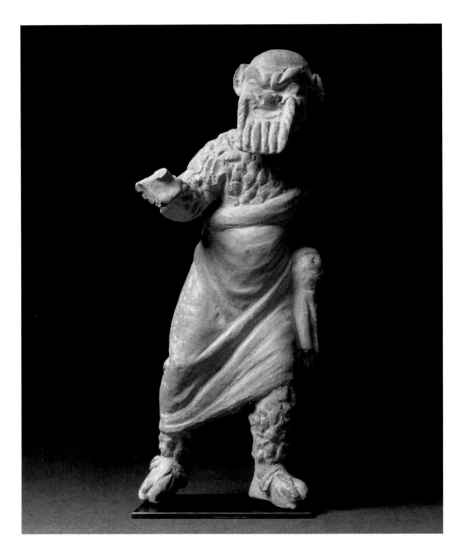

THE COSTUME AND MASK of this terracotta actor figurine identify him as Papposilenos, or old Silenos, an emblematic character in satyr plays. The animality of this hybrid being from the world of Dionysos is seen in his excessive hairiness and his pointed ears. That this character belonged to the realm of the theater is obvious primarily from the presence of *kothornoi*, boots with thick soles that enabled the actor to be seen from a distance; from the mask that, while covering the head entirely, has perfectly visible edges; and, finally, from the fact that the figure is wearing a costume. This is made up of a bodysuit, also called a *chiton chortaios*, with hems that are visible at the wrists and ankles; the bodysuit is embellished here with elements in relief, which ancient sources describe as hay intended to imitate fur. By the fourth century B.C. the Papposilenos figure, the eldest member of a satyr chorus, had evolved to include a bald head and animal ears, a pug nose, a fat body, and a portly stomach; he was known for his ugliness and his jovial nature.

In satyr plays, beginning at the end of the sixth century B.C. and staged in idyllic sets representing the country or the woods, satyrs took on the roles of mythical heroes battling terrible monsters. As Euripides' *Cyclops* or Sophocles' *Trackers* shows us, "tragedy that amuses" (Demetrius, *On Style*, 169) blends the heroic and the comic. The presence of the Papposilenos figurine in tombs in Myrina in the second century B.C. attests to the lasting popularity of that familiar figure. NM

BIBLIOGRAPHY: Winter 1903, no. 4, pl. 397; Besques 1963, p. 142, pl. 172C; *MTS²*, pp. 17, 58, MT 4.

43

**Companions of Odysseus Preparing
a Tree in Order to Blind Polyphemos,
with Satyrs Dancing** (side A)
Four Draped Youths (side B)

Red-figured calyx krater, 420–410 B.C.
Attributed to the Cyclops Painter
From Lucania, South Italy
H: 47 cm (18½ in.); Diam (rim): 45.5 cm (17¹⁵⁄₁₆ in.)
London, The British Museum 1947,0714.18

THE GIANT CYCLOPS POLYPHEMOS lies on the
ground with one arm thrown over his head, lost in
drunken sleep. He has a single large open eye in the
center of his forehead and two sleeping normal eyes.
The wine cup that has brought about his condition
sits on the ground to the right. Odysseus stands above
him, recognizable by his characteristic *pilos*. He turns
to the left to direct the operations of three of his men,
working to uproot the tree that they will make into a
stake to blind Polyphemos. At the far left, two youths
bearing torches approach. They are balanced at the
far right by two satyrs, horse-tailed and snub-nosed,
who dance toward the central scene.

 While fragments of many satyr plays
exist, only Euripides' *Cyclops* (of unknown date)
has survived in its entirety. In satyr plays, the pres-
ence of satyrs is used to convolute the traditional
narrative, here Homeric epic: the satyr chorus are
slaves to Polyphemos. Although they are afraid to
help Odysseus with the physical act of blinding their
master, they know an Orphic charm that will do the
trick, and once he is blinded they distract the Cyclops
while Odysseus and his men escape (lines 700–793).

Although they are depicted as mythological satyrs
rather than men costumed as satyrs, here their dance
and focused gaze on Polyphemos—in the company of
Odysseus with his men pulling down the tree—calls
specific attention to the text and to the choral dance
of satyrs in performance and in iconography. MLH

———

BIBLIOGRAPHY: *LCS*, p. 27, no. 85, pl. 8; *IGD*, II,11; Green
and Handley 1995, p. 29, fig. 10; Krumeich, Pechstein, and
Seidensticker 1999, pp. 431–41, pl. 26b; Seidensticker 2003,
p. 110, fig. 5.8; Woodford 2003, pp. 113–14, fig. 81; Carpenter
2005, pp. 219–20, 227; Hedreen 2007, pp. 182–83.

PLATE 43 | 93

44

Dionysos and the Cast of a Satyr Play
(side A)
Dionysos with Satyrs and Maenads in
Thiasos (side B)

Red-figured volute krater, ca. 400 B.C.
Attributed to the Pronomos Painter
Greek (Attic); found in Ruvo di Puglia in 1835
H: 75 cm (29½ in.); Diam (rim): 33.5 cm (13¼ in.)
Ficco and Cervone Purchase
Naples, Museo Archeologico Nazionale
H 3240 (81673)

THE SO-CALLED PRONOMOS VASE was discovered in a tomb in Ruvo di Puglia, southern Italy, in 1835. It owes its name to an inscription accompanying one of the figures, the *aulos* player seated in the lower register on the front of the vase. Known by historical inscriptions as a famous Theban artist as well as a musician, the Pronomos Painter has received special attention in the archaeological literature, but there are many other names on this vase.

The Pronomos vase offers an extraordinarily rich vision of theatrical practice and shows many remarkable details of masks, dress, and theater production. The vase itself is not very big for a krater, but it bears a great number of figures (thirty in all) and provides a complex vision of the Dionysian festival.

There is no interruption of the picture under the handles between the two sides of the pot, and the two scenes, although different, should be read in continuity. On the main side (A) we see a theatrical troupe: three actors, a dozen choreutai, two musicians, and the poet, as well as the god Dionysos himself reclining on a couch next to a woman, probably Ariadne, with Himeros (Desire) next to her. On the other side of the vase (side B, page 95), the young god is walking as if in a *komos* among four satyrs and three maenads, as well as a

SIDE A

little flying Eros. Two levels of representation are thus connected: the mythic *thiasos* of Dionysos on the back of the vase and the god's theatrical personnel on the main side. Surprisingly, the characters' names, except that of Herakles, are not inscribed, so identifying the play or its subject is impossible. The presence of Athens's favorite hero, however, suggests that it may have been a play concerning one of his adventures. Almost all the choreutai have

inscribed names; these are their citizen names, not their names in the play.

Although these actors have completed an entire tetralogy, the painter is not interested in representing the play as much as he is in depicting the cast, and they are not shown acting. They hold their masks in their hands and seem to be waiting or resting. The only "active" choreut is the satyr dancing next to the *aulos* player, Pronomos (see side A). The

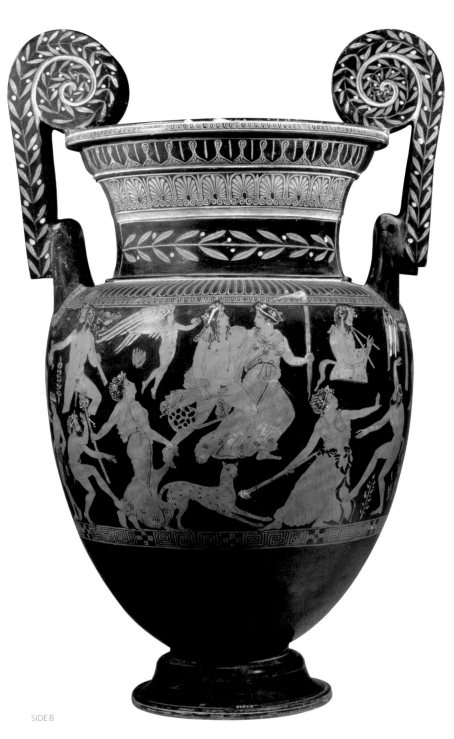

SIDE B

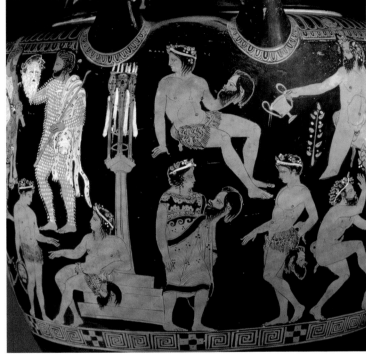

DETAIL, SIDE A/B, HANDLE AREA

satyr bears his mask and dances; his foot is overlapping the decorative band on the ground line as if he were jumping out of the picture. The very vivid effect provides a sharp contrast between the satyr and all the choreutai, whose disguise is clearly shown.

The viewer is invited into the ritual performance at the end of the festival, when the troupe is thanking Dionysos and celebrating its victory. Two tripods next to the handles of the vase indicate that this is a victorious dedication; the one on the right side is placed high on a column, which is itself placed on a base. Moreover, Dionysos himself is present among the chorus as if accepting his tribute. The picture makes visible the presence of the invisible god, and it plays on different levels of reality: actual citizens, named, with their masks in hand, and a dancing one, almost transformed into a real satyr, jumping out of the frame. At the right of the image, a young choreut is holding his mask behind his back; the mask is turned toward the other side of the vase, looking at the satyrs dancing in the *thiasos* (see detail). Step-by-step, the image shifts from the theatrical illusion to the pictorial evocation of Dionysos and his world. FL, ML

BIBLIOGRAPHY: Bieber 1961, p. 10, figs. 31-32; Arias, Hirmer, and Shefton 1962, pp. 377–80 (with bibliog.), pls. 218, 219; *ARV*², p. 1336, no. 1; *Para*², p. 480; *IGD*, II,1; *BAdd*², pp. 365-66 (with refs.); Boardman 1989, pp. 167–68, fig. 323; *LIMC* v (1990), s.v. Herakles, p. 157, no. 3240; Csapo and Slater 1994, pp. 69-70, pl. 8; Green 1994, pp. 84-85, pls. 2.19, 3.25; Green and Handley 1995, pp. 22–23 (fig. 5), 111–12; Krumeich, Pechstein, and Seidensticker 1999, pp. 53–56, 562–65, pls. 8, 9; Lissarrague 2001, pp. 216–20, figs. 177–179; Small 2003, pp. 61, 76, figs. 34, 35; Kaltsas 2004, exh. cat., pp. 284–86; Carpenter 2005, pp. 222–26, fig. 5; Montanaro 2007, pp. 511–13; Taplin 2007, pp. 30–32, fig. 12; Taplin and Wyles 2010 (with bibliog.).

PLATE 44 | 95

45

Gods and Pandora; Actors as Pans with an Aulete (side A)
Dancing Girls with an Aulete; Family of Satyrs (side B)

Red-figured calyx krater, 475–450 B.C.
Attributed to the Niobid Painter
Greek (Attic); from Altamura
H: 49.5 cm (19½ in.); Diam: 59.6 cm (23½ in.)
London, The British Museum 1856,1213.1 (E467)

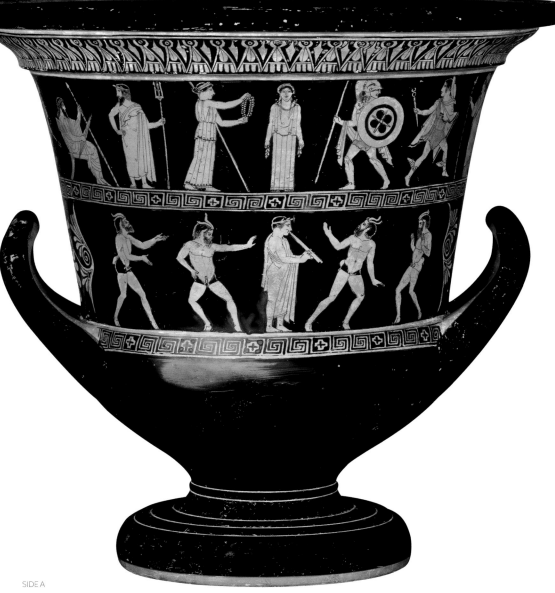

SIDE A

THE KRATER IS DECORATED with scenes on two levels on both sides.

On the upper level of side A, Pandora, the first woman to be created, stands stiffly in the center of the scene, facing front, her arms by her sides, solemnly awaiting animation. To her left, Athena approaches, a spear resting on her shoulder; she extends a wreath toward Pandora. Farther left, Poseidon stands with his upright trident in his hand. At the far left, Zeus is seated, holding his thunderbolt and scepter, supervising the activities, while Iris stands behind him. To the right of Pandora, Ares, helmeted, carrying spear and shield, strides toward Pandora; farther right, Hermes rushes away. Hera stands at the far right. Hesiod (*Works and Days* 59–105) first told the misogynist story of Pandora. A poisoned gift from the gods, sent as punishment for Prometheus's theft of fire, Pandora unleashed all sorts of evils among men.

On the lower level of side A, four men wearing hairy black trunks and masks with goat's horns dance on either side of a wreathed *aulos* player draped in a large himation. The men's costume is typical of the kind used to transform the human members of a chorus into mythical hybrids. Usually in a satyr play the members of the chorus are represented as satyrs with horse's ears and tails. Here we notice an unexpected variant: these chorus members

have goat's horns and feet that make them look more like Pans than satyrs.

On the upper level of side B, an *aulos* player stands in the center wearing a long-sleeved, elaborate theatrical robe. He faces right as three girls dance toward him from the right. To the left are two more dancing girls, a standing himation-draped man, and a third girl.

On the lower level of side B, a family of satyrs, lacking any theatrical disguise, cavorts around a central standing maenad holding a *thyrsos*. She is presented as the "wife" of the satyr on the left, who is clothed in a himation and looks like an ordinary citizen; only his long ears betray the satyr under the

cloak. Between them stands a nude child satyr holding a hoop. At the right, two satyrs carrying companions piggyback approach the center and wait for the "father" to throw them a ball.

The two scenes on the lower level, the chorus of Pans and the satyr family, do not directly illustrate theatrical practice; we have no literary evidence for Pan choruses, and this variant seems to be an invention of the painter. The playful family of satyrs is also an invention of Attic vase-painters, who, from about 450 B.C. on, depicted satyrs looking like citizens but still behaving like children. These two scenes testify to the fact that vase-painting did not merely illustrate what was happening in the theater but explored

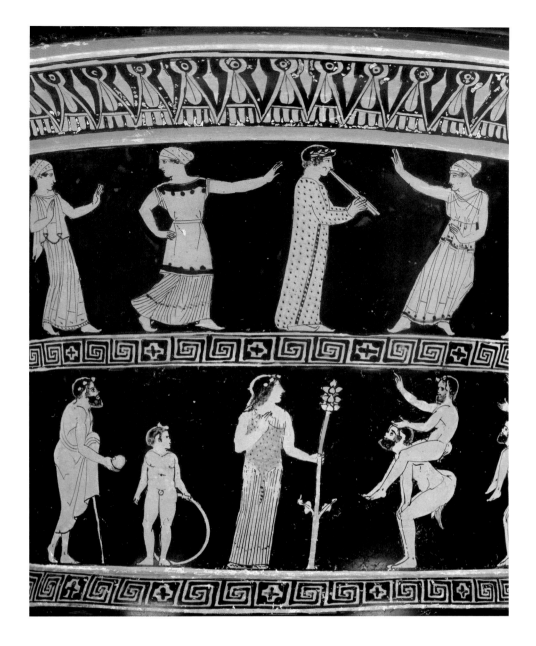

DETAIL (LEFT), SIDE B
DETAIL (BELOW), SIDE A, LOWER PANEL

in its own way the possibilities afforded by this imaginary world where humanity was still touched by some strange animal dimension. It created a specific vision of the Dionysiac world, a very fanciful one, in pictures as well as onstage. FL

BIBLIOGRAPHY: Bieber 1961, fig. 16; *ARV²*, p. 601, no. 23; *DFA²*, fig. 42; Para2, p. 395, no. 23; *LIMC* I (1981), pl. 643, Anesidora 2; *LIMC* II (1984), pl. 367, Ares 87; *DTC²*, pl. 15A; *LIMC* III (1986), pl. 475, Dioskouroi 219; *BAdd²*, p. 266; Boardman 1989, fig. 5; Prange 1989, p. 187, no. 31; Green and Handley 1995, pp. 19–20, fig. 4; Krumeich, Pechstein, and Seidensticker 1999, pp. 379, 669.

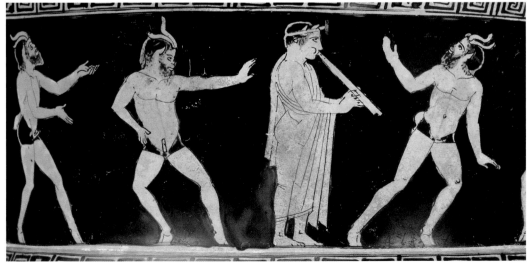

PLATE 45 | 97

46

Satyr Chorus Dancing before an Aulete
Red-figured kalpis, 480–460 B.C.
Attributed to the Leningrad Painter
Attic (Greek)
H: 32.5 cm (12¹³⁄₁₆ in.); Diam: 26.5 cm (10⁷⁄₁₆ in.)
Boston, Museum of Fine Arts 03.788

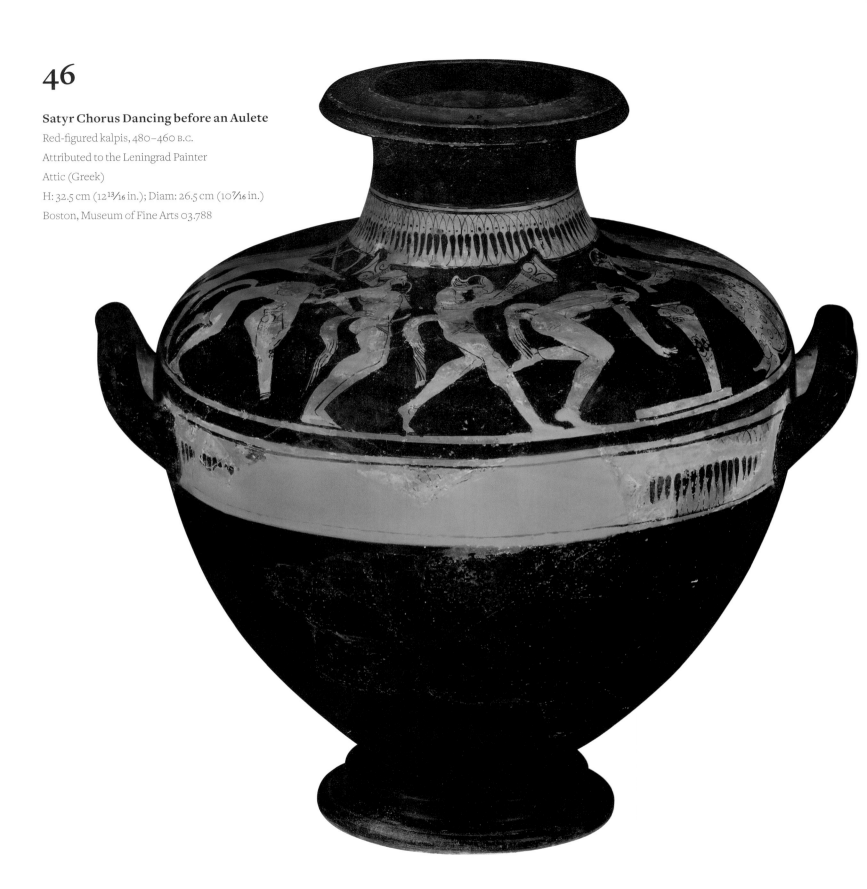

ON THE SHOULDER OF THIS KALPIS, five members of a satyr chorus dance toward two musicians. The chorusmen wear identical full-head masks of satyrs with large ears, *perizoma* (shorts) with attached *phalloi*, and long, bushy horse's tails. Through depiction of choreographed poses of stepping, bending, crouching, and kicking, the vase-painter represents the vivid appearance of a satyr dance. Whereas human choruses typically danced in synchrony, with identical movements, satyr choruses seem to have been characterized by individual variations, though the group moved as a unit. Here, despite the different pose of each dancer, the chorus is united in its task. As the chorusmen dance, they each carry part of a single piece of furniture, probably the legs and crossbars of a symposion couch or a throne (see detail, above right), either of which would be appropriate for the use of Dionysos. The satyr on the far left holds structural crossbars, while each of the other four satyrs carries an elaborately carved leg topped by an Ionic capital. The satyr on the far right sets his leg down in front of a piper, whose elaborate robes billow as he taps his foot (see detail, opposite). Behind him stands a simply clad young man with wide eyes and puffed-out cheeks. Partially surviving relief lines around his mouth may once have indicated the mouthpiece of an instrument; the surface of the vase is too damaged to tell more than that. MLH

BIBLIOGRAPHY: Bieber 1961, pp. 6–7, fig. 15; *ARV*², p. 571, no. 75; *DFA*², fig. 40; Caskey and Beazley 1963, pp. 51–52, no. 151 (with bibliog.), pl. 86.2; Robsjohn-Gibbings and Pullin 1963, p. 34; *MTS*², pp. 46 (AV 14), 145; *Para*², p. 390, no. 75; Boardman 1978, pp. 180 (fig. 325), 223, 234; Hedreen 1992, pp. 108, 112; *LIMC* VIII (1997), s.v. Silenoi, p. 1124, no. 153, pl. 770; Miller 1997, pp. 161–63, n. 68; Seidensticker 2003, pp. 115–16, fig. 5.9; Krumeich 2004, pp. 166–68, pl. 23; Carpenter 2005, pp. 222–23.

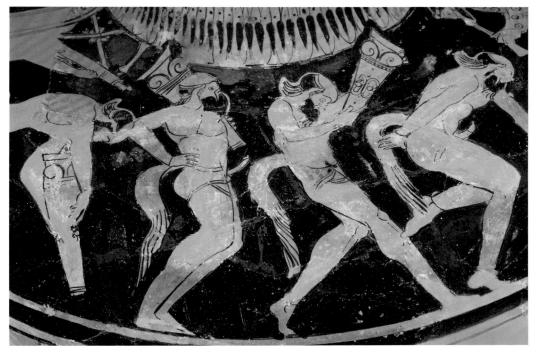

DETAIL, SIDE A

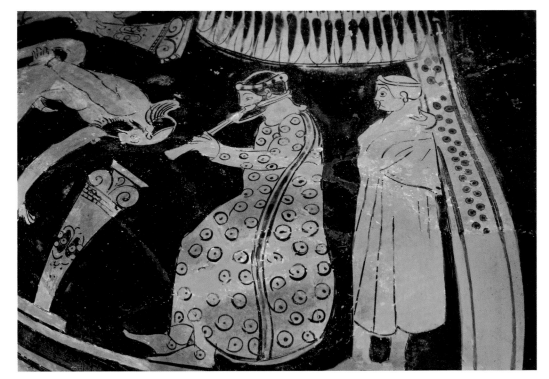

DETAIL, SIDE A/B, HANDLE AREA

PLATE 46 | 99

47

Dionysos with a Satyr (side A)
Satyr Chorusman with a Sword (side B)
Red-figured pelike, 480–470 B.C.
Attributed to the Geras Painter
Greek (Attic)
H: 34 cm (13⅜ in.); Diam (body): 25.6 cm (10⅛ in.);
Diam (rim): 16.2 cm (6⅜ in.)
Boston, Museum of Fine Arts 64.2032

THE PRIMARY SIDE OF THIS PELIKE shows Dionysos attended by a satyr with a himation tied around his waist and wearing a *petasos*. He holds what is probably a cluster of grapes in his left hand and an oinochoe (wine pitcher) in his right.

Side B shows the unframed single figure of a choreut wearing a satyr mask and *perizoma* with an erect *phallos* attached. He faces right in a shallow squatting position, holding out a sword in his right hand and a scabbard in his left. Beazley's suggestion that the sword may have been stolen from Herakles is appealing; such a plot seems characteristic for a satyr play. The unusual but deliberate posture accented by weapons may otherwise indicate a Gigantomachy or a parody of a pyrrhic (armed) dance performed on the occasion of the Panathenaia. That the satyr chorus engaged in military dances is corroborated by other vases and fragments (where they may wear the shorts or not), among them a calyx krater probably by the Phiale Painter (Princeton 1997-68, formerly in the Vermeule collection) and a group of fragments attributed to the Eucharides Painter in the collection of the J. Paul Getty Museum (86.AE.190.1-6 and 86.AE.575). MLH

BIBLIOGRAPHY: *ARV²*, p. 285, no. 2; Berard 1966, pp. 93–94; Vermeule 1968, pp. 49-67; *Para²*, p. 355, no. 2; Buitron 1972, pp. 132–33, no. 73; Padgett 1989, pp. 8–9, 16n23, 17, 27–28 (G.2), 59, 68, 76, 84, 94, 130–31, figs. 6, 7; Boardman 1975, p. 113, fig. 179; Hedreen 1992, pp. 109–11, 119n27; *CVA* J. Paul Getty Museum, fasc. 7, no. 2, pl. 330.

48

Satyr Chorus

Fragment of a red-figured bell krater, 450–440 B.C.

Attributed to the Painter of the Woolly Satyrs

Greek (Attic); found in Taranto, South Italy

H: 9.2 cm (3⅝ in.); W: 10 cm (3¹⁵⁄₁₆ in.)

Paris, Musée du Louvre MNB 2774

ON THIS FRAGMENT of an Attic red-figured krater by the Painter of the Woolly Satyrs there remain only three partial but identifiable figures participating in a scene whose composition must have been very ambitious: the representation of a satyr play. The satyr play presents a chorus of satyrs, naked and ithyphallic, led by an old satyr, Papposilenos. On the fragment, two actors costumed as satyrs wearing false *phalloi* are dancing an expressive dance. The one in the middle, half-bald and wearing a mask, is standing front forward, his head in profile, a leg and an arm raised in the traditional pose of the komast, or the satyr under the influence of drink. One may note the painter's firm hand in defining the musculature, and the attention he paid to the figures caught in fluid and expressive motion. The Painter of the Woolly Satyrs owes his name to his depiction of particularly hairy satyrs on a bell krater in Syracuse (no. 23508, *ARV²* 613, no. 6) portraying a Dionysian *thiasos*. A follower of the Niobid Painter, he excelled in the decoration of large vases (kraters, pelikes, hydriai) while integrating the graphic innovations of his master and borrowing his choice of themes and majestic figural movement. SM

BIBLIOGRAPHY: *ARV²*, p. 614, no. 8.

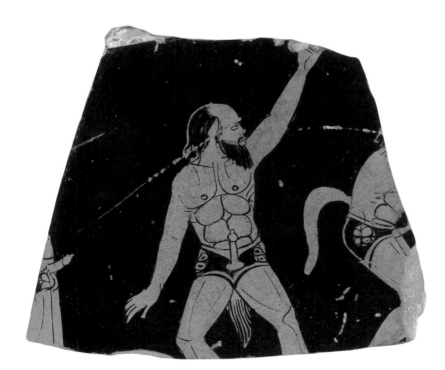

49

Statuette of an Actor Costumed as a Satyr

350–300 B.C.

Western Greek

Bronze

H: 15 cm (5⅞ in.)

Previously Blayds, Pizzati, and Campanari collections

London, The British Museum 1849,0518.33

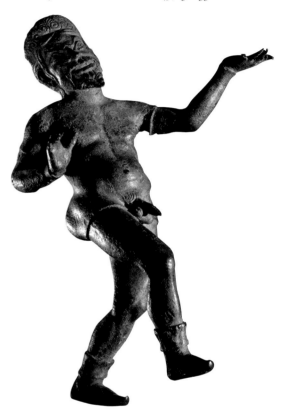

THIS BRONZE FIGURE is in the form of a dancing actor costumed as a satyr from the chorus of a satyr play (as shown in plate 48). He wears a stephane (a head adornment usually reserved for women) incised with palmettes. A *phallos* is attached to his short-sleeved tunic, which is layered over an undergarment, and he wears buskins with the tops turned over (as does the dancing satyr on the reverse of plate 34). The hole in his head suggests that he was attached to something—perhaps a piece of furniture such as a symposion couch—and gives an idea of the dissemination of theater motifs into the decorative arts. MLH

BIBLIOGRAPHY: Walters 1903, 1639.

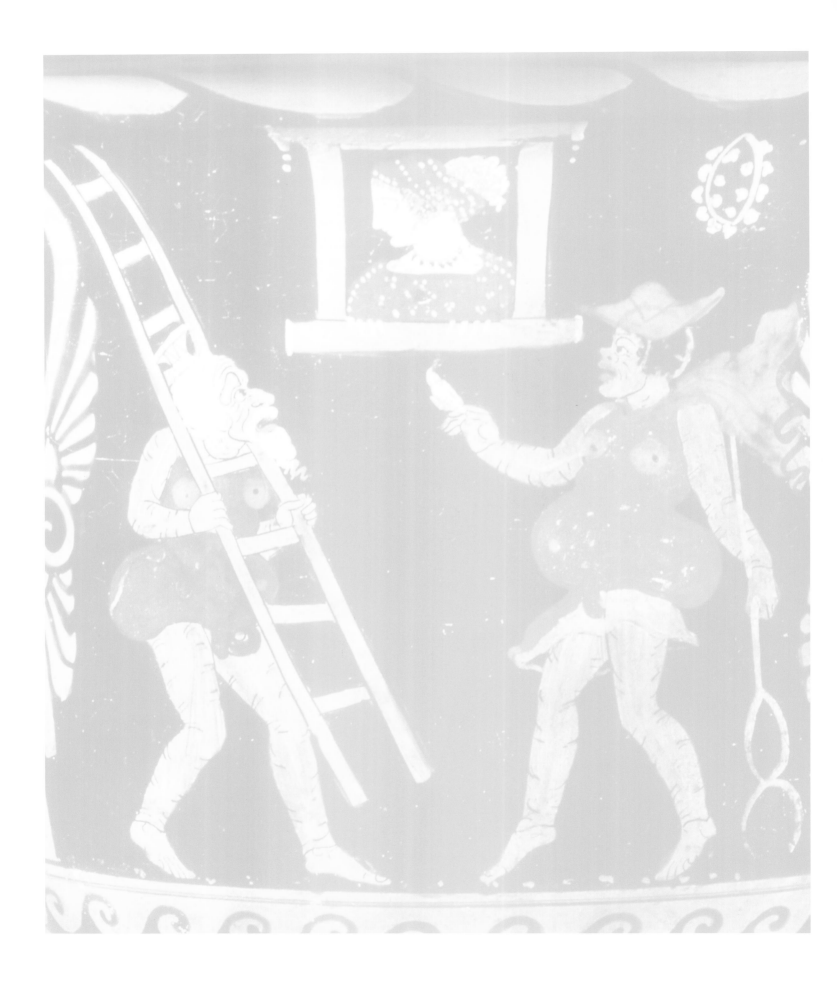

COMEDY

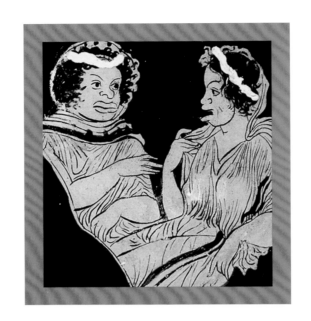

COMEDY VASES FROM MAGNA GRAECIA

MARTINE DENOYELLE

THE LARGE CORPUS OF IMAGES—more than two hundred—portraying comic actors, or *phlyakes*, performing in an often clearly identifiable dramatic context is one of the most interesting aspects of Italiot ceramics. Appearing on objects from all regions, particularly from Apulia and Paestum, these images only rarely have direct antecedents in Attic ceramics.[1] Among the few exceptions, there is a Louvre oinochoe attributed to the Nikias Painter dating from about 410–400 B.C., which features a grotesque Herakles in his chariot pulled by centaurs and preceded by a comic actor in full costume holding torches (plate 52); and a slightly older oinochoe in the Vlasto collection in Athens, on which two men seated at the foot of a stage are watching a grotesque actor disguised as Perseus, who is not, however, wearing the costume characteristic of *phlyax* actors (fig. 3.1).[2] The Athenians' taste for comedy is seen by the number of great authors of comedy—Eupolis, Kratinos, Aristophanes, and Menander among them—as well as by the popularity of the terracotta figurines representing comic figures with masks and costumes; but these subjects do not appear in the repertoire of Attic figured vases, which on the whole do not portray caricature, physical deformities, or the grotesque.

Things were entirely different in southern Italy, where, soon after red-figured vases began to be produced (about 440 B.C.), a parodic, comic, or even farcical tradition encouraged by the freshness of a new figurative language developed, one that was less codified than that of Athenian painters. The term *phlyax*, applied both to the actors and to the plays themselves—and, through a modern extension, to the vases that portray them—is found in the writings of several ancient authors (Athenaeus, Pollux, *The Greek Anthology*): according to them, the term was the one used by the Greeks of Italy to describe their comic theater. It is also found in the epitaph of Rhinthon, a writer of comic plays who was born in Syracuse and lived in Taranto at the end of the fourth century B.C. Rhinthon was famous for his "tragic *phlyakes*" or "hilarotragedies," farces in the Tarentine dialect performed during the Dionysia, which were very effective parodies of the great Athenian tragedies, especially those of Euripides.[3] Although Rhinthon wrote later than the period during which the known series of *phlyax* vases was made—a period stretching from about 420 B.C. to 350 B.C.—his works belong to the same cultural realm. This suggests that the genre had existed in one form or another for a very long time. The meaning of the word *phlyax* itself is not entirely clear:[4] it has been linked to *phlyareo* (to speak rubbish), to *phleo* (swollen, owing to the padded costumes of the actors), and also to *phleos*, a word used to describe Dionysos, whose connection with the theater was particularly close in Magna Graecia.

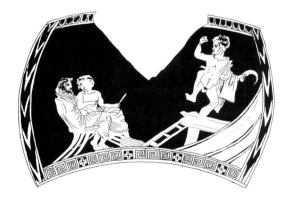

FIGURE 3.1

An Actor Performing as Perseus before a Man and a Youth.
Attic red-figured *chous*, ca. 420 B.C. Name vase of the Group of
the Perseus Dance. Athens, National Museum,
Vlastos Collection. Drawing by E. R. Malyon
after E. Gilliéron. Reproduced from Boardman 1989, fig. 228

PRODUCTION AND POPULARITY

The first *phlyax* scene identified, on a Berlin calyx krater,[5] is attributed to the Amykos Painter or to his workshop and would then have been produced in Metaponto about 420 B.C.: a master is using a stick to beat a slave he is holding by the neck (fig. 3.2). The scene is not specified, but the figures are wearing the classic tight-fitting costume, with a padded posterior and a false *phallos*, as well as the most common mask, that of a bearded old man, the slave slightly balding. Above them is a similar masked head, which is not just a mask hanging freely; rather, given its format and the presence of a gesturing hand, it is probably the head of another slave, this one witnessing the scene. Although the "Lucanian" school subsequently produced only a few examples of *phlyakes* compared with the high output of the Tarentine or Paestan workshops, we should nonetheless emphasize the importance of the Dolon Painter to the introduction of the genre. Fragments of two of his vases from the dumping grounds of the *kerameikos* of Metaponto, skyphoi that date from about 400 B.C.,[6] depict a comic actor. Furthermore, another vase, which is well known and has

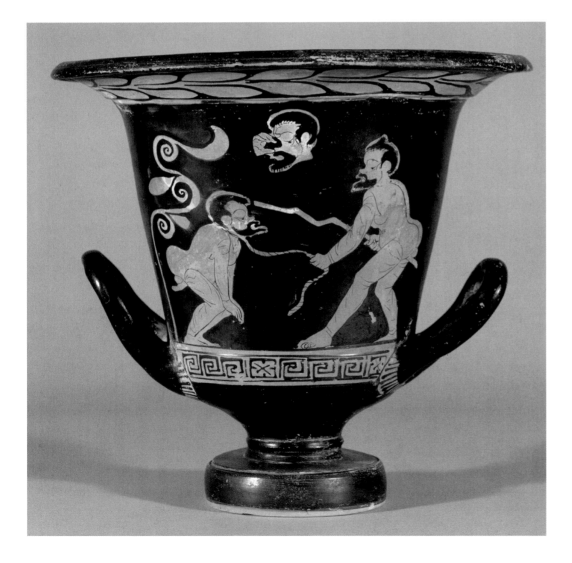

FIGURE 3.2

Phlyax Scene of Master and Slave, attributed to the Amykos Painter or his workshop. Lucanian calyx krater, ca. 420 B.C. Antikensammlung, Staatliche Museen zu Berlin F3043. Photo: Ingrid Geske

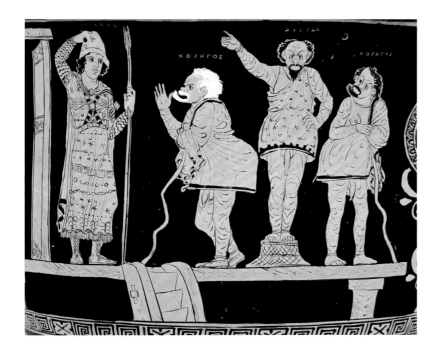

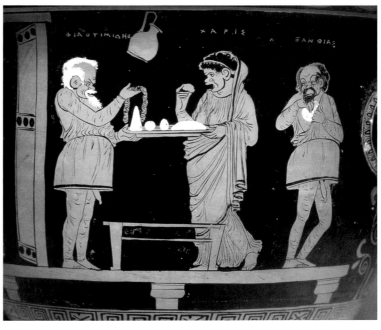

FIGURE 3.3

Phlyax Scene of a Tragic Actor (Aigisthos) Onstage with
Comic Actors (Choregos, Choregos, Pyrrias). Apulian
red-figured bell krater, name vase of the Choregos Painter,
ca. 380 B.C. Photo: Courtesy of the Italian Ministry of Culture,
Department of Antiquities

FIGURE 3.4

Phlyax Scene of a Slave (Xanthias) Stealing Cakes from
His Master (Philotimides) and Mistress (Charis).
Apulian red-figured bell krater attributed to the Choregos
Painter, 400–380 B.C. From Ruvo di Puglia. Milan,
Museo Archaeologico AO.9.285

been attributed up until now to the Tarporley Painter (plate 50), should without a doubt be reattributed to him.[7] In a somewhat disorganized composition with delightful animation that is typical of the painter, a burlesque street scene unfolds with a captive thief, a severe policeman, and a victim standing over a dead goose, around a wooden platform mounted on pillars with scenery depicting the facade of a temple. This is the most ancient example of a stage set that we know of. Through expressive gestures (a distinctive element in the language of *phlyakes*) and inscriptions that transcribe the verbal exchanges between actors (in Attic dialect), the vase—the first in a series—also reveals an experimentation with a direct and very visual art of the moment, of a chosen moment, which immediately distinguishes the comic image from the parallel tragic composition as it appears on Italiot vases.

The first experiments with illustrations of *phlyakes* thus seem to have been made in Metapontum. But at about the same time as the Dolon Painter, act. 400–390 B.C., in Taranto, the Choregos Painter[8] was the first to create elaborately constructed compositions based on a play of allusions, sliding between different theatrical genres and references to Dionysian symbolism: on the bell krater that gives him his name[9] (fig. 3.3), a tragic actor who is playing the role of Aigisthos appears at stage right in the middle of a comic choir. Another, in a Milan collection (fig. 3.4), shows, on one side, two masters, Philotimides and Charis, stuffing themselves with food from a platter while a slave named Xanthias steals a piece of food that he slips inside a gap in his tunic; on the other side, however, the scene is clearly taken from a satyr play, in which Herakles, instead of Atlas, holding up the heavenly vault, finds himself powerless, robbed of his weapons by mischievous satyrs. We may note that beyond the obvious interplay that the painter establishes between the two theatrical genres on the opposite sides, a common theme emerges, that of plunder.[10] A Cleveland bell krater by the same artist develops an identical duality between *phlyax* and Papposilenos, the two sides framing a gigantic bust of Dionysos with an enigmatic expression on his face (plate 3).

In the first half of the fourth century B.C., the Tarentine workshops of the plain style developed a wide range of representations, no doubt both for the use of the inhabitants of the city itself and for that of the indigenous clientele, for whom a large portion of the ceramic production was intended. In the necropolises of Taranto, one primarily finds small vases, oinochoai or lekythoi like those by the Felton Painter and his workshop, decorated with one or two actors or simply with a comic mask;[11] but the world of the Tarentine comic theater was also disseminated on other objects into areas within Apulia, and it is possible that this cultural encounter also played a role in the rise of the creative repertoire.[12] If one examines the distribution sites of *phlyax* vases in other regions of southern Italy, one notes, moreover, that with the exception of Sicily, those vases originate in large part in non-Greek sites: Ruvo di Puglia, Canosa, and Matera in Apulia; Armento in Lucania; Capua and Suessula in Campania; and Buccino, Pontecagnano, and Sant'Agata dei Goti for Paestan vases.

SOURCES OF THE REPERTOIRE: LOCAL FARCE OR ATHENIAN COMEDY?

Regardless of the region where the objects were produced, the themes portrayed on the *phlyax* vases are similar, largely inspired by the comedy of manners and by everyday vaudeville: scenes of theft, dupery, aggression, disputes, gluttony, and the punishment of slaves commonly appear. Some subjects reappear on several vases, such as the scene of the conflict concerning a goose on the calyx krater in the Metropolitan Museum (plate 50), which is portrayed in a simpler version on a Boston Apulian bell krater (plate 51). But there are also many themes taken from mythology, epics (plate 57), or tragic theater, whose characters and subjects are then distorted and mocked. A vase in the British Museum (plate 53), for example, shows Cheiron struggling to climb the steps of a sanctuary, pulled and pushed by slaves, under the watchful eye of Achilles and the nymphs. The story that describes the centaur Cheiron, who sought treatment in a sanctuary of nymphs for a wound he received from a poisoned arrow of Herakles, was known by Pausanias; from the heroic mode, it moves here into the farcical mode through the image of the impotent old man who arrives at the sanctuary to be healed by mineral waters. An interesting detail is the young Achilles, very dignified, wrapped in his himation, who is portrayed as a normal figure, just like Aigisthos on the krater by the Choregos Painter (fig. 3.3) or the little nude figure labeled "Tragoidos" on the calyx krater in the Metropolitan (plate 50), as if they all belonged to a world other than that of the comic play.[13]

The debate among specialists has been lively these past decades in their attempt to identify the sources of this abundant repertoire of images. In opposition to those who uphold the tradition of local farces having been transferred into images are those who maintain that this imagery necessarily came by way of Athenian comic theater and the theater of Old and Middle Comedy. It has even been said that there was no theater, and thus no artistic representation, in certain cities of Magna Graecia, and that therefore the models for images must have come from elsewhere.[14] However, a particularly large number of theater structures have been found in western Greece.[15] Furthermore, as the images themselves often painstakingly show (see plate 55), comedies were performed not in stone theaters but on temporary stages, made from wooden platforms supported by small columns and reached by makeshift stairs, with the space underneath the stage hidden by curtains that perhaps hid production apparatus. Half-open doors or windows allowing the top halves of characters to appear are also sometimes depicted, for example on the Paestan krater by Asteas that portrays Zeus using a ladder to climb up to his lover (plate 58). The vases themselves thus

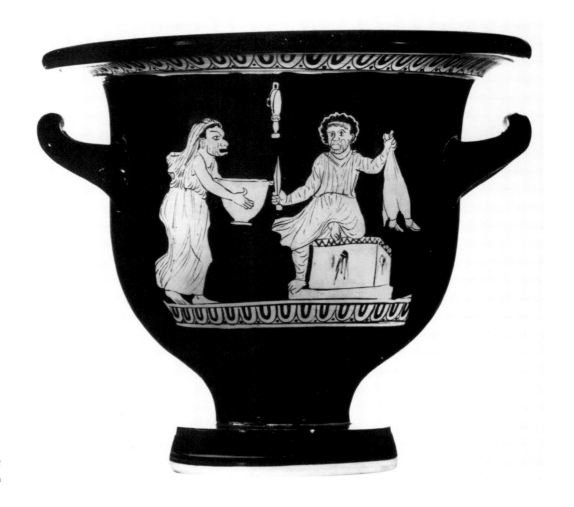

indicate a concrete local practice of comic performances, which accompanied a Magna Graecian literary production extending from Epicharmos in the second half of the fifth century B.C. to Rhinthon at the end of the fourth century.

There is, however, no reason to think that the influence of the Athenian theater, so obvious on Italiot vases in regard to tragedy, does not also constitute one of the important sources for the painted comic repertoire. The most recent interpretations of a Würzburg Apulian bell krater (fig. 3.5) attributed to the Schiller Painter (380–370 B.C.)[16] have even shown how a *phlyax* image that is an obvious parody of Euripides' *Telephos*, performed in 438 B.C. (e.g., plate 27), very specifically refers to a passage from Aristophanes' *Women at the Thesmophoria* (411 B.C.), whose comedic language and gestures it transposes into illustrated form. Half-kneeling on an altar following the figurative schema often employed in Magna Graecia for the supplicant—for the character of Orestes or Telephos, for example—a *phlyax* wearing the form-fitting outfit and a belted tunic is holding a sword in one hand and in the other something that resembles a small wineskin with legs and slippers. A woman hurries with a krater in her hands as if to catch the liquid that is going to come out of it. The scene illustrates the moment in Aristophanes' play when a relative

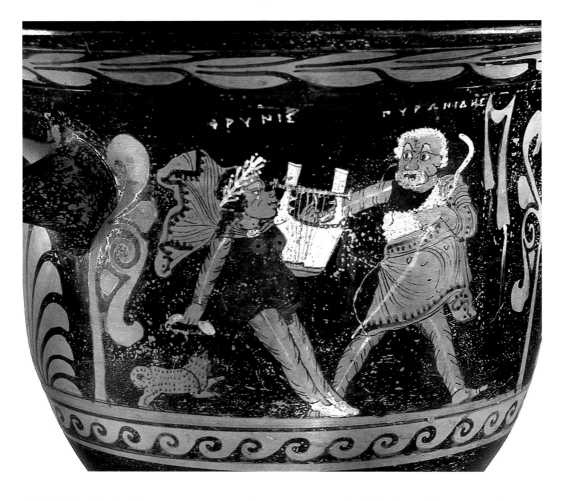

FIGURE 3.6

The Contest of Phrynis of Mytilene and Pyronides of Athens
(detail). Paestan bell krater attributed to Asteas, ca. 350 B.C.
Found at Pontecagnano. Salerno, Museo Provinciale

of Euripides, disguised as a woman to spy on the secret ceremonies of the feasts of Demeter and Kore, is
exposed and ordered to undress in order to confirm that he is a man. Taking refuge on the altar to escape
the women's anger, he threatens to slit the throat of what he has assumed is a child but what is in fact only
a wineskin: "This little girl," he says, "has been transformed into a skin full of wine, and it even has Persian
slippers!" The child's mother, to whom he refuses to surrender her, then asks for a basin so that she can
at least collect the precious blood that is going to pour out. The comic force of the image comes from a
series of layered allusions. Some are visual, like the "noble" schema of the hero taking refuge on the altar;
others play on the oppositions child/wineskin and blood/wine, or on narrative such as the reference to
Aristophanes' play, which itself mocks Euripides' play. The distortion of serious scenes (as in plate 56),
visual antiphrasis, the farcical reworking of dramatic themes or popular figures (Herakles, for example,
whose *phlyax* image abundantly shows gluttony, drunkenness, or stupidity)—these universal tools of the
comic are thus used by the vase-painters within the framework of a theatrical culture that could encom-
pass local productions as well as the great Athenian comic models. The echoes of theatrical discussions
on the poetic or intellectual tendencies of the period are doubtless also present, as on a Paestan krater by
Asteas found in Pontecagnano (fig. 3.6), where the altercation between the young *kithara* player crowned

Phrynis, from Mytilene, and the old Athenian Pyronides, seems to illustrate a "battle of genres" between new and old music, which is perhaps the echo of a passage from *Demoi* by Eupolis, a comic poet rival of Aristophanes.[17]

As was the case for the plays themselves, the goal of these ancient images was above all to amuse, but to do so using the tools that are uniquely available through visual communication: caricature, the distortion of scenes, and the lively, demonstrative, even frenetic gestures of the characters, all of which actually make these images the distant relatives of our cartoon heroes. And beyond the immediate farcical and decorative effect, we must not forget that they also illustrate the rich culture of the societies that produced and used them.

NOTES

1	Trendall 1991, pp. 161–62; Taplin 1993a, pp. 101–4.
2	Group of the Perseus Dance; *ARV*², p. 1215, no. 1; Boardman 1989, fig. 228; Trendall 1991, p. 162; Hughes 2006.
3	Gigante 1988, pp. 275–81.
4	Trendall 1967, p. 9; Trendall 1991, p. 161; Taplin 1993a, p. 49.
5	F 3043; *LCS*, p. 43, no. 212, pl. 16, 5.6.
6	*Phlyax* skyphos 29062(163), *LCS*, supp. 3, D63; and the *phlyax* fragment 29076(89), *LCS*, supp. 3, D51b, from Metapontum.
7	Taplin 1993a; Taplin 2007. On the stylistic ambiguities between the Dolon and Tarporley Painters, see *RVAp*, vol. 1, pp. 53–55; *LCS*, supp. 3, 1983, p. 55.
8	*RVAp*, vol. 2, pp. 7–8. In my opinion, this innovative "painter" was none other than the simple flip side of the Painter of the Birth of Dionysos. His complementary importance in tragic theater can be revealed in his large vases, such as the krater with Alkmene on the pyre, Taplin 2007, p. 171, no. 57.
9	J. Paul Getty Museum 96.AE.29, Taplin 2007, pp. 27–28.
10	Museo Archeologico AO.9.285, Taplin 2007, p. 34.
11	Green 1991, pp. 90–91; Taranto 1991, exh. cat., pp. 65–83.
12	Robinson 2004.
13	See Taplin 1993a, pp. 79–80.
14	Hughes 2003, pp. 282–83 for Paestum, whose vases were inspired by performances given in Sicily; but cf. Bacileri 2001, p. 55ff.
15	Todisco 2002, pp. 138–82.
16	Csapo 1986; Taplin 1993a, pp. 36–40, no. 11.4.
17	Taplin 1993a, no. 16.16; Piqueux 2006; Revermann 2006, pp. 318–19.

50

Phlyax Scene of the Punishment of a Thief
(side A)
Three Youths (side B)

Red-figured calyx krater, ca. 400 B.C.

Traditionally attributed to the Tarporley Painter

From Apulia, South Italy; found in Ruvo di Puglia

H: 30.6 cm (12 in.); Diam: 31.9 cm (12½ in.)

Fletcher Fund, 1924

New York, The Metropolitan Museum of Art

24.97.104

THE _PHLYAX_ MASK hanging in the field, the stage, and three figures wearing actors' attire indicate that a play lies behind this image, which counts among the very earliest theatrical depictions from Magna Graecia. That this presents a later episode from the same play portrayed on the Boston krater (plate 51) is shown by the goose, now dead. Here, the actors utilize both stage and _orchestra_, where the old man at the center is in dire straits. Standing on tiptoe, his arms above his head, he is caught between a younger man wielding a stick and an old lady gesticulating furiously from the stage. She advances from an elaborate doorway, the panels decorated with a satyr and a dancing maenad. To her left is a basket (two baskets yoked, but foreshortened) containing two kids over drapery; beside it lies the dead goose.

At the far left is a fourth figure: a clean-shaven youth, nude except for a bundle of clothing under his arm. He is set apart in space, at a smaller scale; the wavy line under his feet is shorthand for a landscape. He is a bystander whose presence greatly enriches the complexity of the image, for he is not only part of the image of the drama but, like the symposiasts who would have used this krater, also a spectator. He thus provides a link for the three youths on the reverse of the vase, who are shown passing the time in conversation.

Most unusually, quotations from the play (in iambic) are inscribed. The dialect is Attic; the play was therefore Old Comedy. The old woman says, "I shall hand [him, or the evidence] over." The old man chimes in, "He has bound my hands above." Since no rope to bind his hands is indicated, it may be that he is under a spell. The other two inscriptions present greater difficulties. One, clearly spoken by the stick-wielder, "Noraretteblo," might be the gibberish of a foreigner or the binding spell. If read retrograde, like the other quotations from the play, however, it can be construed as "Lift the basket." Above his head is the word _tragoidos_, here probably meaning "tragic actor" rather than "tragic poet" or "member of a tragic chorus." JMPG

BIBLIOGRAPHY: Beazley 1952, pp. 193–95; Webster 1954, pp. 260–61; Bieber 1961, p. 140 (fig. 512); Cambitoglou and Trendall 1961, pp. 31–32, 34, no. 20; Trendall 1967, pp. 53–54, no. 84; Gigante 1971, pp. 71–73; Trendall 1974, pp. 19, 51 (no. B), 122, pl. 28b; _DFA_², pp. 216–17, fig. 105; _IGD_, IV,13; _MMC_³, p. 65; Cambitoglou 1979b, p. 49; _RVAp_, vol. 1, p. 46, no. 7; Mayo and Hamma 1982, exh. cat., pp. 82–83, no. 13 (with bibliog.); _RVAp_ supp. 1, p. 5; _RVAp_ supp. 2, p. 11; Pugliese Caratelli 1983, fig. 699; Dumont 1984, pls. 34–35; Dearden 1988, p. 35; _RVSIS_, fig. 105; Söldner 1993, p. 271; Taplin 1993a, pp. 20, 30–32, pl. 10.2; Taplin 1993b, pp. 532–33, 540, fig. 1; Csapo and Slater 1994, pp. 66–67, pl. 6a; Pöhlmann 1997, p. 6; Schmidt (M.) 1998, pp. 23–28, pl. 5.2; Colvin 2000, pp. 294 (fig. 7), 295; Foley 2000, pp. 281, 283 (fig. 11.3), 292, 293, 304; Hall 2000, p. 412; Wilkins 2000, pp. 336–37; Green 2001, p. 62, no. 7; Marshall 2001; Taplin 2004, p. 21, fig. 5; Hall 2006, p. 227; Marshall 2006, p. 33n74; Revermann 2006, pp. 151–52, 155; Taplin 2007, pp. 1, 13–14 (fig. 5), 27; Carpenter 2007, p. 43, fig. 2; Hall 2007, pp. 5–6; Montanaro 2007, p. 190, no. 324.5; Picón 2007, p. 438, no. 179; Sakellaropoulou 2008, pp. 8, 67, fig. 2; Wiles 2008, p. 377; Sommerstein 2009, pp. 238–39.

51

Phlyax Scene in a Palaistra (side A)
Two Youths (side B)

Red-figured bell krater, 380–370 B.C.
Attributed to a follower of the Tarporley Painter,
comparable to the McDaniel Painter
From Apulia, South Italy; found in Pisticci
H: 28.6 cm (11¼ in.); Diam (rim): 32.9 cm (13 in.);
Diam (foot): 14.4 cm (5¾ in.)
Otis Norcross Fund
Boston, Museum of Fine Arts 69.951

THREE WIDELY SPACED POSTS support a stage on
which two _phlyax_ actors wearing masks and padded
tights converge. At left is a youth, his mask clean-
shaven and with long hair; he toys menacingly with his
stick. Behind him is a herm, strewn with clothes and a
globular aryballos. An old man with thinning hair and
a short beard faces him. He pours oil from a similar
aryballos. Behind him, at right, are two baskets yoked
together. Each contains a kid; additionally, a goose has
been fastened to one by the neck. The goose, perhaps
a pet, was associated with Aphrodite; thus it may have
functioned as a cipher for a romantic plot or sub-
text. The sound of its cry was also compared in New
Comedy to poorly played flutes, which would have
accompanied the play. The baskets' prominent yoke
probably alluded metaphorically to the yokes of mar-
riage and of slavery.

A calyx krater in New York (plate 50) must
reflect a later episode in the same play, following
the goose's demise. The tableau apparently depicts
the punishment of the thief. On the Boston vase, the
prominent herm alludes to the god of thieves, Hermes.
The New York krater is inscribed with quotations from
the play in Attic dialect. On the Boston krater, two
details may have Attic resonances. The generic pur-
suit scene on the reverse shows the pursuer offering a
chous (jug) to his quarry; this shape is associated with
the second day of the Anthesteria, the Athenian spring

festival, when the new wine was opened. The shape of
the aryballoi, furthermore, almost unknown in local
Apulian fabrics, is standard in Attic representations of
athletes cleaning up after exercise. JMPG

———

BIBLIOGRAPHY: Vermeule 1970, pp. 628–29, figs. 103, 104;
Green 1972, p. 14n48; Chamay 1977, p. 58, pl. 14.2; _RVAp_, vol. 1,
p. 100, no. 251; Dearden 1988, pp. 35, 37, pl. 3.2–3; _LIMC_ v
(1990), s.v. Hermes, p. 306, no. 181b; _RVAp_ supp. 2, p. 16;
Dumont 1984, pp. 139–40, 145, pl. 33; Taplin 1993a, pp. 32–34,
41–42, 44, pl. 11.3; Taplin 1993b, p. 533, pl. 2; Padgett et al.
1993, pp. 68–70, no. 13, col. pl. v (with bibliog.); Söldner 1993,
p. 271n114; Cambitoglou and Chamay 1997, p. 291n5; Schmidt
(M.) 1998, pp. 24–25, 27–28, pl. 5.1; Marshall 2001; Hughes
2008, p. 23.

PLATE 51 | 113

52

Phlyax Parody of the Apotheosis of Herakles

Red-figured oinochoe, ca. 410 B.C.

Nikias Painter

Greek (Attic); found in Cyrenaica

H: 21.5 cm (8½ in.); Diam: 17.5 cm (6¹³⁄₁₆ in.)

Paris, Musée du Louvre MN 707 (M 9)

HERAKLES IS CONSISTENTLY the most popular figure in Athenian vase-painting. Many artists eagerly portrayed him in an honorable way, not only by means of his exploits but also through depictions of his apotheosis and entrance to Olympos. In contrast, over much of this large oinochoe the Nikias Painter has created a parody of the apotheosis of Herakles, probably inspired by a theatrical performance. On side A (opposite page), Herakles, recognizable by his attributes—lion skin, club, and bow, which he holds tightly, close to his body—is standing on a chariot energetically driven by the personification of victory (Nike). Four centaurs make up the team, which is preceded by a figure gesticulating and brandishing two torches (see detail, this page). This is most certainly an actor, as his accoutrements show: a himation worn as a scarf, trousers that reveal an exaggeratedly long, artificial *phallos*, and a deformed face that indicates he is wearing a mask. The comic effect of the scene is reinforced by the fixed posture of Herakles, whose head seems too large for his body; the depiction of Nike, whose disfigured face is deformed by a pug nose; and the centaurs' tortured features, which accentuate their bestiality. Everything comes together, then, to point to an interpretation of the scene painted on this Attic vase as a satire mocking the myth of the immortalization of Herakles. This type of depiction caricaturizing episodes from mythology or epics continued in the production of ceramics in Magna Graecia. SM

BIBLIOGRAPHY: Rumpf 1951, pp. 9–11, figs. 5–7; Van Hoorn 1951, p. 169, no. 826; *ARV*², pp. 1335 (no. 34), 1690; *IGD*, IV,2; Robertson 1975, p. 417; *BAdd*², p. 522; *LIMC* I (1982), s.v. Aithiopes, p. 416, no. 22, pl. 325; *LIMC* IV (1988), s.v. Héracles, p. 809, no. 1429; *LIMC* V (1990), s.v. Hermes, p. 361, no. 893; *LIMC* VI (1994), s.v. Niké, p. 874, no. 280; Denoyelle 1994, p. 150 no. 70; *LIMC* VIII (1997), s.v. Kentauroi et Kentaurides, p. 696, no. 299, pl. 451; Foley 2000, pp. 287, 288, 290, 291, 293, fig. 11.6; Walsh 2009, pp. 236–37.

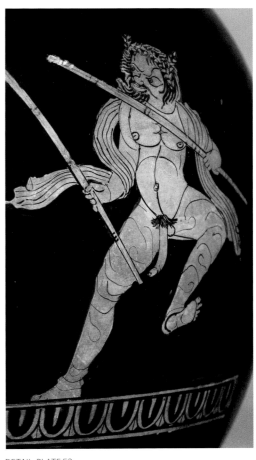

DETAIL, PLATE 52

PLATE 52 | 115

53

Phlyax **Scene with the Centaur Cheiron,
Xanthias, Nymphs, and an Observer** (side A)
**Athlete Seated on a Rock, a Youth on
Either Side** (side B)

Red-figured calyx krater, 380–370 B.C.
Attributed to the McDaniel Painter
From Apulia, South Italy
H: 37.4 cm (14¾ in.); Diam: 39.1 cm (15⅜ in.)
Previously in the Durand collection
London, The British Museum 1849, 0620.13

THE PRIMARY SIDE of this vase shows a striking scene characterized as part of a comic performance by the usual masks and *phlyax* costumes: tight undergarments ending at the wrists and ankles, over which hang too-short overgarments, with large *phalloi* dangling below. The theatrical context is partly indicated by a small, roofed stage at the left. Resting on the stage is a traveler's pack and *pilos* (traveling hat). At the top of a short flight of stairs is a slave, labeled with the characteristic slave name Xanthias, who assists the wise old centaur Cheiron (also labeled). Depicted as old and infirm, Cheiron mounts the steps leaning on a crooked staff while another slave (unnamed) pushes him from behind. His eyes are closed to indicate that he is blind. Cheiron was a wise centaur, a mythical creature part man and part horse, legendarily the teacher of Achilles. Above and to the right, the grotesquely comedic busts of two female figures labeled "nymphs" are shown conversing. Watching this scene from the right is an unmasked youth wearing a himation, probably Achilles. Depicted in smaller scale and not in the guise of an actor, this figure bears resemblance to other nondramatic characters, such as "Aigisthos" in fig. 3.3 (shown in Martine Denoyelle's "Comedy Vases from Magna Graecia," earlier in this volume) or the unidentified observer labeled *tragoidos* on the well-known krater in the Metropolitan Museum (plate 50). Comedies about Cheiron have not survived but are known to have been written by Kratinos, a contemporary of Aristophanes, and later comic poets. In keeping with the farcical South Italian "hilarotragedy" tradition (e.g., plates 52, 54, 56, and 57), the adventures and exploits of gods and heroes provide comic poets with material for parody and farce. In this case, the comedy may have been about the cure of Cheiron after he had been accidentally wounded by one of Herakles' poisoned arrows. The "nymphs" may be linked to the nymphs of Anigros, where Cheiron bathed to heal his wound. MLH

BIBLIOGRAPHY: Bieber 1961, fig. 491; *IGD*, IV,35; Green and Handley 1995, fig. 28; Taplin 1993a, pp. 79–80.

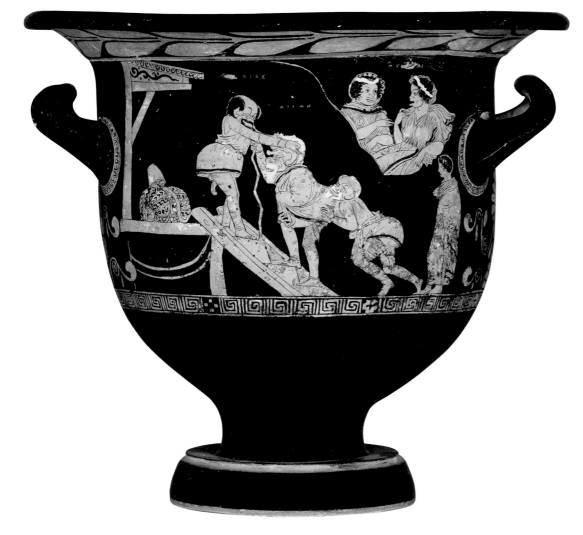

54

Phlyax Scene with Zeus, a Slave, and a Piper (side A)
Two Standing Youths (side B)

Red-figured calyx krater, 380–370 B.C.
Attributed to the Dirce Painter
From Campania, South Italy
H: 31 cm (12¼ in.); Diam: 28 cm (11 in.)
Madrid, Museo Arqueológico Nacional 11026

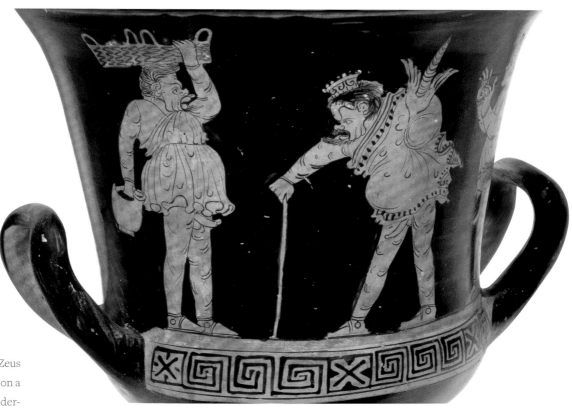

THE GROTESQUELY COMEDIC SCENE places Zeus at the center, hobbled and leaning all his weight on a cane. He is wearing the typical close-fitting undergarment of the _phlyax_ costume, as are the other two figures. They all wear very large false _phalloi_. Zeus is wrapped in a tunic festooned with borders that mark his rank. His attire is completed by a grotesque bearded mask with sparse hair; the ribbons that serve to attach the mask to the head are visible, and above them is a crown in the shape of a _kalathos_. He is turned to his right, toward a figure depicted as a slave who appears to be waiting on him. The slave is dressed in a short _exomis_ (tunic) and carries on his head a _kanoun_ (basket) in which he transports provisions for a banquet or a sacrifice, indicated with added white paint; in his right hand he holds an askos (wine jug) while conversing with the god. Behind Zeus, a beardless aulete is playing the double flute, as indicated by his swollen cheeks and position of his hands. He is wearing his hair gathered up in a _sakkos_, more appropriate to feminine attire, and a short tunic. It is most unusual that he should be costumed as a _phlyax_ actor (without the mask), for musicians typically wore their own distinctive costumes.

The two youths on the reverse side, one of them with a _thyrsos_, may be an allusion to Dionysos and to his connection to theatrical productions.
MMC

BIBLIOGRAPHY: _LCS_, p. 53, no. 82; Trendall 1987, p. 25, no. 6; _LIMC_ VIII (1997), _s.v._ Zeus, p. 440, no. 221; Warden 2004, pp. 139–40 (with figs.); Olmos 2005, pp. 62–63, no. 18 (with bibliog.).

PLATE 54 | 117

55

**_Phlyax_ Scene with Musicians,
an Old Man, and a Piper** (side A)
**Dancing Woman Flanked
by Two Youths** (side B)

Red-figured calyx krater, 365–350 B.C.
Attributed to the Suckling-Salting Group
From Apulia, South Italy
H: 35 cm (13¾ in.); Diam: 35 cm (13¾ in.)
Rome (formerly Bari), Malaguzzi Valeri 52

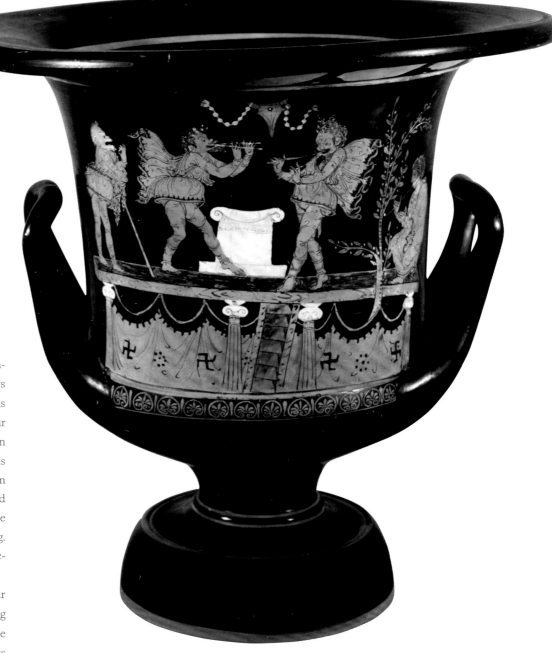

STRIKING IN THIS PICTURE is the vivid represen-
tation of a wooden stage: the grains of its timbers
are differentiated in dilute glaze. Reached by means
of seven steep steps, the stage is supported by four
fluted columns with Ionic capitals picked out in
white (suggesting, perhaps, ivory veneer). From this
and from a tree a festively decorated apron has been
suspended. The tree's pollarded branches, pointed
leaves, and berries resemble olive. At the back of the
stage is a small altar crowned with Ionic molding.
Above, a bucranion and garlands imply the architec-
ture of a sacred place.

Four individuals, evenly spaced, appear
onstage. At the far right the tree conceals a crouching
figure, which raises the question of whether the tree
is merely a stage prop for concealment or whether its
presence is artistic shorthand for an outdoor setting
such as an olive grove. Youthful and possibly female,
the crouching figure wears a piper's traditional
sleeved chiton patterned with dots under a mantle.
Over her head she wears the _phorbeia_ (mouth strap)
that holds her pipes in place. Dress and _phorbeia_ iden-
tify her not as an actor but as an auletris, the musician
playing the _aulos_ for the play.

The drama proper unfolds on the other
side of the tree. Two actors wearing comic gear and
wreathed masks perform a choreographed dance in
front of the altar. Although they carry flutes, without

phorbeiai they are unlikely to produce a sound, which
instead is provided by their concealed colleague.
Their identical outfits and unity of purpose may indi-
cate that they are members of a chorus rather than
two closely related actors. They are observed by a
third actor, an old man leaning on a stick who gesticu-
lates with his right hand.

The reverse shows three figures in an out-
door setting. A young woman seeks to garland a youth
while a second youth, behind her, his chest bared,
looks on. JMPG

BIBLIOGRAPHY: Lo Porto 1979; _RVAp_, vol. 1, p. 400, no. 28,
pl. 140,5; Dumont 1984, pl. 36; _RVSIS_, frontis.; Trendall 1990,
pl. 24.2; Taplin 1991; Trendall 1991, p. 163, fig. 66; Taplin 1993a,
pp. 70-78, 108, 113, pl. 14; _RVAp_ supp. 2, p. 103; Dunbar 1995,
p. 421; Gilula 1995; Hughes 1996, p. 98; Tiverios 1996, p. 203,
fig. 203; Pöhlmann 1997, p. 10; Ashby 1999, p. 47; Dearden
1999, p. 245n102; Green 2001, p. 63, no. 22; Barker, Beaumont,
and Bollen 2004; Hughes 2008, p. 26.

56

Phlyax Scene with the Birth of Helen
(side A)
Three Draped Youths (side B)

Red-figured bell krater, ca. 370 B.C.

Attributed to the Dijon Painter

From Apulia, South Italy

H: 34.3 cm (13½ in.); Diam: 37 cm (14½ in.)

Bari, Museo Archeologico Provinciale di Bari 3899

SCENES OF THE TROJAN SAGA (see also plate 57) occur with some frequency in vase-paintings of South Italian farce and were likely inspired by Athenian burlesques on the same theme. In this scene, perhaps derived from the lost *Nemesis* by Kratinos—one of the early Athenian Old Comedy poets, active about 454–423 B.C., and an older contemporary of Aristophanes—the birth of Helen takes place on a typical wooden stage accentuated by a curtain with a door as scenery to the left.

Helen was the child of Nemesis and Zeus, born from an egg tended by Leda and Tyndareus, the rulers of Sparta. In this scene she rises from a huge egg nestled in a basket, raising her arm in supplication to an ax-wielding *phlyax* in an old man's mask with scant white hair and a short beard. Surely this is Tyndareus, who, unaware of the child's presence, is preparing to cleave the egg in two while a companion to the right raises his hand in alarm and Leda looks on in horror from the doorway to the left.

The men wear the typical tight undergarment of the padded and sagging *phlyax* costume, with evident seams at the ankles and wrists and large *phalloi* hanging below their skimpy tunics. The actor to the right wears a black-bearded mask with a thick head of hair and a stylish fillet with ends trailing down his back, distinguishing him from a slave. Characteristically, the Leda *phlyax* wears an elaborate costume to show her rank, topped by the diademed mask of an ugly old woman, comedically mocking the traditional beauty of the Spartan queen.　AS

BIBLIOGRAPHY: Romagnoli 1907, pp. 251–60, figs. 6, 8–10; Romagnoli 1923, pp. 24–25, figs. 27–29; *IGD*, IV,26; *RVAp*, vol. 1, p. 148, no. 96; *LIMC* IV (1988), s.v. Helena, p. 503, no. 5, pl. 291; Taplin 1993, pp. 79-83, no. 19.20; Nicola 2007, exh. cat., p. 18.; Taplin 1993, pp. 79–83, no. 19.20; Nicola 2007, p. 18.

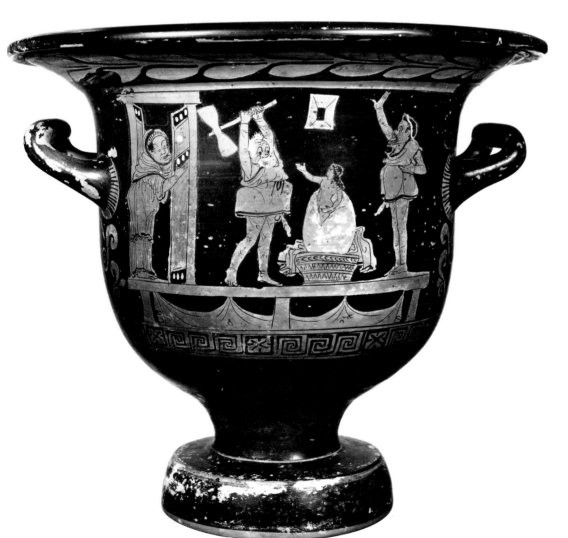

PLATE 56 | 119

57

Phlyax Scene of Priam and Neoptolemos
(side A)
Two Youths (side B)

Red-figured bell krater, 380–370 B.C.
Attributed to the Eton-Nika group
From Apulia, South Italy
H: 22.2 cm (8¾ in.); Diam (at rim): 23.8 cm (9⅜ in.)
Berlin, Antikensammlung, Staatliche
Museen zu Berlin—Preußischer
Kulturbesitz F3045

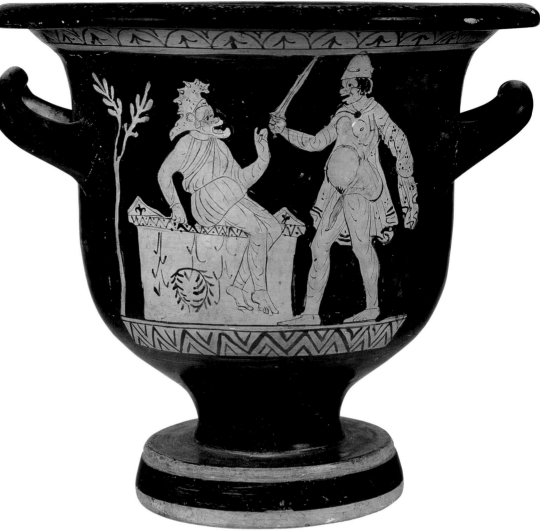

AN OLD MAN with a distinctive headdress and white beard sits atop an altar. He holds up his left hand for protection against a man who advances toward him brandishing a sword. That these are _phlyax_ actors is indicated by their costumes: baggy trousers ending at the ankles; for the old man, an exotic headdress attached to a mask with a prominently jutting jaw; and for the soldier, a parody of heroic nudity instead of armor—a bulging stomach, breasts, and a huge dangling _phallos_. The young man's nude costume is emphasized by his ill-fitting cloak, which falls behind him and completely obscures his left arm. He wears a _pilos_ and the mask of a young man with an open mouth, a fat nose, wide-open eyes, and short hair. At the left is a skimpy tree, probably a laurel.

The scene depicts the death of Priam at the Sack of Troy, arguably the most tragic of epic deaths. It is shown here performed as a comic farce (e.g., see plates 53, 54, 56) in the spirit of an Athenian Old Comedy poet like Kratinos, in whose comedies the most serious mythical themes were brought to a ridiculous level. The iconography of this brutal and sacrilegious murder—the final event in the fall

of Troy—was well established in the repertoire of Athenian vase-painters, who always represented it with respect and pathos (fig. 3.7). The Apulian painter was clearly conversant with this recognizable scene, which he costumed in comedic travesty. MLH

BIBLIOGRAPHY: Trendall 1959, p. 23, no. 20; Bieber 1961, p. 135, fig. 493; _IGD_, IV,29; _RVAp_, vol. 1, p. 78, no. 92, pl. 27,2 (side B); _LIMC_ VII (1994), s.v. Priamos, p. 517, no. 98, pl. 407; Taplin 1993a, p. 82, pl. 18.19; Rodá de Llanza and Musso 2003, exh. cat., p. 173 (with fig.); Kunze and Rügler 2006, exh. cat., p. 79, no. V 4.2 (with bibliog.); Walsh 2009, p. 95, fig. 21, no. 122.

FIGURE 3.7
Death of Priam (detail). Attic red-figured
hydria attributed to the Kleophrades Painter, ca. 480 B.C.
Naples, Museo Archeologico Nazionale di Napoli 2422

58

**_Phlyax_ Scene of Zeus Courting Alkmene
with the Help of Hermes** (side A)
Two Youths (side B)

Red-figured bell krater, 350–340 B.C.

Attributed to Asteas

From Paestum, South Italy

H: 37 cm (14½ in.); Diam: 36 cm (14¼ in.)

In the collection of the painter Anton Raphael
Mengs, 1759–1773; in the Vatican Library,
from 1773–1900

Vatican City, Vatican Museums 17106

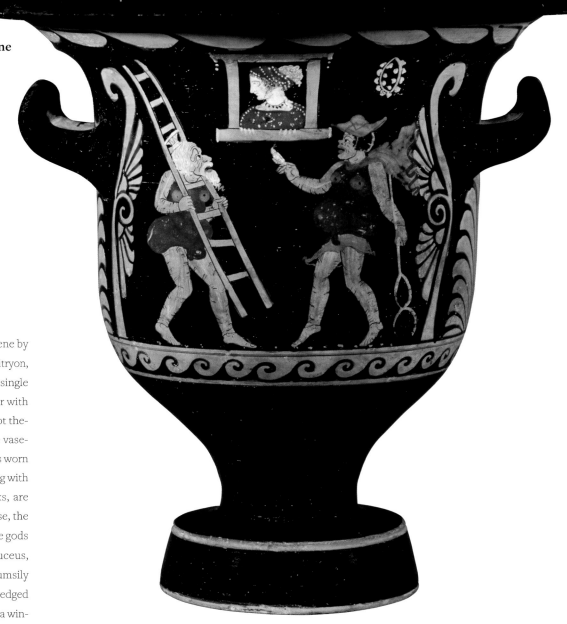

ACCORDING TO MYTH, Zeus courted Alkmene by assuming the appearance of her husband, Amphitryon, and then slowing the passage of time so that a single night lasted the space of three. Her encounter with the god resulted in the birth of Herakles. Italiot theater was a major source of inspiration for the vase-painters of Campania. The grotesque hairstyles worn by the comic actors depicted on this vase, along with the fake padding of the bellies and buttocks, are distinctive features of _phlyax_ plays. In this case, the parody and the caricature even took aim at the gods of Olympos. Hermes, depicted with his caduceus, holds a lamp to light the way for Zeus, who clumsily attempts to erect a ladder, his crowned head wedged between two rungs. Zeus is struggling to reach a window out of which Alkmene is looking; she gazes down on her suitor with both hands on the windowsill.

On the other side of the vase is a depiction of two young men wrapped in himations, each holding a staff. One youth carries a spit threaded with fruit. Both young men wear white footwear; each has a garland of white leaves on his forehead.

The krater is attributed to Asteas, a Paestan painter active about 360–330 B.C., and is considered to be one of his finest unsigned vases. On another vase, now in the British Museum, Asteas depicted a subsequent phase of the same episode, in which an anonymous lover, after climbing the ladder, brings gifts to the woman he is wooing. MS

BIBLIOGRAPHY: Trendall 1953–55, pp. 27–29, U19, pl. 7b; _IGD_, IV,19; Röttgen 1981, pp. 129, 146, fig. 4; Von Bothmer 1983, exh. cat., p. 191, no. 108; _RVP_, p. 124, no. 176, pl. 73a–b; Buranelli and Sannibale 2003, pp. 131, 152 (illus.).

PLATE 58 | **121**

MIDDLE COMEDY FIGURINES OF ACTORS

H. A. SHAPIRO

THE GROUP OF FOURTEEN STATUETTES found in a grave in Athens, of which six are shown here (plates 59–64), provides one of our earliest and most important sources for understanding the performance of Athenian comedies in the Classical period. The precise dating of the group is problematic but almost certainly falls within the first half of the fourth century B.C.[1] In terms of Attic comedy, this means that the earliest can be associated with the later phase of Old Comedy—Aristophanes and his contemporaries—and the latest with the beginnings of the New Comedy of Philemon and Menander; the bulk must reflect the least well-known phase, that of Middle Comedy, of which no complete play and few fragments survive. Thus the group is especially valuable in helping us reconstruct the elusive nature of Middle Comedy. Furthermore, these actors are contemporary with most of the *phlyax* vases, which, though made in Apulia, probably reflect Athenian comedies that were revived in South Italy, as we may infer from the dialogue in Attic dialect on the *phlyax* krater by the Tarporley Painter (plate 50).[2]

The fourteen figurines divide into two sets of seven according to the color of their surface, one reddish, the other yellowish, though this is not necessarily proof that they were fired at different times or even in different kilns.[3] We can only speculate as to whether each set represents the cast of a single production or whether the two sets correspond to stock types used in a variety of comedies. The only recognizable mythological figure in either set is Herakles (plate 64), wearing a lion-skin cap and holding his knotty club, a second lion skin hanging from his shoulder. The finger he holds to his mouth could refer to the hero's reputation for gluttony; two more figures in this yellow set, one carrying a basket of food (plate 69) and the other a water pitcher (plate 70), suggest that a banquet figured in the action of the play.

We are told that many works of Middle Comedy revolved around travesties of heroic myth and the kinds of stories that had been dramatized in tragedy of the fifth century B.C.[4] In our group, a hint in this direction is provided by the figures of a nurse holding a baby in swaddling clothes and a man in distress (plate 59) holding one hand to his eye as if to brush away a tear. Since there are few stories in which Herakles fathers a child, scholars have thought of Auge, the Peloponnesian princess who was raped by Herakles and gave birth to the hero Telephos, later founder of the kingdom of Pergamon in Asia Minor.[5] Indeed, *Auge* was the title of a play by the Middle Comedy playwright Euboulos of which a few lines survive.

There is a further interesting link to both tragedy and Old Comedy, for the grown-up Telephos was the title character of Euripides' most famous (lost) tragedy and figures on fourth-century vases of both

Athens and South Italy in the play's climactic scene, in which Telephos kneels on an altar and threatens to kill the baby Orestes (plate 27, side B).[6] In addition, the play was famously parodied by Aristophanes in two of his surviving comedies, *Acharnians* and *Women at the Thesmophoria*, and the corresponding scene in the latter play (with a wineskin substituting for the baby) has now turned up on an Apulian vase (see fig. 3.5 in Martine Denoyelle's "Comedy Vases from Magna Graecia," earlier in this volume).[7] In other words, there was already a tradition of turning one part of the Telephos myth into a travesty. The Middle Comedy represented by our group might have gone back to an earlier phase in the myth, with Herakles eventually acknowledging his offspring (rather than abandoning Telephos, as in the usual version of the myth) and marrying the baby's mother, Auge, in a festive banquet.

The reddish set of figurines, in contrast, has no mythological characters, but instead a group of stock figures that could belong to the kind of domestic comedy of manners that was later popular in the time of Menander. These include an attractive young woman who pulls up her himation with her right hand and places the left on her hip in a manner that gives her a confident and coquettish air (plate 62), along with a second woman whose pose is somewhat similar but whose mask shows her to be an old crone (plate 63). The younger woman is likely to be a *hetaira* (prostitute), the older one perhaps a madam or procuress. The group also includes three seated male figures in different poses, as exemplified by the works illustrated here: one holding a purse (plate 68), one holding his right index finger to his lower lip in a pensive gesture (plate 60), and one with his chin resting on one hand (plate 61). Although it is difficult to tell a slave from a rustic by the mask or costume,[8] it is probable that at least one of these is a conniving slave (plate 61). The group is completed by a very fat young man clutching his *phallos*—the parasite or moocher—and a mature man standing with legs crossed. The typical New Comedy plot might include a miserly old man parted from his money, a young man falling in love with a prostitute against his family's wishes, scheming slaves who set the plot in motion and resolve it, parasites and other unsavory hangers-on, or some combination of these elements. The group of actors here does not match any known play, but together they provide valuable evidence for how the stock characters of Menander's New Comedy evolved organically out of Old and Middle Comedy and were available, by the middle of the fourth century B.C., for a master playwright to combine them into a new literary genre that would captivate the Athenian audience and later the Roman audience in the Latin adaptations of Plautus and Terence.

NOTES

1 One should be as early as about 400 B.C., since a replica was found in the Athenian agora in a context well dated to 410–390 B.C.: Csapo and Slater 1994, p. 71. Most of the others should be closer to the middle of the century, with a terminus ante quem of 348 B.C., the year of the destruction by the Macedonian king Philip II of Olynthos in northern Greece, where replicas of six figures have been found: *MMC³*, p. 45.

2 On Attic comedy in South Italy, see *DFA²*, p. 216; Taplin 2007, p. 13.

3 *MMC³*, p. 46.

4 Nesselrath 1990.

5 Webster 1970b, p. 71; Bieber 1961, p. 45; *MMC³*, p. 46.

6 Taplin 2007, nos. 75–77.

7 Taplin 2007, p. 14; Csapo 1986.

8 See Webster 1970b, p. 62.

59

Comic Figurine of a Distressed Man

400–350 B.C.

Produced and found in Athens

Terracotta

H: 12.1 cm (4¾ in.)

New York, The Metropolitan Museum of Art 13.225.13

60

Comic Figurine of a Seated Man

400–350 B.C.

Produced and found in Athens

Terracotta

H: 10.8 cm (4¼ in.)

New York, The Metropolitan Museum of Art 13.225.16

61

Comic Figurine of a Seated Man

400–350 B.C.

Produced and found in Athens

Terracotta

H: 8.9 cm (3½ in.)

New York, The Metropolitan Museum of Art 13.225.19

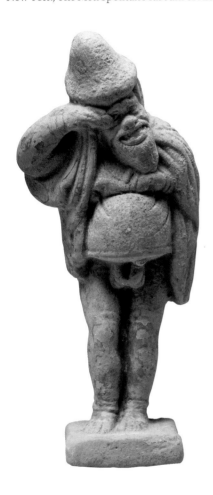

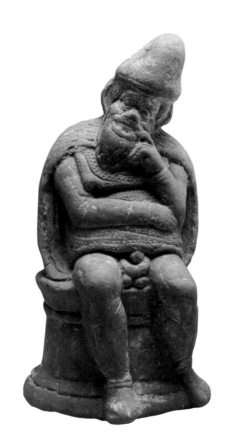

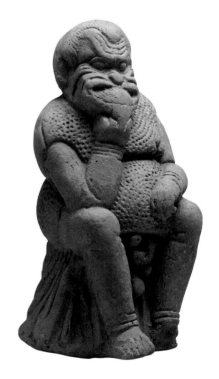

UNIFIED IN STYLE and concept but varied in character, pose, and gesture, these six figurines are part of the important group of fourteen in the Metropolitan Museum. They give us a unique vision of Middle Comedy comic actors and are typologically linked to figurines from other archaeological contexts around the Mediterranean (plates 65–70).

The padded costume worn by each male figurine includes baggy tights ending at the ankles and a short chiton emphasizing his fat padded belly. The shortened chitons allow abnormally large,

infibulated *phalloi* to protrude from underneath them. That the *phalloi* are tied up perhaps makes fun of this practice among aristocratic Athenian youth, who were often shown infibulated for modesty while exercising nude in public.

The figure in plate 59 stands wearing a *pilos* and tilting his head as he appears to wipe a tear from his eye with his cloak. The figure in plate 60, who also wears a *pilos*, sits on an altar to which he has fled in order to escape punishment for some mischievous or unruly behavior. He props up his left elbow with his

right hand and places his finger on his lips. This is the pose of the "plotting" slave who concocts future misdeeds even while escaping current ones. Plate 61 shows another slave seated on an altar; he wears a short chiton perhaps made of fur, topped by a mask with close-cropped hair, a receding hairline, and a wide face. The Herakles figurine in plate 64 points to his own wide-open mouth in order to draw attention to his appetite for food and wine. In contrast to the lion skin and club of the Herakles figurine in the British Museum (plate 65), the attributes of the Metropolitan Herakles are

62

Comic Figurine of a *Hetaira*
400–350 B.C.
Produced and found in Athens
Terracotta
H: 12.4 cm (4⅞ in.)
New York, The Metropolitan Museum of Art 13.225.21

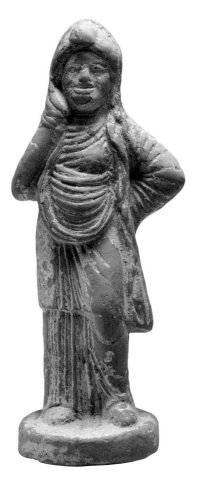

63

Comic Figurine of an Old Woman
400–350 B.C.
Produced and found in Athens
Terracotta
H: 10.5 cm (4⅛ in.)
New York, The Metropolitan Museum of Art
13.225.25

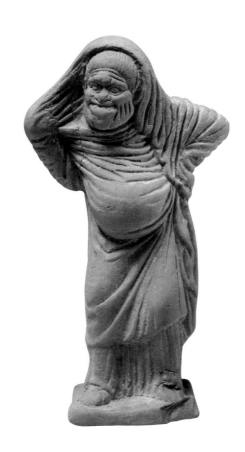

64

Comic Figurine of Herakles
400–350 B.C.
Produced and found in Athens
Terracotta
H: 12 cm (4¾ in.)
New York, The Metropolitan Museum of Art
13.225.27

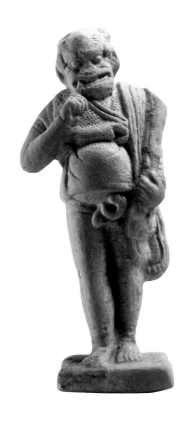

simply rendered; his style and comportment match those of the other male figures in the set.

Plates 62 and 63 show the women in the Metropolitan group. Since they represent men costumed as women and would wear the same padding as part of their costumes, the women also have padded bellies, over which their himations are draped. The young woman in plate 62 stands in an immodest pose, with legs slightly apart and left leg bent at the knee. She is a *pseudokore*, a "false maiden." She provokes an encounter in an aggressive manner, with a

very undignified direct gaze and the knuckles of her left hand resting on her thrust-out hip. Her right arm has become uncovered by the loose himation, which at the same time emphasizes her left breast. A lock of hair has even become loose, peeking out from under the himation. Her bearing and costume identify her as a loose woman in every way. The figurine of the old woman in plate 63 is completely covered by the long chiton and himation but stands in a similar posture. She is probably the *pseudokore*'s procuress, with a huge padded belly supported only by her clothing.

The mask includes thick short hair, chubby cheeks, and a wrinkled brow. She confronts her customer with a wide and knowing grin. MLH

BIBLIOGRAPHY: Metropolitan Museum of Art 1914, pp. 235–36; Webster 1956, pp. 57, 63, 70, 142, pl. 17a; *IGD*, IV,9; *MMC³*, pp. 45–58 (plate 59: p. 46, AT 12a; plate 60: p. 57, AT 21a; plate 61: p. 58, AT 22a; plate 62: p. 52, AT 16a; plate 63: p. 53, AT 17a; plate 64: p. 48, AT 11a); *DFA²*, pp. 214–15, figs. 89–102; Green 1991, p. 32; Csapo and Slater 1994, pp. 70–72, no. 138; Green 2002, p. 119, fig. 26; Picón 2007, pp. 160 (fig. 181), 438 (no. 181).

65

Comic Figurine of Herakles

4th century B.C.
Greek (Attic); found in Melos
Terracotta
H: 8.6 cm (3⅜ in.); W: 3 cm (1⅛ in.); D: 2.5 cm (1 in.)
Previously in the collection of Thomas Burgon
London, The British Museum 1852,0728.752 (T741)

THIS STATUETTE of a lively cross-legged Herakles shows the hero in comic guise, holding his bow and leaning on his club, cloaked in his trademark lion skin. He has a potbelly and a large, infibulated *phallos*. The *phlyax* actor's full-body tights end at his ankles and wrists beneath a short chiton. Herakles was a stock character in comedy, where his gluttony and love of wine rather than his heroic exploits defined his character. This statuette has the same identity as the one in the Metropolitan Museum (plate 64) but was executed with more attention to detail. It also reflects an iconographic variation within the tradition of this type. MLH

BIBLIOGRAPHY: Higgins 1954, no. 741, pl. 98; Green and Handley 1995, fig. 34.

66

Comic Figurine of a *Hetaira*

350–325 B.C.
Greek (Attic)
Terracotta
H: 13.3 cm (5¼ in.); W: 5.4 cm (2⅛ in.)
London, The British Museum 1865,0720.43

THIS FIGURINE retains white slip, with red pigment on the stephane and the upper and lower borders of the chiton, and green pigment on the himation. Female figurines had become more popular by the middle of the fourth century B.C., perhaps indicating a shift toward the more intricate comedic intrigues of New Comedy plots. MLH

BIBLIOGRAPHY: Higgins 1954, no. 746; Green and Handley 1995, pp. 64-65, fig. 40.

67

Comic Figurine of a Woman Veiling Her Face

350–300 B.C.
Greek (probably Attic); found in Cyrenaica
Terracotta
H: 8.5 cm (3¼ in.)
Paris, Musée du Louvre MN 642

ACTORS IN THE FOURTH CENTURY B.C., always men, might have had several roles during the same performance and kept on the padding that formed the foundation of their costumes—hence the large stomach of this female character. The statuette is a parody of a veiled woman, shown standing or dancing; this type of figure was also very common in Athens and subsequently throughout the Greek world, but this Cyrenaican variant was also found in Tanagra. It thus illustrates the connection between different workshops in the Greek world. JB

BIBLIOGRAPHY: Besques 1972, C 646; *MMC³*, p. 47, AT 10; Jeammet 2003, exh. cat., no. 79.

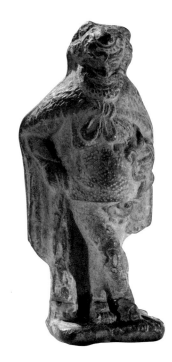

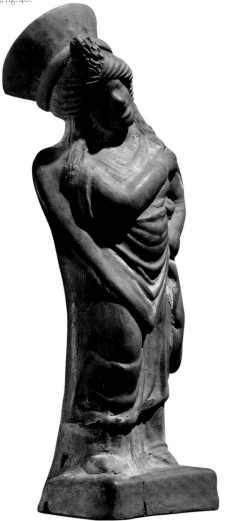

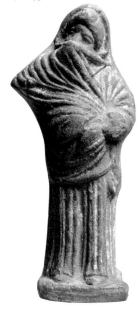

68

Comic Figurine of a Slave with a Coin Purse Seated on an Altar

400–375 B.C.
Greek (probably Attic); found in Locris (?)
Terracotta
H: 9.5 cm (3¾ in.); W: 4.8 cm (1⅞ in.);
D: 4.5 cm (1¾ in.)
Paris, Musée du Louvre CA 265

FEARING A BEATING from his master, the slave has taken refuge on an altar to empty with impunity the purse he has just stolen. This type of figure, characterized by its size, the color of the clay (yellow here; the other noted color is red), and the technique of production used, is consistent with the Metropolitan group (see plates 59–64) and can also be seen in a dozen other pieces. JB

BIBLIOGRAPHY: Besques 1972, C 638; *MMC³*, p. 56, AT 20b; Moretti 2001, pp. 150, 152, fig. 17; Jeammet 2003, exh. cat., no. 78; Bouquillon, Zink, and Porto 2007, p. 98.

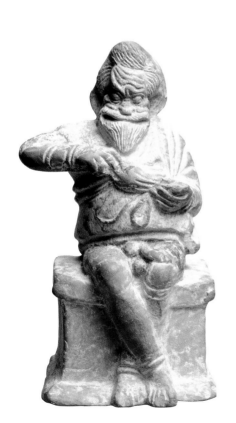

69

Comic Figurine of a Basket-Carrier

400–375 B.C.
Greek (Attic); found in Athens
Terracotta
H: 11.2 cm (4⅜ in.)
Paris, Musée du Louvre CA 20

IN THEME AND TECHNIQUE this actor figurine belongs with the group of Middle Comedy figurines in the Metropolitan Museum. Although the character of the basket-carrier was not included in that group, found together in a tomb in Athens, he has the same bearded mask and costume: the long-sleeved bodysuit over which the short, studded tunic was placed, hiding the padding of the stomach but allowing the false *phallos* to be seen, and the himation placed as a scarf, which could be raised to cover the head. Perfected in Athens at the beginning of the fourth century B.C., this group of actors is characterized by its sculptural quality, owing to the innovative use of a bivalve mold that enabled the creation of works in the round. The detail with which the surface is worked recalls bronzework. The technique initiated a series that was very successful in the Greek world and later exported throughout the entire Mediterranean basin, specifically in Cyrenaica and Kerch (Taman), thereby disseminating the characters of Greek theater as well. VJ

BIBLIOGRAPHY: Besques 1972, p. 3, C 635, pl. 2a; Moretti 2001, pp. 150, 151, fig. 16; Tokyo 2006, exh. cat., pp. 140, 250, no. 90.

70

Comic Figurine of a Man with a Hydria

End of 5th century B.C.
Greek (Boiotian) possibly from Tanagra
Terracotta
H: 9 cm (3½ in.)
Acquired in Paris, 1878
Copenhagen, The National Museum of Denmark 1068

THIS CLAY FIGURINE stands on a square plinth. With his right hand he supports a hydria on his head. He wears a cloak that covers his head and body, leaving the legs bare. The figurine retains white slip, red pigment on the face, and blue pigment on the hydria. BBR

BIBLIOGRAPHY: Breitenstein 1941, no. 329, pl. 39; Robinson (D.M.) 1952, p. 276; *MMC³*, p. 50, AT 14b; *DFA²*, pp. 214-15.

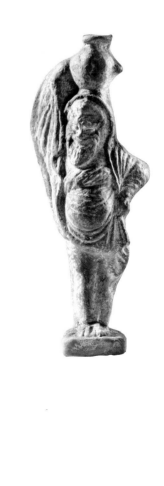

SOCIAL AND DOMESTIC DRAMA

J. MICHAEL WALTON

WHEN ATHENS SUFFERED HER FINAL DEFEAT in the long drawn-out Peloponnesian War against Sparta, it must have seemed like the eclipse of a once-great city-state. The city's population, wealth, and influence had been reduced to a point from which any recovery could be no more than gradual and limited. The cultural life that marked the city to later generations as something wholly unique seemed too to have ground to a halt. A bare two years before the end of the war, Euripides had died, closely followed by Sophocles. In neither the short term nor the long would there be another tragedian writing in Greek whose work would survive.

Less popular in his own lifetime than his contemporaries, Euripides came into his own after his death, when revival of his plays appeared to overshadow those of living playwrights, not only on the Athenian stage but in the repertoire of the whole Greek world. Greek communities from the Black Sea to southern Italy and as far away as North Africa and Spain built their theaters and invited touring troupes of actors to arrive as guest stars to perform at their local civic festivals. The touring system of the Hellenistic world was promoted by a sophisticated and powerful set of guilds that organized and managed a full professional theater circuit.

There were two main reasons why Euripides dominated the repertoire. The first was that, of the three main tragedians of Athens, he was the least parochial. His themes may have spoken, often uncomfortably, to his immediate contemporaries in Athens, but they also demonstrated a kind of universality that has ensured their survival in any age. Alongside this was his versatility as a playwright. Of the nineteen plays of Euripides to survive—and vase-paintings give ample proof of how many more were still known and performed (*Telephos*, for example; plate 27)—there are several that barely deserve the designation of tragedy, and four (*Alkestis*, *Iphigenia among the Taurians*, *Ion*, and *Helen*) that are out-and-out "romance" dramas with strong comic elements and happy endings.

The Old Comedy of Aristophanes, characterized by a ribald mix of farce, politics, and fantasy, had no real place in the fourth century B.C., though he survived the Peloponnesian War and even witnessed Athens's partial revival as a Greek power. His last two plays demonstrate a new direction and are often described as Middle Comedy. One of them, *Assemblywomen* (*Ekklesiazousai*), is a satire on notions of Platonic communism. The women of Athens, tired of the inability of the men to run the city properly, dress up in their husbands' clothes (men dressed as women dressed as men) and vote women into power in

the Assembly. The last play we have, *Wealth* (*Ploutos*), about the restoring of his sight to the blinded god of wealth, was regarded as so morally worthy that it was revived in Renaissance and later times when all of the other plays of Aristophanes were outlawed for their obscenity, or expurgated almost out of existence.

The full-blooded tragedies and comedies of the fifth century B.C. gave way, then, to a new kind of social drama, domestic in its issues and concentrating on family life and relationships. Greek tragedy dealt mostly with the heroes and villains of myth. Aristophanes' leading characters had been ordinary citizens who found themselves in the extraordinary company of local celebrities, gods, personifications, and talking animals—anything from dogs involved in a court case to choruses of clouds, wasps, and frogs, in settings from heaven to hell and in places in between. As the fourth century B.C. wore on, political and military power switched from the southern Greek cities to Macedon in the north. In Athens the age of the poets and the architects turned into the heyday of the orators and the philosophers. One original playwright, influenced by both Euripides and late Aristophanes, was to emerge as the most popular of any other in classical times. His name was Menander (plates 72, 73), and if the name is hardly familiar, it is because until 1957 not a single whole Menander play was known to have survived. In that year *The Grouch* (*Dyskolos*) was discovered and published in slightly mysterious circumstances. *The Woman from Samos* (*Samia*) followed twelve years later.

To give the playwright a context, he was born a few years after Alexander the Great's accession to the throne of Macedon and close to Aristotle's founding of the Lyceum. Menander presented his first play in Athens about 323 B.C., the time of the deaths of both Alexander and Aristotle.

What we now know of Menander's work, augmented by substantial fragments from some of his other plays, and from Latin adaptations by the later playwright Terence, shows that his focus was almost entirely on human relationships: fathers and sons; young men in love; complicated but recognizable situations involving slaves, farmers, citizens, and noncitizens. But what appealed most was his realism. "Oh Life and Menander, which of you is imitating the other?" wrote Aristophanes of Byzantium (head of the library at Alexandria but no relation to the famous Greek comedian). Sometimes this realism took the form of "potential tragedy" or "tragedy averted," as in the lighter plays of Euripides, but it was the lives of ordinary people that were threatened, people with faults and foibles, moods and sensitivities. The situations were personal but still unpredictable. Menander could offer unparalleled portraits of everyday life and everyday living. It was with the joy of recognition that audiences of his own and later times seem to have responded to his plays. The Greek biographer Plutarch, in an essay written some four hundred years after Menander's time, wrote a comparison of Aristophanes and Menander. So much did he prefer Menander that he wondered why anybody would ever go to the theater except to see a Menander play.

But there is a paradox over this acclaimed stage "realism," a paradox that can best be addressed by recourse to the comic scenes preserved on vases and in mosaics. Some of these scenes can be attributed to specific plays or themes from Menander's contemporaries or near contemporaries. Others do no more than hint at stage situations with both mythical and domestic themes, but their dating offers a convincing guide to a diverse theater tradition during the last quarter of the fourth century B.C.

STAGES AND SCENES

The paradox is easily identified. It comes down to the nature of "realism." In later times drama tended to be described as realistic when it was presented in conditions that replicated the physicality of life and when it presented recognizable people rather than abstractions: plays, in other words, concentrating on human action and reaction. If Euripides was the pioneer of such a tendency in his tragedies when he made his mythical characters behave like real men and women, Menander was the Greek playwright to hone the method and to see the theater as a place where audiences could recognize themselves, their friends, and neighbors. So, where is the paradox?

The anomaly comes from the fact that these plays were still initially presented in circumstances that relied on physical conditions wholly at odds with most notions of dramatic realism. The Theater of Dionysos in Athens, for which Euripides probably wrote all his surviving plays, was huge, holding at least eight thousand people, possibly fifteen thousand; Plato estimated thirty thousand. It was an outdoor space, subject to the distractions of the natural world, which could demonstrate what had happened indoors only by use of stage machinery for tableaux. The scenic background was temporary, in the sense of being versatile and mobile, but served for the most part as living quarters for the leading characters. As in fifth-century tragedy and comedy, there was a chorus who danced and sang in the *orchestra*. A central difference in Menander was that the choruses entered only to provide intermezzi, so abstracted from the action proper that what they sang was not preserved with the texts.

By Menander's time, the theater space had changed, thanks to the rebuilding of the precinct of Dionysos by Lykourgos as a more permanent site, with stone seating and a stone *skene* (fig. 3.8). But

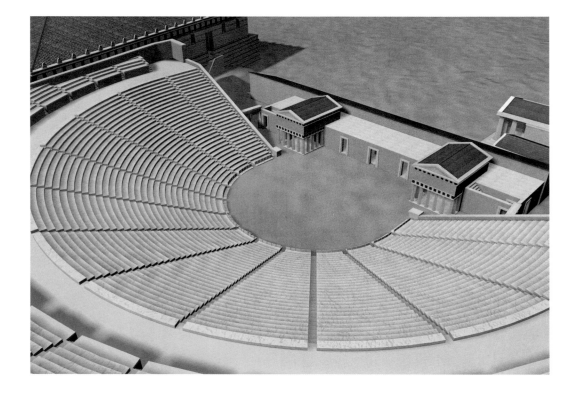

FIGURE 3.8

Computer Model of the Theater of Dionysos in the Fourth Century B.C. Created by Martin Blazeby, King's Visualization Lab, King's College London

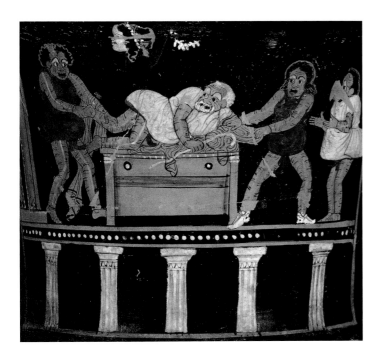

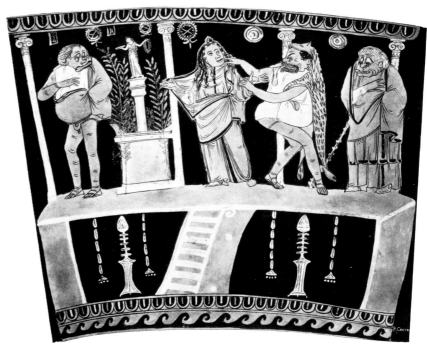

FIGURE 3.9

Scene of a Miser Being Robbed (detail).

Paestan calyx krater attributed to Asteas, 350–340 B.C.

Antikensammlung, Staatliche Museen zu Berlin 3044.

Photo: Johannes Laurentius

FIGURE 3.10

Scene of Herakles and Auge (detail).

Sicilian calyx krater attributed to the Manfria Group,

340–330 B.C. From Lentini. Lentini Archaeological Museum.

Reproduced from *IGD*, fig. IV, 24

this Lykourgan theater was, if anything, grander than the Theater of Dionysos in which Euripides worked. Though reconstruction of the theater in Athens is difficult because of further restructuring during the Roman occupation, Menander seems to have been writing his realistic comedies for this substantial stone, and therefore permanent, scenic background. Disappointingly, the depictions that exist of Menander plays concentrate on the characters rather than on the settings, and most of those associated with the period of New Comedy are not from Athens at all and show a wooden stage, often with a few steps up from the *orchestra*, and curtains either as background or to cover the area below (figs. 3.9, 3.10; plate 55). These accord better with the Roman New Comedy plays of Plautus and Terence, almost all of which were based on Greek originals from the time of Menander or soon after but were played in a marketplace location. Clearly the vases we have indicate more than a single kind of theater tradition; indeed, a majority of these visual representations have been found not in Greece but in Sicily and southern Italy, and probably reflect a much less formal and less scripted kind of entertainment.

The Grouch, the first of the two Menander plays that, for all practical purposes, can be regarded as complete, takes place in a mountain village a few miles north of Athens. There are two farmhouses upstage, one belonging to Knemon, the crusty title character, the other to his neighbor Gorgias. Between, there seems to be a shrine to the god Pan. Several of Menander's other plays—*The Shield* (*Aspis*), *The Apparition* (*Phasma*), and *The Arbitration* (*Epitrepontes*)—also take place in Athens or near Athens, all with two houses.

The Woman from Samos again features two adjacent houses, but with nothing between them. One of the houses belongs to a rich trader, Demeas, the other to his impoverished neighbor Nikeratos. Whether their status was reflected in the setting is unknown, but it seems improbable, since what is required, for the most part, is somewhere for the actors to enter from and somewhere for them to exit to. The arrival of new characters from indoors is sometimes signaled by audible means of some kind as the doors are opening.

Any lack of dependence on a realistic scenic background to identify a specific place may have helped rather than hindered a sense of realism in Menander. Most of the significant action that carries the plot forward takes place offstage and is reported to the audience by a witness. The audience sees and hears only the consequences of offstage events. In *The Grouch*, the young lover's slave attempts to approach the father of the girl his master has fallen for, and is chased away by Knemon in a hail of stones and clods of earth. His report of this scene is punctured by concern that he may still be being chased. Later Knemon falls down a well and is rescued by his stepson. All this is reported. The scenes are concerned not so much with actions as with reactions. This becomes a pattern in *The Woman from Samos*, in which each of the five acts opens with the report of some offstage crisis. The immediate issues are resolved onstage, but then, after a brief choral interlude, news arrives of an even worse offstage disaster.

The freeing of the audience from witnessing these offstage events is a holdover from early Greek tragedy. It allows viewers to concentrate instead on the main characters as characters. The dramatic impetus frequently comes from elaborate misunderstandings, situations in which the characters have at best a partial awareness of what is really happening as opposed to what they *think* is happening. Sometimes the members of the audience know more than the characters do, sometimes less. Here is the major source of comedy, comedy that is dramatically sophisticated. Here too is the other reason why Menander's plays can seem so realistic.

CHARACTERS AND MASKS

The male and female characters in Menander's New Comedy were still played by male actors in masks. Though unfamiliar in modern theater, the mask, far from proving a hindrance to any notion of realism, can actually serve to promote it by requiring from the actor strong feelings to be communicated by physical playing, through action and reaction. This is especially true in comedy (see, e.g., fig. 3.10), where comic responses, takes, double takes, slow burns, false exits, recognitions, and reversals all feed into a kind of playing that will return in later centuries in the Italian commedia dell'arte (with some half-masks), and beyond the physical mask to the figurative one in the comedies of Molière, the English Restoration, and arguably even television sitcoms.

After the complicated range of characters in Aristophanes' comedies, Menander and his contemporaries might seem to have restricted their ambition by concentrating only on the kinds of individuals to be found in the city of Athens or the numerous villages in the surrounding area of Attika. What happens instead is that the broad political dimension of previous drama is transformed into what can better be described as comedy of manners. The earthy coarseness of Aristophanes becomes, if not sentimental, at least genteel, with the introduction of everyday concerns. Any attempts to change the world through the theater have disappeared into the mists of the previous century. If this may seem a watering down of drama's proper function, two factors are worth remembering. First, comedy reflects society, and Athenian society had changed significantly in the years after the death of Aristophanes. Athens was no longer a world center of political power and influence. Second, as the survival of ancient Greek plays into our own era demonstrates, a good play shows that, though the external features of life may change, the internals do not. The people of Menander are still recognizable—fallible and foolish, but at least attempting to live decent and moral lives.

In *The Woman from Samos* there are only six characters. Four appear in each of the five acts, one in four, and one in only one, an arrangement that suggests it was written for a cast of five actors. There is a father, Demeas, and his adopted son, Moschion. Chrysis, the woman from Samos, is what we would today call Demeas's partner. They cannot marry, even if Demeas were willing to, as she is not an Athenian. In addition, there is a neighbor, Nikeratos; a slave, Parmenon; and a cook who is featured in one important scene. The plot revolves around the paternity of a baby and is far too full of twists to summarize here. The various roles seem typical of a Menander comedy in that three of the characters are serious—that is, their relationships matter to them and to an audience. These three are drawn in depth with plausible and usually sympathetic reactions to what they think is happening (plate 89). The other three characters are from farce. They confuse rather than elucidate the plot, frequently making life harder for the central three. Their masks, in consequence, are likely to have been more grotesque (as in plate 86).

By good fortune, one of a series of mosaics from Mytilene features a crucial scene with the figures and the play identified by name (fig. 3.11). These mosaics are from later than Menander's time but are com-

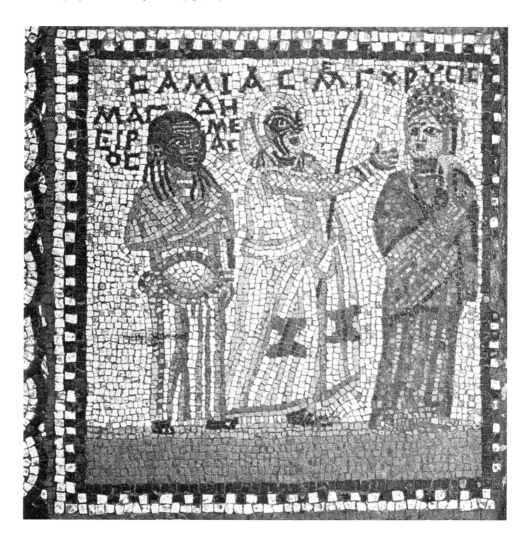

FIGURE 3.11

Scene from *The Woman from Samos* (*Samia*) by Menander.
Mosaic from the House of Menander, Mytilene
(Lesbos, Greece), late 3rd century B.C. Archeological Museum
of Mytilene. Reproduced from Charitonidis, Kahil,
and Ginouvès, pl. 4.1

posed to reflect an actual performance. In the center an angry Demeas is expelling Chrysis from his house for perceived infidelity. The language of the scene is harsh and cruel. The cook (*mageiros*), to the left, with dreadlocks and a dark complexion, is eavesdropping and tries to interfere. His dramatic function is to defuse the viciousness of Demeas's attack and allow the possibility of forgiveness and redemption by the end of the play. All three are clearly in character masks and address the scene accordingly. Their costumes are full and elaborate. Demeas, in the center and carrying a cane, has a light-colored, ankle-length chiton, with a long sleeve. The cook's legs are covered by trousers or a skirt. He has a short jacket across his shoulders and what appears to be a basket slung round his waist. Chrysis, the woman from Samos, is wearing an elaborate and colorful dress, and her mask is topped by a jeweled headdress. She also seems to be carrying the baby. Both men, and possibly Chrysis, have open-toed sandals. Such realism of costume is a far cry from the more numerous illustrations of comic performances in southern Italy in which the male characters, especially older ones, often wear padding and sport grotesque *phalloi* (e.g., plate 50).

Another Menandrian mosaic, this time by Dioskourides, shows three women sitting down to lunch (fig. 3.12). Their simple garments, more like the clothing of the day than stage costume, give an air of intimacy to this scene, often interpreted as one from Menander's *Women Lunching Together* (*Synaristosai*). In addition to such tableaux, figurines in many cases show slaves and other characters reacting as though giving a masked performance (plates 59–70). The popularity of terracotta masks produced for decorative and votive purposes during the fourth century B.C. and the Hellenistic period testifies to the popularity of Menander's characters in the absence of masks that were actually worn in a performance. There is enough similarity as well as variation to suggest that characters within New Comedy conformed to conventional types and were codified so clearly during Menander's career that they would remain recognizable for centuries. More than three hundred years after Menander's death, Julius Pollux in his *Onomastikon* (IV.143–54) identified forty-four character types in New Comedy, divided into groups of old men, young men (there seem to be no middle-aged men in Greek comedy), women, slaves, and professionals (brothelkeepers, doctors, parasites, cooks). Whether Pollux's idea of New Comedy is the same as ours is far from certain, but he gives plenty of leeway and plenty of scope for setting up situations in which his assortment of personalities can interact.

Menander and his lesser-known contemporaries represented a new direction for comedy, gentler but emotionally deeper than anything that had gone before. It would prove appealing to Italian audiences of the century after Menander's death, in adaptations by Plautus and Terence, and laid strong foundations for the whole European comic tradition.

FIGURE 3.12
Scene from *Women Lunching Together* (*Synaristosai*)
by Menander. Mosaic signed by Dioskourides, ca. 125–100 B.C.
Naples, Museo Archeologico Nazionale di Napoli 9987

SOCIAL AND DOMESTIC DRAMA | 135

71

Comic Mask of an Old Man

Early 4th century B.C.

Greek (Boiotian), possibly from Tanagra

Terracotta

H: 8.4 cm (3¼ in.)

Acquired in Paris, 1877

Copenhagen, The National Museum

of Denmark 992

THIS WHITE-BEARDED MASK with hair in a thickly rolled band around the forehead (*speira*) represents a version of the "old man" character popular in comedy from the time of Aristophanes through the plays of Menander in the fourth century B.C. The protruding eyes are large and globular and the mouth is wide open, showing the tongue. The brown terracotta is covered in white slip and painted for the skin, reddish brown for the hair, and light red for the face, lips, and tongue. The eyes are white with blue irises. BBR

BIBLIOGRAPHY: Breitenstein 1941, no. 323, pl. 38; Copenhagen 1970, p. 134, fig. 7.

72

Bust of Menander

A.D. 1–25

Roman

Bronze

H: 17 cm (6¹¹⁄₁₆ in.); Diam (base): 8 cm (3⅛ in.)

Malibu, J. Paul Getty Museum 72.AB.108

ALTHOUGH MORE THAN sixty portraits of this type survive today, the identity of the subject was long debated. Scholars agreed, however, that because the middle-aged, clean-shaven man was paired with illustrious literary figures on several double herms, he was almost certainly a popular poet or a playwright. The most likely candidates were the Roman poet Virgil and the Greek comic playwright Menander (342–291 B.C.). The inscription on the base of this bust, "Menandros," discovered by Bernard Ashmole in 1972, finally settled the argument and positively identified the portrait as the latter.

Menander is described in ancient sources as delicate and handsome despite a squint, which is possibly represented here by the closely set eyes. He died in his fifties, and soon afterward he was honored with a statue in the theater of Athens, created by Kephisodotos and Timarchos, sons of the great sculptor Praxiteles. The sculpture depicted him seated and was probably made of bronze. It is now lost but is attested in ancient sources (Pausanias I.21.1) and archaeological records. The base of a seated statue found behind the stage of the theater in 1862 bears the inscription *Menander, Kephisodotos and Timarchos made* [*this*] in Greek. The prominent display of the Greek original, from which the Getty's bronze bust may be derived, would have accounted for the popularity of the type. LM-C

BIBLIOGRAPHY: Ashmole 1973, p. 61, pls. 11, 12; Fittschen 1991, p. 252, no. 68, pl. 52, no. 3; Richter 1984, pp. 160–61, fig. 121.

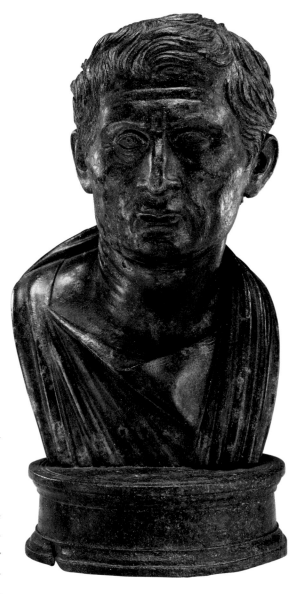

73

Seated Poet (Menander) with Masks of New Comedy

A.D. 40–60

Roman

White marble (probably Italian)

H: 44.3 cm (17⁷⁄₁₆ in.); W: 59.5 cm (23⁷⁄₁₆ in.);

D (greatest): 8.5 cm (3³⁄₈ in.)

Museum purchase, Caroline G. Mather Fund

Princeton, Princeton University Art Museum, y1951-1

OF THE PHYSIOGNOMIC ELEMENTS traditionally associated with Menander, only that of a beardless middle-aged man with a prominent Adam's apple can be used to identify the Greek comic playwright. The strongest argument in favor of this identification is the gesture of the seated man: he gazes at a theatrical mask that he holds in his left hand while two other masks of New Comedy and a scroll rest on the table before him. The masks can be identified as three canonical characters found in Menander's plays, which often revolved around the tribulations of young lovers: the youth, the false maiden, and the old man. The playwright abandoned the traditional mythological themes of Old Comedy in favor of more topical subjects to which viewers could more easily relate. The author of over one hundred plays and much more popular after his death than during his lifetime, Menander became the model and inspiration for later Roman playwrights such as Plautus and Terence.

A comparable relief in the Vatican Museums (Museo Gregoriano Profano 9985), which served as a model for the restoration of the head's upper part, attests to the popularity of Menander in Roman times. Better preserved, the relief presents a more complex composition with the addition of a draped figure on the far right, sometimes interpreted as Skene, the personification of the stage, Thalia, the muse of comedy, or Glykera, Menander's well-known mistress. The seated statue of Menander erected in the theater of Athens is often thought to have served as a prototype for the reliefs and numerous surviving portraits of the playwright (e.g., plate 72). LM-C

BIBLIOGRAPHY: Fittschen 1991, pp. 276–77; Ridgway 1994, 100–106, no. 32, illus.; *MNC*³, vol. 2, pp. 170–71, no. 3AS 5b; Sinn 2006, pp. 136–45, no. 38.

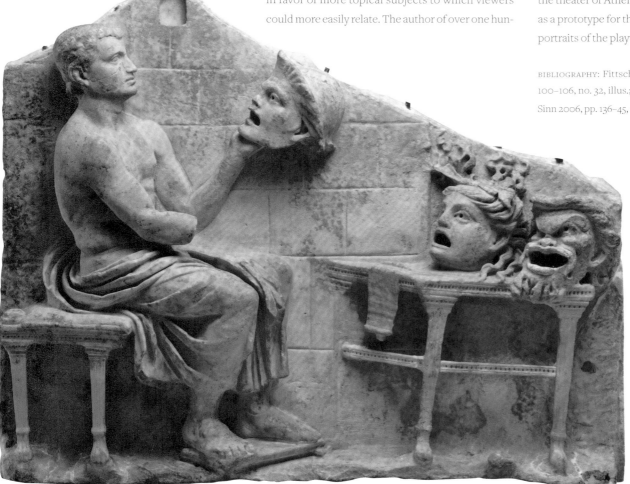

PLATE 73 | **137**

74

Comic Figurine of a Musician

150–100 B.C.

Found in Myrina, Turkey

Terracotta

H: 18.3 cm (7³⁄₁₆ in.)

Acquired in Smyrna (present-day Izmir), 1885

Berlin, Antikensammlung, Staatliche Museen zu
Berlin—Preußischer Kulturbesitz TC 7969

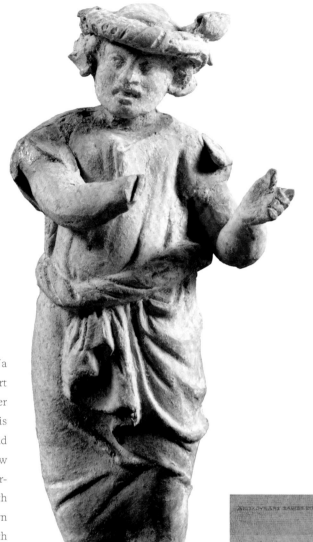

THIS FIGURE REPRESENTS an actor in the role of a
young man in a New Comedy play. He wears a short
pink chiton and a cloak that winds around his lower
body and extends down to his calves. Around his
hips the fabric forms a thick bulge, while the free end
falls down in front in a cascade of folds. His feet, now
lost, would have worn sandals. The mask character-
izes the figure as a beardless youth. A thick wreath
of flowers wound with a ribbon has slipped down
over his forehead. This is the sort of festive wreath
frequently worn at evening banquets. Whatever the
actor was holding in his extended hands, which has
been lost, must have been associated with revelry as
well. It was most likely a musical instrument. Given
the position of the hands, it may have been a *kithara*,
or possibly it was either a hand drum (*tympanon*) or a
pair of cymbals (*cymbala*) like those carried by simi-
larly costumed musicians in the Dioskourides mosaic
from Pompeii (fig. 3.13). This mosaic, signed by the
artist Dioskourides of Samos and now in the National
Archeological Museum in Naples, is known to repre-
sent a scene from Menander's comedy *The Possessed
Girl*, in which a young woman possessed by the spirit
of a god is lured out of the house with music. ASch

FIGURE 3.13

Scene from *The Possessed Girl* (*Theophoroumene*) by Menander.
Mosaic signed by Dioskourides, ca. 125–100 B.C.
Naples, Museo Archeologico Nazionale di Napoli 9985

BIBLIOGRAPHY: Bieber 1961, p. 94, no. 341; Rohde 1970, p. 48,
no. 35 (with illus.); *MNC³*, vol. 2, p. 198, no. 3DT 16a; Froning
2002, p. 94 (illus. on p. 132); Matthies 2006, p. 75ff., no. 166.

75

Comic Figurine of a Soldier

2nd century B.C.

Found in Myrina, Turkey (?)

Terracotta

H: 22.9 cm (9 in.); W: 8.6 cm (3⅜ in.);

D: 11.4 cm (4½ in.)

Purchased in 1883

Berlin, Antikensammlung, Staatliche Museen zu
Berlin—Preußischer Kulturbesitz TC 7820

AN EXTREMELY POPULAR figural type in comedy beginning in the fourth century B.C. was the soldier who boasted of his bravery and of largely fictitious "exploits." Under the name *miles gloriosus*, or "glorious soldier," he continues to appear in Roman comedies. The Berlin collection includes this Hellenistic example that probably dates from the second century B.C. It is inscribed NIKOS, which is identified as the mark of Nikostratos. The soldier is on the march with his kit; he gestures with his extended left hand. A broadsword and a field flask hang from his left hip. On his back he carries a bundle of clothing and his mess bowl. A soldier's cloak, sandals, and a *pilos* (cap) complete his uniform. In addition, to judge from the drilled hole in his right hand, he probably carried a lance. His beard is long and pointed, unlike beards of slaves, which were short and round. His face with its raised eyebrows and bulging eyes wears a devious expression that betrays his character. ASch

BIBLIOGRAPHY: Bruns 1948, p. 35, no. 23; Bieber 1961, p. 40, no. 153; *MNC*³, vol. 2, p. 193, no. 3DT 1a; Schwarzmaier 2006, pp. 65–69, no. IV.25, fig. 156.

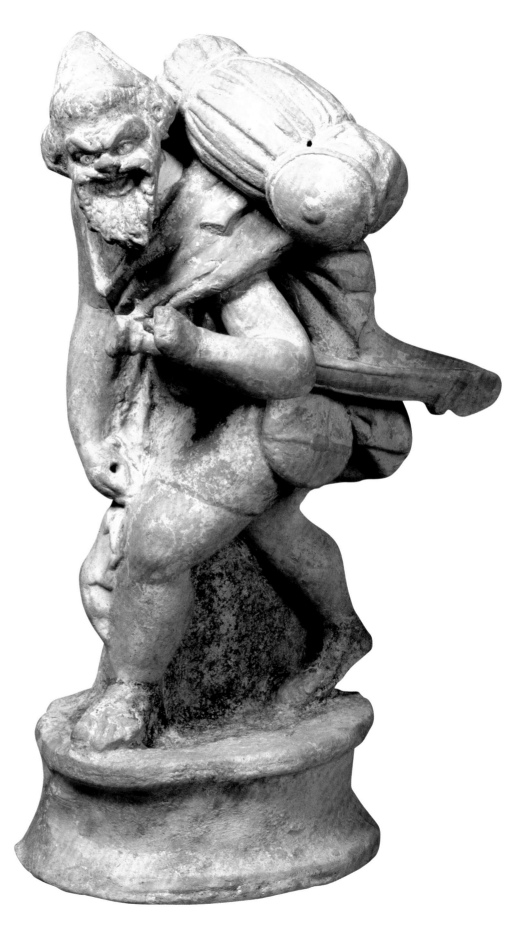

PLATE 75 | 139

76

Comic Mask Traditionally Identified as a *Pornoboskos*

200–135 B.C.

Found in Priene, Turkey; discovered in 1895 beneath the southwest corner of the Athena Terrace Room A or the adjacent room to the north

Terracotta

H: 20.3 cm (8 in.); W: 13 cm (5⅛ in.);

D: 11.4 cm (4½ in.)

Berlin, Antikensammlung, Staatliche Museen zu Berlin—Preußischer Kulturbesitz TC 8568

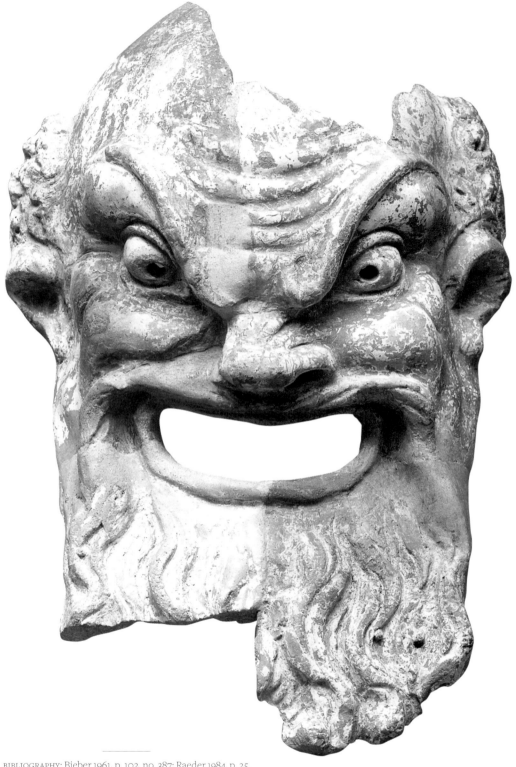

THIS MASK OF A BEARDED, bald-headed old man presents the usual grotesquely exaggerated features associated with characters from New Comedy. The eyeballs nearly pop out of their sockets, and the broad, short nose projects only slightly beyond the mustache. The slanted eyebrows form the shape of a *W* with the base of the nose, and accordingly the forehead, already high, appears to flow downward. A long beard of parallel wavy strands contrasts with the sparse wreath of hair framing the bald pate above his ears.

The long, well-tended beard makes it clear that this is not the mask of a slave. A terracotta figurine from Myrina in the Louvre combines this type of mask with a body clad like a respectable citizen in a shift and a calf-length cloak. The imperial-era dictionary by Julius Pollux, the *Onomastikon*, names four types of masks of old, bald-headed men employed in comedy. Their typical physiognomies must have differed, though the information in the text is contradictory. Scholars have traditionally associated the Berlin mask with the brothel-keeper (*pornoboskos*), a major figure in comedy. As a procurer, he is obviously an adversary of lovestruck young men of good family and stands in the way of their success. ASch

BIBLIOGRAPHY: Bieber 1961, p. 102, no. 387; Raeder 1984, p. 25, no. 19, pl. 4b; *MNC³*, vol. 2, p. 214, no. 3DT 90.1; Kriseleit 2003, p. 180; Rumscheid 2006, p. 530ff., no. 384, pl. 159.1 (with additional bibliog.).

77

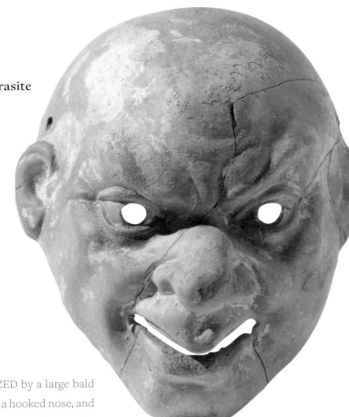

Comic Mask, Possibly a Parasite

Ca. 100 B.C.

From Myrina, Turkey

Terracotta

H: 14.3 cm (5⅝ in.);

W: 10.8 cm (4¼ in.);

D: 6.7 cm (2⅝ in.)

Acquired in 1887

Berlin, Antikensammlung,

Staatliche Museen

zu Berlin—Preußischer

Kulturbesitz TC 8152

THIS MASK IS CHARACTERIZED by a large bald pate, a projecting, knitted brow, a hooked nose, and shaved, sunken cheeks. The wide, protruding mouth, in contrast to that of other masks, is only slightly open. The fact that the mask is beardless links it with masks of young men in comedy, yet the exaggerated features, particularly the hawklike nose, indicate negative character traits. Scholars have therefore associated the mask with the familiar New Comedy type of the sycophant or parasite attached to a wealthy patron. Features such as the bald pate and the hooked nose, however, are closer in form to those of masks connected with early Roman pantomime. ASch

BIBLIOGRAPHY: Bieber 1961, p. 100, pl. 373a–b; Kriseleit 2003, p. 181.

78

Comic Mask of the Admirable Young Man

2nd–1st century B.C.

From South Italy

Terracotta

H: 9.2 cm (3⅝ in.); W: 10.9 cm (4¼ in.);

D: 11.1 cm (4⅜ in.)

Würzburg, Antikensammlung, Martin von Wagner

Museum der Universität Würzburg H 4613

THIS CERAMIC MASK, a small-scale replica of an actual mask, served as a votive object or tomb offering. It represents one of Menander's favorite character types: the young man of good repute who against all odds—and all plot twists—manages to find happiness with the girl he loves.

This mask was produced in a mold, finished with a modeling stylus, and painted. Traces of red pigment survive on the hair, lips, and left eye. The eyes have been pierced and the mouth cut out as on real masks. IW

BIBLIOGRAPHY: Charitonidis, Kahil, and Ginouvès 1970, p. 71, fig. 25.2; Schmidt (E.) 1994, no. 254; Moraw and Nölle 2002, p. 92, fig. 130.

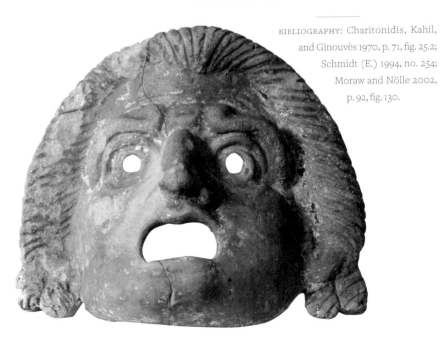

79

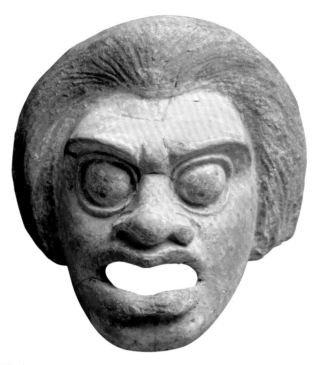

Comic Mask of a Peasant

325–250 B.C.

Greek (Boiotian); found in Tanagra

Terracotta

H: 8.1 cm (3¼ in.)

Paris, Musée du Louvre MNB 506

THIS MINIATURE REPRODUCTION gives us a sense of what theater masks that no longer exist must have looked like. By referring to the list compiled by Julius Pollux in his *Onomastikon*, we can recognize in this clay mask, thanks to very well-defined features (a pug nose, the crown of hair) and the particularly well-preserved polychromy (the "dark skin" of Pollux), the face of a peasant. Although this type of work is believed to have originated in Attika, this very expressive Boiotian version is one of the most beautiful examples. A tomb offering in Tanagra, this type of mask has also been found in sanctuaries. JB

BIBLIOGRAPHY: Besques 1972, D 223; *MNC*³, vol. 1, p. 20, and vol. 2, p. 21, no. 1AT 47; Jeammet 2003, exh. cat., no. 157.

80

Comic Figurine of a Slave Seated on an Altar

325–275 B.C.

From Apulia, South Italy

Terracotta

H: 10.3 cm (4¹/₁₆ in.)

Gift of Barbara and Lawrence Fleischman

Malibu, J. Paul Getty Museum 96.AD.164

IN THE COMEDIES of Menander boisterous slaves often take refuge in a sanctuary, where they sit on an altar to escape punishment and plot future intrigues.

This terracotta statuette represents a comic actor poised on an altar with his legs crossed, his right arm folded at the waist, and his left hand raised to his chin in a "plotting" gesture. He wears the characteristic slave's costume of a short, belted tunic over a long-sleeved garment, leggings, and sandals.

The essential component of the comic costume was the mask, which often emphasized grotesque aspects of comedy. This mask shows the eyebrows knitted together, a wide, grimacing mouth, and the thick, back-combed coiffure known as a *speira*. In many versions the mask obscures the face of the actor who wears it, but here, as in the marble statue of an actor costumed as Papposilenos (plate 41), it is possible to see the actor's lips inside the mouth of the mask. The energetic pose, the exaggerated wide-open mouth, and the jauntily tipped head communicate a vivid sense of humor. AS

BIBLIOGRAPHY: Bieber 1961, p. 104, fig. 406, p. 150, figs. 556–558; Higgins 1969, p. 200, pl. 98, no. 743; *MMC*³, p. 124, pl. Va, b; True and Hamma 1994, pp. 233–34, no. 117.

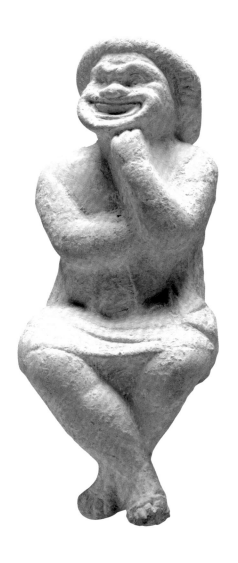

81

Comic Figurine of the Main Slave with Curly Hair

Late 1st century B.C.
Produced and found in Myrina, Turkey
Terracotta
H: 17.5 cm (6⅞ in.)
Paris, Musée du Louvre Myr 317 (Myrina 124)

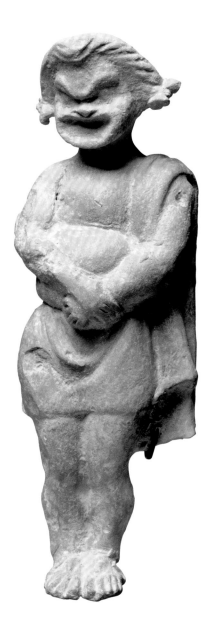

THIS TERRACOTTA FIGURINE represents a male figure wearing a cloth rolled around his hips, a himation thrown over his left shoulder, and a mask. We recognize an actor of the New Comedy here, one who has abandoned the cumbersome Old Comedy costume of a stomach, buttocks, and a false *phallos*. The wig that comes to a point on either side of the face, the very expressive mask with furrowed brow, the wrinkled forehead, the pug nose, and a grimacing mouth surrounded by a short, curly beard all indicate that this is a slave. According to T. B. L. Webster, it might be the "main slave with curly hair" (*episeistos egemon*) listed by Julius Pollux in the *Onomastikon* among the forty-four masks of comedy. The figure is in an unusual position here, with his legs together and his hands folded on his stomach as if he is waiting, upset, or preoccupied. Along with the "main slave," who differs only in the hair, our "main slave with curly hair" leads the group of seven slaves (one of whom is freed). The main slave with curly hair is a recurring motif in terracotta or bronze figurines and is also found on lamps and attachments to furniture. NM

BIBLIOGRAPHY: Winter 1903, pl. 425, no. 7b; Bieber 1961, fig. 405; Besques 1963, p. 141, pl. 172F; *MNC³*, vol. 1, p. 34, and vol. 2, p. 276, no. 4DT 7a.

PLATE 81 | 143

THE ACTORS FROM TOMB C OF MYRINA

NÉGUINE MATHIEUX

THE FIVE FIGURINES SHOWN IN PLATES 81–85, all representing actors, were discovered in the same tomb on September 11, 1880, in the necropolis of Myrina. The characters belong to New Comedy, which satirized the manners of the Athenian bourgeoisie by using easily recognized, stereotypical characters. Their masks—less comic than expressive—and simple costumes served to identify them. Labeling the characters precisely according to the types listed in the *Onomastikon* of Julius Pollux may not be advisable, given not only the great chronological gap between these archaeological artifacts and Pollux's work but also the ambiguity of this isolated literary source. Furthermore, the idea of a strict correspondence between theatrical reality and figural representation is questionable. However, general characterization of a role, particularly when indicating social status, may be especially pertinent for figurines discovered in a funerary context.

Four of the figurines—plates 81–84—represent the character of the slave, who could be either honest or, as here, the deceitful accomplice of a debauched son who appears costumed as a soldier (plate 85). The figurines are caught in animated movement and seem together to compose a single scene.

The unity of the group of slave figurines is strengthened by the identical treatment of the clothing and the similar morphology of the short-legged, plump bodies. The production technique is also very similar: all the figurines are made of a micaceous pinkish-brown clay and show very similar vent holes and the same detail work. To the group of actor figurines found in Myrina, two tragedic masks may be added (Myr 341 and Myr 351).

The figurines must have been specifically commissioned for placement in a tomb. Measuring 1.91 meters in length, 0.54 meter in width, and 0.45 meter in depth, the tomb in which they were found was discovered filled with dirt, and the disintegration of the bones made it impossible to determine the gender or age of the deceased.[1] The presence of an iron strigil next to seven clay flasks was, unfortunately, not enough to confirm the masculine nature of the grouping. Also found were five cloaked erotes, reinforcing the masculine tone of the iconography, a terracotta bas relief showing Aphrodite on a bed surrounded by little erotes, and an unusual piece in the shape of an architectural element on which appears a shield decorated with a Gorgoneion pendant, which may perhaps support the military status of the actors playing young men. The diversity of these objects makes it difficult to understand the function and the meaning of the grouping.

One frequently finds figurines of actors in a funerary context. Tomb 114 in Myrina offers another coherent grouping belonging to the world of theater.[2] Other necropolises in the Mediterranean basin—such as those of Olynthus and Athens, and especially that of Lipari in Italy—have also revealed a large number of actor figurines. These intentional groupings of figures may in some cases indicate the success of the theatrical genre and the popularity of the cult of Dionysos; in other cases they may reveal simply the tastes of the deceased, perhaps an actor himself. These funeral offerings might also relate to the Dionysian mysteries that guaranteed the deceased a happy fate in the hereafter.[3] Recent interpretations see the theater itself as a symbol of transformation. Because an actor incarnates someone other than himself on the stage, and incarnates different moments of existence under the aegis of the gods, perhaps his presence in a tomb relates to the "other being" of the deceased,[4] and was the guarantor of a successful passage between life and death.[5]

NOTES

1 Pottier and Reinach 1887, p. 94.

2 Pottier and Reinach 1887, pp. 98–99.

3 Peredolskaja 1964.

4 Mrogenda 1996, pp. 18–21, 69–73, 139–41, pl. 3.

5 Lucchese 2005, pp. 437–61.

82

Comic Figurine of a Slave
Seated on an Altar

50–1 B.C.

Produced and found in Myrina, Turkey

Terracotta

H: 16.5 cm (6½ in.)

Paris, Musée du Louvre Myr 318 (Myrina 265)

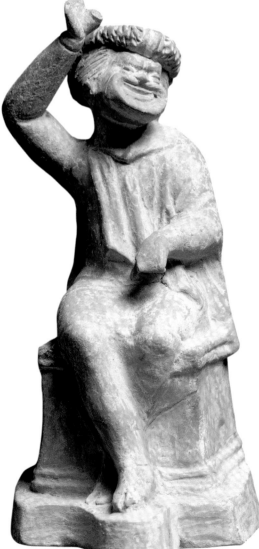

THE FIGURE OF THE SLAVE can be recognized by his excessive gestures and character traits. Wearing a short chiton and a scarf covering his shoulders, he is seated, his legs crossed; with his right arm raised, he seems to be protecting himself. He is the deceitful slave who, after committing one of his stupid or wily deeds, takes refuge on an altar to escape punishment. The presence of the crown assures his immunity even more, as a character in Aristophanes' *Wealth* suggests: "Now that I am crowned you won't beat me" (V. 21). This character from the Old Comedy was one of the most familiar until the Roman period, and it was very often represented in terracotta (another such piece—Myr 671 in Besques 1963—was discovered in Myrina), as well as in bronze, ivory, or marble (see plates 68, 86, 87). NM

BIBLIOGRAPHY: Winter 1903, pl. 425, no. 5; Besques 1963, p. 142, pl. 173A; *MMC³*, vol. 2, p. 277, no. 4DT 9; Lucchese 2005, p. 439, no. 10.

83

Comic Figurine of a Bald-Headed Slave

50–1 B.C.

Produced and found in Myrina, Turkey

Terracotta

H: 17 cm (6¾ in.)

Paris, Musée du Louvre Myr 319 (Myrina 214)

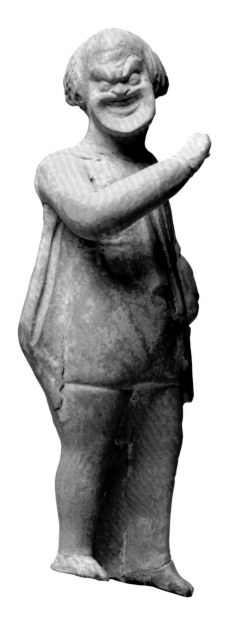

84

Comic Figurine of a Slave

50–1 B.C.
Produced and found in Myrina, Turkey
Terracotta
H: 16 cm (6¼ in.)
Paris, Musée du Louvre Myr 320 (Myrina 37)

STANDING, wearing a short chiton and a scarf, this actor seems to be taking part in an animated scene: his head is turned toward his raised right arm, and he is sticking his left leg forward. His bearded mask with a furrowed brow and megaphone-shaped mouth opening, as well as his wig, which shows a bald spot, indicate that he is perhaps the "slave *maison*" (*maison therapon*), the local cook mentioned by Pollux, Athenaeus (XIV.659a), and Festus (134 M). NM

BIBLIOGRAPHY: Winter 1903, pl. 425, no. 3; Webster 1961, p. 79, MT 4; Besques 1963, p. 141, pl. 172B; *MNC³*, p. 277, no. 4DT 14.

THIS FIGURINE is of an actor representing a slave. Among the masks described by Julius Pollux, we can here perhaps recognize the "main slave" (*hegemon therapon*), with rolls of red hair and a furrowed brow. Standing, the right arm holding the left arm close to the face, he seems caught in a pensive and reflective attitude unusual for this strong and rebellious character. One can easily imagine a wily slave attempting to get out of a scrape or hatching one of his plots. NM

BIBLIOGRAPHY: Winter 1903, pl. 425, no. 4; Webster 1961, p. 80, MT 5; Besques 1963, p. 142, pl. 172D; Higgins 1969, p. 117, pl. 56, fig. C; *MNC³*, vol. 2, p. 276, no. 4DT 8.

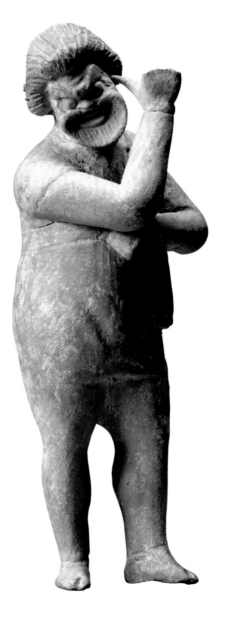

PLATE 84 | 147

85

Comic Figurine of a Young Man

50–1 B.C.

Produced and found in Myrina, Turkey

Terracotta

H: 16 cm (6¼ in.)

Paris, Musée du Louvre Myr 322 (Myrina 383)

THIS FIGURINE OF AN ACTOR stands out from others (plates 80–84) in the soberness of the symmetrical features of the mask, the straight nose, and the regular mouth. Only the slight opening of the eyes and the opening of the mouth enable us to see that it is a mask rather than an actual face. The presence of a wig that covers the hair, visible from behind, confirms that this is a character from New Comedy. In the mask and the long hair of this figure, wearing a short, belted chiton and a scarf attached to the right shoulder, T. B. L. Webster has recognized the type representing the "long-haired soldier" (*episeistos stratiotes*), one of the eleven New Comedy figures of a young man described by Julius Pollux. NM

BIBLIOGRAPHY: Winter 1903, pl. 430, no. 2; Webster 1961, p. 81, MT 16; Besques 1963, p. 142, pl. 173C; *MNC³*, vol. 2, p. 275, no. 4DT 5.

86

Molded Flask in the Form of a Comic Slave Seated on an Altar

Ca. 150 B.C.

Magenta Group

From Campania, South Italy

Terracotta

H: 11.9 cm (4¹¹⁄₁₆ in.)

London, The British Museum 1873,1020.2

THE FAT SLAVE wearing a mask with a broad grin sits perched on an altar. Often in trouble because of their pranks, whether working for their own benefit or on behalf of others, mischievous slaves would seek refuge on an altar in order to place themselves under the protection of a god and escape looming punishment. Red pigment survives on the face and the sandals, blue on the fillet, and brown on the hair. While the majority of these statuettes are simple terracotta mold-made sculptures, this one is hollow inside and has been shaped in the form of a flask to hold liquid. MLH

BIBLIOGRAPHY: Walters 1903, D 322, pl. 34; Bieber 1961, fig. 411; Green and Handley 1995, pp. 80–81, fig. 53.

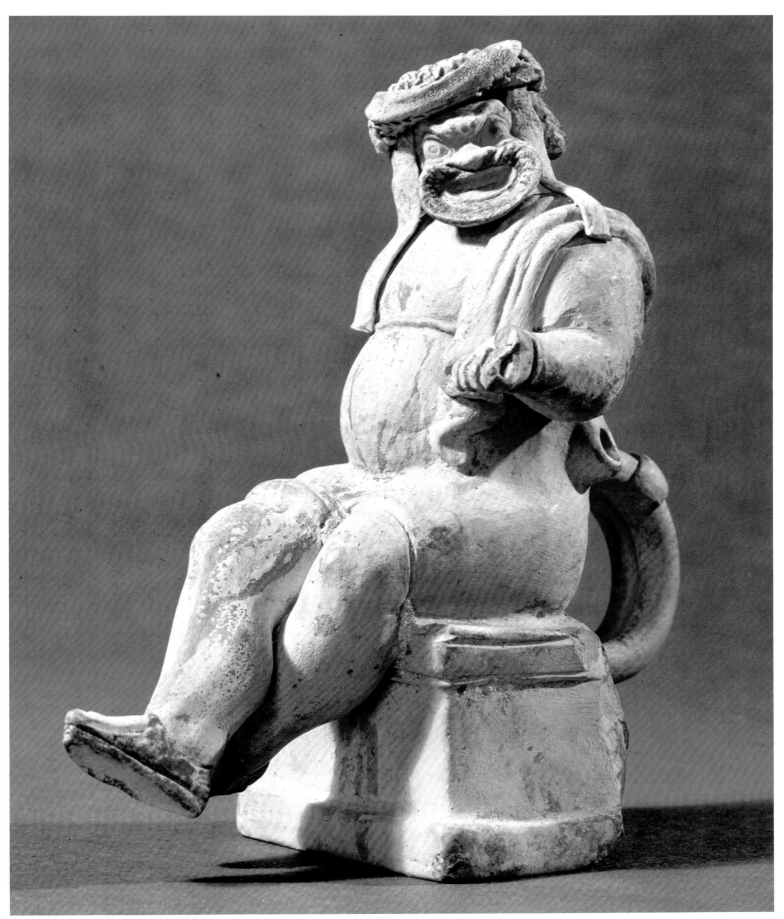

PLATE 86 | 149

87

Incense Burner in the Form of a Comic Actor Seated on an Altar

A.D. 1–50
Roman
Bronze with inlaid silver
H: 23.2 cm (9⅛ in.); W (base): 13.3 cm (5¼ in.)
Malibu, J. Paul Getty Museum 87.AC.143

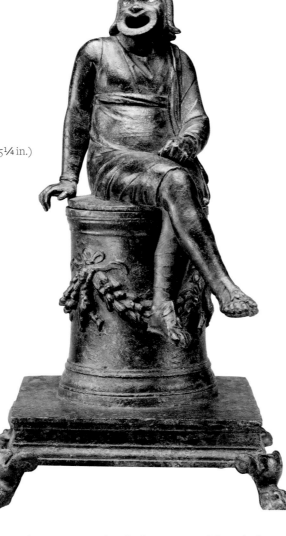

88

Comic Mask of a Slave

2nd century B.C.
Found in Melos, Greece
Terracotta
H: 8.9 cm (3½ in.); W: 8.3 cm (3¼ in.);
D: 6.4 cm (2½ in.)
Acquired in 1856
Berlin, Antikensammlung, Staatliche Museen zu
Berlin—Preußischer Kulturbesitz TC 5166

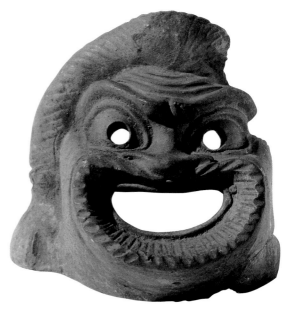

THE FIGURE PERCHED atop the altar wears the typical garb of a comic actor: long-sleeved undergarment and long-legged tights, short tunic, skimpy mantle, and laced sandals. The mask with a frowning brow, mischievous eyes inlaid in silver, snub nose, trumpet-like mouth, and hair combed in a pompadour-like hairstyle called a *speira* identifies the figure as a stock character of New Comedy: the leading slave. Poised, the slave leans back on a cylindrical altar decorated with wingless cupids carrying garlands. His left hand is pierced and originally held a detached wig, suggesting a plot related to disguise, possibly *The Eunuch*, written by Menander and later revived by the Roman comic playwright Terence. The top of the altar swivels on a pin to reveal a hollow compartment perforated with eleven irregular holes at the bottom. This provision for ventilation indicates that the object was used as an incense burner, or thymiaterion, designed so that the fumes emitted from the burning incense would rise through the gaping mouth of the mask.

The slave seeking refuge on the altar to escape punishment for his misdeeds was a recurring theme in Hellenistic and Roman art in various media (e.g., see plates 80, 82, 86). The use of this object as a practical device testifies to the popularity of New Comedy in Roman times, when slaves acquired even greater roles, becoming more impudent and ingenious. The leading slave often appears as a schemer in Menander's plays. In *The Woman from Perinthos* the slave Daos seeks sanctuary on an altar around which Laches, his master, lights a fire to dislodge him.

LM-C

BIBLIOGRAPHY: Seeberg 1986, pp. 270–74; True 1988, pp. 300–302, no. 54; Oliver 1993, pp. 331–36.

89

Comic Mask of a *Hetaira*

3rd–2nd century B.C.

From South Italy

Terracotta

H: 10.6 cm (4³⁄₁₆ in.); W: 10.7 cm (4¼ in.);

D: 16.6 cm (6½ in.)

Würzburg, Antikensammlung, Martin von Wagner

Museum der Universität Würzburg H 4683

THIS MASK, from which a piece of the left temple and the attached hair are missing, is dominated by a wide-open mouth framed by a short, round beard. This funnel-like opening in the form of a recumbent half-moon takes up the entire lower half of the face. Wide-open eyes with large round openings, protruding raised eyebrows, and curved projecting lines representing furrows in the brow characterize the top half. It is framed by the simple rolled arrangement of hair called a *speira*. The grotesque features and the funnel-like mouth formed by the beard are attributes of slave masks from New Comedy. Tradition ultimately credited the playwright Menander not only with the invention of New Comedy but also with the creation of the associated masks, an important feature of comedy up into Roman imperial times. Pompeian wall paintings based on early Hellenistic pictures of the theater present this type of slave mask in association with young lovers who are obviously in trouble. The mask is therefore that of a kindly household slave who as their confidant attempts to help them. ASch

BIBLIOGRAPHY: Bieber 1961, p. 102, no. 390; *MNC³*, vol. 2, p. 280, no. 4DT 27; Kriseleit 2003, p. 179.

THIS EXCEPTIONAL full-head ceramic mask is a small-scale reproduction of an actual mask and served as a votive object or tomb offering. The *hetaira* (prostitute) type from the comedies of Menander was popular and occurred in many varieties. It can be identified from the manner in which the hair is wrapped around the head and tied.

This clay mask was made in a mold, finished with a modeling stylus, and painted. Traces of brown pigment remain on the hair. The eyes have been pierced and the mouth cut out as on real masks. IW

BIBLIOGRAPHY: Simon 1982, pp. 32–33, fig. 12.2; Schmidt (E.) 1994, no. 253.

PLATE 89 | 151

90

Comic Mask of a *Hetaira*

3rd–1st century B.C.

Provenance unknown

Terracotta

H: 12 cm (4¾ in.)

Copenhagen, The National Museum
of Denmark 3246

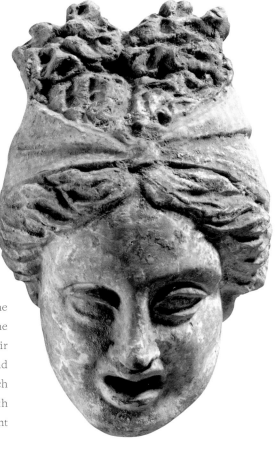

THIS IS AN EXEMPLARY VERSION of one of the
more popular types of New Comedy masks, the
hetaira (prostitute). Typically, her upswept hair
is parted in the middle and covered by a broad
fillet knotted in the front. The mask retains much
of its original pigmentation, light brown with
traces of white slip, traditionally used to represent
female skin. BBR

BIBLIOGRAPHY: Breitenstein 1941, no. 598, pl. 72; Copenhagen
1970, p. 136, fig. 11.

91

Mold of a Comic Female Character

Ca. 200 B.C.

From Taranto, South Italy

Terracotta

H: 14.6 cm (5¾ in.)

London, The British Museum 1887, 0725.7

MOST OF THE TERRACOTTA figurines and masks
in this exhibition were cast from a mold, not formed
by hand. This ancient mold of an actor costumed as a
chattering, plump old woman—perhaps a procuress
or a slave in disguise—is symptomatic of the kind
of ancient coroplastic device used to mass-produce
popular terracotta figurines of all kinds.

Molds have a long tradition of being used to
meet the public's demand for figurines. Plates 59–70
present a good comparative assortment of comic
mold-made figurines produced not only in Athens
but all over the Mediterranean during the fourth cen-
tury B.C. This later mold from Magna Graecia dem-
onstrates the continuity of the tradition; in this case,
to fill a demand for characters from the comedies
of Menander.

The modern plaster cast shown in fig-
ure 3.14 illustrates how an early figurine made from
this mold would have looked. The liveliness of this
figurine is striking. The character's energy is commu-
nicated through the tautly pulled folds of the cloak,
which twists as the figure seems to move forward and
turn her head at the same time. Her large, bulbous
eyes appear to be focused on something or someone,
and the open mouth of her mask indicates that she is
speaking loudly. MLH

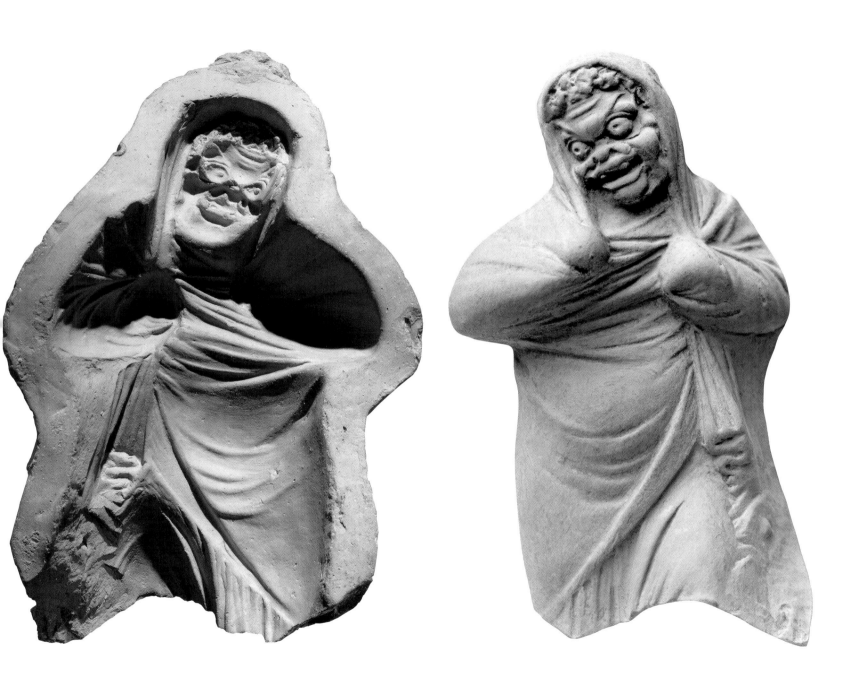

BIBLIOGRAPHY: Walters 1903, E 31; Bieber 1961, fig. 354; Green and Handley 1995, pp. 77–78, fig. 49.

FIGURE 3.14

Comic Female Character. Modern cast made from the antique mold shown in plate 91. Plaster, H: 13.3 cm (5¼ in.). London, The British Museum 1887,0725.7

PLATE 91 | **153**

92

Comic Mask of an Old Woman

3rd–2nd century B.C.

From Taranto, South Italy

H: 8 cm (3⅛ in.); W: 8.6 cm (3⅜ in.);

D: 9.6 cm (3¾ in.)

Würzburg, Antikensammlung, Martin von Wagner
Museum der Universität Würzburg H 4715

THIS CERAMIC MASK is a replica of an actual mask
and served as a votive object or tomb offering. With
exaggerated wrinkles on the forehead and cheeks,
it possibly represents the character type of the "old
procuress" from Menander's comedies. Clay masks
like this one were produced in molds, finished with
a modeling stylus, and painted. Unlike many other
masks, this one does not have its pupils and mouth
drilled with holes to approximate the openings on
a real mask. Presumably the pupils and teeth were
painted. IW

BIBLIOGRAPHY: Charitonidis, Kahil, and Ginouvès 1970, p. 71,
fig. 25.2; Simon 1982, pp. 32–33, fig. 12.1–2; Schmidt (E.) 1994,
nos. 219, 253, 254; Moraw and Nölle 2002, p. 92, fig. 130.

REFERENCES

ABBREVIATIONS

AA	*Archäologischer Anzeiger*
ABV	J. D. Beazley. 1956. *Attic Black-Figure Vase Painters*. Oxford.
AJA	*American Journal of Archaeology*
AJP	*American Journal of Philology*
AK	*Antike Kunst*
ARV²	J. D. Beazley. 1963. *Attic Red-Figure Vase Painters*, 2nd ed. Oxford.
Babesch	*Bulletin Antieke Beschaving*
BAdd²	T. H. Carpenter et al. 1989. *Beazley Addenda*, 2nd ed. Oxford.
BAPD	Beazley Archive Pottery Database: www.beazley.ax.ac.uk
BICS	*Bulletin of the Institute of Classical Studies*
CIG	*Corpus Iscriptionum Graecarum*
CJ	*Classical Journal*
CVA	*Corpus Vasorum Antiquorum*
DFA²	A. W. Pickard-Cambridge. *The Dramatic Festivals of Athens*, 2nd ed. by J. Gould and D. M. Lewis, 1968; reissued with supplement and corrections, 1988. Oxford.
DTC²	A. W. Pickard-Cambridge. 1962. *Dithyramb, Tragedy, and Comedy*, 2nd ed. revised by T. B. L. Webster. Oxford.
JHS	*Journal of Hellenic Studies*
IGD	A. D. Trendall and T. B. L. Webster. 1971. *Illustrations of Greek Drama*. London.
LCS	A. D. Trendall. 1967. *The Red-Figured Vases of Lucania, Campania, and Sicily*. Oxford.
LCS supp. 1	A. D. Trendall. 1970. *The Red-Figured Vases of Lucania, Campania, and Sicily*, 1st supplement. London.
LCS supp. 2	A. D. Trendall. 1973. *The Red-Figured Vases of Lucania, Campania, and Sicily*, 2nd supplement. Oxford.
LCS supp. 3	A. D. Trendall. 1983. *The Red-Figured Vases of Lucania, Campania, and Sicily*, 3rd supplement. Oxford.
LIMC	*Lexicon Iconographicum Mythologiae Classicae*. Vols. I (1981), II (1984), III (1986), IV (1988), V (1990), VI (1992), VII (1994), VIII (1997), Indices (1999). Zurich and Munich.
MeditArch	*Mediterranean Archaeology*
MMC³	T. B. L. Webster. 1978. *Monuments Illustrating Old and Middle Comedy*, 3rd ed. revised and enlarged by J. R. Green. (*BICS* supp. 39.) London.
MNC	T. B. L. Webster. 1961. *Monuments Illustrating New Comedy*. London.
MNC³	J. R. Green and A. Seeberg. 1995. Revised and enlarged edition of T. B. L. Webster's *Monuments Illustrating New Comedy*, vols. 1 and 2. (*BICS* supp. 50.) London.
MTS²	T. B. L. Webster. 1967. *Monuments Illustrating Tragedy and Satyr-Play*, 2nd ed. (*BICS* supp. 20.) London.
OCD	S. Hornblower and A. Spawforth, eds. 1996. *The Oxford Classical Dictionary*, 3rd ed. Oxford.
OJA	*Oxford Journal of Archaeology*
Para²	J. D. Beazley. 1971. *Paralipomena: Additions to Attic Black-Figure Vase-Painters and to Attic Red-Figure Vase-Painters*, 2nd ed. Oxford.
RA	*Revue archéologique*
RM	*Römische Mitteilungen*
RVAp	A. D. Trendall and A. Cambitoglou. *The Red-Figured Vases of Apulia*. Vol. 1 (1978), vol. 2 (1982). Oxford.
RVAp supp. 1	A. D. Trendall and A. Cambitoglou. *The Red-Figured Vases of Apulia*, supplement 1. 1983. London.
RVAp supp. 2	A. D. Trendall and A. Cambitoglou. *The Red-Figured Vases of Apulia*, supplement 2. Part 1 (1991), part 2 (1992), part 3 (1992). London.
RVP	A. D. Trendall. 1987. *The Red-Figured Vases of Paestum*. Oxford.
RVSIS	A. D. Trendall. 1989. *Red Figure Vases of South Italy and Sicily*. London.
ThesCRA	*Thesaurus Cultus et Rituum Antiquorum*. 2004. Los Angeles. J. Paul Getty Museum and Fondation pour le Lexicon Iconographicum Mythologiae Classicae.

Aellen 1994. C. Aellen. *A la recherche de l'ordre cosmique, forme et fonctions des personnifications dans la céramique italiote*, 2 vols. Zurich.

Allan 2001. W. Allan. "Euripides in Megale Hellas: Some Aspects of the Early Reception of Tragedy." *Greece and Rome* 48 (no. 1): 67–86.

Allard Pierson Museum 1980. *A Guide to the Collections of the Allard Pierson Museum*. Amsterdam.

Arias, Hirmer, and Shefton 1962. P. E. Arias, M. Hirmer, and B. B. Shefton. *A History of Greek Vase Painting*. London.

Arnott 1989. P. D. Arnott. *Public and Performance in the Greek Theatre*. London.

Ashby 1999. C. Ashby. *Classical Greek Theatre: New Views of an Old Subject*. Iowa City, Iowa.

Ashmole 1973. B. Ashmole. "Menander: An Inscribed Bust." *AJA* 77 (no. 1): 61, pls. 11, 12.

Bacileri 2001. C. Bacileri. *La rappresentazione dell'edificio teatrale nella ceramica italiota*. BAR International Series 997. Oxford.

Barcelona 2000. *La fundación de la ciudad*. Exh. cat. Barcelona.

Barker, Beaumont, and Bollen 2004. C. D. Barker, L. A. Beaumont, and E. A. Bollen, eds. Festschrift in Honour of J. Richard Green. (*MeditArch* 17.) Sydney.

Beazley 1928. J. D. Beazley. *Greek Vases in Poland*. Oxford.

———1952. J. D. Beazley. "The New York 'Phlyax Vase.'" *AJA* 56: 193–95.

———1955. J. D. Beazley. "Hydria Fragments in Corinth." *Hesperia* 24 (no. 4): 305–19.

Belli 1970. C. Belli. *Il Tesoro di Taras*. Milan.

Berard 1966. C. Berard. "Une nouvelle péliké du Peintre de Geras." *AK* 9: 93–94.

Bernabò Brea 1981. L. Bernabò Brea. *Menandro e il teatro greco nelle terracotte liparesi*. Genoa.

———1998. L. Bernabò Brea. *Le maschere ellenistiche della tragedia greca*. Naples.

Besques 1954. S. Besques. *Catalogue raisonné des figurines et reliefs en terre cuite grecs, étrusques, et romains*, vol. 1. Paris.

———1963. S. Besques. *Catalogue raisonné des figurines et reliefs en terre-cuite grecs, étrusques, et romains*, vol. 2. Myrina and Paris.

———1972. S. Besques. *Catalogue raisonné des figurines et reliefs en terre cuite grecs, étrusques, et romains*, vol. 3. Paris.

Bianco 1998. S. Bianco. "Pelike con la leggenda degli Eraclidi." In *Tesori dell'Italia del sud: Greci e indigeni in Basilicata*, p. 256. Milan.

Bieber 1961. M. Bieber. *History of the Greek and Roman Theater*, 2nd ed. Princeton.

Billing 2008. C. M. Billing. "Representations of Greek Tragedy in Ancient Pottery: A Theatrical Perspective." *New Theatre Quarterly* 24 (no. 3): 229–45.

Blome 1999. P. Blome. *Basel Museum of Ancient Art and Sammlung Ludwig*. Zurich.

Boardman 1975. J. Boardman. *Athenian Black Figure Vases: A Handbook*. London.

———1978. J. Boardman. *Athenian Red Figure Vases: The Archaic Period*. London.

———1989. J. Boardman. *Athenian Red Figure Vases: The Classical Period*. London.

Böhr 1982. E. Böhr. *Der Schaukelmaler*. Mainz.

Borda 1966. M. Borda. *Ceramiche Apule*. Bergamo.

Bouquillon, Zink, and Porto 2007. A. Bouquillon, A. Zink, and E. Porto. "Les Tanagras du Louvre à la lumière des analyses scientifiques." In *Tanagras: De l'objet de collection à l'objet archéologique*, edited by V. Jeammet, pp. 91–99. Paris.

Breitenstein 1941. N. Breitenstein. *Catalogue of Terracottas: Cypriote, Greek, Etrusco-Italian, and Roman*. Copenhagen.

Brijder 1983. H. A. G. Brijder. *Siana Cups I and Komast Cups*. Amsterdam.

———1986. H. A. G. Brijder. "A Pre-dramatic Performance of a Satyr Chorus by the Heidelberg Painter." In *Enthusiasmos: Essays on Greek and Related Pottery*, edited by H. A. G. Brijder, A. A. Drukker, and C. W. Neeft, pp. 69–82. Amsterdam.

———1991. H. A. G. Brijder. *Siana Cups II*. Amsterdam.

Brijder and Jurriaans-Helle 2002. H. A. G. Brijder and G. Jurriaans-Helle. *A Guide to the Collections of the Allard Pierson Museum*. Amsterdam.

Brommer 1959. F. Brommer. *Satyrspiele: Bilder griechischer Vasen*. Berlin.

———1968. F. Brommer. "Antike Stelzentänze: Gypones und Hypogypones." *AK* 11.1: 50–52.

———1973. F. Brommer. *Vasenlisten*. Marburg.

Buranelli and Sannibale 2003. F. Buranelli and M. Sannibale. *Vaticano 3: Museo Gregoriano Etrusco*. Milan.

Buxton 2009. R. Buxton. *Forms of Astonishment: Greek Myths of Metamorphosis*. Oxford.

Cambitoglou 1977. A. Cambitoglou. "Two Vases by the Truro Painter in the Nicholson Museum, Sydney." In *Festschrift für Frank Brommer*, edited by U. Höckmann and A. Krug, pp. 67–76. Mainz.

———1979a. A. Cambitoglou, ed. *Studies in Honour of Arthur Dale Trendall*. Sydney.

———1979b. A. Cambitoglou. "Three Apulian Red-Figure Fragments in the Nicholson Museum, Sydney." In Cambitoglou 1979a, pp. 47–55.

Cambitoglou and Chamay 1997. A. Cambitoglou and J. Chamay. *Céramique de Grande Grèce: La collection de fragments Herbert A. Cahn*. Kilchberg, Switz.

Cambitoglou and Trendall 1961. A. Cambitoglou and A. D. Trendall. *Apulian Red-Figured Vase-Painters of the Plain Style*. Rutland, Vt.

Carpenter 1990. T. H. Carpenter. *Art and Myth in Ancient Greece*. London.

———2005. T. H. Carpenter. "Images of Satyr Plays in South Italy." In Harrison (G. W. M.) 2005, pp. 219–36.

———2007. T. H. Carpenter. Introduction. In Csapo and Miller 2007, pp. 41–47.

———2009. T. H. Carpenter. "Prolegomena to the Study of Apulian Red-Figure Pottery." *AJA* 113: 27–38.

Caskey and Beazley 1931. L. D. Caskey and J. D. Beazley. *Attic Vase Paintings in the Museum of Fine Arts, Boston*, part 1. London.

———1954. L. D. Caskey and J. D. Beazley. *Attic Vase Paintings in the Museum of Fine Arts, Boston*, part 2. London.

Cassano 1996. R. Cassano. *L'Apulia, Ruvo, Canosa, Egnazia e gli scavi dell'Ottocento in I Greci in Occidente: La Magna Grecia nelle collezioni del Museo archeologico di Napoli*. Naples.

Cassimatis 2005. Hélène Cassimatis. "La violence dans les figurations de scènes théatrales portées par la céramique italiote." In *La violence dans les mondes grec et romain*, edited by J.-M. Bertrand, pp. 39–65. Paris.

Catoni 2008. M. L. Catoni. *La forza del bello: L'arte greca conquista l'Italia*. Exh. cat. Milan.

Ceccarelli and Milanezi 2007. Paola Ceccarelli and Silvia Milanezi. "Dithyramb, Tragedy—and Cyrene." In Wilson 2007, pp. 185–214.

Chamay 1977. J. Chamay. "Autour d'un vase phlyaque, un instrument de portage." *AK* 20: 57–60.

Charitonidis, Kahil, and Ginouvès 1970. Sérafim Charitonidis, Lilly Kahil, and René Ginouvès. *Les mosaïques de la maison du Ménandre à Mytilène*. (*AK*, supplement 6.) Bern.

Clair 2005. J. Clair, ed. *Mélancholie: Genie et folie en Occident*. Exh. cat. Paris.

Cleveland Museum of Art 1991a. *Bulletin of the Cleveland Museum of Art* 78, no. 2.

———1991b. *Bulletin of the Cleveland Museum of Art* 78, no. 3.

———1991c. "Recent Acquisitions at the Cleveland Museum of Art 1: Departments of Western Art." *Burlington Magazine* 133 (no. 1054): 63–68.

———1991d. *Handbook of the Cleveland Museum of Art*. Cleveland.

———1992a. *Bulletin of the Cleveland Museum of Art* 79, no. 1.

———1992b. *Bulletin of the Cleveland Museum of Art* 79, no. 2.

———1992c. *Masterpieces from East and West*. New York.

Cohen 1991. B. Cohen. "The Literate Potter: A Tradition of Incised Signatures on Attic Vases." *Metropolitan Museum Journal* 26: 49–95.

———2000. B. Cohen. *Not the Classical Ideal: Athens and the Construction of the Other in Greek Art*. Leiden.

Cohen, Shapiro, and Trendall 1995. B. Cohen, H. A. Shapiro, and A. D. Trendall, eds. *Mother City and Colony: Classical Athenian and South Italian Vases in New Zealand and Australia*. Christchurch, N.Z.

Colvin 2000. S. Colvin. "The Language of Non-Athenians in Old Comedy." In Harvey, Wilkins, and Dover 2000, pp. 285–98.

Copenhagen 1970. *Nationalmuseets Arbejdsmark*. Copenhagen.

Csapo 1986. E. Csapo. "A Note on the Würzburg Bell-Crater H5697 ('Telephus Travestitus')." *Phoenix* 40: 379–92.

———1997. E. Csapo. "Riding the Phallus for Dionysos: Iconology, Ritual, and Gender-Role De/Construction." *Phoenix* 51: 253–96.

———2003. E. Csapo. "The Dolphins of Dionysos." In *Poetry, Theory, Praxis: The Social Life of Myth, Word, and Image in Ancient Greece*, edited by E. Csapo and M. Miller, pp. 69–98. Oxford.

———2008. E. Csapo. "The Iconography of the Exarchos." *MeditArch* 19/20: 55–65.

Csapo and Miller 2007. E. Csapo and M. Miller, eds. *The Origins of Theater in Ancient Greece and Beyond: From Ritual to Drama*. Cambridge.

Csapo and Slater 1994. E. Csapo and W. J. Slater. *The Context of Ancient Drama*. Ann Arbor, Mich.

D'Amicis, Dell'Aglio, and Lippolis 1991. A. D'Amicis, A. Dell'Aglio, and E. Lippolis. *Vecchi scavi, nuovi restauri*. Exh. cat. Taranto.

Davidson and Pomeroy 2003. J. Davidson and A. Pomeroy, eds. *Theatres of Action: Papers for Chris Dearden*. Auckland.

Davies 1978. M. I. Davies. "Sailing, Rowing, and Sporting in One's Cups on the Wine-Dark Sea." In *Athens Comes of Age: From Solon to Salamis*. Princeton, N.J.

Dearden 1988. C. W. Dearden. "Phlyax Comedy in Magna Graecia: A Re-assessment." In *Studies in Honour of T. B. L. Webster*, edited by J. H. Betts, J. T. Hooker, and J. R. Green, pp. 33–41. Bristol, U.K.

———1990. C. W. Dearden. "Fourth-Century Tragedy in Sicily, Athenian or Sicilian?" In Descoeudres 1990, pp. 221–42.

———1999. C. W. Dearden. "Plays for Export." *Phoenix* 53: 222–48.

De Caro 2001. Stefano de Caro. *Ercole: L'eroe, il mito*. Exh. cat. Milan.

Degrassi 1965. N. Degrassi. "Il Pittore di Policoro e l'officina di ceramica protoitaliota di Eraclea Lucana." *Bollettino d'arte* 50: 5–37.

———1967. N. Degrassi. "Meisterwerke Frühitaliotischer Vasenmalerei aus einem Grab in Policoro." In *Archäologische Forschungen in Lukanien*, vol. 2, *Herakleiastudien*, pp. 193–234. Heidelberg.

Denoyelle 1994. M. Denoyelle. *Chefs d'œuvre de la céramique grecque dans les collections du Louvre*. Paris.

———1997. M. Denoyelle. "Attic or Non-Attic? The Case of the Pisticci Painter." In *Athenian Potters and Painters: The Conference Proceedings*, edited by J. Oakley, W. D. E. Coulsen, and O. Palagia, pp. 395–405. Oxford.

———2002. M. Denoyelle. "Style individuel, style local, et centres de production: Retour sur le cratère des 'Karneia.'" *Mélanges de l'École française de Rome, Antiquité* 114: 587–609.

———2009. M. Denoyelle. *Vasi antichi Museo Archeologico Nazionale di Napoli*. Naples.

Descoeudres 1990. J.-P. Descoeudres, ed. *Greek Colonists and Native Populations: Proceedings of the First Australian Congress of Classical Archaeology*. Oxford.

Dolci 2006. M. Dolci. "Cratere a volute apulo a figure rosse." In *Ceramiche attiche e magno greche: Collezione Banca Intesa*, vol. 2, edited by G. Sena Chiesa and F. Slavazzi, pp. 306–9. Exh. cat. Milan.

Dumont 1984. J. C. Dumont. "La comédie phlyaque et les origines du théâtre romain." In *Texte et image: Actes du colloque international de Chantilly*, pp. 135–50. Paris.

Dunbar 1995. N. Dunbar, ed. (with intro. and commentary). *Aristophanes' "Birds."* Oxford.

Easterling 1997. P. Easterling, ed. *The Cambridge Companion to Greek Tragedy*. Cambridge.

Easterling and Hall 2002. P. Easterling and E. Hall, eds. *Greek and Roman Actors: Aspects of an Ancient Profession*. Cambridge.

Fittschen 1991. K. Fittschen. "Zur Rekonstruktion Griechischer Dichterstatuen." *Mitteilungen des Deutschen Archäologischen Instituts, Athenische Abteilung* 106: 276-77.

Foley 2000. H. Foley. "The Comic Body in Greek Art and Drama." In *Not the Classical Ideal: Athens and the Construction of the Other in Greek Art*, edited by B. Cohen, pp. 275–311. Leiden, Boston, Köln.

Friis Johansen 1959. K. Friis Johansen. *Eine Dithyrambos-Aufführung*. Copenhagen.

Fronig 1971. H. Fronig. *Dithyrambos und Vasenmalerei in Athen*. Würzburg.

———2002. H. Fronig. "Maske und Kostüme." In Moraw and Nölle 2002, pp. 70–95.

Gaunt 2002. J. Gaunt. "The Attic Volute Krater." Ph.D. diss. New York.

Gigante 1971. M. Gigante. *Rintone e il teatro in Magna Grecia*. Naples.

———1988. M. Gigante. "Profilo di una storia letteraria della Magna Grecia: Rintone nella civiltà teatrale della Magna Grecia." In *Magna Grecia*, vol. 3, edited by G. Pugliese Carratelli, pp. 275–81. Milan.

Gilula 1995. D. Gilula. "The Choregoi Vase: Comic Yes, but Angels?" *Zeitschrift für Papyrologie und Epigraphik* 109: 5–10.

Giudice 1985. F. Giudice. "I ceramografi del IV secolo A.C." In Pugliese Carratelli 1985, pp. 243–60.

Giuliani and Most 2007. L. Giuliani and G. W. Most. "Medea in Eleusis, in Princeton." In *Visualizing the Tragic: Drama, Myth, and Ritual in Greek Art and Literature*, edited by C. Kraus et al., pp. 197–217. Oxford.

Goette 2007a. Hans Rupprecht Goette. "An Archaeological Appendix." In Wilson 2007, pp. 116–21.

———2007b. Hans Rupprecht Goette. "Choregic Monuments and the Athenian Democracy." In Wilson 2007, pp. 122–49.

Goldhill and Osborne 1999. S. Goldhill and R. Osborne, eds. *Performance Culture and Athenian Democracy*. Cambridge.

Green 1972. J. R. Green. "Oinochoe." *BICS* 19: 1–16.

———1985. J. R. Green. "A Representation of the *Birds* of Aristophanes." In *Greek Vases in the J. Paul Getty Museum: Occasional Papers on Antiquities* 3: 95-118.

———1991. J. R. Green. "On Seeing and Depicting the Theatre in Classical Athens." *Greek, Roman and Byzantine Studies* 32: 15–50.

———1994. J. R. Green. *Theater in Ancient Greek Society*. London and New York.

———1999. J. R. Green. "Tragedy and the Spectacle of the Mind: Messenger Speeches, Actors, Narrative, and Audience Imagination in Fourth-Century BCE Vase-Painting." In *The Art of Ancient Spectacle*, edited by B. Bergman and C. Kondoleon, pp. 37–63. Washington, D.C.

———2001. J. R. Green. "Comic Cuts: Snippets of Action on the Greek Comic Stage." *BICS* 45: 37–64.

———2002. J. R. Green. "Towards a Reconstruction of Performance Style." In Easterling and Hall 2002, pp. 93–126.

———2003. J. R. Green. *Ancient Voices, Modern Echoes: Theatre in the Greek World*. Exh. cat. Sydney.

———2004. J. R. Green. "Bell Krater Depicting Three Chorusmen from a Satyr-Play." In *Treasures of the Nicholson Museum*, edited by D. Potts and K. Sowada, p. 96. Sydney.

———2007a. J. R. Green. "Let's Hear It for the Fat Man: Padded Dancers and the Prehistory of Drama." In Csapo and Miller 2007, pp. 96–107.

———2007b. J. R. Green. "Art and the Theatre in the Ancient World." In McDonald and Walton 2007, pp. 163–83.

———2007c. J. R. Green. *Greek and Roman Treasures in Christchurch*. Christchurch, N.Z.

———2009. *A Catalogue of the James Logie Memorial Collection of Classical Antiquities at the University of Canterbury*. Christchurch, N.Z.

Green and Handley 1995. J. R. Green and E. Handley. *Images of the Greek Theater*. Austin, Tex.

Griffiths 1995. Alan Griffiths, ed. *Stage Directions: Essays in Ancient Drama in Honour of E. W. Handley*. London.

Hall 2000. E. Hall. "Female Figures and Metapoetry in Old Comedy." In *The Rivals of Aristophanes: Studies in Athenian Old Comedy*, edited by F. D. Harvey, J. Wilkins, and K. J. Dover, pp. 407–18. London.

———2006. E. Hall. *The Theatrical Cast of Athens: Interactions between Ancient Greek Drama and Society*. Oxford.

———2007. "Introduction: Aristophanic Laughter across the Centuries." In *Aristophanes in Performance, 421 BC–AD 2007: Peace, Birds, and Frogs*, edited by E. Hall and A. Wrigley, pp. 1–29. London.

Halliwell 1993. S. Halliwell. "The Function and Aesthetics of the Greek Tragic Mask." In *Intertextualität in der griechisch-römischen Komödie*, edited by N. Slater and B. Zimmermann, p. 195ff. Stuttgart.

———1998. S. Halliwell. *Aristotle's Poetics*. Chicago.

Halm-Tisserant 1989. M. Halm-Tisserant. "Cephalophorie." *Babesch* 64: 100–113.

Harrison (G. W. M.) 2005. G. W. M. Harrison, ed. *Satyr Drama: Tragedy at Play*. Swansea, U.K.

Harrison (T.) 1990. T. Harrison. *The Trackers of Oxyrhynchus*. London.

Hedreen 1992. G. Hedreen. *Silens in Attic Black-Figure Vase-Painting: Myth and Performance*. Ann Arbor, Mich.

———2007. G. Hedreen. "Myths of Ritual in Athenian Vase-Paintings of Silens." In Csapo and Miller 2007, pp. 150–95.

Henle 1973. J. E. Henle. *Greek Myths: A Vase Painter's Notebook*. Bloomington, Ind.

Herington 1967. C. J. Herington. "Aeschylus in Sicily." *JHS* 87: 75–85.

Higgins 1967. R. A. Higgins. *Greek Terracottas*. London.

———1969. R. A. Higgins. *Catalogue of Terracottas in the Department of Greek and Roman Antiquities, British Museum*, vol. 1. London.

———1986. R. A. Higgins. *Tanagra and the Figurines*. London.

Hughes 1996. A. Hughes. "Comic Stages in Magna Graecia: The Evidence of the Vases." *Theatre Research International* 21 (no. 2): 95–108.

———2003. A. Hughes. "Comedy in Paestan Vase Painting." *OJA* 22: 281–301.

———2006. A. Hughes. "The 'Perseus Dance' Vase Revisited." *OJA* 25: 418–33.

———2008. A. Hughes. "Ai Dionysiazusai." *BICS* 51: 1–27.

Hunt 1912. A. S. Hunt, ed. *The Oxyrhynchus Papyri*, part 9. London.

———1927. A. S. Hunt, ed. *The Oxyrhynchus Papyri*, part 17. London.

Hurschmann 1985. R. Hurschmann. *Symposiensszenen auf unteritalischen Vasen*. Würzburg.

Iacopi 1958. G. Iacopi. "Un attore comico travestito da Papposileno: Statuetta marmorea da Torre Astura." *Bollettino d'arte* 2: 97–106.

Jeammet 2003. V. Jeammet, ed. *Tanagra: Mythe et archéologie*. Exh. cat. Paris.

Kaltsas 2004. Nikolaos Kaltsas, ed. *Agon*. Exh. cat. Athens.

Knoepfler 1993. Denis Knoepfler. *Les imagiers de l'Orestie*. Zurich.

Kossatz-Deissmann 1978. A. Kossatz-Deissmann. *Dramen des Aischylos auf westgriechischen Vasen*. Mainz.

Kraus 2007. C. Kraus, ed. *Visualizing the Tragic: Drama, Myth, and Ritual in Greek Art and Literature*. Oxford.

Kriseleit 2003. I. Kriseleit. In Rodá de Llanza and Musso 2003, pp. 180, 181.

Krumeich 2004. R. Krumeich. "Schöne und Geschmückte Choreuten in Attischen Theaterbildern der Spätarchaischen und Frühklassischen Zeit." In Barker, Beaumont, and Bollen 2004, pp. 158–63.

Krumeich, Pechstein, and Seidensticker 1999. R. Krumeich, N. Pechstein, and B. Seidensticker, eds. *Das Griechische Satyrspiel*. Darmstadt, Ger.

Kunze and Rügler 2006. M. Kunze and A. Rügler, eds. *Satyr Maske Festspiel: Aus der Welt des antiken Theaters*. Exh. cat. Stendal, Ger.

Ley 2006. G. Ley. *A Short Introduction to the Ancient Greek Theater*, rev. ed. Chicago.

Lissarrague 1990. F. Lissarrague. "Why Satyrs Are Good to Represent." In *Nothing to Do with Dionysos? Athenian Drama in Its Social Context*, edited by J. Winkler and F. I. Zeitlin, pp. 228–36. Princeton, N.J.

———1993. F. Lissarrague. "Wildness of Satyrs." In *Masks of Dionysos*, edited by T. H. Carpenter and C. A. Faraone, pp. 207–20. Ithaca, N.Y.

———2007. F. Lissarrague. *Greek Vases: The Athenians and Their Images*. New York.

Lloyd-Jones 1996. H. Lloyd-Jones, ed. and trans. *Sophocles*, vol. 3, *Fragments*. Cambridge, Mass., and London.

Lo Porto 1979. F. G. Lo Porto. "Un vaso apulo con scena fliacica." In Cambitoglou 1979a, pp. 107–10.

Madsen 1997. E. A. Madsen. "Celebrating the Pot-Feast in the Company of Aeschylus: An Approach to an Interpretation of the Exeter Pelike." *Classica et mediaevalia* 48: 53–73.

Malkin 1994. I. Malkin. *Myth and Territory in the Spartan Mediterranean*. Cambridge.

Marshall 2001. C. W. Marshall. "A Gander at the Goose Play." *Theatre Journal* 53: 53–71.

———2006. C. W. Marshall. *The Stagecraft and Performance of Roman Comedy*. Cambridge.

Matheson 1995. S. B. Matheson. *Polygnotos and Vase Painting in Classical Athens*. Madison, Wis.

———1997-98. S. B. Matheson. "Hounded by Furies." *Yale University Art Gallery Bulletin* 1997–98: 19–29.

Matthies 2006. S. Mathies. "Köstume." In Kunze and Rügler 2006, pp. 71–80.

Mattusch 1992. C. Mattusch. "A Bronze Warrior from Corinth." *Hesperia* 61: 79–84.

Mayo and Hamma 1982. M. E. Mayo and K. Hamma. *The Art of South Italy: Vases from Magna Graecia*. Exh. cat. Richmond, Va.

McDonald and Walton 2007. M. McDonald and J. M. Walton. *The Cambridge Companion to Greek and Roman Theatre*. Cambridge.

Mertens-Pack 3 Online Database: <*http://promethee.philo.ulg.ac.be/cedopal/indexsimpleanglais.asp*>

Messerschmidt 1932. F. Messerschmidt. "Bühnenbild und Vasenmalerei**.**" *RM* 47: 134–37.

Metropolitan Museum of Art 1914. *Bulletin of the Metropolitan Museum of Art* 9 (no. 11).

Miller 1997. M. C. Miller. *Athens and Persia in the Fifth Century B.C.* Cambridge.

———1999. M. C. Miller. "Reexamining Transvestism in Archaic and Classical Athens: The Zewadski Stamnos." *AJA* 103 (no. 2): 223–53.

Miller 2004. M. Miller. "In Strange Company: Persians in Early Attic Theatre Imagery." In Barker, Beaumont, and Bollen 2004, pp. 165–72, pls. 23–24.

Milne 1927. H. J. M. Milne, ed. *Catalogue of the Literary Papyri in the British Museum*. London.

Mingazzini 1966. P. Mingazzini. *Ceramica greca*. Milan.

Moltesen 1995. M. Moltesen. *Greece in the Classical Period: Ny Carlsberg Glyptotek*. Copenhagen.

Montanaro 2007. A. C. Montanaro. *Ruvo di Puglia e il suo territorio: Le necropoli*. Rome.

Moon 1929. N. R. Moon. "Some Early South Italian Vase-Painters." *Papers of the British School at Rome* 11: 30–49.

Moraw and Nölle 2002. S. Moraw and E. Nölle, eds. *Die Geburt des Theaters in der griechischen Antike*. Mainz.

Moret 1979. J. M. Moret. "Un ancêtre du phylactère: Le pilier inscrit des vases italiotes," part 2. *RA* (fasc. 2): 235–58.

Moretti 2001. J. C. Moretti. *Théâtre et société dans la Grèce antique*. Paris.

Mrogenda 1996. U. Mrogenda. *Die Terrakottafiguren von Myrina: Eine Untersuchung ihrer möglichen Bedeutung und Funktion im Grabzusammenhang*. Frankfurt.

Museo Nazionale Romano 1979. *Museo Nazionale Romano: Le sculture*, vol. 1. Rome.

Neils et al. 2003. J. Neils et al. *Coming of Age in Ancient Greece: Images of Childhood from the Classical Past*. Exh. cat. New Haven and London.

Nesselrath 1990. H.-G. Nesselrath. *Die attische mittlere Komödie: Ihre Stellung in der antiken Literaturkritik und Literaturgeschichte*. Berlin.

Nicola 2007. S. Nicola, ed. *In Scaena: Il teatro di Roma antica*. Exh. cat. Milan.

Oakley 1990. J. H. Oakley. *The Phiale Painter*. Mainz.

Olmos 2005. R. Olmos. "Cratera de cáliz con Zeus en escena de flíacos." In *Hijos de Crono: Vasos griegos del Museo Arqueológico Nacional*, edited by P. Cabrera and A. Castellano, pp. 62–63. Madrid.

Padgett 1989. J. M. Padgett. "The Geras Painter: An Athenian Eccentric and His Associates." Ph.D. diss. Cambridge, Mass.

Padgett et al. 1993. J. M. Padgett, M. B. Comstock, J. J. Herrmann, and C. C. Vermeule. *Vase-Painting in Italy: Red-Figure and Related Works in the Museum of Fine Arts, Boston*. Boston.

Paris 1990. Rita Paris, ed. *Persona: La maschera nel teatro antico*. Exh. cat. Rome.

Peredolskaja 1964. A. A. Peredolskaja. "Attische Tonfiguren aus einem südrussischen Grab." Reprinted in A. Schwarzmaier, "Ich werde immer Kore heissen: Zur Grabstele der Polyxena in der berliner Antikensammlung." *Jahrbuch des Deutschen Archäologischen Instituts* 121 (2006): 174–226.

Pianu 1989. G. Pianu 1989. "Riflessioni sulla cd. 'Tomba del Pittore di Policoro.'" In *Studi su Siris-Eraclea, Archaeologia Perusina*, vol. 8, pp. 85–94. Rome.

———1997. G. Pianu. "Contributi allo studio della politica ateniese in Magna Grecia nel V secolo A.C." *Ostraka* 6 (no. 1): 87–165.

Pickard-Cambridge 1966. A. Pickard-Cambridge. *The Theatre of Dionysus in Athens*, 2nd ed. Oxford.

———1988. A. Pickard-Cambridge. *The Dramatic Festivals of Athens*, 2nd ed. Oxford.

Picón 2007. C. A. Picón et al. *Art of the Classical World in the Metropolitan Museum of Art*. New York.

Piqueux 2006. A. Piqueux. "Quelques réflexions à propos du cratère en cloche d'Astéas, Phrynis, et Pyronidès." *Apollo* 22: 3–10.

Pöhlmann 1997. E. Pöhlmann. "La scène ambulante des Technites." In *De la scène aux gradins: Théâter et représantations dramatiques après Alexandre le grand*, edited by B. Le Guen, pp. 3–12. Toulouse.

Polacco and Anti 1990. L. Polacco and C. Anti. *Il Teatro di Siracusa: Pars Altera*. Padua.

Portale 1996. E. C. Portale. "Scheda." In Pugliese Carratelli 1996.

Pottier and Reinach 1887. E. Pottier and S. Reinach. *La nécropole de Myrina*. Paris.

Poulsen 1951. F. Poulsen. *Catalogue of Ancient Sculpture in the Ny Carlsberg Glyptotek*. Copenhagen.

Prag 1985. A. J. N. W. Prag. *The Oresteia*. Chicago.

Prange 1989. M. Prange. *Der Niobidenmaler und seine Werkstatt*. Frankfurt.

Pugliese Carratelli 1983. G. Pugliese Carratelli. *Megale Hellas: Storia e civiltà della Magna Grecia*. Milan.

———1985. G. Pugliese Carratelli, ed. *Sikanie: Storia e civiltà della Sicilia greca*. Milan.

———1990. G. Pugliese Carratelli, ed. *Magna Grecia*, vol. 4, *Arte e artigianato*. Milan.

———1996. G. Pugliese Carratelli, ed. *I greci in occidente*. Exh. cat. Venice.

Raeder 1983. J. Raeder. *Die statuarische Ausstattung der Villa Hadriana bei Tivoli*. Frankfurt.

———1984. J. Raeder. *Priene: Funde aus einer griechischen Stadt*. Berlin.

Rehm 1992. R. Rehm. *Greek Tragic Theatre*. London.

Reilly 1994. J. Reilly. "Standards, Maypoles, and Sacred Trees?" *AA* 109: 499–505.

Revermann 2005. Martin Revermann. "The 'Cleveland Medea' Calyx Crater and the Iconography of Ancient Greek Theater." *Theatre Research International* 30: 3–18.

———2006. *Comic Business: Theatricality, Dramatic Technique, and Performance Contexts*. Oxford.

Richter 1927. G. M. A. Richter. "Two Theatre Vases." *Bulletin of the Metropolitan Museum of Art* 22 (no. 2): 54–58.

———1965. G. M. A. Richter. *The Portraits of the Greeks*, 3 vols. London.

———1984. G. M. A. Richter. *The Portraits of the Greeks*, rev. ed. Ithaca, N.Y.

Ridgway 1994. B. S. Ridgway. *Greek Sculpture in the Art Museum, Princeton University: Greek Originals, Roman Copies and Variants*. Princeton, N.J.

Robertson 1975. M. Robertson. *A History of Greek Art*. Cambridge.

Robinson (D. M.) 1952. D. M. Robinson. *Excavations at Olynthus*, vol. 14. Baltimore.

Robinson (E. G. D.) 2004. E. G. D. Robinson. "Reception of Comic Theatre amongst the Indigenous South Italians." In Barker, Beaumont, and Bollen 2004, pp. 193–212.

Robsjohn-Gibbings and Pullin 1963. T. H. Robsjohn-Gibbings and C. Pullin. *Furniture of Classical Greece*. New York.

Rodá de Llanza and Musso 2003. I. Rodá de Llanza and O. Musso, eds. *El Teatro Romano: La puesta en escena*. Exh. cat. Zaragoza, Spain.

Rohde 1970. E. Rohde. *Griechische Terrakotten*. Tübingen.

Romagnoli 1907. E. Romagnoli. "Vasi del Museo di Bari con rappresentazioni fliaciche." *Ausonia* 2: 251–60.

———1923. *Nel regno di Dioniso*. Bologna.

Röttgen 1981. S. Röttgen. "Zum Antikenbesitz des Anton Raphael Mengs und zur Geschichte und Wirkung seiner Abgufs- und Formensammlung." In *Antikensammlungen im 18. Jahrhundert: Symposion Frankfurt 1978*. Berlin.

Rumpf 1951. A. Rumpf. "Parrhasios." *AJA* 55: 1–12.

———1961. A. Rumpf. "Attische Feste—Attische Vasen." *Bonner Jahrbücher* 161: 208-14.

Rumscheid 2006. F. Rumscheid. *Die figürlichen Terrakotten von Priene*. Berlin.

Russell and Winterbottom 1989. D. A. Russell and M. Winterbottom. *Classical Literary Criticism*. New York.

Rusten 2006. Jeffrey Rusten. "Who 'Invented' Comedy? The Ancient Candidates for the Origins of Comedy and the Visual Evidence." *AJP* 127: 37-66.

Sakellaropoulou 2008. Ph. Sakellaropoulou. Σκηνικά προβλήματα στους Βατραχους του Αριστοφάνη. Patras, Greece.

Salskov 2002. R. H. Salskov. "Pots for the Living, Pots for the Dead." *Acta Hyperborea* 9: 9–32.

Sannibale 2005. M. Sannibale. "Python." In *Il settecento a Roma*, edited by A. Lo Bianco and A. Negro, pp. 289, 296–97. Exh. cat. Cinisello Balsamo, Italy.

Schauenburg 1960. K. Schauenburg. *Perseus in der Kunst des Altertums*. Bonn.

Schefold and Jung 1989. K. Schefold and F. Jung. *Die Sagen von den Argonauten, von Theben und Troia in der klassischen und hellenistischen Kunst*. Munich.

Schmidt (E.) 1994. E. Schmidt. *Katalog der antiken Terrakotten*, vol. 1, *Die figürlichen Terrakotten*. Mainz.

Schmidt (M.) 1967. M. Schmidt. "Dionysien." *AK* 10: 70–81.

———1986. M. Schmidt. "Medea und Herakles: Zwei tragische Kindermörder." In *Studien zur Mythologie und Vasenmalerei*, edited by Elke Böhr and Wolfram Martini, pp. 169–74. Mainz.

———1998. M. Schmidt. "Komische Arme Teufel und andere Gesellen auf der griechischen Komödienbühne." *AK* 41: 17–32.

Scholl 2000. A. Scholl. "Die Älteste Satyrmaske des Griechischen Theaters? Zur Kopie Eines Frühklassischen Reliefs in Kopenhagen." *AK* 43: 44–51.

Schwarzmaier 2006. A. Schwarzmaier. In Kunze and Rügler 2006, p. 61.

Séchan 1926. L. Séchan. *Études sur la tragédie grecque dans ses rapports avec la céramique*. Paris.

Seidensticker 2003. B. Seidensticker. "The Chorus in Greek Satyrplay." In Csapo and Miller 2003, pp. 100–121.

Sena Chiesa and Arslan 2004. G. Sena Chiesa and E. Arslan. *Miti Greci: Archeologia e pittura dalla Magna Grecia al collezionismo*. Exh. cat. Milan.

Sena Chiesa and Slavazzi 2006. G. Sena Chiesa and F. Slavazzi, eds. *Ceramiche attiche e magnogreche: Collezione Banca Intesa*. Exh. cat. Milan.

Shapiro 1989. H. A. Shapiro. *Art and Cult under the Tyrants in Athens*. Mainz.

———1994. H. A. Shapiro. *Myth into Art: Poet and Painter in Classical Greece*. London and New York.

Sifakis 1967. G. M. Sifakis. "Singing Dolphin Riders." *BICS* 14: 36–37.

———1971. *Parabasis and Animal Choruses*. London.

Simon 1969. E. Simon. *Götter der Griechen*. Munich.

———1982. E. Simon. *The Ancient Theater*. New York.

———1983. E. Simon. *Festivals of Attica*. Madison, Wis.

Sinn 2006. F. Sinn. *Reliefgeschmückte Gattungen römischer Lebenskultur: Griechische Originalskulptur: Monumente orientalischer Kulte*. Wiesbaden.

Small 2003. J. P. Small. *The Parallel Worlds of Classical Art and Text*. Cambridge.

———2005. J. P. Small. "Pictures of Tragedy?" In *A Companion to Greek Tragedy*, edited by J. Gregory, pp. 103–18. Oxford.

Söldner 1993. M. Söldner. "Statuenbasen? Die 'flachen Basen': Motivesgeschichte und problematic eines Bildelements in der unteritalischen Vasenmalerei." *Jahrbuch des Deutschen Archäologischen Instituts* 108: 255–320.

Sommerstein 2009. A. H. Sommerstein. *Talking about Laughter and Other Studies in Greek Comedy*. Oxford.

Sotheby's New York 1990. *The Nelson Bunker Hunt Collection: Important Greek Vases*. 19 June 1990.

Sourvinou-Inwood 1997. C. Sourvinou-Inwood. "Medea at a Shifting Distance: Images and Euripidean Tragedy." In *Medea: Essays on Medea in Myth, Literature, Philosophy, and Art*, edited by J. J. Clauss and S. I. Johnston, pp. 253–96. Princeton, N.J.

Steinhart 2004. M. Steinhart. *Die Kunst der Nachahmung: Darstellungen memetischer Vorführungen in der griechischen Bildkunst archaischer und klassischer Zeit*. Mainz.

———2007. M. Steinhart. "From Ritual to Narrative." In Csapo and Miller 2007, pp. 196–220.

Storey and Allan 2005. I. C. Storey and A. Allan. *A Guide to Ancient Greek Drama*. Malden, Mass., and Oxford.

Summerer 1999. L. Summerer. *Hellenistisch Terrakotten aus Amisos*. Stuttgart.

Sutton 1984. Dana F. Sutton. "Scenes from Greek Satyr Plays Illustrated in Greek Vase-Paintings." *Ancient World* 9: 119–26.

Taplin 1977. O. Taplin. *The Stagecraft of Aeschylus*. Oxford.

———1978. O. Taplin. *Greek Tragedy in Action*. London.

———1987. O. Taplin. "Phallology, Phlyakes, Iconography, and Aristophanes." *Proceedings of the Cambridge Philological Society* 13 (no. 30): 92–104.

———1991. O. Taplin. "Auletai and Auletrides in Greek Comedy and Comic Vase-Painting." *Numismatica ed Antichità Classica, Quaderni Ticinesi* 20: 31–48.

———1993a. O. Taplin. *Comic Angels*. Oxford.

———1993b. O. Taplin. "Do the 'Phlyax Vases' Have Bearings on Athenian Comedy and the Polis?" In *Tragedy, Comedy, and the Polis: Papers from the Greek Drama Conference, Nottingham 18–20 July 1990*, edited by A. H. Sommerstein et al., pp. 527–44. Bari, Italy.

———1994. O. Taplin. "The Beauty of the Ugly: Reflections of Comedy in the Fleischman Collection." In True and Hamma 2004, pp. 15–27.

———1997. O. Taplin. "The Pictorial Record." In Easterling 1997, pp. 69–90.

———1998. O. Taplin. "Narrative Variation in Vase-Painting and Tragedy: The Example of Dirke." *AK* 41: 33–39, pls. 8, 9.

———1999. O. Taplin. "Spreading the Word through Performance." In Goldhill and Osborne 1999, pp. 33–57.

———2004. O. Taplin. "The Beauty of the Ugly: Reflections of Comedy in the Fleischman Collection." In True and Hamma 2004, pp. 15–27.

———2007. O. Taplin. *Pots and Plays: Reflections of Tragedy and Comedy in Greek Painted Pottery of the Fourth Century B.C.* Los Angeles.

Taplin and Wyles 2010. O. Taplin and Rosie Wyles, eds. *The Pronomos Vase and Its Context*. Oxford.

Tiverios 1996. M. Tiverios. *Ellenike techne, archaia aggeia*. Athens.

Todisco 1990. L. Todisco. "Teatro e *theatra* nelle immagini e nell'edilizia monumentale della Magna Grecia." In Pugliese Carratelli 1990, pp. 103–58.

———2002. L. Todisco. *Teatro e spettacolo in Magna Grecia e in Sicilia: Testi, immagini, architettura*. Milan.

———2003. L. Todisco. *La ceramica figurata a soggetto tragico in Magna Grecia e Sicilia*. Rome.

Tokyo 2006. *Masterpieces of the Louvre Museum: Classical Greece*. Exh. cat. Tokyo.

Tompkins 1983. J. F. Tompkins, ed. *Wealth of the Ancient World*. Fort Worth, Tex.

Trendall 1936. A. D. Trendall. *Paestan Pottery*. London

———1938. A. D. Trendall. *Frühitaliotische Vasen*. Leipzig.

———1953-55. A. D. Trendall. *Vasi italioti ed etruschi a figure rosse*, vols. 1 and 2. Vatican City.

———1959. A. D. Trendall. *Phlyax Vases*. London.

———1967. A. D. Trendall. *Phlyax Vases*, 2nd ed. BICS supp. 19.

———1969-70. A. D. Trendall. "Archaeology in South Italy and Sicily." *Arceological Reports. London*. 16: 45ff.

———1971. A. D. Trendall. *Greek Vases in the Logie Collection*. Christchurch, N.Z.

———1974. A. D. Trendall. *Early South Italian Vase-Painting*. Mainz.

———1984. A. D. Trendall. "Medea at Eleusis on a Volute Krater by the Darius Painter." *Record of the Art Museum, Princeton University* 43 (no. 1): 4–17.

———1987. A. D. Trendall. *The Red-Figured Vases of Paestum*. Rome.

———1990. A. D. Trendall. "On the Divergence of South Italian from Attic Red-Figure Vase-Painting." In Descouedres 1990, pp. 217–30.

———1991. A. D. Trendall. "Farce and Tragedy in South Italian Vase Painting." In *Looking at Greek Vases*, edited by T. Rasmussen and N. Spivey, pp. 151–82. Cambridge.

———1992. A. D. Trendall. "A New Early Apulian Phlyax Vase." *Bulletin of the Cleveland Museum of Art* 79 (no. 1): 2–15.

True 1988. M. True. "Incense Burner in the Form of a Comic Actor Seated on an Altar."
In *The Gods' Delight: The Human Figure in Classical Bronze*, edited by A. Kozloff and
D. G. Mitten, pp. 300–302, no. 54. Exh. cat. Cleveland.

True and Hamma 1994. M. True and K. Hamma, eds. *A Passion for Antiquities: Ancient Art from
the Collection of Barbara and Lawrence Fleischman*. Los Angeles.

Turner 2004. M. Turner. "Hamilton and Dionysos: Modern Provenance, Ancient Context."
In Barker, Beaumont, and Bollen 2004, pp. 93–103.

Van Hoorn 1951. G. Van Hoorn. *Choes and Anthesteria*. Leiden.

Vermeule 1968. C. Vermeule. "Vases and Terracottas in Boston: Recent Acquisitions." *CJ* 64
(no. 1): 49–67.

———1970. C. Vermeule. "Greek Vases in Boston: Important Recent Acquisitions." *Burlington
Magazine* 112 (no. 809): 624–34.

Vernant and Vidal-Naquet 1988. J.-P. Vernant and P. Vidal-Naquet. *Myth and Tragedy in Ancient
Greece*. New York.

Villard 1946. F. Villard. "L'évolution des coupes attiques à figures noires." *Revue des Etudes
Anciennes* 48: 153–81.

Von Bothmer 1983. D. von Bothmer, ed. *The Vatican Collections: The Papacy and Art*. Exh. cat.
New York.

Voza 1973. G. Voza. "Esplorazioni nell'area delle necropoli e dell'abitato." In *Archeologia nella
Sicilia Sud-Orientale*, edited by P. Pelagatti and G. Voza, pp. 81–107. Naples.

Walsh 2009. D. Walsh. *Distorted Ideals in Greek Vase-Painting: The World of Mythological
Burlesque*. Cambridge.

Walters 1903. H. B. Walters. *Catalogue of Terracottas in the Department of Greek and Roman
Antiquities*. London.

Walton 1980. J. M. Walton. *Greek Theater Practice*. London.

———1984. J. M. Walton. *The Greek Sense of Theatre: Tragedy Reviewed*. London. Rev. ed. 1996,
Amsterdam.

Warden 2004. G. Warden, ed. *Greek Vase Painting—Form, Figure, and Narrative: Treasures of
the National Archaeological Museum in Madrid*. Dallas.

Webster 1948. T. B. L. Webster. "South Italian Vases and Attic Drama." *Classical Quarterly* 25:
15–27.

———1954. T. B. L. Webster. "Some Monuments of Greek Comedy." In *Neue Beiträge zur
klassischen Altertumswissenschaft: Festschrift zum 60. Geburtstag von B. Schweitzer*, edited
by R. Lullies, pp. 260–63. Stuttgart.

———1956. T. B. L. Webster. *Greek Theatre Production*, vol. 1. London.

———1959. T. B. L. Webster. *Greek Art and Literature, 700-530 BC*. Dunedin, N.Z.

———1961. T. B. L. Webster. *Monuments Illustrating New Comedy*. London.

———1970a. T. B. L. Webster. *The Greek Chorus*. London.

———1970b. T. B. L. Webster. *Greek Theatre Production*, vol. 2. London.

———1972. T. B. L. Webster. *Potter and Patron in Classical Athens*. London.

Wiles 1991. D. Wiles. *The Masks of Menander*. Cambridge.

———1997. D. Wiles. *Tragedy in Athens: Performance Space and Theatrical Meaning*. Cambridge.

———2007. D. Wiles. *Mask and Performance in Greek Tragedy*. Cambridge.

———2008. D. Wiles. "The Poetics of the Mask in Old Comedy." In *Performance, Iconography,
Reception: Studies in Honour of Oliver Taplin*, edited by M. Revermann and P. Wilson,
pp. 374–94. Oxford.

Wilkins 2000. J. Wilkins. *The Boastful Chef: The Discourse of Food in Ancient Greek Comedy*.
Oxford.

Williams 1985. D. Williams. *Greek Vases*. London.

Wilson 1999. P. Wilson. "The Aulos in Athens." In Goldhill and Osborne 1999, pp. 58–95.

———2000. P. Wilson. *The Athenian Institution of the "Khoregia": The Chorus, the City, and the
Stage*. Cambridge.

———2002. P. Wilson. "The Musicians among the Actors." In Easterling and Hall 2002,
pp. 41–70.

———2007. P. Wilson, ed. *The Greek Theatre and Festivals*. Oxford.

———2010. P. Wilson. "The Musical World of Pronomos." In Taplin and Wyles 2010.

Winter 1903. F. Winter. *Die Typen der figürlichen Terrakotten*, vol. 2. Berlin.

Woodford 2003. Susan Woodford. *Images of Myths in Classical Antiquity*. London.

Wuilleumier 1939. P. Wuilleumier. *Tarente des origins à la conquète romaine*. Paris.

INDEX

ILLUSTRATION CREDITS

Basel, Antikenmuseum Basel und Sammlung Ludwig: plate 12. Photo: Andreas F. Voegelin.

Berlin, Antikensammlung, Staatliche Museen zu Berlin—Preussischer Kulturbesitz: figs. 1.4, 1.8, 3.2, 3.9, © Bildarchiv Preussischer Kulturbesitz / Art Resource, NY. | plates 32, 37, 74, 77, 88, Bildarchiv Preussischer Kulturbesitz / Antikensammlung, Staatliche Museen zu Berlin. Photos: Johannes Laurentius. | plate 57, Bildarchiv Preussischer Kulturbesitz / Antikensammlung, Staatliche Museen zu Berlin. | plate 75, Bildarchiv Preussischer Kulturbesitz / Antikensammlung, Staatliche Museen zu Berlin. Photo: Karin Marz. | plate 76, Bildarchiv Preussischer Kulturbesitz / Antikensammlung, Staatliche Museen zu Berlin. Photo: Ingrid Geske.

Boston, Museum of Fine Arts, Boston: plates 8, 15, 51, Courtesy of Museum of Fine Arts, Boston. | plate 46, Courtesy of Museum of Fine Arts, Boston. Francis Bartlett Donation of 1900, Museum of Fine Arts, Boston. | plate 47, Courtesy of Museum of Fine Arts, Boston. Frederick Brown Fund, Museum of Fine Arts, Boston.

Copenhagen, The National Museum of Denmark: plates 13, 20, 70, 71, 90, Copyright The National Museum of Denmark, Collection of Classical and Near Eastern Antiquities. Photographer: John Lee.

Copenhagen, Ny Carlsberg Glyptotek: plate 1, Photograph: H. R. Goette.

London, British Library: plate 40, © British Library Board (Papyrus 2098).

London, British Museum: fig 3.14; plates 11, 25, 36, 43, 45, 49, 53, 65, 66, 86, 91, © The Trustees of the British Museum.

Madrid, Photo Archive, Museo Arqueológico Nacional: plates 33, 54.

Milan, Museo Archaeologico: fig. 3.4, Courtesy of Civiche Raccolte Archeologiche di Milano.

Naples, Museo Archeologico Nazionale di Napoli: fig. 1.9, 2.1, 3.7, 3.12, 3.13; plates 21, 35, 44.

New York, The Metropolitan Museum of Art: plate 9, Gift of Norbert Schimmel Trust, 1989, The Metropolitan Museum of Art © The Metropolitan Museum of Art / Art Resource, NY. | plate 50, © The Metropolitan Museum of Art / Art Resource, NY. | plates 59–64, Rogers Fund, 1913, The Metropolitan Museum of Art © The Metropolitan Museum of Art / Art Resource, NY.

Paris, Département des Antiquités Grecques, Etrusques et Romaines, Musée du Louvre: fig. 2.3; plates 5, 10, 18, 19, 22, 24, 29, 38, 39, 42, 48, 52, 52, 67–69, 79, 81–85, © Réunion des Musées Nationaux / Art Resource, NY.

Policoro, Museo Nazionale della Siritide: plates 28, 31, Ministero per i Beni e le Attivita Culturali, Direzione Regionale per i Beni Culturali e Paesaggistici della Basilicata, Archivio della Soprintendenza per i Beni Archeologici della Basilicata.

Princeton, Princeton University Art Museum: plate 30, 73. Photos: Bruce M. White.

Rome, il Ministero per i Beni e le Attiva Culturali della Repubblica Italiana: figs. 1.6, 3.3.

Rome, Palazzo Massimo alle Terme, Museo Nazionale Romano: plate 41, Ministero per i Beni Culturali Soprintendenza Speciale per i Beni Archeologici di Roma. © Vanni / Art Resource, NY.

Rome, Private Collection: plate 55. Photo: Vincenzo Pirozzi, Rome.

Salerno, Museo Archeologico Provinciale di Salerno: fig. 3.6.

Siracuasa, Museo Archeologico Regionale "Paolo Orsi" di Siracuasa: plate 26, Courtesy of Assessorato ai Beni Culturali e dell Identità Siciliana della Regione Siciliana—Palermo.

Sydney, Nicholson Museum, University of Sydney: plate 16.

Taranto, Museo Archeologico Nazionale di Taranto: plate 56, Courtesy of Ministero per i Beni e le Attivita Culturali—Soprintendenza per i Beni Archeologici della Puglia.

Vatican State, Museo Gregoriano Etrusco, Vatican Museums: plate 17, © Alnari / Art Resource, NY. | plate 58, © Scala / Art Resource, NY.

Vicenza, Intesa Sanpaolo Collection: plate 34.

Würzburg, Martin von Wagner Museum der Universität Würzburg: fig. 1.16; plates 14, 78, 89, 92. Photos: Peter Neckermann.

ABOUT THE AUTHORS

JULIETTE BECQ is studies engineer in HALMA-IPEL-UMR 8164 of the National Center for Scientific Research at the Université de Lille 3, Ministère de la Culture et de la Communication, Lille, France.

MICHAEL BENNETT is curator of Greek and Roman art at the Cleveland Museum of Art.

SALVATORE BIANCO is director of the Museo Archeologico Nazionale della Siritide, Policoro (MT), Italy.

HERMAN BRIJDER is professor emeritus of classical archaeology and history of ancient art at the Universiteit van Amsterdam and former director of the Allard Pierson Museum, Amsterdam.

ÁNGELES CASTELLANO is curator of the Department of Greek and Roman Antiquities at the Museo Arqueológico Nacional, Madrid.

MARGARITA MORENO CONDE is conservator at the Museo Arqueológico Nacional, Madrid.

ANITA CRISPINO is an archaeologist at the Museo Archeologico Regionale "Paolo Orsi," Syracuse, Sicily.

MARTINE DENOYELLE is research adviser in the history of ancient art and the history of archaeology at the Institut National d'Histoire de l'Art, Paris.

JUAN GARCÉS is curator in the medieval and earlier manuscripts section at the British Library, London.

JASPER GAUNT is curator of Greek and Roman art at the Michael C. Carlos Museum of Emory University, Atlanta.

FEDERICA GIACOBELLO is an independent researcher, currently working in the Department of Antiquity Sciences at the Università degli Studi di Milano.

ALISON GRIFFITH is head of the Department of Classics at the University of Canterbury, Christchurch, New Zealand.

MARY LOUISE HART is associate curator of antiquities in the Department of Antiquities at the J. Paul Getty Museum, Los Angeles.

VIOLAINE JEAMMET is senior curator in the Department of Greek, Etruscan, and Roman Antiquities at the Musée du Louvre, Paris.

FRANÇOIS LISSARRAGUE is director of studies at the School of Advanced Studies in Social Sciences at the Centre Louis Gernet at the Institut National d'Histoire de l'Art, Paris.

MARINELLA LISTA is coordinating director of archaeology at the Museo Archeologico Nazionale, Naples.

LAURE MAREST-CAFFEY is a former curatorial assistant in the Department of Antiquities at the J. Paul Getty Museum, Los Angeles.

SOPHIE MARMOIS is a documentary researcher in the Department of Greek, Etruscan, and Roman Antiquities at the Musée du Louvre, Paris.

JEAN-LUC MARTINEZ is head of the Department of Greek, Etruscan, and Roman Antiquities at the Musée du Louvre, Paris.

NÉGUINE MATHIEUX is a researcher in the Department of Greek, Etruscan, and Roman Antiquities at the Musée du Louvre, Paris.

METTE MOLTESEN is curator at the Ny Carlsberg Glyptotek, Copenhagen.

BODIL BUNDGAARD RASMUSSEN is keeper of classical and Near Eastern antiquities at the Nationalmuseet, Copenhagen.

MIRIA ROGHI is curatorial assistant at the Palazzo Massimo alle Terme of the Museo Nazionale Romano, Rome.

MAURIZIO SANNIBALE is curator of the Gregorian Etruscan Museum, Vatican Museums, Vatican City.

AGNES SCHWARZMAIER is curator of antiquities at the Staatliche Museen zu Berlin.

H. A. SHAPIRO is professor of archaeology and classics at the Johns Hopkins University, Baltimore.

AMBRA SPINELLI served as the 2009–10 intern in the Department of Antiquities at the J. Paul Getty Museum, Los Angeles.

MICHAEL TURNER is senior curator at the Nicholson Museum, University of Sydney.

RENÉ VAN BEEK is curator at the Allard Pierson Museum, Amsterdam.

J. MICHAEL WALTON is emeritus professor of drama at the University of Hull, U.K.

IRMA WEHGARTNER is curator of antiquities at the Martin von Wagner Museum at the Universität Würzburg, Germany.